Süleyman the Magnificent

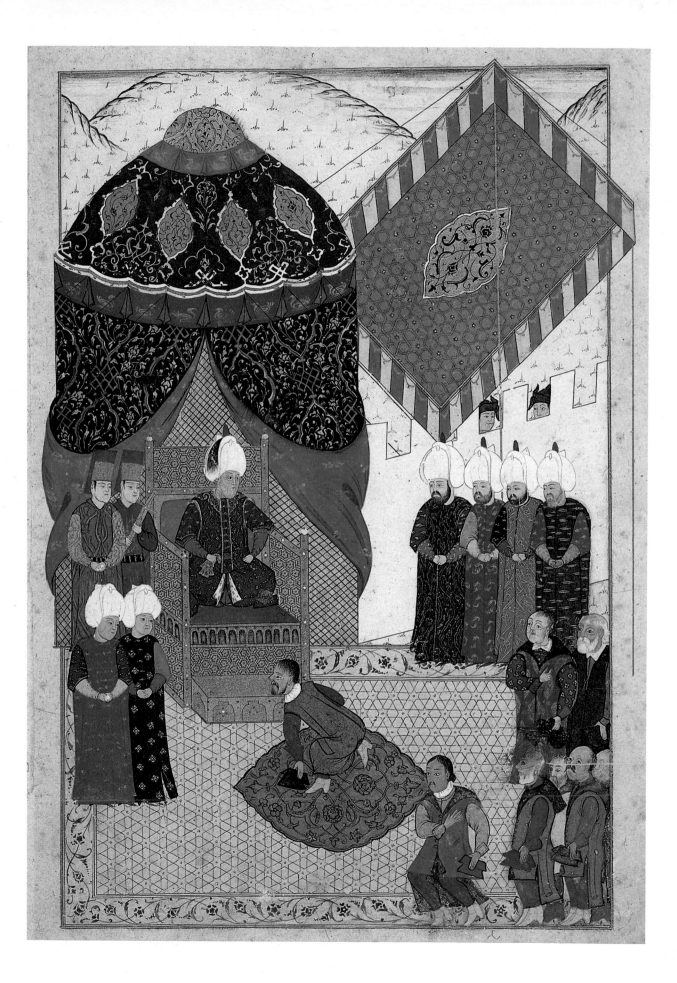

Süleyman the Magnificent

J.M. Rogers and R.M. Ward

Published for the
Trustees of the British Museum
by British Museum Publications

The Trustees of the British Museum
acknowledge with gratitude
generous assistance towards the
production of this book from
Standard Chartered PLC

and Interbank, Turkey

INTERBANK ULUSLARARASI

Published by British Museum Publications Ltd
46 Bloomsbury Street, London WC1B 3QQ

British Library Cataloguing in Publication data

Rogers, J.M.
 Süleyman the Magnificent.
 1. Art, Turkish——History——Catalogs
 2. Art, Medieval——Turkey——Catalogs
 I. Title II. Ward, R.M.
 709'.561 N7165

ISBN 0-7141-1440-5

Designed by Harry Green

Set in Linotron Garamond 3
by Tradespools Ltd, Frome, Somerset,
and printed in Italy by Motta

Photography by Reha Güney

with additional photographs by members of the British
Museum Photographic Service

Cover 45b. The battle of Mohács, from *Süleymānnāme*
(ff. 219b-220a).

Page 2 46a. Süleyman receiving John Sigismund ('Stephen')
Zápolya, his vassal, in Transylvania, from *Nüzhet esrār al-
aḫbār der sefer-i Sigetvār* (f. 16b).

Under the Patronage of

Her Majesty The Queen

His Excellency The President
of the Republic of Turkey

Committee of Honour

UNITED KINGDOM

The Rt Hon. Sir Geoffrey Howe QC MP
*Secretary of State for Foreign and Commonwealth
Affairs*

The Rt Hon. Richard Luce MP
Minister for the Arts

Mr Timothy Daunt CMG
HM Ambassador to Turkey

Sir Mark Russell KCMG
*Chief Clerk
Foreign and Commonwealth Office*

The Lord Windlesham CVO PC
Chairman of the Trustees of the British Museum

Sir David Wilson FBA
Director of the British Museum

REPUBLIC OF TURKEY

H E Mr Vahit Halefoğlu
The Minister of Foreign Affairs

H E Mr A. Mesut Yılmaz
The Minister of Culture and Tourism

H E Mr Rahmi Gümrükçüoğlu
Turkish Ambassador to the United Kingdom

Mr Ertan Cireli
*Under Secretary of the Ministry of Culture and
Tourism*

H E Mr Pulat Tacar
*Ambassador
Director-General for Cultural Affairs of the
Ministry of Foreign Affairs*

Dr Nurettin Yardımcı
*Director-General of Antiquities and Museums of
the Ministry of Culture and Tourism*

Contents

Message

from H E Mr A. Mesut Yılmaz,
Minister of Culture and Tourism, the Republic of Turkey

Exhibitions play a major role in bringing together people from different countries, enabling them to see, understand and appreciate fully the history and social characteristics of different nations. Taking this idea as our starting-point, an exhibition has been organised to present the times of Sultan Süleyman the Magnificent, a figure who has a special place in both Turkish and world history.

Without question one of the best ways to portray a period of history is through its works of art. Sultan Süleyman the Magnificent is generally known for his military exploits and conquests. By means of the objects in this exhibition, however, it is hoped to show his contribution to history as a lawgiver, educationalist and patron of the arts, and to emphasise the just nature of his rule.

It is our aim to provide visitors to the exhibition with an entertaining and educational insight into a particular period of history. The exhibition comprises objects which we regard as the cultural heritage of the whole world and which were made by man's creative spirit to reflect human emotions and ideas.

The exhibition attracted great interest when it was held in three major American cities during 1987, and it gives us considerable pleasure that, when shown for the first time in Europe, it should come to the United Kingdom where art and culture are so much appreciated.

I should like to take this opportunity to express a wish that by means of this exhibition, which is a major cultural event, a new link will be forged between our countries, and that it will provide an opportunity for those who already enjoy cultural and social ties of long standing to get to know each other even more closely. I should also like to express my thanks to all those who have contributed to the preparation of this exhibition.

Message

from the Rt Hon. Richard Luce MP,
Minister for the Arts, the United Kingdom

It is a great pleasure to welcome this splendid exhibition to Britain and to thank the Turkish Government for so generously lending some of Turkey's most important national treasures.

The Ottoman Sultan Süleyman, justly called 'the Magnificent', was one of the greatest figures on the European stage of the sixteenth century. Politically, militarily and culturally the Ottoman Empire was a bridge between East and West, while the sparkling wealth and opulence of Süleyman's court brought together treasures from every corner of Europe and Asia. I hope very much that this exhibition will serve to strengthen ties of understanding and friendship between our two countries which date back many centuries.

I also welcome the joint sponsorship by two great banking houses from our two countries, Standard Chartered PLC and Interbank, Turkey.

Foreword

by Sir David Wilson,
Director, British Museum

The first loan of objects from the splendid national collections of Turkey was to the great Munich exhibition of 1910, 'Meisterwerke Muhammedanischer Kunst', from the Topkapı Saray and other Turkish museums. There was then a substantial component, particularly manuscripts, in the Persian exhibition at the Royal Academy, London, in 1931, which further demonstrated the richness of Persian art in the collections of Istanbul. Since that time, however, apart from a small exhibition at the Fitzwilliam Museum, Cambridge, in the summer of 1967, England has not had the good fortune to play host to an exhibition from Turkey. In the 1950s and 60s two travelling exhibitions to France and to the United States of America awakened further interest in the important Turkish contribution to the arts of Islam and somewhat rectified the bias in favour of the arts of Persia which tradition and the exhibition of 1931 had implanted in the views of the art-loving public. The way was open for an exhibition entirely devoted to Turkey when in 1971 there was a setback as sudden as it was serious. The recently opened Opera House in Istanbul, to which objects had been lent for an exhibition from the collections of the Topkapı Saray, was destroyed by fire. To obviate further accidents the Turkish government passed legislation forbidding the loan of museum objects to outside exhibitions.

Then came the great Council of Europe exhibition of 1983 in Istanbul, 'The Anatolian Civilisations', to which the British Museum was proud to be asked to lend. This was a revelation, of the taste, scholarship and energy of those involved in mounting it and of the excellence of Ottoman art. What the Munich exhibition of 1910 had done for Islamic art in general and the exhibition of 1931 had done for Persian art, this did for Ottoman art, bringing about a revaluation of the place of the Sultans as patrons and collectors. It was justifiably acclaimed throughout Europe.

Our Turkish colleagues did not rest on their laurels but continued to press for the repeal of the legislation, to enable museums abroad to display some of these treasures, many of them previously unknown or unpublished, for the delight of the great public. They were successful, and the outcome was a large loan exhibition to Japan and the exhibition, 'Türkische Kunst und Kultur aus Osmanischer Zeit', which inaugurated the new Museum für Kunsthandwerk at Frankfurt am Main in 1985. The Trustees of the British Museum had been hoping for many years to display an exhibition of the great achievements of sixteenth-century Ottoman art, and

it is appropriate that this first major exhibition of Turkish art in the United Kingdom should be associated with one of the greatest European figures of his time, Süleyman the Magnificent, whose life, conquests and works eclipse even the glories of the Tudor monarchy.

The vast majority of the exhibits were shown previously in the United States in the exhibition, 'The Age of Süleyman the Magnificent', which opened at the National Gallery in Washington DC. The generous co-operation of Dr Esin Atıl, its Guest Curator, and her assistant, Mary-Rose Smythe, and the kindness, thoughtfulness and efficiency of the Gallery's Registrar, Mary Suzor and its Editor, Melanie B. Ness, have much facilitated the preparation of this text for the press.

This exhibition would not have been possible without the support of H.E. the Turkish Minister of Foreign Affairs, Mr Vahit Halefoğlu, and the Department of Cultural Relations of the Ministry of Foreign Affairs under its then head, Ambassador Ergun Sav, and of H.E. the Minister of Culture and Tourism, Mr Mesut Yılmaz, and Mr Ertan Cireli, Under Secretary, and Mr Aytuğ Iz'at, Deputy Under Secretary at that Ministry, and Dr Nurettin Yardımcı, Director-General of Antiquities and Museums. In London, H.E. the Turkish ambassador, Mr Rahmi Gümrükçüoğlu, Mr Aydın Şahinbaş, Mr Kaya Türkmen and Mr Hasan Göğüş of the Turkish Embassy have been patient and encouraging. We are deeply grateful to them all, as well as to the British ambassador in Ankara, Mr T.L.A. Daunt, C.M.G., and his predecessor, Sir Mark Russell, K.C.M.G., now Chief Clerk, the Foreign and Commonwealth Office, and Mr Edmund Marsden of the British Council, for their hospitality, and good offices.

Authors' acknowledgements

The generous co-operation of our colleagues in the Topkapı Saray Museum made our work easy and delightful: we wish to thank particularly Dr Sabahettin Türkoğlu (Director), Ülkü Altındağ (Archives), Emine Bilirgin (Treasury), Selma Delibaş (Embroideries), Banu Mahir (Library), Hülye Tezcan (Costumes and Textiles) and Turgay Tezcan (Arms and Armour). In the Turkish and Islamic Art Museum (TIEM) the Director, Dr Nazan Tapan-Ölçer, the Librarian, Şule Aksoy-Kutlukan, and the Deputy Director, Serab Aykoç, and the Librarian of Istanbul University were equally welcoming. Our greatest debt, however, is to three friends, Dr Filiz Çağman, the Librarian of the Topkapı Saray, who co-ordinated the loan, Professor Nurhan Atasoy of Istanbul University and Dr Zeren Tanındı, now of Bursa University. Their learning places them in the forefront of scholarship on Ottoman art, their wide sympathies and their curiosity make them stimulating and delightful colleagues, and their generosity and kindness over many years to scholars and visitors from all over the world have made them deservedly loved and admired.

To collaborators and colleagues in the British Museum we are grateful for much information and help – John Rowlands, Anthony Griffiths and Duncan Smith of the Department of Prints and Drawings, Mark Jones of the Department of Coins and Medals, T.H. Wilson of the Department of Medieval and Later Antiquities, who has written the entries for nos 47 and 48, and Ann Searight – and to Janet Backhouse, Chris Michaelides and M.I. Waley of the British Library. The Syndics of the Fitzwilliam Museum, Cambridge, and Professor Michael Jaffé generously lent their fine Agostino Veneziano woodcut of Barbarossa. The dauntingly wide scope of the material in the present exhibition has also led us to pester the most diverse people, and an alphabetical list gives little idea of the enormous value of their help: David Alexander, Metropolitan Museum of Art, New York; Sarah Bevan, Keeper of Edged Weapons, The Tower Armouries; Claude Bouheret, French Cultural Attaché, Istanbul; Professor John Carswell, University of Chicago; T.H. Clarke; Giovanni Curatola, University of Venice; Professor Suraiya Faroqhi, Middle East Technical University, Ankara; Professor Cornell Fleischer, Washington University, St Louis; Professor Barbara Flemming, University of Leiden; Professor Turhan Ganjei, School of Oriental and African Studies, University of London; Godfrey Goodwin, Librarian of the Royal Asiatic Society; Professor Richard Goldthwaite, Johns Hopkins University; Basil Gray; Professor Claus-Peter Haase, University of Kiel; Professor Halil Inalcık, University of Chicago; A.A. Ivanov, The Hermitage, Leningrad; David James, Chester Beatty Library, Dublin; Professor Klaus Kreiser, University of Bamberg; Professor Peter Levi, Oxford; Chris Lightfoot, British Institute of Archaeology at Ankara; Piers Mackesy, Pembroke College, Oxford; Nermin Menemencioğlu; Professor Michael Meinecke and Dr Viktoria Meinecke Berg, Deutsches Archäologisches Institut, Damascus; Diana Mott, University of Georgia; Helen Philon, the Benaki Museum, Athens; Julian Raby, St Hugh's College, Oxford; Tim Stanley, the Macmillan Dictionary of Art; Peter Stocks, Department of Oriental Manuscripts and Printed Books, the British Library; and Oliver Watson and Jennifer Wearden of the Victoria and Albert Museum. Specific debts are as far as possible acknowledged in the text. We also owe, however, a debt of gratitude which is difficult to express to Professor V.L. Ménage, whose skill in deciphering Roxelana's scribbles and construing her grammar made important new documents available to us and whose generous criticisms have spared us many faults. Special thanks must also go to Dr Esin Atıl, whose catalogue was invaluable in the preparation of this exhibition and its catalogue.

Claire Randell cheerfully and speedily typed out the text from drafts to perfect copies. Venetia Porter read the proofs and offered many valuable comments. Our designer, Geoff Pickup, has contributed much to the way we have come to see the objects exhibited here, and our editor, Deborah Wakeling, has created order out of chaos.

J.M. ROGERS and R.M. WARD
Oriental Antiquities, British Museum

Note on transliteration

Modern Turkish is a largely phonetic language with a Romanised script. The following letters are supplementary:

Vowels: ı, ö, ü

Consonants: c (j), ç (ch), ğ (gh), ş (sh)

For the transliteration of Ottoman there is a more or less accepted system, supplementing the modern Turkish alphabet with a number of diacritics

Long vowels: ā, ī, ō, ū

Consonants: ḍ, ṣ, ṭ, ẓ, ʿ, ẕ (dh), s̱ (th), j (zh), ñ (ng)

for letters of the Arabic or Persian alphabets or phonetic distinctions which no longer exist in modern Turkish. The system is partly transcription (i.e. giving phonetic equivalents) and partly transliteration (i.e. giving the equivalent of the letters without concern for their pronunciation) and when applied to Arabic or Persian may give bizarre or misleading results. While absolute consistency is almost impossible, we have transliterated Arabic or Persian, in an Arabic or Persian context, in accordance with the generally accepted European system (*IJMES*).

We have attempted to keep Turkish terminology to a minimum: the commonest terms will be found in the Glossary. As far as possible with familiar terms and names the Turkish construct (*izafet*) has been ignored, for example, Topkapı *Saray* not *sarayı*, *beglerbeg* not *beglerbegi*, etc. In Turkish dictionaries letters with diacritics follow the letter plain. For ease of reference in the Bibliography, however, the letters c, ç; g, ğ; ı, i; o, ö; s, ş; u, ü are conflated.

Abbreviations

AI *Ars Islamica*

AO *Ars Orientalis*

BBA *Başbakanlık Archives*

Bull. SOAS *Bulletin of the School of Oriental and African Studies*

DTCF (Ankara Üniversitesi) *Dil, Tarih ve Cografya Fakültesi*

EI² *Encyclopaedia of Islam*, 2nd edn

JA *Journal Asiatique*

JAOS *Journal of the American Oriental Society*

JRAS *Journal of the Royal Asiatic Society*

IA *Islam Ansiklopedisi*

IJMES *International Journal of Middle East Studies*

IUK Istanbul University Library

KO *Kunst des Orients*

QDAP *Quarterly of the Department of Antiquities of Palestine*

STY *Sanat Tarihi Yıllığı*

TD *Tarih Dergisi*

TED *Türk Etnografya Dergisi*

TIEM Türk ve Islam Eserleri Müzesi/Turkish and Islamic Art Museum

TKS Topkapı Saray Museum

TKSA Topkapı Saray Museum Archives

TOCS *Transactions of the Oriental Ceramic Society*

TTAED *Türk Tarih, Arkeologya ve Etnografya Dergisi*

TTK Türk Tarih Kurumu

WZKM *Wiener Zeitschrift für die Kunde des Morgenlandes*

ZDMG *Zeitschrift der Deutschen Morgenländischen Gesellschaft*

Certain common press marks in the Library of the Topkapı Saray Museum record the original locations of the manuscripts:

A. Library of Ahmed III

B. Baghdad Köşk

EH. Treasury attached to the shrine of the Hırka-i Saadet (*Emanet Hazinesi*)

H. Treasury (*Hazine*)

HS. Hırka-i Saadet

R. Revan Köşk

The exhibited manuscripts from Istanbul University Library are all from the nineteenth-century Palace of Yıldız, the library of which was made up of choice manuscripts from the Topkapı Saray library.

Chronology

1494	Süleyman born at Trebizond
1509	Accession of Henry VIII of England
1514	Selim I's victory over the Safavids at Çaldıran
1517	Ottoman conquest of Syria, Egypt and the Yemen
1519	Charles V elected emperor of Germany
1520	Accession as Sultan (30 September); Field of the Cloth of Gold, parley of Francis I of France with Henry VIII of England
1521	Capture of Belgrade (29 August); Diet of Worms (17 April)
1522	Capture of Rhodes (26 December)
1523	Ibrahim Paşa made Grand Vizier (27 June)
1524	Revolt of Ahmed Paşa in Egypt; Ibrahim Paşa's marriage (23 May–6 June)
1525	Ibrahim Paşa's Egyptian campaign; Francis I defeated at Pavia and made prisoner by Charles V (24 February)
1526	Hungarian campaign: Battle of Mohács (29 August); occupation of Buda (10 September); János Zápolya becomes King of Hungary; declaration of unity of Bohemia, Austria and Hungary by Ferdinand I
1527	Ferdinand of Austria in Buda; sack of Rome (May)
1529	Süleyman recaptures Buda (8 September); Zápolya crowned in Buda (14 September); siege of Vienna (26 September–16 October)
1530	(June–July) Circumcision feast for the Şehzades Mustafa and Cihangir
1532	Süleyman's 'German' campaign; capture of Güns (Köszeg) (28 August); Andrea Doria captures Coron (8 August)
1533	Peace with Ferdinand (22 June); Hayreddin Barbarossa becomes Admiral, conquers Tunis (August); war with Iran (August); accession of Ivan the Terrible of Muscovy, a tyrant (d. 1584)
1534	Conquest of Tabriz (13 July); Süleyman arrives at Baghdad to winter there;

	Barbarossa sacks coast of Apulia and Calabria
1535	Süleyman returns to Tabriz (spring); Charles V captures Tunis (21 July)
1536	Süleyman returns to Istanbul (8 January); execution of Ibrahim Paşa (16 March)
1537	War with Venice; Süleyman in Albania; devastation of Apulia (July); siege of Corfu (25 August)
1538	Süleyman in Moldavia (summer); annexation of southern Moldavia (4 October); Hadim Süleyman Paşa and Ottoman fleet besiege Portuguese factory of Bandar Diu in Gujarat (4 September); naval victory at Preveza (29 September)
1539	Conquest of Castelnuovo (10 August); circumcision feast for Şehzades Selim and Bayazid; marriage of Mihrimah Sultan to Rüstem Paşa
1540	Peace with Venice (2 October); surrender of Monemvasia and Napoli di Romagna (Nauplion); death of Zápolya; Austrians besiege Buda
1541	Süleyman's campaign against Ferdinand and re-entry into Buda (2 September); annexation of Hungary; Charles V before Algiers (20 October)
1543	Franco–Ottoman fleet takes Nice (20 August); Süleyman in Hungary; capture of Valpovo, Pécs, Siklós and Esztergom/Gran; Barbarossa winters at Toulon; death of Şehzade Mehmed (21 September)
1544	Ottoman fleet returns to Istanbul; Rüstem Paşa appointed Grand Vizier
1545	Armistice with Ferdinand
1546	Death of Francis I; death of Barbarossa
1547	Peace treaty with Habsburgs; Alqās Mīrzā arrives in Istanbul; accession of Henri II of France; Charles V defeats the Protestant Confederation at Mühlberg (24 April)
1548	Süleyman's second Iranian campaign; capture of Van (25 August); Süleyman winters in Aleppo

1549	Conquests in Georgia; Süleyman returns to Istanbul (12 December)
1551	Ottomans in Transylvania; conquest of Becskerek, Várad, Csanád and Lippa; Turgut (Dragut) Reis captures Tripoli (14 August)
1552	Conquest of Temesvár (July) and other cities in the Banat; Muscat and Hurmuz besieged and Suez fleet anchors at Basra; Russian occupation of Kazan
1553	War with Iran; execution of Şehzade Mustafa at Ereğli (Karaman) (21 September); accession of Queen Mary Tudor
1554	Conquest of Nahçıvan and Erevan; Russian occupation of Astrakhan
1555	Peace with Iran at Amasya (29 May)
1556	Abdication of Charles V
1557	Inauguration of Süleymaniye (16 August)
1556–9	Continued warfare against Austrians in Hungary
1558	Accession of Queen Elizabeth I; Death of Roxelana (Hürrem Sultan) (April)
1559	Civil war between Şehzade Bayazid and Şehzade Selim (May); Şehzade Bayazid takes refuge in Iran (November)
1560	Spaniards on Djerba; Piyale Paşa, the Admiral of the fleet captures Djerba (31 July)
1561	Şehzade Bayazid executed (25 September); Cossacks attack Azov
1562	Peace with Emperor Ferdinand (1 July)
1565	Siege of Malta (20 May–11 September)
1566	Siege of Szigetvár (6 September); death of Süleyman and accession of Selim II (24 September); occupation of Chios

NOTE
The dates mostly follow those given in Hammer 1828. Inevitably, however, there are certain discrepancies between the accounts of the various sources, and in some cases the dates given must be regarded as approximate.

Introduction

Süleyman (1494–1566)

Süleyman the Magnificent was born on 6 Ṣafar 900/6 November 1494 at Trebizond (Trabzon) where his father, later Selim I, had his princely court, remaining there until he was fifteen.[1] Although the imperial splendour of the last Byzantine emperor had passed, Trabzon was still a considerable port controlling much of the overland traffic to Tabrīz, a centre of silverworking and the main outlet for silver from the mines of Byzantine Argyropolis (near the modern Gümüşhane): in later legend both Selim and Süleyman were even believed to have learned the craft of a silversmith in their youth. In Rabīʿ II 915/August 1509 he was appointed Governor of Kaffa (Kefe) in the Crimea, a former Genoese colony which had fallen to the Ottomans in 1475 and a principal strategic port in the slave trade from the steppes which furnished the armies of Mamluk Egypt. In the year following Selim's accession in 918/1512 he was transferred to Manisa in Saruhan while Selim, in a sinister prefiguration of the latter part of Süleyman's reign, was engaged in a deadly struggle with his stepbrothers. He mounted the throne on 17 Şevvāl 926/20 September 1520.

At his accession Europe was already polarised by a dynastic conflict between the Habsburgs in Austria, Germany and Spain and Francis I of France, with Italy and Germany as their principal battlegrounds. A further cause of strife was religion, the growing influence of Lutheranism and the political allegiances of the Protestant states. These effectively prevented the realisation of the Emperor Charles V's dreams of a Europe united under a single religion and a crusade against the Turks. They also made Süleyman a welcome ally to the French and to the Lutheran rulers, at least up to the treaty of Cateau-Cambrésis in 1559. No doubt there was an element of opportunism in the way Süleyman engaged himself, but these alliances favoured, directly or indirectly, his long-term aims.

The first decade of Süleyman's reign was a period of incessant activity at home and abroad. On the European and Mediterranean fronts a campaign against Hungary (1521), in reprisal for Lajos II's mistreatment of Ottoman ambassadors, resulted in the fall of Belgrade, and Rhodes was besieged and captured in 1522–3. The Hungarian monarchy was elective, controlled by factions of great magnates who were selfishly opposed to strong kings.[2] This internal weakness gave the European powers constant pretexts for interference which were exacerbated by the Habsburg–Valois struggle.[3] Francis I's appeal to Süleyman from prison in Pavia in 1525 proposed a two-pronged attack, by himself on the coasts of Italy and by Süleyman on Hungary. The upshot was the grand campaign (*sefer-i humāyūn*) of spring 1526 which resulted in the Battle of Mohács, the occupation of Buda and the setting of János Zápolya on the throne of Hungary.

The following year Ferdinand of Austria had himself elected in his place, Habsburg embassies to Istanbul failed to mollify the Sultan, and the Vienna campaign of 1529 became inevitable. Vienna did not fall, but the siege may have been an afterthought; and it certainly gave the Habsburgs a bad fright. Süleyman's German campaign of 1532 was another fright, but progress was crucially delayed by the protracted siege of the fortress of Güns/Kőszeg, which left too little time for a further advance on Vienna before the coming of winter. The Habsburgs sued for peace, and the resulting truce with Austria left Süleyman free to concentrate on Iran.

With the establishment of the militantly Shīʿī and nationalist Safavid dynasty at Tabriz, Selim I, and then Süleyman, found an enemy which through its influence on the Turcoman tribes of Anatolia could bring internal disorder almost to the coasts of the Mediterranean and presented as much of a religious threat as any hypothetical European

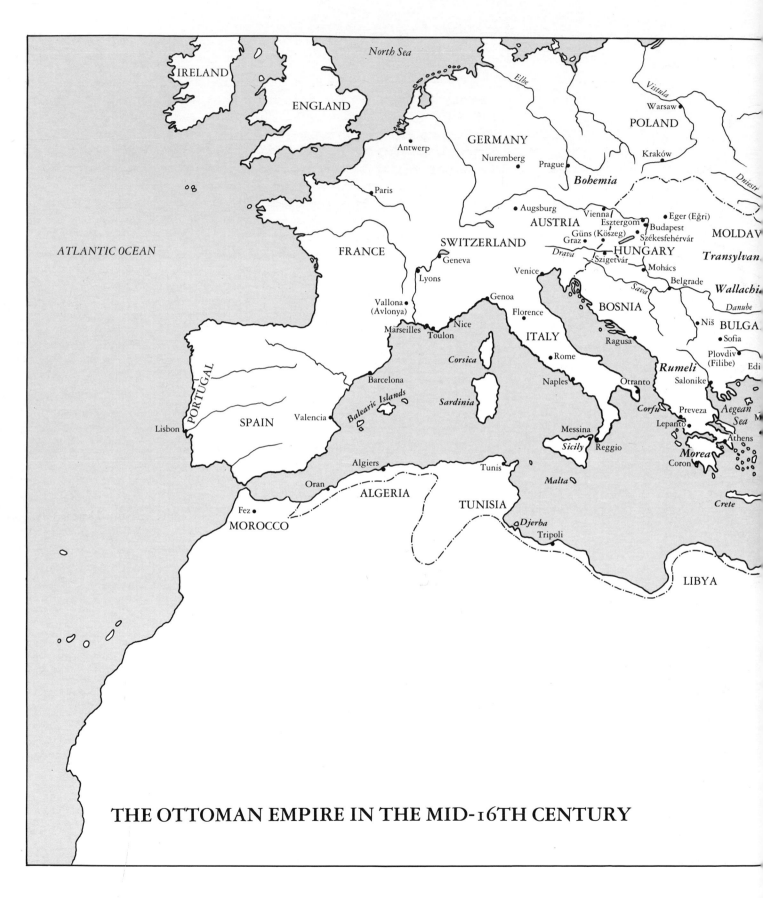

THE OTTOMAN EMPIRE IN THE MID-16TH CENTURY

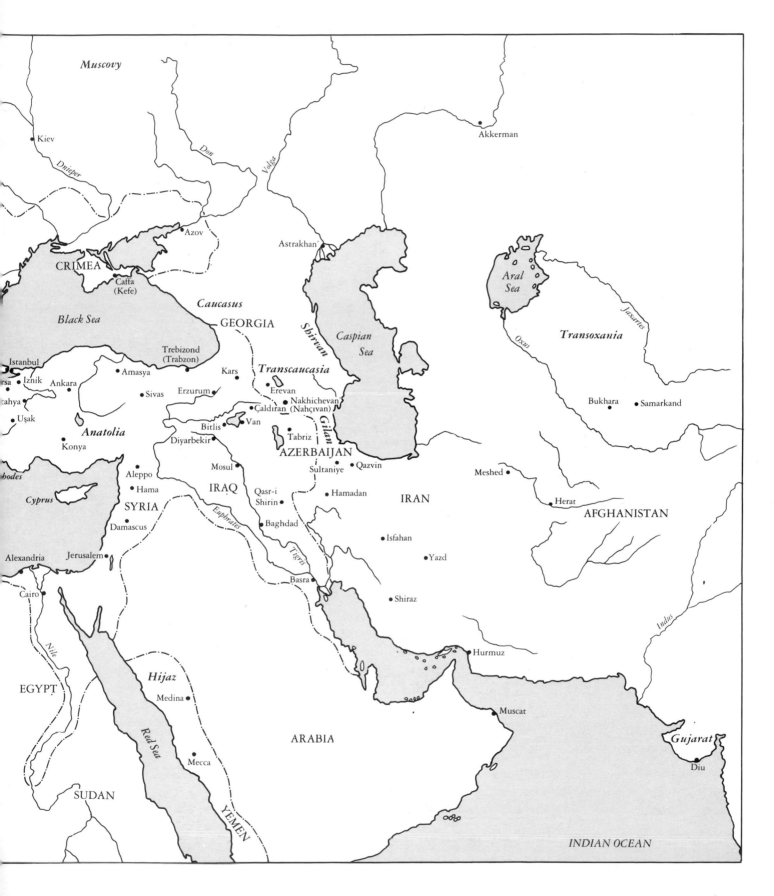

crusade. Distinguished refugees from the Safavid court also gave the hope of further territorial gains in north-west Iran and Transcaucasia, or at least the stabilisation of the frontier east of Erzurum. It is almost surprising that Süleyman waited so long to deal with the Iranian threat.

The immediate reason for the campaign of 1533–5 was the defection of Ulāma Beg, the Safavid governor of Azerbaijan,[4] to Süleyman, and the promise of the surrender of Baghdad by its Safavid governor, who sent Süleyman the keys of the city. Süleyman sent Ibrahim Paşa on ahead,[5] intending to winter at Diyarbekir, but murmurs among the troops against his conspicuous absence led him to push on to Tabriz and then south to winter at Baghdad instead. While there, he paid official visits to the shrines of Najaf and Kerbela, and magnificently restored the tomb of Abū Ḥanīfa (the founder of the Ḥanafī school of law to which the Ottomans subscribed) at Baghdad. Maṭrākçı Naṣūḥ's illustrated record of the campaign, the *Mecmū'a-i Menāzil*[6] (no. 43a–b) reads, indeed, as if it were not a campaign diary at all but the record of a pilgrimage, and it is fair to say that most of the illustrations are not of fortresses, encampments or strongholds, but shrines. In spring 1535 Süleyman returned through Persia and reoccupied Tabriz; far from settling the Safavid problem, however, this was to be the first of three major offensives against Shah Ṭahmāsp.

The activities of Shah Ṭahmāsp's brothers and stepbrothers go some way towards suggesting that the Ottoman custom, sanctioned in the *ḳanūnnāme* of Mehmed II, that on his accession a sultan should put to death any of his brothers who were still alive, 'for sedition (*fitna*) is worse than killing' (Koran II, 191), would have been adopted with advantage by Shah Ṭahmāsp. Süleyman on his return to Tabriz was joined by Ṭahmāsp's brother Sām Mīrzā, whose rebellion considerably facilitated the Ottoman triumph; and the next campaign of 1548–9 was set off by another brother, Alqās Mīrzā,[7] Governor of Shirvan and Derbend, who fled to Istanbul to offer his services to Süleyman. Although Tabriz was quickly reached, the strong Ḳızılbaş support promised by Alqās was lacking and Ṭahmāsp's scorched-earth policy forced the Ottomans to withdraw. He then asked for troops and money, probably to establish a permanent base inside Safavid territory, and marched on Isfahan, but failed to establish any base at all. Fearing Süleyman's displeasure, he sent him the royal booty he had captured but simultaneously reopened negotiations with his brother Shah Ṭahmāsp for reinstatement as governor of Shirvan. Süleyman somewhat reluctantly disowned him; Alqās Mīrzā had to surrender and was delivered over to Shah Ṭahmāsp. He was not, of course, reinstated but imprisoned in the Safavid fortress of Qahqaha, and six months later he was killed. An unrepeatable opportunity for subversion of the Safavid regime had come to nothing, possibly because Alqās Mīrzā was even more incompetent and untrustworthy than most turncoats, or lacked the power, energy or personal magnetism to establish himself as a rival to his brother, the Shah. Süleyman's final Persian compaign was provoked by Shah Ṭahmāsp's attack on the Van area in 1552. It was commanded by Rüstem Paşa (whose intrigues may actually have played a part in Alqās Mīrzā's fall). The outcome was the peace of Amasya (1555) which left the Persian front quiet for almost twenty years.

On Süleyman's return to Istanbul from the first Persian campaign, he signed in 1536 a secret treaty with France, the Turkish text of which is now lost, giving the French in the Ottoman Empire similar commercial privileges to the Venetians. These were the last negotiations in which Ibrahim Paşa was involved, and it may be that Süleyman's concentration on naval activities of the next six or seven years was prompted by the difficulty of adapting himself to land campaigns without his great minister. At sea the victory at Preveza (1538) over a European coalition and devastation of the Apulian coast

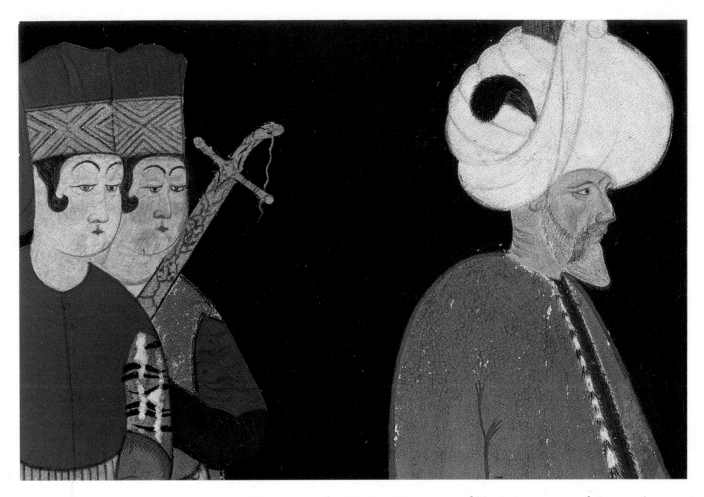

Haydar Reis (Nīgārī),
Süleyman the Magnificent with
attendants (detail); gouache on
card, c. 1560 (TKS H. 2134/8)

were suitable reprisals for Charles V's capture of Tunis in 1535, and a campaign was launched from Egypt in aid of the ruler of Gujarat who was simultaneously under pressure from the Portuguese and the Mughal Emperor, Humāyūn. Of the two the Portuguese threat was the more dangerous; the Ottoman commander, Hadim Süleyman Paşa, besieged Bandar Diu, their principal factory in Gujarat, and then retired to consolidate the Ottoman hold on Aden, Yemen and the Red Sea.[8]

On the Mediterranean front great successes were still to come, notably Barbarossa's campaign of 1543–4,[9] in which Nice was besieged and the Spanish coast pillaged. Tunis fell (1551), and 1560 saw the recapture of Djerba, although the failure of the siege of Malta (1565) dashed Ottoman hopes of naval supremacy in the western Mediterranean. Even so the Ottoman fleets and their corsair colleagues had been able to control the western Mediterranean remarkably well.

The remaining land campaigns of Süleyman's reign were largely consolidation. Buda was besieged in May 1541, becoming an Ottoman fortress, and Hungary became a new Ottoman province. In 1543 Esztergom, with the tombs of the kings of Hungary, Siklós and Székesfehérvár were made new *sancaks*. Pressure for war with the Habsburgs continued from France even after Francis I's death in 1546 and, although after 1551–2 Transylvania became virtually another Ottoman military governorate, the wavering loyalties of János Zápolya's widow and her son gave still further pretexts for Habsburg interference. The political crisis in Hungary built up with continuing unrest in Transylvania, disputes over the payment of Habsburg tribute and finally the death of the

vizier, Semiz ᶜAli Paşa, Busbecq's friend and a moderating force,[10] in 1565. In 1566 Süleyman concentrated a campaign on the Hungarian fortresses of Eger and Szigetvár. This was to be his last. He died outside the walls of Szigetvár on 7 September 1566.

If Süleyman's campaigns were partly inspired reaction to the Habsburg–Valois conflict, he was as conscious of the role of empire as Charles V, who saw himself as the heir of Charlemagne, the secular head of a united Christendom whose duty was to see that the Pope, his spiritual coadjutor, did his duty too. Although distracted by internal European politics, the rise of Lutheran and Calvinist states, the Hungarian question and conflict with the Papacy which resulted in the scandal of the sack of Rome (1527), he never abandoned his aim of a renewed crusade, stimulated not so much by political resentment or fear of Ottoman expansion but by the desire to see the whole Mediterranean a single Christian stronghold. Simultaneously Süleyman was engaged on a counter-crusade, even if at times this showed itself chiefly in his eastern campaigns against his fellow Muslims – a striking parallel with Charles V's preoccupation with Protestantism.

Charles V may perhaps have been mistaken in assuming that, despite the struggle for the Hungarian throne and even the siege of Vienna in 1529, Süleyman's main target was central Europe, for even in the 1540s his land campaigns, as Elton has observed, were more like gigantic raids than the wars of conquest which had established Ottoman power in the Balkans over the previous 150 years. The real threat was to come in the Mediterranean, and in the 1530s there was even a danger that Rome might fall to the Ottomans. In 1531 Pietro Zen, the Venetian ambassador, ventured to hope in his audience with Süleyman that he might visit Venice. Certainly, came the reply, but he would capture Rome first.[11] Subsequently he had too many distractions, but Ottoman imperialism was probably the largest single factor in the consolidation and legitimation of Protestant Lutheranism and after 1526 all the major concessions to it were connected with Ottoman activities in eastern and central Europe.

This rather inexorable list of land and sea campaigns, often annual though not all on the grandest scale (Süleyman himself avoided going to sea and appears never to have made the pilgrimage to Mecca), presents Süleyman *par excellence* as a warrior. This may be somewhat misleading for the formulation of policy inevitably conceals the extent to which jockeying for power among his sons or the influence of Roxelana or his viziers may have led him to adopt the military solution. We know, for example, from Busbecq's account of his missions to Istanbul that certainly in the latter part of Süleyman's reign Semiz ᶜAli Paşa and other viziers were in favour of peace. The general conduct of Ottoman–Habsburg relations in his reign suggests, indeed, that he regarded diplomacy, even if rather disdainful of his adversaries, as at least as successful a tool in forwarding his long-term aims – undisputed control of the eastern Mediterranean and the Egyptian trade; domination of the north African coast; a united Balkans from the Black Sea to the Adriatic; a firm base in central Europe; and, as well, whatever good fortune or his enemies' incompetence put in his way.

Süleyman and his viziers

Even, however, given Süleyman's skilful exploitation of deep-seated national antagonisms in the great states of Europe, he needed generals and administrators of the highest calibre to defeat his enemies, conquer and occupy new territories, reinforce the Ottoman hold upon them, maintain internal order against periodic insurrections, and plan and execute campaigns. His viziers' ability was at least partly a function of their janissary

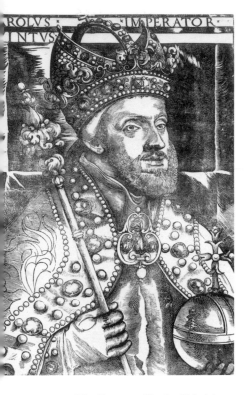

The Emperor Charles V in his coronation robes; anonymous woodcut, *c.* 1530 (BM, P & D 1860. 4–14. 152)

recruitment and training, notably from the *devşirme*[12] or periodic levy primarily from the Christian populations of eastern Europe, which was evidently applied when there was a need for manpower not otherwise catered for by prisoners or voluntary recruits. This provided only about one-third of the total manpower introduced into the Ottoman ranks but was one of the routes to highest office in the Ottoman system and immensely impressed European travellers and diplomats in mid-sixteenth-century Turkey, such as Busbecq, d'Aramon, Nicolas de Nicolay and Salomon Schweigger. There were many statutory exemptions, including married boys or only sons and, for example, miners or guardians of passes whose services to the State were of a strategic nature. On the other hand, the Bosnians, although early converted to Islam, requested to be subject to the *devşirme*, and Muslims, although probably non-Turkish-speaking, were certainly drafted in the sixteenth century. The system gave the Ottoman armies under Süleyman a character which inspired the fear and admiration of all their adversaries.

On their arrival in Istanbul, after a period on the land to toughen them up, the most intelligent and presentable boys were selected for the palace school, where, after a basic education in the classics of Islam and Ottoman history, poetry and literature, horsemanship and weaponry, they were encouraged to specialise or follow their aptitudes, either military or administrative.[13] Parallel to the palace the viziers and other high officials had their own households in which other able *devşirme* boys were trained. While the general level of education was probably not much higher than in a modern military academy, the products of the palace school under Süleyman the Magnificent included many men of distinction: poets, as well as directors of the Chancery and financial bureaux, historians, and even lawyers; and one of the finest military and administrative cadres in sixteenth-century Europe.

The *devşirme* boys remained the Sultan's 'slaves',[14] unlike the Mamluks in Egypt who were manumitted on the completion of their training. In fact it is easy to exaggerate slave status, since the Ottoman word *ḳul* could be used to cover anyone in the Sultan's service, and the *devşirme* boys, anyway, competed with free-born Muslims educated with them in the palace school – sons of viziers and other great officials; sons of princes, like the Ramazanoğulları rulers of the Adana area whose domains had been absorbed by the Ottoman sultans in the fifteenth century; and distinguished refugees or renegades from neighbouring states. Nevertheless, the picture given by Busbecq of a great meritocracy in which even the Sultan's chief ministers were his slaves and owed him their absolute loyalty, inaccurate as it is in some respects, caught the European imagination.

There were two basic departments of administration, the palace (*Enderūn*) and the provinces (*Taşra*) with, however, considerable interchange between the two. For most of the sixteenth century, for example, those appointed to the four vizierates of the Dome had all spent considerable periods in provincial administration, which was rightly judged necessary for proper experience. This hierarchical system of rotating provincial governorates filled by graduates from the palace (whether janissaries or not) who could well return to higher office there, was an admirable tribute to the administrative genius of Mehmed II, refined under Bayazid into the 'ḳānūnnāme of Süleyman'. However, it could not have worked in war without the rank and file, whose discipline and efficiency made them the envy, as well as the terror, of Europe. If we except the siege of Malta in 1565,[15] which was a land and sea operation, it is fair to say that the Ottoman armies under Süleyman did not suffer a single reverse. This is a tremendous tribute to planning and co-ordination of the engineers, the artillery and the commissariat, and to finance, and it is worth recalling the judgement of G. R. Elton on the poor impression made so often by Süleyman's main enemies:

If, in assessing all these campaigns, one is to avoid the not uncommon error of expressing contempt for their alleged feebleness or fatuity, one must always remember that the plans and ambitions of all these commanders lacked the support of disciplined armies and the backing of efficient taxation. The mercenaries who won Charles V's battles, as they won Francis I's, fought well and often (since recruitment was by countries) patriotically, but they fought only as long as they were paid. This was true not only of the German Landsknechte, the Swiss and Italians who formed so large a part of all the armies, but also of the Spanish *tercios* and the French legions which came nearer to being genuine national standing armies.[16]

If money is the sinews of war, the Ottoman sinews, like their troops, were tougher.

Elton's judgement is, however, also a warning against romantic bias. The Ottoman troops, no less than their Western counterparts, were swayed by conflicting loyalties – the execution of Şehzade Mustafa in 1553 provoked janissary uprisings – and by their own interest. D'Aramon, the Valois ambassador who accompanied Süleyman to eastern Anatolia in 1548 on his Persian campaign, states that the janissaries were unwilling to fight at all because they could neither loot nor enslave the prisoners they captured, the Safavids being Muslims even if detested as heretics.

They also had a crucial physical limitation: they could not fight against the weather. This explains Süleyman's failure to capture Vienna[17] in 1529, although the siege was so

The Subaşı of Istanbul, followed by high janissary officers, from no. 3, Süleyman the Magnificent riding to the Friday prayer; anonymous Venetian woodcut, engraved/published by Domenico de' Franceschi, *c.* 1563 (BM, P & D 1866. 7–14. 55)

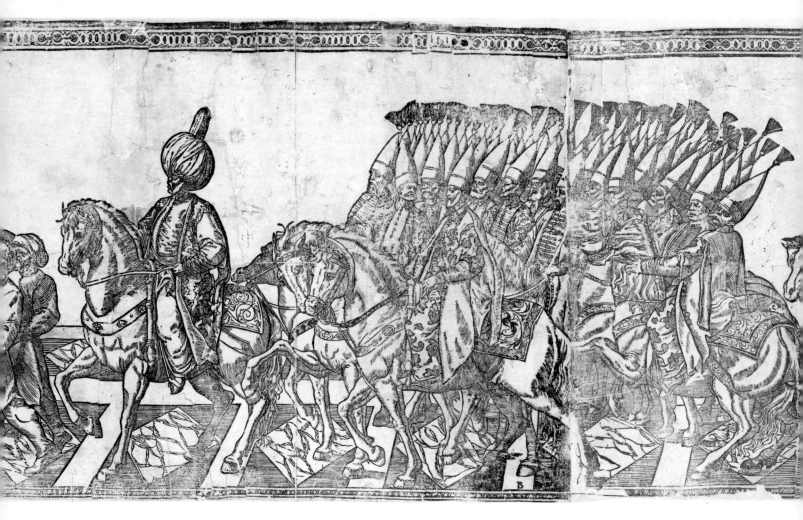

effective as publicity that it would be absurd to account it a reverse. At the outset of the campaign in May 1529 there were considerable delays from heavy rain in Thrace and in the Balkans. The rains continued. In Hungary there were numerous complaints from the army of the cold and the wet: it is evident from the campaign journals that in the rain the armies had no alternative but to remain in camp, which caused further delay. By the time they reached Vienna, time was too short for a successful conclusion to the siege for it was out of the question to winter in Austria, and in less than three weeks the armies turned back. The return was far from glorious: further snow and floods caused considerable losses of men, munitions, and pack animals bogged down in the Balkan mud, and complaints against shortages of food. This experience evidently determined Süleyman and his viziers that, if campaigns were to continue through the winter, they must be not in Europe but in the East, where Diyarbekir or Aleppo posed fewer logistical or climatic problems. This was no more than common sense: a rapidly moving army of 100,000 men and more than 300 cannon, even with efficient supply trains, faced crucial shortages in provisioning with the coming of a cold wet winter.

Süleyman's European enemies were no less bound by the exigencies of the campaign season, but the initial victories of his reign were also to leave his armies at a technological disadvantage with respect to Europe. After their expulsion from Rhodes in 1522, the fortress the Knights Hospitallers built on arrival in Malta[18] was designed to be impregnable to Ottoman assault, and, indeed, this was one of the reasons why Malta failed to fall in 1565. Similarly, refortification of the remaining Venetian possessions in the eastern Mediterranean made campaigns more arduous and prolonged. On the land front the victory of Mohács in 1526, which was ultimately to transform Hungary into an Ottoman province, brought Süleyman into confrontation with the Habsburgs and other Renaissance and Reformation states which were quick to apply scientific advances to military technology that were not balanced on the Ottoman side. Busbecq records that during his time in Istanbul[19] a Grand Vizier had attempted to create a corps of musket-bearing cavalry to make the army more able to withstand the Habsburg challenge. However, like the Mamluks before them and cavalrymen everywhere, they were quick to find this innovation undignified and simply refused to carry them.

The Sultan, as the head of this highly centralised system, took the initiative in planning the overall strategy, although details of tactics fell to his viziers. Two of them were particularly colourful, important and influential. The agent of most of Süleyman's early conquests was his second Grand Vizier, Ibrahim Paşa (?1493–1536), who appears to have been captured from near Parga on the coast of Epirus.[20] Possibly after a period in the service of a rich widow of Manisa, he entered the palace school and while still very young was then presented as a gift to Süleyman during his period as Governor of Kaffa. Although insignificant in personal appearance, he was clever and charming – the Venetian Baylo Bragadin (1526)[21] states that he was widely read in history and warfare, being conversant with the life of Alexander the Great and the campaigns of Hannibal, spoke several languages, played the violin, and composed music with a Persian master in his household. He captivated the young prince, following him to Istanbul on his accession in 1520, when Ibrahim Paşa was appointed Hasodabaşı, or head of the Privy Chamber, and a palace was built on the Hippodrome from Süleyman's privy purse.

His appointment as Grand Vizier in 1523, in defiance of the customary rules of seniority, aroused some dispute when he was made Beglerbeg of Turkey in Europe (Rumeli). Ahmed Paşa, his disappointed rival, sought the post of Beglerbeg of Egypt, where shortly afterwards he rebelled (early in 1524). Ibrahim Paşa set sail with a considerable fleet: on his staff were Pīrī Reis (see p.103), who used the occasion to

investigate the mouths of the Nile, and the historian Celālzāde Muṣṭafā, who was then his private secretary. He suppressed the rebellion and reorganised the finances of Egypt. He was made Commander-in-Chief of Süleyman's Hungarian campaign of 1526, preceding Süleyman on the advance, capturing fortresses, building bridges and making possible the decisive victory, at Mohács. For the 1529 Hungarian campaign, which culminated in the siege of Vienna, he was again appointed Commander-in-Chief with estates worth 3 million *akçe* per annum:[22] he hubristically demanded 4 million, but Süleyman gently refused. There followed the Iraq campaign of late 1533 on which again he was Commander-in-Chief and more in control than ever. Ibrahim's sudden execution shortly after his triumphant return to Istanbul is still difficult to explain.[23] No one ever again in Süleyman's reign attained such a degree of personal power.

Ibrahim Paşa's career was one of unparalleled magnificence for a boy who had been presented as a slave to Süleyman and, to judge from the humble tone of a letter to Süleyman may never have been manumitted.[24] Not only was his palace in the Hippodrome (now ably restored as the Museum of Turkish and Islamic Art) as splendid as any of Süleyman's outside Istanbul (the best contemporary description, unfortunately too brief to give much idea of its state rooms, is by Schepper, who was received there in 1533).[25] His wedding festivities in May 1524 set the pattern for the other great festival of Süleyman's reign, the circumcision feast of 1530. Splendid tents were set up on the Hippodrome including the royal tents captured from Uzūn Ḥasan by Mehmed II at Otluk Beli in 1473, from Shah Ismāʿīl by Selim I at Çaldıran (1514) and from the Mamluk Sultan Qānṣūh al-Ghawrī in 1516.[26] Great feasts were held for the various corps of the army and the ʿulema; the Sultan was entertained by wrestlers, janissary swordsmen, strong men and buffoons, and spectacles of fireworks. Early the next morning Ibrahim Paşa made his entry, preceded by a series of columns of wax (*nahil*)[27] decorated with all sorts of fantastic balls and ornaments and floats planted as gardens full of late spring flowers, with pools, arbours, peacocks on their lawns and parrots in the trees, as well as orchards full of flowering and fruiting trees, and paper figures of sea monsters, phoenixes and other fantastic creatures.[28] Ibrahim's present to the Sultan was of ten magnificently dressed slaves, bearing gold vessels, all sorts of lavish textiles and fine furs, fine steeds, as well as camels and mules, and a diamond bought from Venice valued at 25,000 ducats. This was followed by a gallop with mounted archers demonstrating their prowess 'in Circassian style' before the Sultan and an audience of more than 50,000. The procession of the bride with her attendants bearing the dowry to the bridal home took all day.

At least a part of this great expense must have been borne by the Privy Purse, an impressive demonstration of Süleyman's friendship for Ibrahim. It is often asserted that his bride was Süleyman's own sister, Hatice Sultan;[29] but Muṣṭafā does not say so, and the Venetian account refers to the presence of the bride's parents. At least, therefore, it was not known that he was marrying into the Ottoman imperial family.[30] Clinching evidence seems to be a letter from Ibrahim Paşa to his wife datable to early summer 1534 in which he expresses his relief that she had been to the funeral of Süleyman's mother, Hafsa Sultan, who had died in March 1534.[31] She had also evidently asked, at her brother's suggestion, permission to attend court entertainments. This Ibrahim would not countenance: she had refused to attend the princes' circumcision in 1530, even though invited (by Hafsa Sultan) several times, and if she now started to go out her earlier absences would be interpreted as dislike of Hafsa Sultan. Ibrahim Paşa rightly foresaw that Süleyman would be annoyed; but if Süleyman had been her brother and commanded her to attend, neither she, nor Ibrahim Paşa, could have refused.

Such letters remind us of the dominant personal element in Süleyman's relations with his viziers, which the deadening reports of European diplomats either suppress or which is inflated into speculation or ill-informed gossip. Ibrahim Paşa's thirteen-year term of office is a testimony both to Süleyman's enduring friendship and to his own immense ability; his extravagant life[32] was an appropriate setting for the European diplomatic negotiations which were left largely in his hands. His palace reflected the splendour of Süleyman's household, with lavish patronage of poets and writers and of 'renegades' like Luigi Gritti,[33] who may first have come to his attention as an agent for the purchase of jewels from Venice, and who doubtless played a role in the sale of the Venetian gold crown (see no. 6) through Ibrahim Paşa to Süleyman himself in 1532. In the period 1526–36 the West, no less than the Ottoman Empire, needed an intermediary. Ibrahim Paşa was the man for his time.

On his disgrace not only were his estates, his *vakf* foundations and his possessions confiscated; his exploits and even his name are largely ignored in the later histories of Süleyman's reign. He remains, therefore, a somewhat shadowy figure. A later Grand Vizier, Rüstem Paşa,[34] born *c*.1500, was married to Süleyman's daughter Mihrimah Sultan, and although probably less brilliant, survived a controversial career to die in office in 1561. A Bosnian,[35] and possibly a Muslim by birth, he entered the palace school, followed by his brother Sinan Paşa, who became an admiral. At Mohács he was Süleyman's sword-bearer and in the next fifteen years he went through a series of court appointments and provincial governorates to become Grand Vizier in 1544. He married Mihrimah Sultan in 1539 and henceforth embroiled himself in the factional policies of Hürrem Sultan. Most notably, in 1552 he commanded the Eastern campaign which Süleyman was too ill to lead and was generally thought to be her instrument in the death of Şehzade Mustafa. This led to his dismissal, but he returned to office as Grand Vizier in 1555, holding it until his death.

Although owing his initial advancement to his generalship, his abilities were primarily financial; as an inscription in the Treasury of the Topkapı Saray noted, he kept the Sultan's Treasury filled through decades of almost continuous warfare. In the view even of contemporaries, however, his policies presaged the long financial decline of the empire. The urgent need to offset the increasing military superiority of the European powers led to the growth of a standing army paid in cash, financed, inevitably, by tax-farms. Accusations of corruption abounded. This unpopularity may have deflected criticism of Süleyman himself, but charges of massive speculation in wheat and other foodstuffs with foreign merchants in Istanbul, improper diversion of funds intended for the Treasury and other irregularities are to a considerable extent substantiated.[36] Speculation in supplies seems, though, to have been a common way for provincial governors to supplement their revenues from the State,[37] and it is difficult to believe that Rüstem Paşa was the only official of his time to take bribes. However, his immense riches (Gerlach states that Mihrimah Sultan received 2,000 ducats a day from the tax-farm of the Bursa silk-looms and the saltpans of Clissa) and the vast fortune in estates, cash and luxuries he left at his death suggest that, even if they were partly acquired on his wife's behalf, what irregularities there were were practised on a massive scale.

The most famous of Rüstem Paşa's many pious foundations is his mosque built by Sinan in Istanbul in the markets on the Golden Horn, brilliantly using a restricted space and with probably the finest and certainly the most luxurious Iznik tile revetment in existence. A recently published ferman shows that it was not complete at his death in 1561,[38] and his widow had to petition her father to bring works to a conclusion. She herself may have paid for the Iznik tilework and other choice decoration (the tiles of

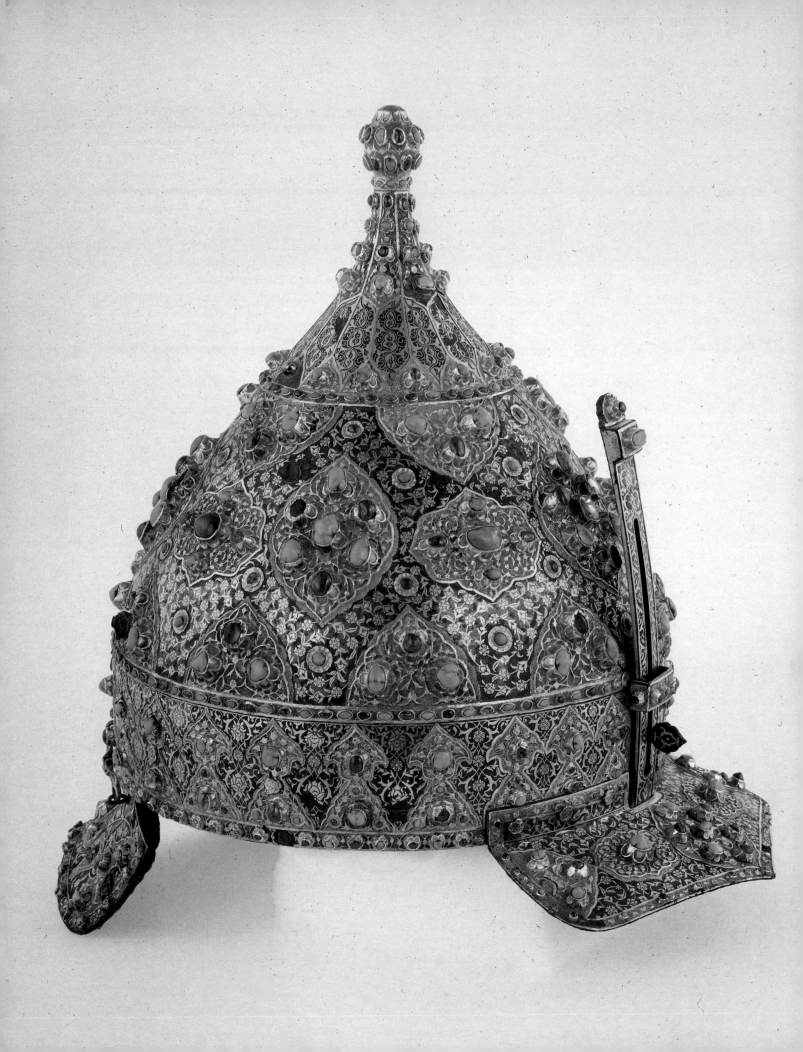

Rüstem Paşa's tomb at Şehzadebaşı, in Istanbul, evidently built before his death, are ambitious but technically unsuccessful), as well as obtaining the privilege of the services of Sinan. He also left a great library estimated at 8,000 to 15,000 calligraphed volumes and 5,000 chests of miscellaneous books and papers[39] (cf. no. 20 with a note on the flyleaf that it was commissioned by him).

All things considered, Süleyman's court was not notably more hazardous to life and limb than the courts of his European contemporaries, and infinitely less than Shah Ṭahmāsp's at Tabriz. Punishments for failure were, however, more severe, and the competition for highest office probably even greater. However, Ibrahim Paşa was no more constrained nor more unfortunate than Schiller's Wallenstein, for example, with whom, across the decades and religious and cultural barriers, he perhaps finds his closest historical parallel.

Warfare and Expansion at Sea (1520–66)

87, parade helmet; see also pp. 150–1

In Ottoman naval actions of the early decades of Süleyman's reign Egypt was of considerable importance because it controlled Ottoman access to the *ḥajj* routes, because of the immense yearly tribute it furnished to Istanbul and because, despite the Portuguese exploitation of the sea route to India, of its continuing role as entrepôt in the spice trade.[40] If Süleyman had needed an economic or strategic justification for the siege of Rhodes and the expulsion of the Knights Hospitallers in 1522, therefore, it is more than likely that sea communications with Egypt played some part in his calculations. To a considerable extent Ottoman policy in the Red Sea and the Gulf was a continuation of Mamluk opposition to Portuguese attempts to enforce a monopoly of the spice trade,[41] but activity was surprisingly sporadic, and the crucial base of Aden was not captured until June 1538. In the ensuing Ottoman–Portuguese conflict for the Abyssinian coast (the vilayet of Habeş) it was the Ottomans who had to withdraw. A further blow was the 1551 campaign, commanded by the cartographer Pīrī Reis, which left Suez, captured Muscat and besieged but failed to capture Hurmuz, the main Portuguese base in the Gulf, but was then abandoned at Basra by its commander.[42]

This suggests that the Ottoman navy was overstretched on the Red Sea front in the early decades of Süleyman's reign. However, dominion of the Yemeni seaboard crucially established Egypt in Western eyes as the most prosperous centre of the Eastern trade in the Ottoman Empire, and a welcome competitor to the Portuguese. Estimates of exports to Europe via the Ottoman Empire between 1500 and 1560 suggest a rise in consumption of spices of up to 100 per cent. This may well include coffee, the drinking of which was established in Ottoman Istanbul by 1550 and which soon came to dominate the Eyptian market. At the end of Süleyman's reign spices were so abundant in Cairo that the Portuguese Lourenço Pirez de Távora, showing actually an extraordinary lack of confidence in Portuguese shipping and the sea route round Africa, seriously argued for a treaty with the Sultan to have spices brought overland from the Gulf or via the Red Sea to Egypt.[43]

The eastern Mediterranean

In the eastern Mediterranean Süleyman's employment of corsair admirals continued a policy initiated by Bayazid II, harnessing the corsairs' traditional lust for booty to the higher motivation of war against the infidel; corsairs sound barbarous but the Genoese admiral Andrea Doria, the Ottomans' most serious adversary in the sixteenth century, was himself a *condottiere* by origin, and the navies of Europe had little moral superiority in

this respect.[44] For much of the sixteenth century there was no clear distinction between piracy and commerce or even between individual clashes at sea and those of a fleet under the orders of a government. Recruitment on both sides was a constant problem and explains, for example, the high proportion of slaves in the Barbary galleys, and of criminals in the Ottoman, French and Spanish fleets.[45]

The corsair bases were mostly on or off the north African coast, notably on the island of Djerba, despite the absence of timber, pitch, sailcloth or even hemp: much of the fleet must have been in fact captured ships refitted or cannibalised. More important was Algiers – which had been granted by Selim I to Oruç Beg (killed in action against Spain in 1518) – which promised control of the western Mediterranean too. He was succeeded by Hayreddin (d. 1546), later known as Barbaros or Barbarossa, who rebuilt the harbour and organised the city as a corsair state, financed by plunder and ransom.[46] In 1533, most probably to counter Andrea Doria's successes in the eastern Mediterranean he was summoned to Istanbul and appointed Admiral of the Fleet, his principal task being to build up the Ottoman fleet in the imperial dockyards of Istanbul and the Dardanelles. Charles V's expedition of 1535 brought Tunis temporarily under Habsburg control, but Barbarossa's impressive defeat of a European naval coalition under Doria at Preveza in 1538 was then a prelude to annual amphibious campaigns, in which the galleys of Barbarossa dominated the eastern Mediterranean and the coasts of Italy, France and Spain.[47]

Galleys favoured amphibious rather than simply naval operations and, thus, became less reliable the further they had to range; but they were more than adequate for warfare in the sixteenth-century Mediterranean, for, as the Mediterranean powers in the sixteenth century frequently found to their cost, the weather made warfare at sea a seasonal operation and amphibious exercises were the most rational utilisation of men and munitions. Ottoman firepower was much on a par with the Spanish galleys and, although the markedly shorter Venetian cannon were reputed to be the best, lighter artillery in the sixteenth century was always in short supply.[48] The bow, moreover – a superbly accurate and rapid weapon – was only gradually driven out, not by Western superiority in firearms, which suffered from quite prodigious recoil, but by the thorough training and practice it required, and by the very expensive and very slow rate of production of composite bows.

Corsairs, free booters and *condottieri* all at times appear to be ready to be bought. Charles V vainly attempted to persuade Barbarossa to join an alliance to crush France and Venice (whose resolute pursuit of neutrality was an affront to Charles V's ideal of a united Christian Europe). However, Barbarossa's most remarkable campaign in 1543 was prompted by the invitation of Francis I: to the scandalisation of his enemies, the Ottoman fleet sacked Nice, wintered at Toulon, sailed westwards to bombard Barcelona and then returned to Istanbul in 1544, laying waste the coastal cities of Tuscany and the Spanish territories of Naples and Sicily on the way.[49]

On one thing the European and the Ottoman historians' accounts (no. 44) of the campaign concur: the French behaved badly. Barbarossa's fleet wintered at Toulon under admirable discipline, but Francis I could not properly finance or supply it and even let his own ships run short of powder. Destructive as Francis I's initiative was in its immediate effects, therefore, it probably did the Valois cause little good in the longer run. Jérôme Maurand of Antibes, Chaplain to the French ambassador, who sailed with the Ottoman fleet to Istanbul in May 1544, gives a curious account of how the later stages of the campaign were waged.[50]

Barbarossa's fleet ravaged the Neapolitan and Apulian coasts. However, the thousands

Francis I of France, Agostino
Veneziano; woodcut, 1535
(BM, P & D H. 7–2)

of prisoners and the booty taken posed considerable transport problems and the Ottoman fleet, so ill-supplied by the French, was not equipped to carry on. The solution was ingenious: periodic slave markets of prisoners were held and the proceeds used to acquire supplies. Other prisoners were ransomed, some directly by the French ambassador, but others *en masse*. The prisoners taken from Lipari, for example, were ransomed by the Messinese, and it was evidently typical of Barbarossa's system to take prisoners at one stage and put them to ransom at a later stage of the expedition. In that way the accumulation of surplus prisoners was avoided, additional transport ships were not required, and the expedition was made virtually self-financing in provisions and cash, while artillery and munitions were seized from the towns and fortresses Barbarossa sacked. Maurand, cleric though he was, seems to have found it all admirably efficient.

The fear of these almost annual raids obsessed cities as distant as Antwerp, to the extent that the first concern of diplomatic reports from the Levant was whether an Ottoman fleet was to be expected, and this fear long survived Barbarossa's death. However, of all the Ottoman admirals, he had the greatest European reputation. He married a daughter of the Governor of Reggio in Calabria and corresponded with Matteo Bembo, the Venetian Governor of Cattaro.[51] His portrait in middle age (he may have been only in his sixties at his death) was done by Nīgārī, the talented sea captain Haydar Reis, and appears in the *Süleymānnāme* of ʿArifī (no. 45c). A portrait of him was also engraved by Agostino Veneziano (Musi) in 1535, *tiré sur le vif*, according to François Rabelais who sent a copy of it to Rome in 1536 (no. 5).[52]

These almost annual naval campaigns in the Mediterranean were largely politically motivated – to secure Ottoman shipping, prevent Habsburg territorial expansion, and support the Valois cause. The Ottomans had no desire to discourage trade and warred with Venice and Genoa arguably only because of their military bases and local pretensions within the eastern Mediterranean. With other trading states and commercial cities like Florence, Ancona or Ragusa, which had no possessions in the Levant, relations remained good, and in the regular punitive campaigns on the Italian coasts their cities were generally spared the worst.[53] Venice, in any case, stood to lose far more commercially from a protracted war with Süleyman than she stood to recoup militarily from a Spanish alliance, and her foreign policy was primarily dedicated to neutrality. Although Fernand Braudel's claims for a Mediterranean 'symbiosis' in these decades is a somewhat misleading exaggeration, there was some recognition of a common interest on both sides, which the permanent Venetian diplomatic representatives in Istanbul did much to foster.[54]

The Black Sea

On the Black Sea[55] Süleyman's naval policy was less successful, for it failed to stop the expansion of Muscovy. Following the fall of Kaffa (Kefe) in 1465 to Mehmed the Conqueror, the Black Sea was virtually closed to European shipping, trade from northern Europe coming down the Dniestr to Akkerman and thence overland through Moldavia-Wallachia to Edirne and Istanbul. In the Crimea the Khanate formed a feeble bulwark against Russia and against Safavid pressure. Further east the predicament of the Uzbeks in Bukhara, who suffered from Safavid interference with trade westwards and the *ḥajj*, was exacerbated by Ivan the Terrible's seizure of Kazan and of Astrakhan on the Volga (1554), which gave him a direct outlet to the Caspian and to trade with Safavid Iran. To aid the Uzbeks, to block the access of Muscovy to the Caspian and to control Transcaucasia from the sea a Volga–Don canal was planned. The idea seems to have been adopted by Süleyman, although it was only attempted under Selim II in 1569. It was a

total failure but arguably, even had it succeeded, defence on the steppes would have been far too costly in men, transport and munitions. The is little sign that either Süleyman or Selim was seriously interested in expanding the empire into Central Asia, otherwise more realistic use would have been made of the strategic value of the Black Sea and its lands.

Arguably the naval campaigns of Süleyman's reign were less than a total success. In particular his failure to exploit his temporary superiority in the Indian Ocean left the way open for the Portuguese and the Dutch in the India trade, while Turkey was isolated from the great conquests of Spain and Portugal in the New World. The ultimate consequence was the enrichment of the European maritime powers at the expense of the Ottoman Empire. However, the use of the Ottoman navy during Süleyman's reign to maximise tax revenues from conquered territories and booty, tribute and ransom from the cities of the northern Mediterranean, together with tax, tribute and booty from his land campaigns in Iran, the Balkans and central Europe, more than outweighed his lack of interest in world domination.[56]

Süleyman and his family

Roxelana (Hürrem Sultan)

Bragadin in 1526[57] states that Süleyman had had sons by a consort, Gülfem (variously said to be Circassian or Montenegrin), of whom only the eldest, Şehzade Mustafa, survived into adulthood, but that a Russian (in fact, most probably Ruthenian) woman known to the West as Roxelana had already presented him with four sons, Mehmed (the eldest, born 928/1522), Cihangir (a hunchback), Bayazid and Selim, as well as a daughter, Mihrimah, who in 1539 was to marry his Vizier Rüstem Paşa. His passion for Roxelana, known to him and Ottoman historians as Hürrem Sultan,[58] was to affect his actions deeply.

Captured as a young girl, Hürrem was evidently presented to Süleyman as a slave concubine. There was no stigma in this, since slave concubines' children had equal rights in the succession and it was not the Sultans' habit to take legal wives anyway. However, Süleyman's contemporaries, both foreign and native, concur that without being especially beautiful she captivated his affections, persuading him first to free her and once free refusing him her favours until he agreed to marry her. Codignac[59] writing in 1553 plausibly suggests that the occasion was the foundation of her *vakf* in Istanbul, for no slave was legally entitled to endow a pious foundation. The date of the wedding does not appear to be known but, shortly after a serious fire in the Old Palace of Mehmed the Conqueror (1541), where the Sultan's womenfolk had traditionally been segregated, she moved with her household into the Topkapı Saray. Under Süleyman's successors this was to give ever-increasing importance to the Harem in the making and practice of imperial policy (the so-called Kadınlar Saltanatı), and much of the resentment at her position and activities must have been fear of what 'the monstrous regiment of women' might bring. In 1543 her eldest son Şehzade Mehmed died while Governor of Manisa in Saruhan; and the chronogram giving this date, *Şehzādeler güzīdesi Sulṭān Meḥemmed* ('Şehzade Mehmed the chosen of the princes'), gives his status in Süleyman's affections.[60] Şehzade Selim was appointed to succeed him at Manisa in 1543, his elder stepbrother Mustafa being sent to distant Amasya, and Hürrem's favourite son, Bayazid, being sent to Kütahya. Like the appointment of Rüstem Paşa as Grand Vizier in that same year, these moves were a clear sign of the ascendancy of Hürrem and her daughter Mihrimah.

It is to be regretted that the Ottomans did not follow their Mughal contemporaries in

In Venetia per Mathio Pagan in Fre
zaria tien per infegna la Fede

La piu bella e piu fauorita donna
del gran Turcho dita la Roſa

4b, portrait of Roxelana; see
also p. 51

cultivating the art of autobiography. For, while even Süleyman's chroniclers cannot
totally gloss over his personal feelings or reactions in the face of adversity, his
correspondence with his family has disappeared and the ladies, except for a few letters
from Hürrem Sultan and from Mihrimah which have been preserved in the Topkapı
Saray, like the workers in other cultures are mute.[61] Those letters of Hürrem which
appear to be autograph are in a competent if not learned hand. If, as some writers have

suggested, the Harem was among other things a school for young ladies,[62] grammar and syntax cannot have been regarded as essential subjects, although some apparent solecisms may in fact be idiomatic expressions which have not come down to us. Not all the surviving letters are autograph; two datable to *c.* 1526 by internal evidence (TKSA E. 5662, 5426) are evidently compositions by an ambitious secretary, with pretentious verses, exaggerated hopes and a great deal of repetition for stylistic effect, protesting Hürrem's grief at Süleyman's absence, her concern for his safety and her longing for his return. They would have been, one feels, more appropriately expressed, as in her autograph letters, in simpler style.

The autograph letters all start with a simpler formula of greeting, rubbing the face in the dust at her consort's feet, and contain references to day-to-day affairs – the plague in Istanbul, rumours of Süleyman's victory, concern for his gout, treatment for Cihangir's hump, the bath she was intending to endow near Ayasofya, and pleas to him to disregard slanders about Rüstem Paşa.

The contents are, however, mostly baffling because they are presumably isolated fragments from a continuing correspondence. One autograph letter (TKSA E. 5426) contains two interesting passages.[63] The first relates to a talismanic shirt (cf. nos 110–11) which was inscribed with auspicious names and would turn away bullets. An addition at the side (apparently in the same hand, however) seems to be reproaches poured on Gülfem, the mother of Şehzade Mustafa, with whom Hürrem was evidently on good terms, casting curious light on the early history of eau-de-Cologne. Omitting endearments, it reads:

You sent me, Gülfem, a box of eau-de-Cologne and 60 ducats. I consumed the Cologne quickly – and so what happened to me! There was a guest in the house. I don't know what I was saying, but for a long day I dozed, some people flicked my nose [. . .]. You have made me a laughing stock everywhere. When we meet we shall discuss it.

Did she think eau-de-Cologne was a drink? Or did the Ottoman ladies sometimes find unwise consolation in the bottle? However, it could easily have been a joke, a sprightly story to amuse Süleyman away on his campaign.

There are two other letters in the nature of informal congratulations from Hürrem in the Polish archives[64] to Sigismund (Zygmunt) Augustus, who had succeeded to the Polish throne in 1548 but sent no ambassador to the Sublime Porte until 1550. One of them evidently accompanied a gift of two pairs of shirts and pants with girdles, six handkerchiefs (*destimāl*) and a face towel, all in an embroidered wrapper, with apologies for their modesty and promises of more and better. The present was, indeed, modest by the standards of diplomatic exchanges of the period, and Hürrem's approach may, therefore, have recalled the place of her birth, which was at the time in Poland, at Rohatyn on the Gnilaya Lipa River (now in the Ukrainian SSR).[65] On a more ceremonious level the correspondence between Shah Ṭahmāsp's sister and Hürrem Sultan on the inauguration of Süleymaniye[66] disguises the triviality of the contents in copious formulas of stifling politeness, which obviously gave the Ottoman and the Safavid Chancery scribes a field day.

If Codignac[67] was right and Hürrem's intention in founding a pious institution was an ingenious attempt to gain her liberty and establish her position as Süleyman's consort, she was not the first Ottoman foundress. The scale of her foundations was, however, unprecedented in Istanbul. In addition to her complex foundation (*vakfiye* dated 28 Receb 947/28 November 1540, cf. no. 12) initially consisting of a mosque, a *medrese*, a Koran school (*mekteb*) and a public soup kitchen (*'imaret*), and later a hospital

(*vakfiye* dated 958/1551–2, TIEM 2194), she endowed a mosque at Kağıthane (cf. TKSA D. 4575 dated 965/1557–8) and a *zaviye* for dervishes at Balat (cf. TKSA D. 7788, mid-Zilhicce 955/mid-January 1549), its expenses being paid by a levy on the Jews of Istanbul. Outside Istanbul she built a mosque at Edirne; a mosque at Ankara (cf. no. 12) with endowments *inter alia* in the Jewish quarter; [68] *zaviyes* in European Turkey and at Karapınar near Aksaray in Anatolia; a mosque in Jerusalem, a building with fifty-five cells for the permanent inhabitants (*mücāvirān*) of the Ḥaram al-Sharīf, and an *ʿimaret* with caravanserais and stables (final version of the *vakfiye* (TIEM 2192), dated mid-Şaʿbān 964/mid-June 1557);[69] and an *ʿimaret* and four *medreses* (or a four-rite *medrese*) at Mecca (*vakfiye* dated 964/1556–7, TIEM 2193, unpublished). The foundations attributed to her in Quṭb al-Dīn Makkī's account of an embassy from Mecca to Istanbul in 965/1557–8 (*al-Fawāʾid al-Thāniyya fī Riḥlat al-Madīna waʾl-Rūmiyya*, Istanbul, Beyazit, Devlet Kütüphanesi, Veliyeddin Efendi 2440) at Damascus, restorations at Baghdad at the tombs of Abū Ḥanīfa, Ibn Ḥanbal and the founder of the Qādirī order of dervishes and at Konya at the shrine of Mevlānā Jalāl al-Dīn Rūmī, are, however, ascribed in all other sources to Süleyman's own initiatives.

The history of the Istanbul foundation is also illuminated by the later *vakfiyes* of Hürrem's lifetime and by itemised lists of income and expenditure (TKSA D. 4575 and D. 4573), dated, respectively, 965/1557–8 and 968/1560–61.[70] The *ʿimaret* is dated late Rabīʿ II 947/late August 1540. The *medrese* was begun in 945/1538–9 (a panel of *cuerda seca* tiles now in the Çinili Köşk is dated 946/1539–40), and we may assume that it and the mosque (begun 945–6) must have been substantially complete by the time the 947 *vakfiye* was drawn up. Since it was held to be illegal to draw up a *vakfiye* before the buildings of a foundation were complete, the hospital was evidently an afterthought. This was completed in 957/1550–1. The name of the quarter of Istanbul, Avratpazarı ('women's market'), has suggested that it was for women and, indeed, a modern women's hospital there is dedicated to her memory, although the name more probably refers to a female slave market, or to a market restricted to women on one day a week. Neither Ayvansarayî's chronogram giving its date *Dār al-ṣifāʾ nāfiʿ-i nās-i cihān* (roughly, 'a hospital for the benefit of mankind') nor the *vakfiye* of 958/1551–2 indicates that it was for women.[71] Unlike Süleyman's hospitals at Süleymaniye it had no students on the foundation, but the staff was numerous, including two physicians, the senior at 25 dirhams a day, oculists, surgeons, pharmacists, with a kitchen and a bath for the patients, and nurses, launderers, cleaners and a gardener, as well as the usual administrative staff. Little is known of the careers of the doctors, but they all appear to have been Muslims.

The *ʿimaret* with a total annual revenue in 968/1560–1 of 1,257,181 *akçe* was exceptionally well endowed. The urban revenues are mostly rents from houses, shops, caravanserais, bakeries and woodstores in Istanbul. Of these properties by far the most profitable was the double bath Hürrem had built at Ayasofya, the annual revenue from which in 965 is listed (TKSA D. 4575) as more than 85,000 *akçe*; but even the gardens surrounding the complex provided fruit and produce valued in 968 at 600 *akçe*. The revenues for each of these years are completely disproportionate to the outgoings from *ʿimaret*, hospital and *medrese*, even including wages and salaries and running expenses and food.[72]

There is ample evidence of large surpluses in *vakf* revenues of this time, although nothing on this scale. Surpluses could not benefit the staff on the foundation since their wages and salaries were fixed in the deed. They were therefore for investment in property (*müstağallāt*) to provide for upkeep and hedge against inflation but part of the surplus

was often (in accordance with the provisions of *vakf ahlī* or family trusts) for the founder's kin. The principal survey of the *vakf* foundations of sixteenth-century Istanbul,[73] however, ignores foundations by sultans and their families and, since Hürrem's descendants were *ipso facto* potential heirs to the throne, she can hardly have been establishing a family trust. Perhaps the income reverted to the Crown?[74]

The provisions of the 947/1540–1 Istanbul *vakfiye* (no. 12) show considerable discrepancies with the text as given in N. Taşkıran and reproduced by E. Atıl, and it is possible that she has taken the *vakfiye* of 958 which includes the first endowment deed of the hospital as the final text. Although Muslim law has often frowned upon the practice, Hürrem's *vakfiye* of her Jerusalem foundations, appointing herself as its first comptroller (*mütevellī*) for life, reserves her the right to make any changes in its provisions and she may well have exercised this right with respect to her foundation in Istanbul.

The vast endowments of Hürrem's Jerusalem foundations[75] (full version of the *vakfiye* (TIEM 2192) dated mid-Şaʿbān 964/mid-June 1557), also produced correspondingly large surpluses, the disposal of which even in recent times has been the object of lawyers' attentions.

The scope of Hürrem's original foundations in Istanbul was not exceptional in the mid-sixteenth century, and the hospital may have been added to give it the distinction appropriate to a royal foundress. The *medrese*, with a salary for the professor of 50 *akçe* a day (Sinan's as court architect was no more than 55 *akçe*), was immediately placed among the most favoured of Istanbul, and appointment to it became a prelude to high office. Among distinguished early holders of the position were the moralist Kınalızāde ʿAlī Çelebi and Şemseddīn Aḥmed, the son of Süleyman's Şeyhülislam Ebusuûd, whose early career was brilliant although his life was dissolute.[76] Both later held high positions at the *medreses* of Fatih.

Hürrem's right to endow pious foundations was limited not only by her own legal status but also by the legal need to prove that the endowments were private property, not lands belonging to the State. In Ottoman land law this required an imperial grant[77] (*mülknāme*, *temliknāme*, cf. nos 10–11). Such grants are sumptuously written with lavishly illuminated *tuğras*, and were evidently specially drawn up by the Chancery to flatter the addressee. That reproduced by Ferīdūn contains references to villages designated some years previously in 948/1541–2 and 951/1544–5, when the endowments may have already shown themselves to be unsatisfactory or inadequate; alternatively, they may have been determined in advance as a rationalisation of land-holdings. None of these documents are, however, really specific when it comes to designating boundaries and their validity, therefore, depended upon detailed and comprehensive land registers. This gives an idea perhaps of the legal complexities and paperwork involved in drawing up a really large *vakf*, and it is scarcely surprising that Hürrem's numerous *vakfiyes* survive in several drafts, sometimes decorative like a draft of her endowments in Jerusalem[78] with an illuminated heading and even a gold *tuğra*, but mostly in Turkish, not in Arabic as the law required.

Süleyman's sons

By 1553 Süleyman, almost in his sixties, was an ailing man suffering from chronic gout and possibly other serious undiagnosed conditions. Had Şehzade Mehmed not died young, he would indisputably have succeeded Süleyman in spite of being younger than Mustafa,[79] so that, in principle, Hürrem's support of her other sons against Mustafa was not unreasonable. This was opposed by a strong faction in the Ottoman army and, however honourably Mustafa behaved, civil war was threatened. The most circumstan-

tial account[80] is European and doubtless contains as much unsubstantiated gossip as historical fact. In particular, its presentation of Hürrem and Mihrimah as mere villainesses is an exaggeration: but the struggle certainly involved an attack on Mustafa, presenting him as a traitor conspiring with Shah Ṭahmāsp and his support from the army as active rebellion, misrepresentation which was all the easier since at Amasya he was so far away. Süleyman was sufficiently alarmed to ask Ebussuûd, the Şeyhülislam, for a *fetvā* justifying the execution of Mustafa, which Ebussuûd issued, though covering his tracks carefully. This *fetvā* was in Rüstem Paşa's hands when he set out for eastern Anatolia in August 1553 in command of Süleyman's Persian campaign of that year. Süleyman followed later to winter at Aleppo, stopping at Ereğli, where the unsuspecting Mustafa was commanded to attend him. Once in his father's presence he was seized by mutes and in spite of his struggles was done to death. Codignac adds[81] that Şehzade Cihangir, his invalid brother, committed suicide on hearing the news. We could not expect Süleyman's chroniclers to admit that, but he certainly died soon after, of fear or grief.[82]

Who was really responsible? There is no need to resort to the speculations and gossip of not always well-informed European diplomats. The army, the clerisy and the bureaucracy were unanimous: Hürrem and Rüstem Paşa. The favourite chronogram giving the date of Mustafa's death was *mekr-i Rüstem* ('the wiles of Rüstem'). Süleyman was forced to dismiss him on the spot, and a letter to him from Mihrimah[83] shortly afterwards suggests that only her intercession saved his head. The uproar among the janissaries was appeased by lavish bounties; but there were revolts in Thrace as well as Anatolia and the appearance of a Pretender which could well have threatened Süleyman's own position. On Süleyman's speedy return to Istanbul the rebels were severely punished. The way, however, was now left open for the struggle between Bayazid and Selim which was to provide a second disastrous confrontation.

At best the premeditated execution of an eldest son must appear as a blot on Süleyman's reputation, but the picture of him as an inhumane tyrant seduced by the baseless accusations of a scheming woman into killing an innocent son is not the moralistic judgement of the censorious modern historian but of his own contemporaries. For the affair provoked a virtual torrent of laments or elegies (*mersiye*), of which no fewer than ten have been published[84] – including two by a female poet, Nisāī,[85] and one by Ḥayālī Beg (d. 1556), who stood in high honour at Süleyman's court – openly arraigning his injustice, as a verse from that by Sāmī shows.

O king of noble blood is this justice?
You may be the lord of the world but is this proper government?
Is this the practice of the great emperors of history?
Is this the practical wisdom of those who rule with judgement and skill?
You may be Muḥibbī but is this affection?
Is this tenderness to kill someone as dear to you as Mustafa?
You killed him deluded by a lying trick and where is the truth in that?
You have been deluded by the words of an enemy: is that love?
You have shed his blood, is that the justice of a caliph?
What's become of Mustafa, why did you kill him, my sultan?

Note: Muḥibbī, Süleyman's pen name, 'the affectionate one'

Earlier, dramatic struggles for the throne among the Ottoman princes or the deaths of Mehmed the Conqueror and Bayazid II, for example, were not, as far as we know,

conventionally marked by laments. This spontaneous demonstration matched by strength of feeling is a clear indication that Ebussuûd's *fetvā* was regarded as an ignoble pretext for the removal of a prince who in popular eyes was the proper successor of Süleyman. The most famous and courageous of these elegies was by a soldier, Taşlıcalı Yahyā,[86] a descendant of the Dukakin Begs of Albania, who told Mustafā ⁽Alī when they met in 982/1574–5 that the rough draft with explicit accusations against Rüstem Paşa was seen by someone who visited his tent and immediately copied and circulated among the army.

God save us! the world is falling about our ears. The insurgents of Death have seized Mustafa Han.

The sun of beauty of the house of ⁽Osman has set, its counsels lie in disorder and by a trick its honour has been besmirched.

The devil's work has caused the passing of this man worth many men.

A liar's blow, the secret hatred of the calumniator, has caused our tears to flow and burned us with the torment of grief.

This beloved youth had done no crime and by his death the columns have been swept away in the torrent of disaster [i.e. Süleyman has been deprived of his proper successor].

My eye has never seen such a spectacle before nor has it beheld such shame and pity.

When Rüstem Paşa returned to power he had Yahyā accused of *lèse-majesté*. His terse retort, '*öldürenlerle bile öldürdük, ağlayanlarla bile ağladık*', recorded by Mustafā ⁽Alī (roughly, 'If we killed him with his executioners we lamented him with his mourners'), left Rüstem Paşa without a reply, although it finished Yahyā's career.

It is extremely difficult, nevertheless, to be certain that Mustafa's execution was entirely unjustified. European accounts like Codignac's put into Süleyman's mouth the accusation that for ten years Mustafa's rebellious spirit had given him no rest. He must have been acutely conscious of the parallels between his own situation and that of his grandfather Bayazid II, from whom his own father Selim had wrested the Sultanate.[87] Mustafa's popularity with the army made him dangerous, a danger augmented by Süleyman's increasing bad health,[88] which encouraged repeated rumours that he was either dying or incapable of ruling. He was already seriously ill at the time of Hürrem's death in 1558 and became much worse from grief. Possibly, therefore, Mustafa's tragic end, like that of his stepbrother Bayazid eight years later, fatally coincided with one of Süleyman's serious indispositions: this gave an urgency and danger to their movements which, when he was younger and in better health, he could probably have ignored.

Whatever part Hürrem played in the Mustafa affair[89] her behaviour was probably not conspicuously worse than that of her female contemporaries, particularly given the generality that social and political pressures at Islamic courts have often driven female rulers into violence. There is, in any case, no doubt that Bayazid's struggle with his brother Selim, where right was much less obviously on his side, was totally against her wishes and that up to her death in 1558 she did all she could to suppress it. Things were, however, more serious, for popular discontent in Anatolia was widespread and increasing – Kızılbaş sympathising with Shah Ṭahmāsp; Celali rebels; wandering dervishes preaching sedition; unemployed *medrese* students (*softa*); fief-holders discontented with falling revenues and the growing power of the standing army. To the extent to which these elements rallied round him, Bayazid was actually, not just potentially, a divisive force.

107, detail of caftan; see also p. 172

Süleyman in the 1550s seems to have been more in favour of Şehzade Selim, who played a prominent role in the Nahçıvan campaign of 1553–5 and who was Governor of the privileged *sancak* of Manisa, which singled him out as the heir apparent, while Bayazid remained Governor of Kütahya. On Hürrem's death he acted to keep them apart, sending Selim to Konya and Bayazid to Amasya. Bayazid protested violently, complained of lack of money, and did all he could to remain at Kütahya. (Süleyman's own letters have not been preserved, but much can be deduced from Bayazid's own.) He finally obeyed but on the way from Kütahya to Amasya collected an army of malcontents, probably to eliminate Selim, although the possibility that he intended to seize the throne cannot be ruled out. Selim had too small an army of his own to defeat him and relied therefore on his father's tacit support. In June 1559 Süleyman ordered him to prepare for a defensive war, sent his viziers to various parts of Anatolia to ensure order, and obtained a *fetvā* from Ebussuûd that for the sake of preserving order and justice Bayazid might be executed too.[90] Bayazid was defeated in battle at Konya and fled with his family and a small force to Amasya where, too late, he sued for pardon. It is probably from here that he addressed his father under the pen name 'Şāhī' in verse, with the refrain *Bī-günāhim, Ḥaḳḳ bilür, devletlü Sultānım bābā*:

O noble Emperor, who is there to present my petition to you?
I am an orphan, separated from my mother and my brothers.
 There is no spark of disobedience in me as God knows.
Father my illustrious Sultan, I am guiltless, God knows.

He was gradually forced eastwards and crossed into Persia. At Qazvin he was at first greeted warmly by Shah Ṭahmāsp, who saw in this refugee his revenge for his brother Alqās Mīrzā's treachery (see p. 4). However, Bayazid's army was expensive and dangerous to lodge: it was dispersed and Bayazid put under house arrest while Shah Ṭahmāsp began to bargain. In return for a large cash subsidy[91] and the cession of various fortresses in eastern Anatolia including Kars, he would surrender Bayazid. Eventually an agreement was reached. An emissary of Selim's arrived in September 1561; Bayazid and his sons were handed over and promptly strangled. Shah Ṭahmāsp's despicable conduct brought him little reward: he never got the fortresses and not even all the cash he had demanded.

The residual unrest in Anatolia was easily suppressed.[92] This time no voices were raised against Süleyman. The text of the *fetvās* pronounced by Ebussuûd makes it clear that by the time he obtained them Süleyman was convinced that Bayazid was in rebellion against him; and Bayazid's own behaviour does little to suggest that he was mistaken. The necessity was grievous and must have afflicted him, but the tone of Şehzade Bayazid's surviving letters would have alienated even an indulgent parent. At any rate, with Bayazid out of the way Selim was the undisputed successor, and on that account at least Süleyman must have felt some relief in his last years.

Süleyman the lawgiver

Conqueror, administrator, patron, poet, uxorious husband, even tragic hero in the eyes of subjects and adversaries alike, Süleyman's exploits justify his epithet 'the Magnificent' far more than the vain show of Francis I or Henry VIII, the campaigns of Charles V, the petty struggles of the princelings of central and eastern Europe, the desperate excesses of Ivan IV of Muscovy, which more than merited his epithet 'the Terrible', or even the achievements of his contemporaries Bābur and Humāyūn in India. And yet this title was

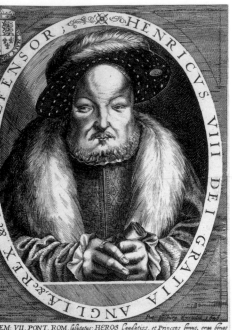

Henry VIII of England;
contemporary woodcut,
c. 1530 (BM P & D O. 9–32)

given him by foreigners, possibly only as late as the seventeenth and eighteenth centuries, for in the Venetian chronicles *magnifico* is used as a standard honorific not only for the Gran Signor or Il Signor Turco but also for his ambassadors received by the Venetian Senate, his admirals addressed in correspondence, and his viziers when they were visited by ambassadors in Istanbul; and its force was devalued by over-use.[93]

The earliest official use of 'Magnificent' even in Europe may be late sixteenth century: in the title of an anonymous Venetian account of his 'coronation'. Magnificent (Arabic *muhtasham*; modern Turkish *muhteşem*) was not used by Süleyman's Chancery, even in the titulature of the full text of the foundation inscription of Süleymaniye drawn up by the Şeyhülislam Ebussuûd[94] or in the *vakfiye* of Hürrem Sultan (no. 12). To Süleyman's Ottoman contemporaries and immediate successors, particularly in the disorder and decline after 1580 when they looked back nostalgically to his reign as an age of order and prosperity, he was the Lawgiver, *Ḳānūnī*. Doubtless, gestures at the outset of his reign like the return of craftsmen brought from Egypt and Iran by Selim I to their homes (although not all may have wanted to go and quite a lot actually stayed), the raising of the trade embargo with Iran established by Selim I and the summary execution of the Admiral Caᶜfer Beg for oppression were made deliberately to establish his reputation for justice; but it is for criminal, administrative and constitutional law (*ḳānūn*)[95] that he was famous.

The view that the Muslim law, the *Sharīᶜa*, in practice, needed supplementing by *ad hoc* regulations had been grudgingly accepted in many Muslim societies. The treatment of the religious law as actually being complementary to administrative law, however, is peculiarly Turkish,[96] and early in the reign of Mehmed II two *ḳānūnnāmes* were promulgated regulating by statute the penal code, the tax structure and government administration. These *ḳānūnnāmes* combined description of actual practice with an acknowledgement of precedent, in particular in Muslim lands which had come under Ottoman domination, and indicated normal or desirable practice, while allowing for exceptions in exceptional circumstances. In the later sixteenth century there was a tendency exemplified in Muṣṭafā ᶜĀlī's writings[97] to present earlier *ḳānūnnāmes* as having fixed practice so that any deviation from them was *ipso facto* illegal; but this must be seen as sentimental anachronism.

Such *ḳānūnnāmes* had to be validated on the accession of a new sultan. This was not automatic and, in fact, Bayazid II was inclined to turn back to the belief that the *Sharīᶜa* was the only proper body of law. It was, however, in his reign (probably between 1492 and 1501) that the so-called *ḳānūnnāme* of Süleyman seems to have been compiled. This, of course, is not to deprive Süleyman of his title *Ḳānūnī*. In his reign we find systematically arranged *ḳānūnnāmes* for practically every military administrative district, regulating in detail the conditions of land tenure, as well as series of decrees containing laws and regulations on particular subjects, mostly drawn up in the Chancery in response to petitions but on occasion drawn up by Süleyman himself. The general code written down under Bayazid II was also in general use. The copies of it distributed to the Kadis' courts were, of course, modified by later decisions; but the publication of the code made the administration of justice for practical purposes identical all over Süleyman's domains, and was one of the great achievements of his reign.

Simultaneously came a rise in the importance of the central bureaucracy dominated by the Chancellor (Nişancı), the Chief Clerk (Reisülküttab) and the Treasurer (Defterdar). The key figure in this was the historian Celālzāde Muṣṭafā, Chancellor from 1534 to 1556, who not only established the documentary forms and diplomatic formulas used for the rest of the century but also played a leading role in the codification and

standardisation of *ḳānūn*, working with the Şeyhülislam Ebussuûd to harmonise it with the *Sharīʿa* and establishing the Chancellor as the secular counterpart to the Şeyhülislam. A further result was to establish the higher bureaucracy (*kalemiye*) as a path to the highest office parallel to the military (*seyfiye*) or the clerisy (*ʿilmiye*). These developments were paralleled in France under Francis I and in Spain under Charles V, and doubtless explain why all these monarchs could afford to spend so much time abroad on campaign. The growth of a specialised administrative class does much to explain the emphasis of later sixteenth-century historians on *ḳānūn* as constitutionality and their idealisation of Süleyman's reign as a time when order was paramount and the bureaucracy worked, but it enshrined many inherent imperfections. Even under Celālzāde Muṣṭafā the Ottoman bureaucracy must have been to a degree a cloak for cowardice, if not actually a form of cowardice itself: but in the last resort cowardice has its attractions like other forms of social life.

Süleyman's magnificence

In writing of Süleyman, or any of his eastern contemporaries with the exception of Bābur, the founder of the Mughal dynasty in India, there is a considerable absence of autobiographical or even anecdotal literature to offset the rich contemporary panegyric histories or the administrative documents. The *relazioni* of the European diplomats in Istanbul, moreover, with very rare exceptions like the letters of Ogier Ghislain de Busbecq, tell us more of their writers, their prejudices and cloistered ignorance than the Turkey of which they were ostensibly writing. Not that we can afford to reject them, but we do know that if we were to write the histories of Henry VIII, Francis I or even Charles V on the basis of similar material the result would be subtly, even blatantly, different from what we know them to have been. It is not that the panegyric historians were false but that for dynastic or political reasons they emphasise certain aspects of Süleyman's reign like, for example, the war against the Infidel, which minimise the personal element in his motivation and which very probably did not reflect what he himself thought. This lack of a personal view has, not surprisingly, encouraged some historians to explain Süleyman's policies abroad in terms of mechanistic theories, even reviving the long dead balance of power for the purpose.

As for the administrative documents – apart from the tax-registers which clearly indicate how the constant wars of Süleyman's reign could have been financed – we practically never have any idea of how effective they might have been. In the light of our experience of other bureaucracies we may well suspect that many repeated orders must have been necessary to regulate certain states of affairs and that certain other states of affairs must in fact never have been regulated at all.

The aridity of the source material may encourage reactions of despair, to treat Süleyman as an 'Oriental' potentate, with the somewhat dubious standards of the genre, whose motivation is obscure to us, trained in the tradition of the West. If there are such things as 'Oriental' potentates, it is not Süleyman who deserves the name but his contemporary Ivan the Terrible, whose sobriquet is well applied. Slightly more naïve but equally despairing and equally misleading is the view now more prevalent that the panegyrics should be taken at their face value. However, to weigh the many peccadilloes of Francis I, who was a close approximation to an 'Occidental' despot himself, Henry VIII or even Charles V against the apparently unblemished rectitude of Süleyman's court is, even if unprovably, an error of judgement. There is, in fact, no cause for despair, and

further publication of documents will certainly throw much more light on his personality. If we are to estimate his greatness, we must inevitably use criteria by which we evaluate his contemporaries, and in this the *Letters* of Busbecq, which present the Turks as friends, not a race apart, must be our guide. Although we may concede that Süleyman's absolutism had elements which had little in common with his fellow monarchs in Europe, his similarities to them are on the whole more striking than the differences.

On one point, however, the Venetian *relazioni*, the administrative documents and Süleyman's chroniclers are satisfactory enough – his magnificence. His personal appearance, jewellery and robes set him apart as the most absolute of absolute monarchs, although like his predecessors he and his court openly flouted the sumptuary laws of Muslim tradition (*ḥadīth*) which forbade the wearing of silks by men. Jérôme Maurand, who was present at an audience with him in 1544,[98] well conveys the splendour of his appearance: enthroned on cushions of cloth of gold he wore a gown of white satin with a medium-sized turban over a bonnet of pleated crimson velvet. On the turban was a gold medallion or rosette, set with a sparkling cut ruby, the size of a hazelnut, and in his right ear there was a pearl, pear-shaped, similar in size and curiously wrought.

As it had been for his predecessors, the festivities and public ceremonies of his reign, like his departures on campaign, were part of a highly formalised routine, though on a previously unknown scale, to enhance his glory, show him as the head of Church and State, and inspire dread in the enemy. Unlike the Medici, the Gonzagas or the Doges of Venice, whose triumphs were as much symbolic as real, Süleyman had no need to address himself to emblems. It was perhaps this directness which made Ottoman spectacle so impressive to the worldly, sophisticated Italian ambassadors. On such occasions as in some virtuoso Ottoman art nothing succeeds like excess.

There is an account in Sinan Çavuş's history of Süleyman (now believed to have been written by Maṭrāḳçı Naṣūḥ) of his ceremonial departure from Edirne on his Hungarian campaign of 1543,[99] which demonstrates the degree to which magnificence was not merely personal taste or style but an inherent feature of Ottoman society, the parts of which Busbecq found so admirably subordinated to the Sultan. At the head of the parade were the water-carriers, preceding a baggage train of 2,000 mules, 900 horses and 5,000 camels laden with supplies and munitions. Then came the advance corps – 1,000 armourers, 500 sappers, 800 bombardiers and 400 men in charge of the gun-carriages all with their commanders and officers. After these rode palace officials, the Keeper of the Pantry, the (Kilercibaşı), the Keeper of the Treasury (Hazinedarbaşı) and the Head Doorkeeper (Kapıağası), followed by the cavalry, 2,000 to each wing, and then the ᶜUlufecis and the Gureba similarly divided, all with their coloured banners and pennants flying. There followed the Divan officials, the Nişancı, Celālzāde Muṣṭafā, the Treasurers, the military judges (*kazasker*) and the four Viziers, each accompanied by a staff, slaves and servants. Hard upon these followed the Sultan's huntsmen, houndsmen and falconers (for Süleyman invariably combined business and pleasure on campaign), then innumerable fine steeds, richly saddled and caparisoned, accompanied by the Master of the Horse, saddlers and armed riders and a group of 300 mounted chamberlains (*kapıcıbaşı*). The janissaries numbered 12,000 with their long white felt head-dresses, armed with swords and lances and bows across their shoulders. The Sultan's party was preceded by seven gold striped banners and seven columns (*tuğ*) with golden yaks' tails, 100 trumpeters with their trumpets slung round their necks on gold chains, 100 kettle-drummers and the 400 strong life guard (*solak*), whose commanders marched by the Sultan's stirrups, all with white felt bonnets, rich turban ornaments,

silken sashes and richly worked bow cases and quivers. With the *solaks* marched 150 pursuivants (*çavuş*), headed by the Çavuşbaşı, all bearing silver staves garlanded with silver chains and adding their huzzas to the clamour of trumpet and drum. Within the *solaks* marched the *peyks* (runners armed with lances), richly apparelled and with gold helmets and spears, with the Sultan riding in their midst as it were shaded by the plumes of the *solaks*.

This order of battle, much more elaborate and grander than Süleyman's Friday procession to the mosque, was not merely to impress his subjects but to cast terror on his enemies. For who could offer battle to such a brilliant host?

As for the 'bread and circuses' side of Süleyman's reign, the culminating spectacle of the first decades of his reign was probably the twenty days' circumcision festivities of June–July 1530[100] in the Hippodrome in Istanbul, before the ambassadors, the tributary princes, the Paşas and military commanders assembled in the presence of a vast but orderly and silent crowd. In the great hall of Ibrahim Paşa's palace overlooking the Hippodrome a throne for Süleyman had been set on carpets and cloth of gold for him to receive the congratulations of the guests. Ibrahim Paşa's own gifts included a casket of jewels from Cipriani in Venice, fine manuscripts, robes of honour, silks and eleven pages bearing handsome services of silver gilt each worth 50,000 ducats. As in 1524, on the following days there were spectacles of all sorts in the Hippodrome watched by the Sultan from the palace of Ibrahim Paşa – strong men, military exercises, including those in 'Circassian Mamluk style' (*al modo de questi altissimi cerchassi*),[101] mock sieges of cardboard and wooden Hungarian castles realised by Maṭrākçı Naṣūḥ,[102] funambulists on tightropes tied to the obelisks in the Hippodrome, processions of animals from the menagerie with their tamers, buffoons, men on stilts, followed on each occasion by a banquet for all served on porcelain dishes, for no fewer, Mocenigo estimated, than 8,000 to 10,000 people at a time, with fireworks in the evening to follow.

Much of this splendour and ceremonial would have been entirely appropriate at a European festivity like the Field of the Cloth of Gold, although it must have eclipsed that, and the splendid Venetian and Florentine court spectacles. The firework displays also exceeded any spectacle in Europe, culminating in a display on the day of the circumcision with animals which moved about discharging rockets, horses, elephants and giants, a fire-breathing serpent almost 4 metres long, windmills, and a great ship with a galley sailing against it, with rockets enough to set the sky alight. The circumcision feast established the 'book', so to say, of such festivals, a dazzling equivalent to the public festivals of Renaissance and Mannerist Europe, and the lavish celebrations of Süleyman's wedding to Hürrem[103] were in many respects identical.

Süleyman the collector

Süleyman's many conquests, and his diplomacy and wars against the Habsburgs and the Safavids stimulated trade and tribute to an extent unparalleled in Ottoman history. These gave the arts in his reign brilliance, virtuosity and a certain eclectic character which bring them close in spirit, though not always in effect, to the arts at the Mannerist courts of Europe, Florence, Mantua, Fontainebleau and, slightly later, Prague. As with contemporary Europe there is no easy distinction between the major and the minor arts, the decorative and the 'serious': a cannon cast for Süleyman in 1524 is as boldly decorated as the minarets of the mosque of Şehzade (completed in 1548) in Istanbul, and from the largest to the smallest there is an overriding concern with

62, silver tray,
details of chasing

exquisitely worked detail, sometimes to the extent of obscuring the object or the building which bears it. The expense, in labour and materials, was correspondingly great: the richer the effect, the richer the patron. In this, Turkey under Süleyman, like the later Medici and the Habsburgs, benefited initially from the flow of treasure into Europe from the New World. The catastrophic inflationary effects which hit Spain in the 1550s do not appear to have affected Turkey much before the final decades of the sixteenth century. Süleyman's reign was, thus, financially a halcyon period for the arts.

Selim I's victory at Çaldıran in 1514 and the ensuing sack of Tabriz, and his conquests of Aleppo, Damascus and Cairo, were important because they gave the victorious Ottoman armies the taste for spoils. A short, incomplete, account book dated early October 1514[104] lists porcelains, rock-crystals, amber and jades taken from the Heşt Bihişt palace at Tabriz. There is always an indiscriminate element in collection by loot, although the porcelains collected by Süleyman and his viziers, like Iznik dishes showing the direct influence of Chinese prototypes, reveal a confirmed taste for Yuan or early Ming blue and white.[105] The hardstones, some of which are listed as unworked plaques, made possible the achievements of the goldsmiths and jewellers of the later sixteenth century but they also brought the Ottomans the nucleus of a collection of Central Asian jade carving.

No less than Turcoman and Safavid Iran, the Ottomans saw themselves as heirs to the culture of Timurid Central Asia, even if, unlike the Mughals in India, they could not claim a direct family relationship. This was not mere political pretension. ᶜAlī Ḳūşçī, Ulugh Beg's last Astronomer-Royal in Samarkand, had made his way westwards on his patron's death, arriving in Istanbul with a considerable part of the observatory's valuable library in 1471, when he was immediately appointed Astronomer at the mosque of

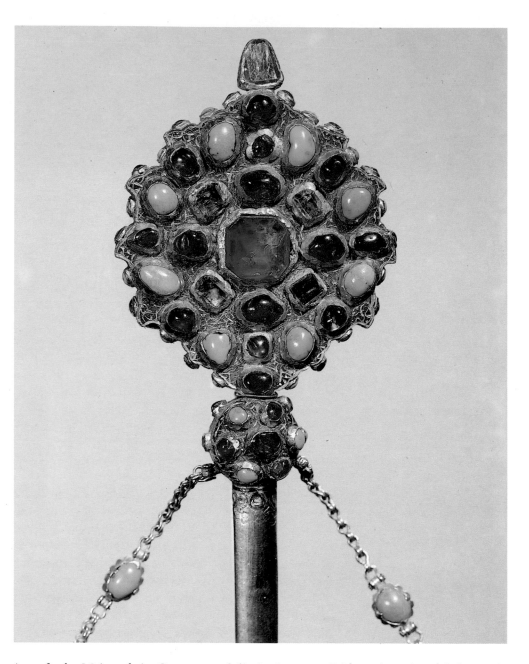

61, detail of turban ornament
(front); see also p. 129

Ayasofya by Mehmed the Conqueror. Selim's victory at Çaldıran (1514) and Süleyman's
victorious campaigns also brought the sultans into direct contact with the jade and other
hardstone objects in which Ulugh Beg had set a fashion. This played a formative role not
only in Mughal but in Safavid taste. There is in the Treasury of the Topkapı Saray a
black nephrite jug[106] with a dragon handle, inlaid in gold with the titles of Shah
Ismāᶜīl, which is very probably a reworked Timurid piece, and even more prestigious
was the drinking cup in the British Museum inscribed with Ulugh Beg's name (no. 67),
which was carefully repaired with a new inscribed silver lip. The repair and the
inscription strongly suggest that it was once in the Ottoman Treasury. The Treasury of
the Topkapı Saray also contains a magnificent carved sandalwood box with ivory inlay in
Ulugh Beg's name, evidently from the same source.

The role of tradition in Selim I's and Süleyman's collecting is difficult to evaluate

precisely for the Ottoman annalists are mostly silent; but Selim, for example, collected relics from Mecca and Medina to rehouse in a shrine (the Hırka-i Saadet Dairesi) in the Topkapı Saray. What in Süleyman's reign was new was an interest in trophies from late Renaissance and Mannerist Europe, which the constant expeditions of his reign into central and eastern Europe had brought within his grasp. Their influence was vastly augmented by tribute from the Saxon goldsmiths of Transylvania, Moldavia and Wallachia and gifts from the Habsburg and Valois kings.

A particularly significant episode was Süleyman's capture in 1526 of Buda, which still bore much of the fame of the humanist ruler and patron Matthias Corvinus (d. 1490). Not only had Italian merchants brought goldsmiths' work from Venice and Naples, rich textiles from Florence, Venice and Milan, arms from Modena and Milan, glass from Venice, and ceramics from Faenza, Urbino and Florence; there was also a maiolica workshop attached to the citadel, Venetian glass-blowers were resident in Buda, and the architectural marbles of Matthias's palace were commissioned (1488–90) from the workshop of Giovanni Dalmata (from Traù, Trogir), who had won fame in Florence and at the Papal Court in Rome.

The most famous of all Matthias's foundations was the library, the Bibliotheca Corviniana,[107] rich in Florentine humanist manuscripts illuminated in the workshops of Attavante degli Attavanti (1452–*c.*1517) and others, and in manuscripts and illuminated coats of arms (*Wappenmalerei*) executed for Matthias in the scriptorium he assembled in his palace at Buda. Although depleted by his feckless heirs, it continued to evoke rapturous descriptions from visitors up to the end of the sixteenth century. Süleyman must have gone round it soon after his occupation of the citadel of Buda in 1526, and a considerable number of its manuscripts were removed to Istanbul. Those which are traceable are mostly literary and by late Classical authors and some of them are scarcely collectors' items. However, among the finer manuscripts which returned from Istanbul within decades of the occupation of Buda is a Horace, with the *Satires* of Juvenal and Persius (British Library MSS, Lansdowne 836) made in Florence *c.* 1450–70, which bears a note on the flyleaf that it was acquired by Anton Verancsics (Vrančić), Bishop of Pécs (Fünfkirchen), in Istanbul on a diplomatic mission in 1556–7 (no. 38). How far did these reflect Süleyman's own literary and artistic taste? Few of the finest Florentine illuminated manuscripts may have been carried off, but although Attavante's decoration, with its elaborate *grotteschi*, its dazzling vignettes and its architectural fantasies is as rich as anything made for Süleyman, its style is very different from sixteenth-century Ottoman painting and illumination. Nor is the 'European' appearance of some of the illustrations to accounts of Süleyman's campaigns (e.g. nos 45a–d) in Hungary simply attributable to Florentine manuscript-painting, or to any other European painting, from the Corviniana.

Such manuscripts were, however, by no means Süleyman's only booty from Buda. Foreign visitors to the Hippodrome in Istanbul in the 1530s noted[108] a conspicuously displayed sculptural group on a column, variously identified as Mars, Diana, Hercules or Apollo, but more probably, consonant with Matthias's own idea of himself as the reviver of the glories of ancient Rome, Mars protecting Romulus and Remus, the legendary founders of Rome.[109] They also appear to have been Florentine work and represent a rare occasion when Süleyman may have shown interest in European sculpture. The figures are clearly shown in illustrations to Volume II of Lokmān's *Hünernāme* (TKS H. 1524, dated 996/1588) made for Murad III, in scenes of the circumcision festivities for his sons held in the Hippodrome in 1530 among the ancient monuments from the spina of the Byzantine building. This is rather astonishing; but the still-standing obelisk of

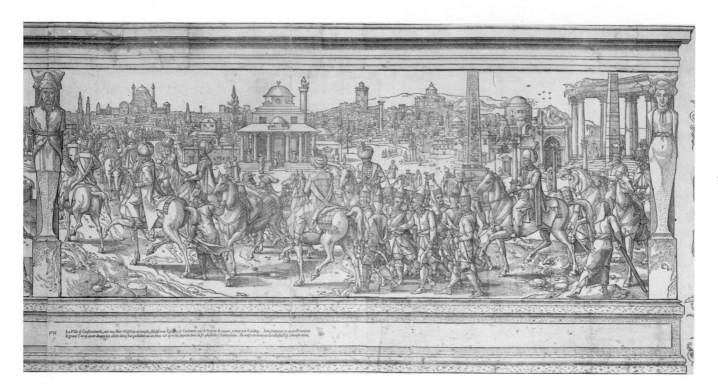

Süleyman the Magnificent in procession in the Hippodrome in Istanbul; anonymous woodcut (dated 1553) after Pieter Coecke van Aelst (BM, P & D E. 6 (6½–7)). In the background on a column can be seen the three statues brought from Matthias Corvinus' palace at Buda

Tutmosis III with its hieroglyphs and the column of Theodosius with its heavily sculptured marble base show that, if it was merely fanatical dislike of figural sculpture which prompted the removal of the Buda figures, it was of a somewhat selective nature.[110]

Also associated with the sack of Buda is a pair of bronze lampstands at the *mihrab* of Ayasofya,[111] each with two verse inscriptions dated 933/1526–7 commemorating their removal and referring to the destruction of the churches there, and most probably from the Cathedral of the Virgin on the citadel of Buda. The offering of such trophies to Ayasofya interestingly recalls Justinian's original intention to make his church, Haghia Sophia, a physical embodiment of the triumph of Christianity over paganism by incorporating into it marbles and other precious materials from all the great monuments of the pagan past. Something of this survived in the Muslim legends associated with the church and Süleyman's offering may, therefore, not be entirely an accident.[112]

Much less is known of the trophies Süleyman collected from other European cities and fortresses, like the rare icon of the Virgin from Belgrade (1521), which the Orthodox patriarch in Istanbul later acquired for 12,000 ducats.[113] What became, for example, of the relics from the treasury of the Knights of Rhodes when they quitted their fortress in 1522 and their cathedral was turned into a mosque?[114] Or were the frequent raids on the Adriatic and the Mediterranean coasts of Italy as productive of cultural spoils as of slaves, cargoes and specie? The Stephanskron, the holy crown of the Hungarian kings, was, indeed, saved for Hungary by Süleyman from Ferdinand of Austria,[115] and it is a pleasing thought that, had Vienna fallen in 1529 the Coronation mantle of Roger II of Sicily and other Habsburg regalia might now have graced the Topkapı Saray rather than the Hofburg.

Collection by booty in manufactured objects as well as in raw materials in Süleyman's reign was far exceeded by tribute and the luxury trades. From Iran, despite periodic embargoes, the Ottomans imported raw silk in bulk, although much of it was immediately re-exported to Italy or to France from Aleppo or from Bursa, while

turquoises came from Nishapur. The India trade brought Chinese porcelains, diamonds, garnets, rubies and semi-precious stones to Basra or via Aden to Egypt. Egypt continued to be the main entrepôt for the European spice trade,[116] after a short-lived Portuguese attempt in the early sixteenth century to base a spice monopoly in Lisbon. Increasingly, spices were supplemented by coffee from the Yemen which rapidly conquered the initial doubts of the Ottoman *ulema*,[117] although the authorities were not always content. An order, for example, from the end of Süleyman's reign, shut the coffee houses in Jerusalem on the grounds that they set a bad example of idleness and fostered sedition.[118]

From the north, Poland and Muscovy, came amber,[119] fish tooth (walrus ivory) and enormous quantities of furs – an essential in Ottoman society, both for show and to mitigate the rigours of the harsh winter climate of Istanbul. Problematically, however, with overtrapping, Russian trappers had to move eastwards towards Siberia, which diverted the southwards trade to the Volga and the Caspian, so that the furs reached not the Ottomans but their inveterate enemy, Safavid Iran. The strict Muscovite bureaucratic controls on foreign trade favoured centralised control of the fur trade in Ottoman Turkey, but the state merchants who became a feature of this trade in the 1570s and 1580s may not have been so prominent under Süleyman.[120] From Venice, Genoa, Leghorn, Ancona and Ragusa came the finest woollens, and considerable quantities of Venetian and Florentine velvets, brocades and other silk textiles, which the sultans distributed as robes of honour to reward those in favour and also wore themselves.[121] Relatively little of the products of the New World which in the mid-sixteenth century were flooding European markets reached Ottoman Turkey, but by 1560 quite a lot of the emeralds used by Ottoman jewellers appear to have been Colombian.

From south Germany, Transylvania, Ragusa and Venice came silver- and goldsmiths' work, which was expected as a matter of course from any foreign diplomatic mission seeking peace, alliance or commercial privileges. Much of it was sent straight to the Mint to be melted down. Nevertheless, it encouraged European craftsmen to think that the Ottomans liked it and even prompted speculations like the bizarre four-tiered gold crown, commissioned by a consortium of Venetian goldsmiths in 1532, which was ultimately sold to Süleyman (no. 6). This scarcely suggests an accurate idea of Süleyman's tastes, which contemporary commentators like Pietro Aretino rather disdainfully dismissed as a childish love of extravagance.[122]

Under Süleyman foreign merchants dominated the luxury import trade, sometimes Venetian residents in Istanbul but sometimes also the *bailo* himself or ambassadors from Venice,[123] although, as in the case of the four-tiered crown, they depended heavily upon middlemen high in the Sultan's favour. Many of them got no nearer to Süleyman than his viziers or even quite minor officials, but among his personal friends was Luigi (Venetian, Alvise) Gritti,[124] the natural son of the Doge Andrea Gritti, who was precluded by his birth from high office in Venice and who chose to make his career in Istanbul. His magnificent palace in Pera, commemorated by the modern name for Pera, Beyoğlu, was frequented by both Ibrahim Paşa and Süleyman himself.

Although he owed much of his influence to Ibrahim Paşa, Gritti was particularly important as an intermediary in diplomatic negotiations with the European powers and was the principal instrument of Süleyman's anti-Habsburg diplomacy in Hungary and eastern Europe. In Hungary he was, successively or concurrently, Bishop of Eger (Erlau), in which his son succeeded him; Governor General, Treasurer and Captain General of the Hungarian kingdom; a great fief-holder; and a Muslim. This last chiefly gave him his European reputation of being a renegade,[125] although it little affected his

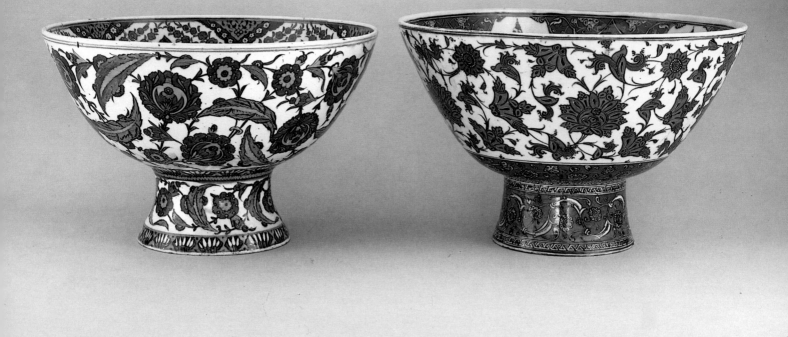

143 (left), 131 (right); see also
pp. 192, 199

influence in Venice, where his brother Lorenzo, with whom he remained on good terms,
was an important commercial and cultural link, furnishing him with jewels, hounds and
even a wonderful cat, and he was evidently an important channel for luxury objects for
the Sultan and his court.[126] Too little is yet known of the workings of the trade in gems
with Europe, but there are indications that Jewish merchants were already important
both as importers and as employers of gem-cutters particularly when it came to more
ambitious cut forms than table-cutting which remained the principal cut form at the
Ottoman court for most of the sixteenth century.[127]

Among the most extravagant European luxuries collected by Süleyman the
Magnificent were clocks and watches, particularly from Lyons, Nuremberg and
Augsburg, not so much timepieces as elaborate automata, planetaria or mechanical
organs, often to the detriment of their accuracy, but the work of the finest makers of the
time. They were collected all over Europe, from England to Muscovy, but early pieces
specifically for the Ottoman market included a gold ring with a striking watch set in the
bezel in 1531 made by a Vicenzan craftsman. This was sent together with a mechanical
ship which would serve as a table ornament (*nef, navicella*) and a wooden mechanical doll
which walked. Ten years later, the embassy from Ferdinand of Austria suing for peace
presented to Süleyman a magnificent silver planetarium which had been made for
Maximilian I. It took twelve men to carry it into the audience chamber and it was
accompanied by its maker, who left behind an instruction manual should repairs be
necessary. It is described in detail in Paolo Giovio's *Historiarum sui temporis libri*
(1577);[128] he attributes Süleyman's interest in astronomy and cosmography to his Jewish
physician, Moses Hamon (d. 1554).[129] In 1543–4 Francis I presented Barbarossa, who
was wintering at Toulon, with a clock which was also a terrestrial globe and in 1547 sent
to Süleyman a combined table fountain and clock, probably a clepsydra, made at Lyons.
In this same year the Ottoman treaty with Austria included a stipulation that the annual
tribute (euphemistically described as the *Türckhisches Präsent* or *Türkenverehrung*) should

be partly in clocks, which must all be novelties: four such clocks were sent the following year, with a clockmaker to ensure that they were all in working order when they arrived.

There are drawings from the early 1570s for comparatively sober clocks for the Grand Vizier, Sokollu Mehmed Paşa,[130] and those destined for the Sultan may have been deliberately restrained in their effects. Few, however, survive, even in the great European collections, for their mechanisms were mostly too elaborate and rapidly broke down; clockmakers were not always available to repair them; and it was generally easier, if not cheaper, to order new pieces. Their appearance, which may to some extent be reconstructed from contemporary European inventories or chronicles, suggests that, despite their magnificent goldsmiths' work, enamelling and jewelling, the effects they employed – including elephants with rolling eyes, dancing figures in Turkish costume, singing birds – showed little regard for Ottoman sensibilities. Otto Kurz has, indeed, remarked that such clocks and their decoration were really no different from any made for the sultans' European contemporaries.

What was the reason for their extraordinary popularity at the courts of Süleyman and his successors? As Busbecq noted, the *ulema* calculated the times of prayer astronomically and instead of the twenty-four equal hours which were standard practice in European clockmaking they divided each day and each night into twelve hours, so that a European clock would only have told Turkish time properly on the equinoxes and would have been far less use than a properly calibrated sundial. Accurate timekeeping for short periods would, moreover, have been quite adequately catered for by the Ottoman hourglasses in everyday use. They must, therefore, have admired their rich decoration, their elaborate mechanisms and, sometimes, even their jokes, but as toys, not Renaissance machines demonstrating the principles of physics. Their influence upon Ottoman technology was thus somewhat limited, although their popularity at the court certainly stimulated a wider demand for simpler or cheaper watches in Istanbul, and probably by the end of Süleyman's reign there were clockmakers resident in Istanbul.

Among the pioneers of this movement was a Syrian astronomer, Taqī al-Dīn (d. 993/ 1585), who ultimately became the director of Murad III's short-lived observatory at Tophane[131] and who wrote the only known sixteenth-century treatise in Europe on the making of weight-driven or spring-driven clocks. Suggestions that in his youth he studied in Rome have not been substantiated and he must have learned to make his clocks by experiment on broken European clocks in the palace. By 971/1563–4, he reports, he fulfilled an order to build a clock showing the Islamic prayer times and the Western months, an enterprise of considerable mechanical sophistication. He exploited his theoretical treatise in the instruments he made for the Tophane observatory designed for the calculation of new star tables to correct those made for Ulugh Beg in Samarkand in the mid-fifteenth century.[132] The sad episode of the destruction of the observatory in 1579 on the orders of the Şeyhülislam, possibly a panic reaction to the appearance of a comet in 1577–8 which sowed terror in the Ottoman dominions, lies outside the scope of Süleyman's reign; but the result was the suppression of Taqī al-Dīn's treatise and his experimental works.

Süleyman the builder

Of Süleyman's small palaces and hunting lodges in the neighbourhood of Istanbul, Bursa and Edirne, all that we have are Busbecq's descriptions, evocative but insufficiently circumstantial, although in a pavilion up the Bosphorus near the Black Sea he saw doors with a depiction of the defeat of the Safavid Shah Ismāʿīl at Çaldıran in

1514.[133] The present appearance of the Topkapı Saray owes most to his immediate successors, Selim II and Murad III, and only the Palace he built for Ibrahim Paşa on the Hippodrome in Istanbul soon after his accession (now the Museum of Turkish and Islamic Art) gives some idea of the grandeur of the great houses of Istanbul and Galata in the sixteenth century.[134] However, palace architecture is often transient and subject to rulers' whims, and it is to Süleyman's pious foundations, the rich endowments of which have guaranteed their survival in good condition and which transformed the appearance of city after city of the Ottoman empire – Mecca, Baghdad, Jerusalem, Damascus, Konya, Adana, etc. – that we must look for a proper evaluation of his architectural patronage.

One of Süleyman's first tasks on his accession was the completion of the mosque of Selimiye in Istanbul for his late father Selim I. He then turned to Mecca, where he restored the Ḥaram and commissioned waterworks, and then to Jerusalem. In 1524, following a lawsuit brought before the *müftī* of Istanbul by discontented Jews who complained of the difficulty of access to the tomb of David (Maqām Dā'ūd) in the vicinity, the Franciscans were expelled from the Convent of the Last Supper (the Coenaculum), which was turned into a mosque.[135] Süleyman set to restore the Ḥaram al-Sharīf, a project which was to occupy him for almost all of his reign.[136] The earliest inscription of his reign on the Dome of the Rock is dated 1529, evidently just before his departure on the campaign which culminated in the siege of Vienna; further works are recorded by a series of inscriptions dated particularly to the 1540s but continuing up to the 1560s, notably the revetment of the exterior drum and the octagon with tiles, by craftsmen from Tabriz; these are known to have been fired on the spot. The latest inscription, commemorating the brass-plated wooden doors of the Dome of the Rock, is dated 972/1564–5. Simultaneously the Aqṣā Mosque was restored; in no more than six months a reservoir and a system of fountains were built inside the city; and between 1537 and 1540 the walls were refurbished and partially rebuilt, although there was little danger to Jerusalem apart from marauding bands of Bedouin. The rebuilding was mostly on the basis of the Crusader walls which, contrary to general belief, seem to have been only partially dismantled in 1229 following the treaty of the Ayyubid ruler al-Malik al-Muᶜaẓẓam ᶜĪsā with Frederick II of Hohenstaufen, and the florid inscriptions erected by Süleyman commemorate, in fact, relatively minor works. Part of the explanation why the works continued so long is that, as administrative documents show, men and building materials could not be found locally but had to be brought from Damascus:[137] although the organisation of this was well within the capacities of the Ottoman provincial administration, it could easily have led to considerable delays.

This concentration of activity had remarkable results: on the evidence of tax registers between 932/1525–6 and 961/1553–4 the population of Jerusalem grew from approximately 4,000 to 12,000,[138] and, as the foundation of Hasseki Hürrem's great *ᶜimaret* [cf. no. 10] there shows, this must be directly connected with the growing attention given to the pilgrimage to Jerusalem (cf. no. 36). Jerusalem was as ancient a Muslim pilgrimage place as Mecca and Medina, but the increasing frequentation of Palestine by European pilgrims[139] made access to the Christian Holy Places a prominent factor in the diplomacy of the European powers with Ottoman Turkey. One may see Süleyman's policy, therefore, as a facet of his European campaigns, gaining the ascendancy on the religious plane as his armies and his fleet guaranteed territorial expansion.

Partly, however, the slow progress of these early works in Jerusalem lay in the fact that Sinan, the greatest of Ottoman architects and an administrative genius, was yet to

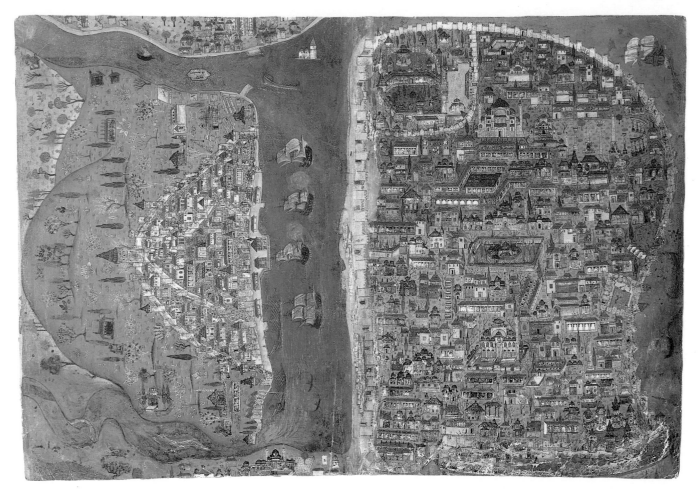

43a, *Mecmū^ca-i Menāzil*,
Istanbul-Galata (ff. 8b–9a); see
also p. 106

appear on the scene. He had entered the janissaries in 1521 and had had a distinguished career in the Cavalry and the Musketeers (Tüfenkçiyān) – and served on all Süleyman's major campaigns up to his appointment as court architect (Hassa Mi^cmar) in 1538. His building experience seems to have been gained entirely from amateur projects, like the wooden bridge he erected over the River Prut on Süleyman's Moldavian campaign of 1538. Ground plans were often stereotyped and architectural elements well on the way to being standardised while safety factors in building were extravagantly high. Many of the building operations could, therefore, safely be left to the masons and jobbing builders he employed, leaving him with time to exercise his most valuable responsibilities, namely to organise and cost the larger works as well as to conscript, train and promote staff. Even so his achievement was immense: of the 477 buildings reliably attributed to him 196 are still standing, mostly in Istanbul and Edirne and on the royal road joining the two cities. Of the total 106 are mosques, of which 62 still stand.[140]

Among his earliest buildings in Istanbul are a complex ordered by Süleyman's beloved wife, Hasseki Hürrem Sultan (945/1538–9, cf. no. 12) with a *medrese*, a soup kitchen (*^cimaret*) and a Koran school for orphans to which was later added a hospital: there is no evidence in its foundation charter (*vakfiye*) that she intended it as a women's hospital, although by the mid-seventeenth century, Evliya Çelebi reports, it had become partly a lunatic asylum and partly a hospice for destitute women. In 948/1541–2 he built the tomb of Barbarossa at Beşiktaş and in 950/1543–4 work was begun on the funerary mosque of Şehzade Mehmed, Süleyman's son by Hürrem Sultan. The splendid green, blue, yellow and purple tiles in his tomb are one of the last uses of the traditional *cuerda seca* fired tiles in Ottoman architecture.

A series of smaller buildings for viziers and the royal ladies, notably for Mihrimah, one of Hürrem Sultan's daughters at Üsküdar (late 954/early 1548), was then the prelude to Süleyman's greatest foundation, Süleymaniye, in the grounds of the old palace (Eski Saray) which up to its serious damage by fire, possibly in 1541, had been the Sultan's residence and that of his women. Following the fire Hürrem and her attendants moved across to the Topkapı Saray where she was installed in what was to become the Harem apartments and, although the Eski Saray remained the lodgings of disused or disgraced concubines, the gardens became a building site. Works began in 1550 and continued until after the inauguration of the mosque in 1557. A vast area was levelled, men and materials were collected from all over the Ottoman Empire, and the detailed account books, which have been brilliantly analysed by the late Ömer Lutfî Barkan,[141] give a graphic picture of the labour force, their pay and recruitment, the immensely complex operations necessary to obtain the desired building materials and even the day-to-day progress of works. Architecturally the mosque is at the centre of a complex of *medreses* and other institutions of learning (deliberately conceived as the culminating stages in the *cursus honorum* of the Ottoman clerisy), a bath, a hospital for teaching, and one for treatment, a soup kitchen and other buildings, all furnished with water from new works (Kırkçeşme) running from a series of dams and collection points in the Forest of Belgrade behind Istanbul across the Roman aqueduct of Valens: these in the eyes of Süleyman's successors were one of the greatest achievements of his reign.[142] The effect, partly determined by the lie of the land, which falls steeply from the central terrace, is to emphasise the great mass of the mosque with its piled-up domes entirely without visual obstruction.

The foundation inscription was composed by the Şeyhülislam, Ebussuûd, and executed by the great calligrapher Ḥasan Çelebi, the adoptive son of Aḥmed Ḳaraḥiṣārī. For the first time in the history of Ottoman architecture Iznik tiles were ordered to decorate the *qibla* wall. 'Specially large' carpets for the mosque were ordered from Cairo and the Uşak area. And, as the accounts and a series of court orders (TKS H. 1424) reveal, a vast archaeological and military operation was mounted to locate and transport fine coloured marbles for the paving, door and window jambs and other architectural details of the interior. This was all the more necessary in that, although the Ottoman sultans were fond of marble, the marble quarries on the Island of Marmara, which had provided the eastern Mediterranean in the ancient world with most of its marble, do not appear to have been worked between the death of Justinian and the early seventeenth century.[143]

Two of the Süleymaniye account books[144] (it is a minor detail that the accounts often do not add up) concur in giving a partial total of expenditure of 26,251,938 *akçe* on the complex, somewhat less than half the total expenditure, Barkan has calculated, over the whole period 961–6/1553–8: of this something like 25,802,000 *akçe* would have been direct from the Sultan's private Treasury (ʿan Ḫizāne-i ʿĀmire). These totals cover materials and skilled craftsmen's wages: they were, at least in part, conscripted but had to be paid, for injustice (*zülm*) was generally held to invalidate a *vakf*. Much of the unskilled work, land and sea transport, and hewing of stone in the quarries, was, however, carried out by the rank and file of the janissaries or by prisoners or convicts (*forsa*) who instead of daily wages received a nominal amount for subsistence. Some of the marbles, moreover, were from 'ruins' so would have been free except for transport. The account books represent, therefore, expenditure rather than a realistic estimate of costs of labour and materials. The 'materials' accounting for 8,125,332 *akçe* (the totals add up, in fact, to 8,131,032) include hire and food for pack animals; baskets, tools and nails for the workmen; timber, brick, mortar and most of the stone for the complex; iron

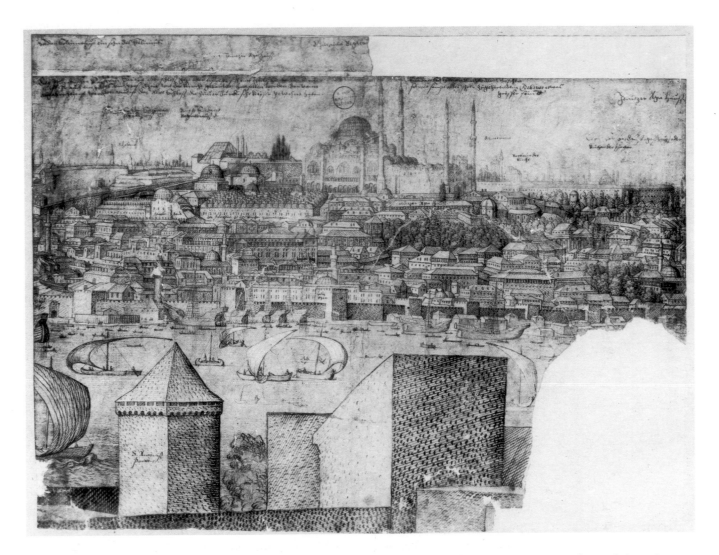

Melchior Lorchs (Lorichs),
view of Süleymaniye and the
Golden Horn from Galata;
drawing, 1559 (University
Library, Leiden)

for chains, cauldrons, brass or bronze for window grilles or the sockets of the columns, lead for cramps and for the roofs, glass (cullet) for the windows; and Iznik tilework, gold foil, precious pigments including lapis lazuli and cinnabar, and appropriate media for the painted decoration, as well as ostrich eggs, 'to decorate the mosque'.

Wages and salaries, totalling 18,126,607 *akçe*, cover payments to the carpenters, stone masons, builders, blacksmiths, glaziers, foundation-diggers, plumbers, decorators and porters, many of them in effect being paid twice. Thus the glaziers are paid by the number of days they are calculated to have worked and in addition for the execution of glass windows for the mosque. Even if it is only a matter of accounting, it is odd that the accountants should have adopted it; but the practice is reflected in the daily wages paid to palace craftsmen in the *mevācib* defters with additional payments, rewards or commissions for work executed. The decorators[145] (*naḳḳāşlar*) are recorded as having worked in Süleymaniye from 27 March to 30 September 1557, when the building works were all but complete. A group of seven master artisans and six apprentices (*şāgird*) worked mostly over the whole time. Each month supplementary craftsmen, and apprentices when appropriate, were taken on, the largest number in August–September, evidently because work was getting behind, at a going rate for master craftsmen of 10–12 *akçe* and 3, 4, 5, 6 or 7 *akçe* for apprentices. Rates are, of course, no

guarantee of uniform competence, since urgency might have led authorities to be less discriminating or more generous.

On the other hand many craftsmen including gilders, joiners (for the windows, shutters and doors of the mosque), boatmen and animal-drivers for transport do not appear in the first list by groups and are accordingly paid for their work specified more or less by piecework. These unexplained distinctions are further complicated by payments, evidently afterthoughts, to unspecified workmen for particular works which would have better appeared in expenditure on raw materials and semi-finished objects. The block accounts of costs and wages are supplemented by smaller accounts for materials and labour which evidently could not be fitted into the general planning of the operation, including pay to the administrative staff, the clerks (kātibs) and functionaries of the janissaries like imams and muezzins, who were evidently required to be on the spot.

The accounts thus disguise important differences in the costing of the works. Wages must have been paid, at least partly in arrears, for work actually done. The progress of works must, on the other hand, have depended upon forward buying of materials, and references to an imperial storehouse (ambār-i ʿĀmire) suggest that an essential preliminary to the works was contractors' estimates, which it doubtless fell to Sinan, as court architect (Hassa Miʿmar), or to Sinan Beg, the superintendent of works (bīna emīni), or the two together, to draw up. Payments for these in the accounts, particularly in bulk, may, therefore, not represent actual disbursements but more or less notional accounts for what had been bought previously. For reasons of prudence they are likely to have been on the high side, with some calculation for contingencies to obviate inconvenient hiccoughs in supply; and any unused materials could presumably have gone back into the imperial stores. Surpluses, however, are always embarrassing: the breakdowns as given, therefore, may not represent more than the clerks' own ideas as to what would be least likely to arouse questions from the Sultan.

Some of these observations pertain, in any case, more to the history of accountancy than to the history of architecture and its patronage. It remains that the Süleymaniye building accounts give a uniquely detailed picture of the progress of works on the site or even, on the basis of the holidays they were allowed, the religious affiliations of the craftsmen. Not only the buildings themselves, therefore, but their documentation puts them in the forefront of the great works of sixteenth-century Europe.

Among Sinan's other major buildings in Istanbul are the mosque of Rüstem Paşa (d. 1561), completed after his death,[146] and the mosque of another Grand Vizier, Sokollu Mehmed Paşa, completed in 979/1571–2, the latter approached dramatically by a steep stairway from the basement. Although both rather small they brilliantly exploit standardisation of architectural elements and even materials,[147] and exhibit Sinan's genius in adapting basic plans to difficult or cramped sites. In the latter case the mosque and its appurtenances are on a terrace cut from the steep hill which dominates the Kadırga Limanı: the elevation is almost exaggeratedly tall as if to match the steep slope behind the building. These two mosques are famous for their Iznik tilework, which was carefully calculated to harmonise as well as to fit the interior spaces and is further indication of the minute care with which such architecture was planned and supervised by Sinan. A third Istanbul mosque, for Mihrimah Sultan, the widow of Rüstem Paşa, built at the Edirnekapı between 1562 and 1565, is an experiment in quite another direction, carrying the use of glass in an Ottoman building almost to its limit.

Sinan's activity in planning and supervising buildings all over the Ottoman empire was immense. On the royal road to Edirne, the summer capital of the sultans, he built, for example, a chain of bridges across the lagoons at Büyükçekmece (completed 975/

1567–8), following a flood which caught Süleyman there in September 1563 and which could have had serious consequences. At Edirne between 1569 and 1575 he erected what he regarded as his masterpiece, the mosque of Selim II, inaugurated in 1572. Its scale demonstrates that his highly compressed foundations at Istanbul were less from conviction than from the need to use restricted space to the best possible effect.

Long before his death in 996/1587–8 Sinan was a famous personality, the nonpareil of Ottoman architects. The sheer numbers of the buildings he erected, which did more than those of any other builder to give Istanbul its present aspect, and their numerous variations and spatial experiments, which left little room for improvement to his successors, more than justify their encomia and give him a strong claim to a European reputation. As for Sinan's actual responsibility for the buildings attributed to him, he had, of course, a staff of junior architects and contractors, and in a few cases the contribution of the Hassa Miᶜmar's office may have been merely to draw up a plan, the realisation of which could be left to builders on the spot. As Hassa Miᶜmar his prime responsibility was for the Sultan's works, so that, for example, during the building of Süleymaniye he had to be on the spot to supervise, with the result that other works in progress would have been delegated to a colleague. This must have been the case, for example, with Hasseki Hürrem's foundations in Jerusalem and at Mecca (which, nevertheless, appear in some of the catalogues of Sinan's works as his) for their building coincided precisely with the Süleymaniye works. Meinecke has also observed, moreover, that despite Süleyman's permanent concern with Jerusalem the works, including the ᶜimaret of Hasseki Hürrem, were carried out not by craftsmen from Istanbul but by masons and other artisans trained in the schools of Aleppo, Damascus and even Cairo. If Sinan was, indeed, in charge of Hürrem's buildings, therefore, his contribution is difficult to assess.

By no means all the buildings for which Sinan was responsible were State works, for he built many viziers' pious foundations. Was he paid for these over and above the daily wage of 55 *akçe* he received from the Sultan? It is just conceivable that in the gaps between imperial works he was accorded freedom to take on private commissions; but so many viziers married into the Sultan's family that this may well have given them title to Sinan's services. Even when this was not the case, it was common for the Sultan to make grants of land and cash for the endowment of pious foundations; with these, doubtless, went grants of the court architect's services too.

NOTES

1. 'Süleyman I', *IA*; Uzunçarşılı 1975, 659–96.

2. Elton 1963, 133–9.

3. Gökbilgin 1970, 5–30; Lefaivre 1902.

4. Cornell Fleischer, 'Alqās Mīrzā', *Encyclopaedia Iranica*.

5. Gökbilgin 1957, 449–82.

6. Taeschner 1956, 53–5.

7. 'Alḳās Mīrzā', *EI²*; 'Elkas Mirza', *IA*; 'Alqās Mīrzā', *Encyclopaedia Iranica*; Walsh 1976, 61–78.

8. Longworth Dames 1921, 1–28; Orhonlu 1962, 1–24.

9. Deny and Laroche 1969, 161–211.

10. 'ᶜAli Paşa, Semiz', *IA*.

11. Letter from Constantinople, 1531 (Marino Sanuto, *Diarii* LV (1899–1900), 231):
Poi parlò di le belleze di Veniexia, et per il turziman li fo ditto gran ben e di richissime fabriche, et è inexpugnabile per le acque l'à torno. Il bassà disse, voria veder questa. Li dissi: 'Sultano quando tu la vedesti, trovaresti più amor e fede che beleze.' Disse: 'Il credo. Quando faremo la empresa di Roma visiteremo quelli signori; ne vederè volontiere, perche i ama questo imperador.'

12. Kunt 1983; 'Devshirme' *EI²*; Ménage 1966, 64–78; 'Ghulām', *EI²*.

13. Miller 1941; Uzunçarşılı 1945.

14. Uzunçarşılı 1943–4; Ménage 1966, 64–78.

15. Turan 1970, 47–117.

16. Elton 1963.

17. Behrnauer 1858; Schaendlinger 1978.

18. Hale 1983; id. 1985, esp. 179 ff.

19. *Letters*, 123–4.

20. 'Ibrahim Paşa, Pargalı', *IA*.

21. Marino Sanuto, *Diarii* XLI (1894), 526–7.

22. Ferīdūn 1274–5/1858, I, 544–6.

23. Cf., however, the significant exchange reported with Schepper, the Imperial ambassador, when Ibrahim Paşa indiscreetly boasted that his power equalled the Sultan's and that without his agreement the Sultan was powerless. 'Ibrahim Paşa, Pargalı', *IA*.

24. August 1534. A clash with the Safavid Shah Ṭahmāsp was imminent and

the correct form required evidently that Süleyman should defeat him in person. The encounter did not in fact take place. Gökbilgin 1957, 449–82.

25. Saint-Genois and Yssel de Schepper 1857, 119–20.

26. Kappert 1981, 118b; Marino Sanuto, *Diarii* XXXVI (1892–3), 505–7.

27. Uzunçarşılı 1976, 55–65; Kappert 1981.

28. It is probable that the gardens, particularly the unseasonably fruiting branches, were paper too. It would have been quite dangerous enough to entrust the celebrations to the Istanbul weather without having the equivalent of the Chelsea Flower Show as well.

29. 'İbrahim Paşa, Pargalı', *IA*. Jenkins (1911) concludes, on what evidence is unclear, that İbrahim Paşa was a eunuch.

30. It was quite frequent for the Grand Viziers to marry into the Sultan's family. For the crucial arguments against Hatice Sultan, see Uzunçarşılı 1965, 355–61.

31. Cf. Uluçay 1960, 71–3, no. 7, TKSA E. 5860, not autograph. The information here is entirely the generous work of Professor V. L. Ménage. A few other letters from İbrahim Paşa to his wife have been preserved, some from the Egyptian campaign of 1524, only a few months after his marriage and others from the Persian campaign of 1533–5.

32. TKSA D. 6107 gives the monthly expenditure of his palace on food alone as 18,358 akçe. His jewel books, TSKA D. 543, 5927, 10023, which must be extremely informative, have not been studied.

33. Through his brother Lorenzo, whose letters give a vivid picture of the Venetian gem trade, cf. Kretschmayr 1897, 104 ff.

34. 'Rüstem Paşa', *IA*.

35. Kreševljaković 1928, 272–87.

36. Gökbilgin 1955, 11–50.

37. Kunt 1983.

38. TIEM 2404, dated late Cumādā II 967/late February–early March 1562, Istanbul 1986, no. 16.

39. An anonymous chronicle ending with his death in 1561 by a partisan of Hürrem's whom it describes as 'that great benefactress who left no place devoid of the marks of her generosity', and which varnishes over the deaths of Şehzade Mustafa and Şehzade Bayazid, has often been attributed to him. Although it could be Rüstem's own work, it more probably is not and is now generally ascribed to Matrākçı Naṣūh.

40. Raymond 1973–4, 107–64; Hess 1970, 1892–1919.

41. Boxer 1973, 39–65; Orhonlu 1962, 1-24.

42. Orhonlu 1970, 235–54.

43. Lane 1940; 1966, 25–34.

44. Guilmartin 1974.

45. Ipşirli 1982, 203-48.

46. Achard 1939; Fisher 1957.

47. 'Hayreddin, Barbaros Paşa', *IA*; 'Khayr al-Dīn', *EI²*.

48. Cipolla 1965.

49. Deny and Laroche 1969, 161–211. Francis I's behaviour to his fellow monarchs makes one wonder how his successors ever had the nerve to accuse Albion of perfidiousness.

50. Dorez 1901.

51. Ruscelli 1564–77, 59 ff.

52. François Rabelais, *Lettres*, ed. Mme de Sainte Marthe (Brussels, 1710), 23–4.

53. Lybyer 1915, 577–88.

54. Tucci 1985, 38–55; Simon 1985, 56–69.

55. Allen 1963; Inalcık 1979, 74–110; Kortepeter 1966, 86–113.

56. Hess 1970, 1919, no. 1

57. Marino Sanuto, *Diarii* XLI (1894), 526.

58. 'Khurrem', *EI²*; 'Hürrem Sultan', *IA*.

59. In Ruscelli 1564–77, 166b–172a.

60. 'Süleyman I', *IA*; Kappert 1981, 375b–9a.

61. Uluçay 1960, 29–47; id. 1956; id. 1970, 227–57. Despite, or because of, publication in transliteration the texts are extremely difficult to read,

and it is the generous work of Professor V. L. Ménage which makes it possible to notice them here.

62. Uluçay 1971, 17–19.

63. Uluçay 1960, 36. The important passage in italics, p.175, omitted from Uluçay's transcription was read by Professor Ménage from the facsimile.

64. Askenazy 1896, 113–17.

65. Cf. 'Hürrem', *IA*.

66. Hammer 1828, III, 346–8; Ferīdūn 1274–5/1858, II, 63–6.

67. Ruscelli 1564–77, 166b–172a

68. The references to Hürrem's mosque in Ankara in the index to Ongan 1974 are wrong.

69. Stephan 1944, 170–94; Hammer 1828, III, 346–8; Ferīdūn 1274–5/1858, II, 63–6.

70. Taşkıran 1972, 185–98.

71. The earliest indication that women patients were specially catered for seems to be in the mid-seventeenth century, when Evliya Çelebi states that it was partly a madhouse and partly a hospice for women; but this transformation may have nothing to do with the foundress's intentions.

72. The total annual revenue for 965/1557–8 including a surplus of 100,000 from the previous year was 900,000 akçe (TKSA D. 4575). Three years later 968/1560–1 (TKSA D. 4573), excluding rents for villages on Aydos and in the kazas of Ahyolı and Çorlu but with a large surplus from the previous year, the total revenue was 1,500,000 akçe. That year the outgoings were at most 800,000 akçe, giving a surplus of almost fifty per cent.

73. Barkan and Ayverdi 1970, passim.

74. Washington 1987, 287; cf. Taşkıran 1972, 46–8.

75. Largely lands and villages in the sancaks of Jerusalem, Nablus, Gaza, Safad and Sidon, but also urban property in Tripoli and in its surroundings. Much of Jericho also belonged to the foundation, but in Muḥarram 972/August 1564 this was in the hands of insurgents and an exchange for further property from the Ḫāṣṣ fiefs of the military governors of Jerusalem and Gaza was sanctioned.

76. Fleischer 1986, 28.

77. Grants for the Istanbul foundation were made mostly in small amounts of two or three villages shortly before the first vakfiye was drawn up (TKSA fermans E. 9517 early Muḥarram 946/late May 1539; E. 9099 Ramaḍān 946/January–February 1540; E. 7766 early Ramaḍān 947/early January 1541); but further grants were made in mid-Cumādā I 958/mid-May 1551 (Ferīdūn 1274–5/1858, I 608) and even later (ibid., 765), 12 Cumādā II 964/14 March 1557, doubtless to take account of the addition of the hospital.

78. Stephan 1944, Jerusalem Khalidiyya Library 116.

79. Kappert 1981, 375b–79a.

80. This account is based on Turan 1961. It is not without interest that Süleyman's şehnameci, ᶜĀrifī (cf. no. 45a–d), wrote up the struggle between Bayazid and Selim up to the Battle of Konya, in Persian verse, 'exaggerated and poetical', as Veḳāyiᶜ-i Sulṭān Bāyazīd maᶜa Selīm Ḫān (TKS R. 1540 mük).

81. I.e. Ruscelli 1564–77, 166b–172a.

82. Cf. Düzdağ 1972, nos 964–6.

83. Uluçay 1956; Gökbilgin 1955, 11–50.

84. Çavuşoğlu 1982, 641–86.

85. Cavuşoğlu 1978, 405–16.

86. Fleischer 1986, 63–4, 222–3.

87. Turan 1961; Uluçay 1955, 185–200.

88. Charrière 1848–60 II, 103, 716–18.

89. 'Süleyman I', *IA*.

90. Düzdağ, loc. cit., no. 7.

91. Uzunçarşılı 1960, 103–10.

92. Under Selim II and his successors the custom of sending the junior princes out to provincial governorates was abandoned so that potential rivals could no longer exploit disaffected elements. Uzunçarsılı 1975, 659–96.

93. Anon. 1589. Not listed in Göllner 1961–8.

94. Çulpan 1970, 291–9.

95. 'Ḳānūn', *EI²*. Among Süleyman's titles in the Süleymaniye inscription is *nāshir al-qawānīn al-Sulṭāniyya* ('he who promulgates the *ḳānūns* of the Sultans').

96. Inalcık 1969, 105–38.

97. Fleischer 1986, 191–213.

98. Dorez 1901, 216–17.

99. Hammer 1828, III, 248–51.

100. Invitations were sent out little more than a month before (1 Ramaḍān 936/29 April 1530) (Marino Sanuto, *Diarii* LIII (Venice 1898–9, 254–5), a clear sign that the Turks' much-admired capacity to stage grand festivals at minimum notice was already well developed. Celālzāde Muṣṭafā's detailed account (Kappert 1981, 194a–201b) is admirably supplemented by the relations of Pietro Zen and Tomà Mocenigo, the Venetian ambassadors deputed to attend the celebrations (Sanuto, ibid., 443–59). Ibrahim Paşa is, however, reported to have sneered that it was not at all as fine as his wedding celebrations in 1524.

101. There is a remarkable description of the feats of marksmanship, bareback riding and mock sieges of the Mamluk troops in 1507 in the reign of Qānṣūh al-Ghawrī in Baumgarten's *Travels in Egypt* (1473–1535). This well explains the Ottomans' enthusiasm for them and indeed the appointment of Maṭrāḳçı Naṣūḥ to organise and stage them.

102. Explained Yurdaydın 1976, 7, 125–6, in Naṣūḥ's *Tuḥfat al-Ghuzāt* (Süleymaniye Library, Esad Efendi 2206) written in 936/1529–30. The line drawings, which could well be Naṣūḥ's own, indicate his indebtedness to the Mamluk tradition of military reviews as described by Baumgarten. The *Tuḥfat al-Ghuzāt* was not a work of mere theory. The text of a *ferman* dated late Zilkaʿde 936/late June 1530 (Yurdaydın 1976, 8, 127), in fact a citation of his practical expertise as organiser of such reviews, is copied into one of his arithmetical works, the *ʿUmdat al-Hisāb*, Nuruosmaniye 2984, ff. 173a–4b.

103. Undated letter from the archives of the Banca di San Giorgio in Genoa, translated in Davey 1907, 18–19. We still do not know exactly when the wedding of Süleyman and Roxelana took place.

104. TKSA D. 10734.

105. Raby and Yücel, 'Chinese Porcelains at the Ottoman Court', in Krahl *et al.* 1986, 27–54.

106. Köseoğlu 1987, pl. 48.

107. Deissmann 1933; Berkovits 1963; Csapodi and Csapodi-Gárdonyi 1978; Schallaburg 1982.

108. The Flemish tapestry designer, Pieter Coecke van Aelst, also depicted them in his collection of prints, *Ces moeurs et fachons de faire de Turcz . . .*, published, probably in Antwerp, in 1553.

109. An identification cogently argued by Karabacek 1913, 3–109. They are not, however, recorded in Dorez 1901.

110. It cannot yet be excluded that the statues were not Süleyman's booty but Ibrahim Paşa's (which would explain why they were erected outside *his* palace on the Hippodrome and not in the Topkapı Saray). Certainly he was held responsible for what was in the eyes of the orthodox an affront to religion. A couplet by one of Ibrahim Paşa's protégés Figānī (cf. Karahan 1966) contrasts him, wittily but disparagingly, with the patriarch Abraham who pulled idols down. For this rather mild joke Ibrahim Paşa had him paraded round Istanbul on the back of an ass and executed.

111. Fehér, *Kanunî Armağanı* (1970), 203–6.

112. Hasluck 1928, I, 9–13.

113. Hammer 1828, III, 14–15.

114. Cf. Babinger 1956, which chronicles the cult of relics, religious, aesthetic and opportunistic, at the court of Mehmed II and Bayazid II.

115. Cf. Atıl 1986, f. 289a.

116. Lane 1966, 25–34.

117. Raymond 1973–4, I, 1–209.

118. Heyd 1960, 160–1, dated 10 Cumādā I 973/3 December 1565. If this

119. Busbecq, *Letters*, 138. 'As a large quantity of amber is exported [from Danzig] to Turkey, he was anxious to know to what use it was put and whether it was exported to still more distant lands. He finally discovered that it was sent to Persia, where it is highly valued, being used for ornamenting rooms, cabinets and shrines.'

120. For the fur trade see Tezcan and Delibaş 1986, 42–5 and references. For the rise of the State merchants we still have only indications, cf. Bennigsen and Lemercier-Quelquejay 1970, 363–90.

121. Rogers, *In Memoriam Vančo Boškov*, 1986, 135–55. From 1536, when Francis I was accorded special trading privileges by Süleyman, the share of Marseilles in this lucrative cloth trade was considerably augmented.

122. *Il primo libro delle lettere*, ed. E. Nicolini (1913), 369.

123. Tucci 1985, 38–55; Simon 1985, 56–69.

124. Kretschmayr 1897, 1–106.

125. There is a letter dated September 1534 from Pietro Aretino to Gritti, evidently accompanying a copy of his commentary to the Seven Penitential Psalms of David, sermonising on Gritti's public and private faults (Kretschmayr 1897, 104), cf. Benzoni 1985, 91–133.

126. In 1533 Gritti, already embroiled in Transylvania and in need of ready cash, raised a large sum from the population by the forced purchase of a large amount of saffron: it is rather extraordinary that he should have had so much at his disposal.

127. Falk 1975; Evans 1970; Kurz 1975; Cipolla 1981; Marino Sanuto, *Diarii* LV, 14, 55,636.

128. 459 ff. He was writing almost immediately after the event.

129. For the biographical details of this important figure see Heyd 1963, 152–70; Terzioğlu 1977. His career, like that of his father who came to Turkey in 1493 following the fall of Granada, shows the difference between the court physicians, who were not necessarily Muslim, and the staff of hospitals like those endowed by Süleyman and Hürrem Sultan, which were evidently exclusively Muslim. Moses Hamon was ultimately involved in a polemic with another of Süleyman's physicians, a Muslim this time, Shaykh Maḥmūd al-Ḳaysūnī, on the correctness of his treatment of Süleyman's chronic gout with opium. This he lost, was disgraced and died soon afterwards in 1554.

130. Mraz 1980, 37–48; Vienna 1983, nos 97, 100.

131. Tekeli 1966.

132. Ünver 1969; Mordtmann 1923, 82–93; Sayılı 1956, 429–84.

133. *Letters*, 39.

134. Atasoy 1972b.

135. Berchem 1927, 403–12. Among those expelled was Ignatius Loyola, the future founder of the Jesuits, who was on a pilgrimage to the Holy Land.

136. Berchem 1922; Meinecke (forthcoming); Rogers in Serageldin *et al.* 1982, 53–61.

137. Heyd 1960, 143–4, no. 91, dated 23 Receb 959/15 July 1552.

138. 'Al-Kuds, History', *EI²*.

139. Berchem 1922, 377–411.

140. Refik 1931; Meriç 1965; Goodwin 1971, esp, 241–83;

141. Barkan 1972; 1979, I–II; cf. Rogers, *IJMES*, 13–14 (1982).

142. Çeçen 1986; Anhegger, *TD* I (n.d.), 119–38.

143. Rogers, *IJMES* 13 (1982), n. 9.

144. Barkan 1972, I, 14–40.

145. Barkan 1972, I, 326–8.

146. Cf. ferman dated late Cumādā II 967/late February–early March 1562, TIEM 2404, Istanbul 1986, no. 16.

147. Barkan 1972, I, 331–55; II, 32–50.

Catalogue

1 Iconography (nos 1–7)

The only surviving portrait of Süleyman done from the life is by the talented sea captain Haydar Reis (Nīgārī)[1] who evidently in the late 1550s portrayed him as an elderly man. However, at least one engraved portrait of him by Melchior Lorchs, a standing figure with the mosque of Süleymaniye in the background (probably therefore executed in 1557, the date of its inauguration, no. 2), is either after Lorchs's own sketches or after Ottoman portraits of similar type. Of the other European 'portraits' of him the most striking is a Dürer head in the Musée Bonnat at Bayonne dated 1526[2] showing him as a young man turbanned, clean shaven but with luxuriant moustaches and with a remarkably long neck.[3] We can only guess at the painting which was Dürer's source, but the extant oil-paintings of Süleyman like that in Budapest (Magyar Nemzeti Museum, Historische Bildergalerie, no. 438), sometimes attributed to the circle of Titian[4] and part of the current Renaissance fashion for portraits of *viri illustri*, follow a rather similar type.

A medal, ascribed to the Ferrarese sculptor and medallist Alfonso Cittadella (Lombardi), with the turbanned head of a young man and the cast inscription SOLYMAN IMP TVR is based on a similar prototype, and is known in a number of examples with somewhat different inscriptions.[5] Yet more distant is an anonymous Italian medal, with cast inscription showing a turbanned head in high relief with a tall bonnet (British Museum, Coins and Medals M. 2071). Although, clearly, Süleyman had no prejudice against portraiture as such, unlike Mehmed the Conqueror he never appears to have commissioned portraits from European artists and would have been far too grand to sit for the attendants of the ambassadors and other foreigners he received.

All European commentators remark upon Süleyman's austerely dignified appearance and erect bearing, but evidently in later middle age he became aware that his appearance was no longer what it could be. Busbecq writes in 1555 of his poor complexion:[6]

And indeed it is generally believed that he has an incurable ulcer or gangrene on his leg [this is more generally stated to have been chronic gout]. This defect of complexion he remedies by painting his face with a coating of red powder, when he wishes departing ambassadors to take with them a strong impression of his good health; for he fancies that it contributes to inspire greater fear in foreign potentates if they think he is well and strong. I noticed a clear indication of this practice on the present occasion; for his appearance when he received me in the final audience was very different from that which he presented when he gave me an interview on my arrival.

NOTES
1. Eyice, *Kanunî Armağanı*, 129–70.

2. Panofsky 1943.
3. Cf. Bragadin in 1526, Marino Sanuto, *Diarii* XLI (1894), 526.
4. Vienna 1980, no. 91. No fewer than four Titian 'portraits' of Süleyman, all lost, are recorded in contemporary documents. The first was evidently that executed for Federico Gonzaga, Duke of Mantua, in 1538. Its execution was delayed because of lack of a prototype: a man named Marcantonio Motta owned a picture of Süleyman in Venice but refused to lend it, and the Duke had to wait until Titian found a medal and another likeness, perhaps a European print. Given such a diversity of prototypes one might expect European depictions of Süleyman to differ considerably, but the Süleyman portraits optimistically attributed to Titian's followers do in fact show a degree of uniformity (Wethey 1971, 190ff.). The source for the Dürer drawing may have been the painting formerly in the Kress foundation known to Panofsky (no. 1039).
5. Planiscig 1919, no. 385. I am grateful to Mr Mark Jones for this reference and for showing me the British Museum medal.
6. *Letters*, 66.

1 Ḳiyāfetü'l-Insānīye fī Şemā'ilü'l-ʿOsmānīye

Seyyid Loḳmān, 88 folios, Ottoman Turkish, clear *naskhī*, 11 lines per page, dated late Şevvāl [99]7/early September 1589
Page 25 × 15.5 cm
British Library, Department of Oriental Manuscripts and Printed Books, Add. 7880; from the collection of Claudius James Rich
Literature: Atasoy 1972, 2–14; Atasoy and Çağman 1974, 38–9; Stchoukine 1966, 69, 126–7, pls XL–XLI; Sohrweide 1970; Titley 1981, no. 46; Çağman and Tanındı 1986, pl. 156.

The *Ḳiyāfetü'l-Insānīye* is a short illustrated account of the first twelve Ottoman sultans written by Loḳmān, the Şehnameci of Selim II and later of Murad III, expressly to record the appearance of the Ottoman sultans while there was still documentation in existence, and Loḳmān states that for the illustrations his painters used not only Ottoman but Western material, which was collected by Loḳmān's first patron the Grand Vizier, Sokollu Mehmed Paşa. The difficulties European painters found in obtaining Ottoman originals in Istanbul on which they could base their portraits make it probable, however, that much of the 'Western material' was apocryphal, like the series of portraits executed for the Medici and now in the Uffizi in Florence, or etchings by engravers like the Hopfers, or the Behams published by Hans Guldenmundt and others (cf. Vienna 1980, no. 151/1–2). In any case the sultans depicted in the original illustrations are all shown in sixteenth-century dress, so that even in their own terms the portraits are of limited historicity.

The earliest copy, evidently for presentation to Murad III, is dated 987/1579–80 (IUK T. 6087), but other copies seem to have been made very soon afterwards (IUK T. 6088, c.1580; TKS H. 1563, c.1579–80). That dated 987/1579–80 contains illustrations in the hand of Nakkaş ʿOsmān, the head of Murad III's studio and a painter of very considerable talent. The British Library copy is one of a group of later manuscripts executed perhaps for presentation to viziers or even to foreign ambassadors (TKS R. 1264, dated 996/1587–8; TKS R. 1265,

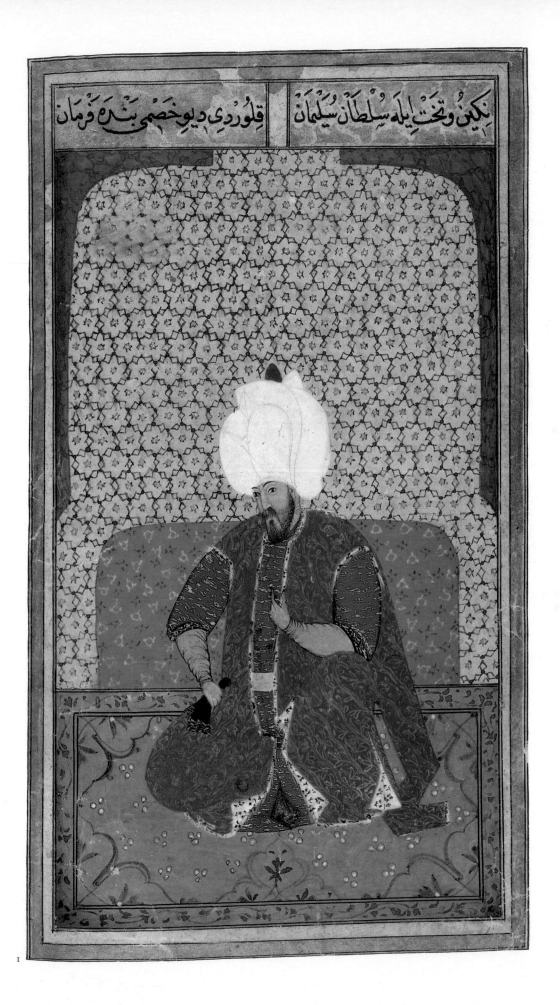

dated 1003/1594–5; and Dresden, Sächsische Landes-bibliothek, E. 373).

The manuscript may never have been fully illustrated. Folios 65–85 with extremely poor-quality portraits of sultans up to the early eighteenth century are a much later addition, and possibly the date (f. 88b) was deliberately defaced when the volume was made up. Some of the original portraits have also been repainted in a similar style.

Süleyman is here depicted (f.53b) as elderly (cf. his portrait in the *Nüzhet esrār al-aḫbār der sefer-i Sigetvār* of Aḥmed Ferīdūn (no. 46), wearing a sleeveless caftan of red brocade with a pattern in gold and ermine lining over a robe of blue brocade, possibly with gold tiger stripes, with a gold belt. Under that is a long-sleeved dull green robe. Busbecq (*Letters*, 50–1) remarks that Süleyman normally wore green. His tall turban is identified as a *Süleymānī* turban, the fashion for which, Loḳmān states, he introduced. He carries a dark brown or black embroidered handkerchief.

Loḳmān's text, despite his stated object, is a rather breathless survey of Süleyman's campaigns, his diplomacy and his public works which gives practically no idea of his actual appearance. Loḳmān's initiative interestingly parallels that of Paolo Giovio who established a famous collection of portraits of the notables of his age, Ottoman as well as European, in his villa-museum at Como, which provided the originals for the Ambras Collection. The portraits were engraved by Tobias Stimmer and were also used to illustrate Giovio's *Elogia virorum bellica virtute illustrium* (Basle, 1575), and it may be that Loḳmān's idea came from this source.

2 Süleyman the Magnificent

Melchior Lorchs (Lorichs), engraved 1559
31.4 × 43.5 cm
BM, P&D 1848. 11–25. 24
Literature: Donati 1956; Eyice, *Kanunî Armağanı*, 1970; Lesure 1972; London 1983, no. 82

Süleyman is shown with the mosque of Süleymaniye (inaugurated 1557) seen through a triumphal arch in which stands a richly caparisoned elephant from the menagerie with its driver and a figure holding a forked banner. Below Süleymaniye is a building, possibly the imperial stables. Süleyman is shown in middle age with drawn face and heavy beard, girded with a sword and wearing a moiré caftan with a voluminous sash under his outer robe. This is not a portrait from the life: Süleyman would not have sat for a European painter, and his stance suggests that the source was an Ottoman portrait, possibly a gift to the imperial ambassador Busbecq in whose entourage Lorchs was employed. Compared with the Lorchs drawings of Istanbul made in 1557 just after Süleymaniye was built the background is highly stylised, but the similarities of features to the probably contemporary Nīgārī portrait of Süleyman (TKS H. 2134/8) show that Lorchs's portrait is a faithful likeness.

3 Süleyman riding in procession to the Friday prayer

Anonymous Venetian woodcut in 9 sheets (A–I), published/engraved by Domenico de' Franceschi, *c.*1563
43.7 × 498 cm (overall)
BM, P&D 1866. 7–14. 55
Literature: Busbecq, *Letters*, 143; Sansovino 1573, f. 306b; Stirling Maxwell 1977; 'Franceschi, Domenico dei', Thieme-Becker, *Künstlerlexikon*; Eyice, *Kanunî Armağanı*, 1970

The sheets are of variable dimensions and most show considerable damage or wear: many details have been, as usual, inked in by hand.

The groups of figures are identified in the brief descriptions below the set in the Uffizi, Florence, which also (on pl. C/III) bears the publisher's announcement dated 1563 (from left to right):

1. Mounted *sipahis*, miscellaneous courtiers and *ḫavāṣṣ* on foot.
2. The Subaşı of Istanbul, and two groups of high janissary officers, Bölükbaşıs and Yayabaşıs.
3. *Caşnegirs* ('tasters') and janissary foot-soldiers.
4. The Commander (Ağa) of the janissaries with the Admiral of the Fleet and the Imrahor Başı (Master of the Horse).
5. The four *kapıcıbaşıs* ('door keepers') mounted, and the three principal *defterdars* ('treasurers').
6. The two *kazaskers* ('military judges') and the Sultan's bodyguard.
7. *Çavuş* ('pursuivants') and the Çavuşbaşı, and senior viziers.
8. The Grand Vizier, other junior mounted Pursuivants and *peyk* ('foot-runners').
9. Süleyman himself followed by two young pages or grooms mounted with a cushion for him to sit on.

The identifications may not always be entirely correct, but obviously the draughtsman took the trouble to enquire. Although the descriptions on the British Museum set have been almost entirely cut off, enough remains to show that they cannot have corresponded exactly. It was common for such prints to be extensively reworked, and the Uffizi set appears to be made up of impressions from at least two different states.

The only other known set, dated 1568, is in an album of processions, triumphs, stage sets and depictions of fireworks by various engravers from the library of George III (British Library 135, g. 1). This lacks the upper border, and while the captions are almost identical with the Uffizi set they are in a different typeface and there are a number of discrepancies. The 1568 set follows the Uffizi one in showing Süleyman as an elderly bearded figure: this must therefore be a correction to an earlier state, which may be approximately dated by the notice on the two dated sets that Şehzade Bayazid (strangled in 1561) was still alive.

Although the classicising columns and Renaissance marble floor are additions purely to Venetian taste, the exact details of turban ornaments, arms and frogging and even textile patterns show careful observation, and ample time to work them up.

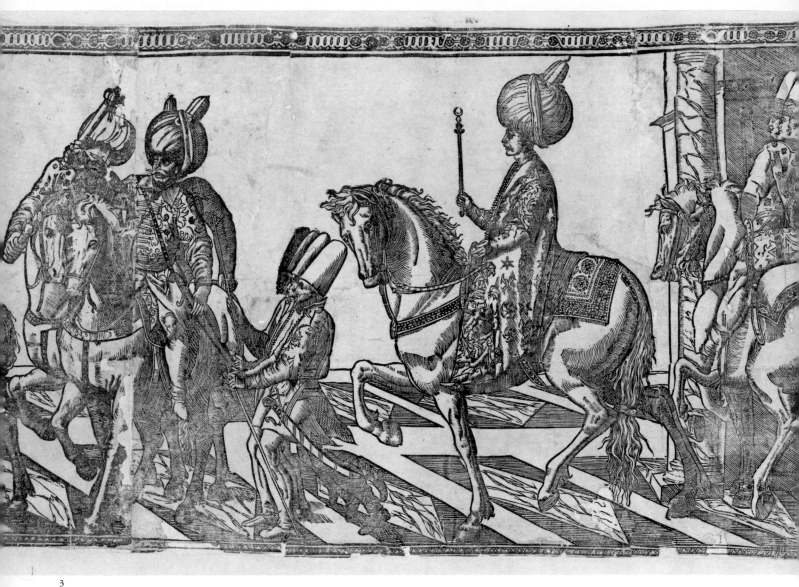

3

This could not have been done on the street where a foreigner sketching would certainly have been arrested as a spy, and must have been from the security of a private house, possibly the Elçi Hanı on the Divan Yolu (the royal processional route), where foreign ambassadors were often segregated, or perhaps a private house, like that hired by Busbecq in 1559 (*Letters*, 143–4) to watch Süleyman's departure for Asia, and which he discovered to be a synagogue. The treatment by groups, moreover, suggests that the draughtsman concentrated on one group at a time, so that the worked-up composition could well have taken several months to put together. Inappropriately, Süleyman is shown not as an elderly bearded man but as a young man, rather as in the Dürer portrait of 1526 in the Musée Bonnat, Bayonne, which may be after an apocryphal prototype.

There is a broadly similar contemporary description of Süleyman's weekly procession for the Friday prayer by Luigi Bassano of Zara in Francesco Sansovino, *Historia universale dell'origine et imperio de' Turchi* (Venice, 1564), f. 306b:

When at Constantinople the Great Turk goes to the Mosque of St Sophia, in which case it is difficult to see him, as it is close to the Seraglio; or the Mosque of Sultan Mahomet (Fatih); or to the Mosque of Sultan Mustapha [read Şehzade Mehmed]. To one or other of these three Mosques go thirty or fifty Chiaus or Mace-bearers, on horseback. They are followed by perhaps two thousand Janissaries on foot, with swords, axes at their girdles, and guns with barrels five palms long at their backs; and by about the same number of Spahis and Solacks on horseback, with swords, bows and arrows, and maces at their saddle-bows. All march in silence, nothing being heard but the sound of their feet and the trampling of the horses. Then come fifteen or twenty led horses, all with rich head-trappings, adorned with carbuncles, diamonds, sapphires, turquoises, and great pearls, the saddles not being seen because they are covered with housings of scarlet velvet. Near the Great Turk himself no one rides, but four grooms, walking on either side of him, about a pike's length off, to keep off the people, unless he should call one of the Pashas or other officers to talk with

him. Before him always go three pages, one carrying his bow and arrows, another his sabre, and the third, a golden bottle of scented water to wash with at the door of the Mosque, though many say to drink but they are mistaken (i.e. a *maṭhara*, *matara*, cf. no. 63).

4a–b Portraits of Süleyman and Roxelana

Anonymous Venetian woodcuts, published by Mathio Pagani, Venice, *c.* 1550
52.5 × 36.1 cm; 51.9 × 35.8 cm
BM, P&D 1878. 7–13. 4164, 4166

Süleyman is shown bearded wearing a brocade shirt with feathery leaves and chinoiserie lotuses (perhaps derived from a pattern similar to no. 106) under a plain caftan. Hürrem, described here as 'la più bella e più favorita donna del Gran Turcho dita la Rossa', has a jewelled four-horned diadem paralleled in some peris' head-dresses in sixteenth-century Ottoman and Safavid painting. She wears a gown of alternating crescents and stars over a chemise with scrollwork, reminiscent of Bursa textiles, and composite flowers on the reverse.

The portrait of Roxelana is clearly apocryphal, and it is probable that the Süleyman portrait is too. Both Western observers and illustrations in the *Süleymānnāme* – for example, no. 45 – show him in middle age, when he grew his beard, in austerely plain robes, while in youth he was clean shaven, as appears, for example, in an anonymous north Italian woodcut in Vienna (Albertina P. vi 125,3), dated 1526, possibly by Master AA.

A similar head-dress occurs in a portrait of 'Cameria, daughter of Suleiman the Magnificent as St Catherine' in the Courtauld Institute Galleries (ex Princes Gate Collection Catalogue, London, 1981, no. 121). Süleyman had no daughter of that name nor would she have sat for a painter even transmuted into St Catherine. The identification may be traceable back to Paolo Giovio's celebrated collection at Como, copies after which are similarly inscribed. The painting is tentatively attributed to Titian, in which case Titian would have copied Giovio's portrait, but the grounds for the attribution anyway do not appear to be convincing. (Cf. Wethey 1971, 190ff.)

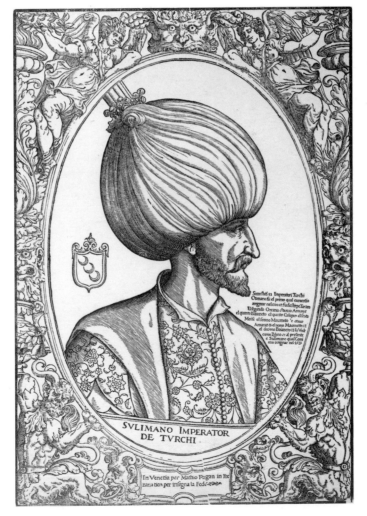

SVLIMANO IMPERATOR
DE TVRCHI

4a; 4b illustrated on p. 17

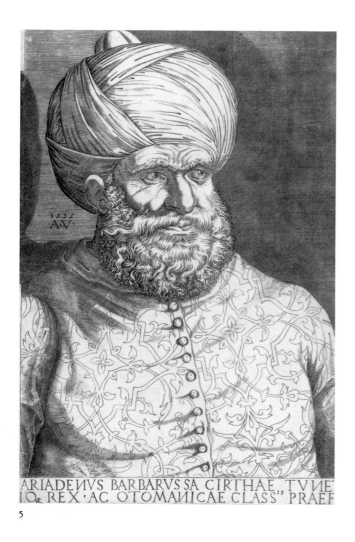

5

ARIADEИVS BARBARVSSA CIRTHAE TVИE
IQ. REX·AC OTOMAИICAE CLASS'S PRAEF

5 Hayreddin Barbaros Paşa

Known to Europe as Barbarossa (d. 1546), ruler of Algiers and Admiral of the
 Ottoman fleet
Woodcut, by Agostino Veneziano, dated 1535
43.5 × 30.5 cm
Fitzwilliam Museum, Cambridge
Literature: Bartsch, *Le peintre-graveur* XIV, no. 520; Klinger and Raby 1988

The portrait, inscribed below ARIADENVS BARBARVSSA CIR-
THAE TVNET IQ REX AC OTOMANICAE CLASSIS PRAEF, is half-
length showing Barbarossa almost full-face but looking to the
left, turbaned and with a buttoned brocade caftan with an
ogival pattern below and medallions with a counterpoint of
spiralling scrolls on the chest. The forehead is low, the gaze
penetrating, and the beard and moustaches bristle ferociously.
The face is so powerfully drawn that it is easy to agree with
Rabelais that it was drawn from the life. It could well have
been the work of a Venetian painter in Istanbul when
Barbarossa arrived there in 1533 from Algiers, perhaps Gian-
Maria di Andrian Gian-Battista, an otherwise unrecorded
painter who is, however, known to have been there in 1533, or
possibly one of the 'sculptors and painters' known from Pietro
Aretino's *La cortigiana* (*Tutte le commedie*, ed. G.B. de Sanctis
(Milan, 1968), 173) to have followed the Venetian goldsmith
Luigi Caorlini to Istanbul in 1532. Barbarossa was much
admired, and feared, by his Italian contemporaries. Paolo
Giovio not only obtained a painting of him from Istanbul
which was then worked up for his famous villa-museum at
Como but also prized his Koran, a velvet caftan and the vessels
he used for eating and washing which had been captured in
1535 on the Habsburg occupation of Tunis. It was this
success, although it was only temporary, which encouraged
Agostino Veneziano to issue prints of Charles V, Francis I and
of Süleyman and Barbarossa too.

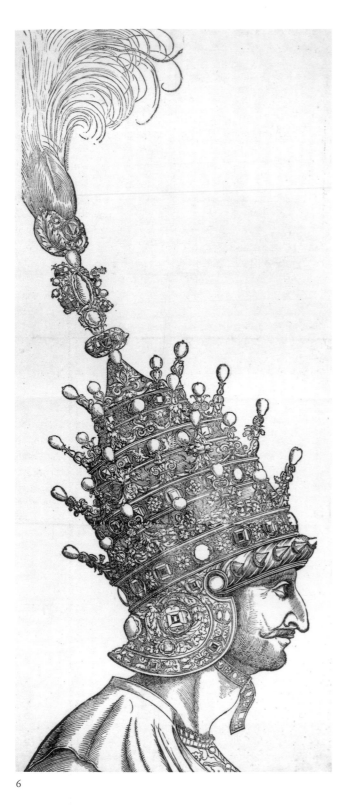

6

6 Turk wearing a tiara

Anonymous Venetian woodcut in 3 sheets, 1532
87 × 37.7 cm
BM, P&D 1845. 8–19. 1726
Literature: Kurz 1969, unwarrantably gives 116,000 ducats; Berlin 1971,
 no. 28; London 1983, no. 81

The quadruple gold crown, representing symbolically each of the kingdoms over which Süleyman ruled, is set with rubies, diamonds, pearls, a fine oblong emerald and a large turquoise, and with a plume, possibly of bird of paradise feathers, described by Marino Sanuto as 'the plumage of an animal which stays and lives in the air, has very soft feathers of various colours and comes from India; it is called chameleon and is worth a fortune'. It was made by a consortium of Venetian goldsmiths and dispatched with other remarkable objects to Istanbul in 1532 when it was sold to Süleyman for 115,000 ducats.

The head is somewhat in the tradition of the Dürer portrait of 1526 in the Musée Bonnat, Bayonne, but there is nothing to justify the superscription on the New York specimen of the print, the most complete version known, SVLIMAN OTOMAN. REX. TVRC. X, or the same inscription on the copy after this by Agostino Veneziano (Musi), dated 1535. The head is evidently a type and is therefore more important as a demonstration of the vagaries of European and Ottoman taste than of the appearance of Süleyman himself.

Kurz argued that the present version is the original, that in New York being a copy, and a single sheet, without the plume, in Berlin being a copy after Agostino Veneziano. While it is very difficult to be categorical, the Berlin leaf is certainly not after Agostino Veneziano and is closely related to the New York version; certain minor discrepancies suggest that the present version is the copy and most probably the Berlin version the original.

On 13 March 1532 Marino Sanuto (*Diarii* LV (1899–1900), 634–5) inspected on the Rialto in Venice a remarkable quadruple jewelled crown commissioned from the Caorlini by a consortium, which included Pietro Zen, the Venetian ambassador in Istanbul, and valued at 100,000 ducats. Together with a jewelled saddle made by another firm and also valued at 100,000 ducats it was sent off to Ragusa by sea and was escorted thence by an official sent there by Ibrahim Paşa. Sanuto gives a separate list of the gold, gems and the case of ebony, gold and satin in which it travelled – 50 diamonds, 47 rubies, 27 emeralds (the largest valued at 15,000 ducats), 49 pearls and the large turquoise – giving a total valuation of 144,000 ducats. Can these estimates have been inflated for the benefit of the Turks? Through the good offices of Ibrahim Paşa (*Diarii* LVI, 361), who had been well satisfied by the gift a few months previously of a narwhal tusk even more splendid than one offered to the Sultan, it was sold to Süleyman.

The crown, of course, was not at all the sort of thing which Süleyman would ever have worn, and its ultimate fate was

doubtless to be melted down and the gems reset. An anonymous German engraving, however, of Mehmed IV, c. 1644 (cf. Münster 1983, no. 59) wearing the very same crown, with a note that its value was half a million ducats, shows that in Europe at least it had passed into legend.

7 Süleymaniye viewed from the north-east

From *Wohlgerissene und geschnittene Figuren zu Ross und sampt schoenen Tuerckischen Gebaewden und allerhand was in der Tuerckey zu sehen* (Hamburg, 1626)

Signed MLF (Melchior Lorchs Flensburgensis), dated 1570

18.1 × 54 cm

BM, P&D 1904. 2–6. 107(120)

Literature: Oberhummer 1902; Wulzinger 1932, 355–68; Eyice, *Kanunî Armağanı*, 129–70; Eyice 1970, 93–130

In actual fact the surrounding buildings on this side of the mosque are, from left to right, a bath and the two senior *medreses* of the complex; in this illustration the bath appears to have been shifted to the centre, the *medreses* crowded to the right, and the space on the left has been filled by a nondescript façade. As for the domes behind, that on the left is evidently the lodgings for the cemetery keeper (*türbedar*), with the tomb of Hürrem Sultan to the right of it. Süleyman's tomb, which should be free-standing, seems to have been mistakenly incorporated into the mosque in an apse-like extension. The plate is dated 1570, and the inaccuracies, which contrast strikingly with Lorchs's drawings of Istanbul done in 1557, must reflect work from sketches. Eyice has suggested that the view was sketched from the Elçi Hanı in which Busbecq was incarcerated with his suite in the later stages of his residence in Istanbul.

7

2 Calligraphy and illumination (nos 8–20)

Calligraphy

Despite the indisputable mastery of many of the objects made for Süleyman, the vast majority are unsigned; but among the extant craftsmen's signatures of his reign the names of scribes and calligraphers figure almost exclusively. Why in the general context of anonymity their names should figure so prominently is unclear, but the great calligraphic works of Süleyman's reign bear out the encomia of Muṣṭafā ʿĀlī's *Menāḳib-i Hünerverān*[1] (written for Murad III in 995/1586–7) and testify to the reverence as well as to the esteem in which good writing was held.

The Ottomans resembled their predecessors and their contemporaries in Iran and Central Asia in viewing calligraphy as a matter of tradition and connoisseurship, forming their hands on the canonical 'six scripts' established in the mid-thirteenth century by the Baghdad calligrapher Yāqūt al-Mustaʿṣimī and his pupils and priding themselves upon their ability to recognise specimens of such hands (nos 19–20). While, undeniably, this reverential attitude arose from traditional pietistic Muslim respect for the written word, which encomiasts like Muṣṭafā ʿĀlī played upon to sanctify the calligrapher's status, calligraphy owed its actual importance to its role in the imperial chancery where, exactly as in Europe, grand individualised scripts were evolved less with legibility in mind than to dignify the sovereign's edicts and, as far as possible, make forgery impossible. Although the great calligraphers of Süleyman's reign were most esteemed for and thought most highly of the Korans and collections of prayers or *ḥadīth* they wrote (nos 16–18, for example), their usefulness lay rather in forming the staff of the Chancery and generally in keeping up the standards of day-to-day manuscript production.

A banal though fundamental reason for the importance of calligraphy was that, however long-lived a calligrapher might be, and some of the sixteenth-century Ottoman calligraphers lived to a great age, his hand died with him: hence the dynasty of pupils and descendants which evolved at Amasya under Şeyḫ Ḥamdallāh (cf. no 13) – who died late in 1520 just after Süleyman's accession – and whose names are associated with Korans, secular manuscripts and even inscriptions throughout the sixteenth century. Their hands were held to have recognisable similarities, and one might see their status as similar to the Italian type founts of the period – with the obvious difference that those were designed to be mechanically reproducible.

One notable feature of Süleyman's reign is that although, as in many of the industrial arts, there was a strong, even natural, tendency for the occupation of calligrapher to become heredi-

tary, distinguished calligraphers not only came from the Chancery or from the learned classes, but also included viziers like Farhad Paşa (d. 1575), a pupil of Karahiṣārī's who mostly wrote Korans (TKS Y. 811, for example), and even a cannon-founder, Yūsuf, known as Demirci Kulu (d. 1611). These may, of course, have been exceptions, for to judge from letters in the hands of Ibrahim Paşa or the manuscript of the *Dīvān-i Muḥibbī* (cf. no. 28), stated to be in Süleyman's own hand (there is reason to think the statement is misleading), pretentions to distinction in calligraphy in Süleyman's own family or entourage were exaggerated.

One can group these calligraphers into amateurs, who devoted their spare time to fine writing, and professionals, either copyists in the palace studio or scribes in the Chancery executing the documents of State drawn up by the Nişancı. But there was another class of professionals whose reputation depended upon their distinction in monumental scripts and who seem to have been employed exclusively, at rather high daily wages, by the court.[2] Two figures were outstanding in Süleyman's reign, Aḥmed Karahiṣārī (d. 1556), who signs himself the pupil of Asadallāh al-Kirmānī, who wrote Korans, specimen alphabets and selections of *ḥadīth*; and his adopted son Ḥasan Çelebi (d. after 1594), who was almost as highly esteemed as Karahiṣārī but who also designed monumental inscriptions like that of Süleymaniye, and the interior Koranic tile inscriptions of Selimiye at Edirne, which were sent to Iznik for the tileworkers to execute.[3] They worked consciously in the classical hands standardised by Yāqūt and his contemporaries, regarding themselves as their spiritual successors.

In principle, the Chancery and the palace studio worked in parallel in the copying of fermans and manuscripts, but in practice scribes from the Chancery were drafted in when the Sultan commissioned a particularly sumptuous or urgent work for his library, like the *Süleymānnāme* (no. 45a–d), or copyists or illuminators were required to bring out a series of grand fermans. However, the Chancery was almost certainly the more important as being a reservoir of scripts and scribes. This was partly because of the convention that Korans and Holy Writ were written in the canonical six rounded scripts or, for *sancak* Korans, e.g. no. 27, in a minute fine script known as *ġubarī* (Arabic *ghabr*/dust); whereas secular works were written in forms of *nastaʿlīq* (Turkish *talik*, confusingly since *taʿlīq*, one of the 'six scripts', is something quite different), which had been developed at the Timurid courts of Tabriz, Shiraz and Herat in the early fifteenth century and which even in the sixteenth century was most admired for its practitioners at the court of Shah Ṭahmāsp. Meḥmed Şerīf, of Tabrizi origin, who copied *inter alia* two volumes of the *Dīvān-i Muḥibbī* (cf. nos 29, 31), may be the Mawlānā Muḥammad Sharīf[4] recorded in the Qāḍī Aḥmad's chronicle of poets and painters, but the work of even more famous Persian calligraphers in *nastaʿlīq*, like that of Shāh Maḥmūd al-Naysābūrī,[5] from Nishapur (d.

974/1564–5), was also greatly admired at the Ottoman court. There is even a remarkable *nasta'līq* Koran in the Topkapı Saray (H.S. 25) written by Shāh Maḥmūd, dated 14 Muḥarram 945/13 June 1538, evidently presented to Murad III on his accession in 1574 by Shah Ṭahmāsp. Although Karahiṣārī and Ḥasan Çelebi were both, doubtless, capable of writing *nasta'līq* that was evidently left to a specialist group, which gave the Chancery its peculiar importance.

There were two other important Chancery hands – *siyāḳat* or Treasury cipher used for many records and registers but not a calligraphic hand, which seems to have evolved as a means of preventing forgery of account books. The other was *dīvānī*, used for fermans and other imperial decrees, with eccentric ligatures and successive diagonals giving a broad line rising towards the end like the prow of a ship (hence *sefine* from the Arabic for 'ship') and, for decorative effect, often written in various coloured inks. The course of its evolution is difficult to chart,[6] but high Chancery officials would be expected to master it. Celālzāde Muṣṭafā, himself the son of the famous Tosya calligrapher Celāleddīn (d. 1529),[7] was reputed to be a fine practitioner, although his other numerous responsibilities in the Chancery and his historical writing can have left him little time to write it. Maṭrāḳçı Naṣūḥ is also credited in Muṣṭafā 'Ālī's *Menāḳib-i Hünerverān* with having introduced a form of *dīvānī*, *ceb*, which was more immediately legible, although if, as is sometimes asserted, he copied the *Mecmū'a-i Menāzil* (no. 43a–b) himself, one would not expect calligraphic innovation, or even calligraphy, from him. The fame and the court pensions may have gone principally to Karahiṣārī and his peers for the grand Korans they wrote for Süleyman, but it was the Chancery calligraphers who kept calligraphy before the eyes of the public and who, generally speaking, gave the calligraphy of the Ottoman sixteenth century its peculiar importance.

Karahiṣārī and Ḥasan Çelebi, in signing their own works, use an eccentric but bold hand with elements of the classical *ta'līq* deriving probably from similar signatures by Yāqūt al-Musta'ṣimī and his contemporaries such as 'Abdallāh al-Ṣayrafī (nos 19–20). Even more striking, however, and so far unique is Ḥasan Çelebi's foundation inscription for Süleymaniye[8] executed by an anonymous stonemason which, unlike his Iznik tile inscriptions for Selimiye at Edirne, divorces itself from the rounded manuscript hands and enormously elongates the shafts and their serifs, continuing words vertically above the base line or including whole lines to fill the space above. This was perhaps sheer necessity in the first place, since the text drawn up by Süleyman's Şeyhülislam, Ebussuûd, was sixty words longer than the inscription as it is now and even in its cut version must have caused problems; but he also arranged words so that similar letter groups regularly recur to give balance and sometimes even a repeating pattern. Just how many attempts Ḥasan Çelebi had to make before this visually and textually satisfactory arrangement was achieved we can

only guess at, but the difficulty of his task can scarcely be exaggerated. Ottoman architecture does not, in fact, make much use of lapidary inscriptions, but Ḥasan Çelebi's achievement demonstrates that these great Ottoman calligraphers' genius was not limited to the written page.

An Ottoman peculiarity was cut-out script (*ḳiṭ'a*, modern Turkish *kaatı*), a technique which was doubtless an application of filigree paper or leather cuts much used for the *doublures* of bindings from the Timurid period onwards and some of which are included in the so-called Ya'ḳūb Beg album (H. 2153) in the Topkapı Saray. Indeed, in Ottoman inventories of the sixteenth century such cut-out work (cf. no. 24a–b) is known as *mücellid işi* ('bookbinder's work', that is, filigree).

Muṣṭafā 'Ālī's *Menāḳib-i Hünerverān*,[9] states that its inventor was 'Abd Allāh, the son of the calligrapher 'Ālī (d. Herat 1544). The other masters named by Muṣṭafā 'Ālī are Sangī 'Ālī Badakhshī,[10] who settled at Meshed and was so able that, when he cut out a page of Mīr 'Ālī's script, the page remaining was undamaged and was then the reverse of the original; Mawlānā Muḥammad Bāqir, a second son of Mīr 'Ālī; and Faḥrī of Bursa, in his eyes evidently the star Ottoman *ḳāti'* or cut-out worker. Although it is not clear that similar skills were involved, Muṣṭafā 'Ālī credits Faḥrī with the invention of cut-out garden scenes; perhaps, therefore, an unsigned double garden scene in the Murad III album in Vienna (National-bibliothek, mixt. 313), or the even more skilful and splendid paper collage of a garden scene in no. 53a–f (IUK F. 1426, f. 47a), also unsigned, must be attributed to him.

Fermans

The term *ferman*[11] (Persian 'command') conventionally covers a large number of different Ottoman administrative documents, almost universal in their coverage: appointments; promotions; grants of land in fee or private property; administration of nomads, Christian monasteries, conquered provinces; taxes and immunities; market regulations, capitulations or commercial treaties; diplomatic instruments; supplies to the armies; crimes; public works, especially fortifications; and all sorts of complaints – all this in such extraordinary detail (the tone of even the most general order is personal, from the Sultan to one of his subjects) that Philip II's notorious obsession with the administration of Spain seems mere zeal in comparison. Matuz[12] has calculated that over Süleyman's reign (1520–66) no fewer than 150,000 documents of this type must have been emitted, with a probable yearly average of 3,400. This is a colossal output, of which only a small fraction has survived.

The most splendid of them, normally written in *dīvānī* and technically known as *nāme* (Persian: 'letter'), relate to correspondence between sovereigns,[13] and announcements of victories, decrees of appointment or grants of land. They follow, depending upon the sort of document they are, a set arrangement[14] (in the terminology of diplomatic), *invocatio*, or doxology; the *tuğra*; the *intitulatio* and *inscriptio*, in which the

Süleymān

şāh

b.

Selīm

şāh

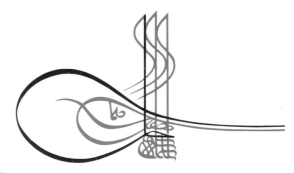

ḫān

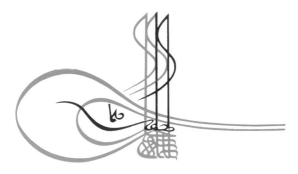

al-muẓaffar dā'iman

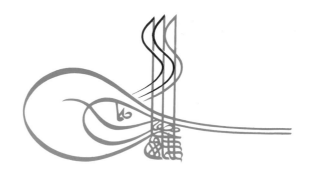

(decorative strokes completing the design)

Sultan addresses the recipient in the first person with the grand titles of the Sultan and, sometimes disparagingly, with the titles of the addressee; the *narratio* and *dispositio*, giving the grounds for the issue of the document, and its contents; a *sanctio* exhorting the relevant officials to comply with the decision or even threats (*comminatio*) should they not do so; a *corroboratio* stating that all should have confidence in the authenticity of the document; and finally the place and date of issue. Not all these elements are invariably present but in particular grand and formal documents there may be a second *invocatio*,[15] in fact an integral part of the *intitulatio* but raised so that the names of God, Muḥammad and the Rightly Guided Caliphs take precedence over the Sultan's name in the *tuğra*. This innovation was possibly introduced by Celālzāde Muṣṭafā, who was appointed Reisülküttab (Head of the Chancery) in 1525, and was then Süleyman's High Chancellor (Nişancı) for practically the rest of his reign.

Many fermans lack the *invocatio*, but V.L. Ménage observes that it was right at the top of the scroll and was therefore particularly liable to be lost or cut off. Only the grandest, moreover, bear illuminated *tuğras*, the imperial monogram consisting of the Sultan's name, his patronymics, his title Ḫān and a formula *muẓaffar dā'iman*[16] ('ever victorious': from Selim I to Mehmed III that appears as '*al-muẓaffar dā'iman*'). The elements of the *tuğra* were categorised by Paul Wittek:[17] the monogram proper, or *sere* (Turkish 'palm'); the loops or *beyze* (Turkish 'egg, oval'); shafts or *tuğ* (Turkish 'battle standard') with dependent sweeps or *zülfe* (Turkish 'locks'); and pincer-like projections to the right, *kol* or *hancer* (Turkish 'arm'; 'dagger'). Some of these are documented in the historians, but they are not really accepted technical terms and the English equivalents are more graphic.

Since, in common with many other Islamic dynasties, the Ottoman sultans did not sign their decrees, the *tuğra* was the ultimate authentication, which it fell to the Nişancı to affix as the final element in the emission of the document, once the copy had been checked. In fact, this order of practice was a counsel of perfection, for when the Grand Vizier and certain other viziers were away from the capital, they were often provided with blank papers with the *tuğra* already imposed, to enable them to issue fermans on the spot.[18] Similarly, when the Court was at Edirne or the Grand Vizier was at the front, such blank papers would be sent to the Vizier at Istanbul who had been left in charge. If the ferman was long and further sheets were required, they were pasted on and the Vizier would add his own mark of authentication. It follows that often a decree was not submitted to the Sultan for his approval or correction, a tendency which from the reign of Selim II onwards becomes much more marked.

This strict order of composition and arrangement implies also a strict order of paperwork which culminated in the issue of an edict. First, therefore, in response to an incoming report or on the government's own initiative, a decision was made

and the Chancery was ordered to prepare a document to that effect (in contrast to *vakfiyes*, almost always in Ottoman Turkish: fermans in Arabic seem only to have been addressed to native governors of Arabic-speaking provinces or to rulers and Arabic-speaking notables beyond the Ottoman frontiers). The draft was written, examined and corrected, the fair copy of the ferman was made, and the *tuğra* applied if it had not previously been applied to a blank paper. The decree was registered and the fair copy was dispatched to the addressee. Extant papers make it apparent that often several drafts must have been gone through, and as many fair copies, although these were not invariable. In the case of the endowment of a pious foundation, the necessary demonstration that the property was legally the endower's own often entailed the issue of numerous fermans making the drafting of the constitution a very considerable operation. This readily explains the existence in the Ottoman archives of *vakfiyes* (for example that of Hasseki Hürrem Sultan's endowments at the Ḥaram al-Sharīf in Jerusalem (cf. no. 10) in several preliminary drafts, often in Ottoman Turkish rather than in their final, Arabic form.

The affixing of the *tuğra* itself, although in theory a simple operation, is not entirely devoid of obscurity. In theory it was to be affixed by the Nişancı but the duty must often have devolved upon junior officials. Celālzāde Muṣṭafā may have owed his early preferment to his writing of *dīvānī* script; as Nişancı, however, his function was to draw up the formulas and check the facts. Yet he was also, among other things, a lawyer and a distinguished historian, so that he can have had no time at all to spare to affix *tuğras* to documents. Many of the less elaborate fermans of Suleyman's reign, indeed, have handwritten *tuğras*, sometimes rather undistinguished in appearance, but the grand *tuğras* show considerable standardisation, not only of form, which was important in their authenticating effect, but also of dimensions in clear sharp painted lines which owe nothing to the calligrapher's pen. The imposing effect and their brilliant illumination in contrasting gold, black and blue suggests close co-operation between the *tuğra*-drawer and an illuminator. This makes it probable that the Chancery employed a staff of illuminators as well as calligraphers or scribes, although they could on occasion have been transferred to the scriptorium. The Ottoman Chancery like other Islamic Chanceries thus followed tradition in being a centre of training for the arts of the book.

Tuğras must, however, have been difficult to get absolutely right. This added to the pressure on the Chancery scribes and illuminators and it is reasonable, therefore, to enquire how far the *tuğras* and their illumination could be mechanically reproduced. Professor V.L. Ménage[19] has noted a *tuğra* of *c.* 1490 pricked to serve as a stencil, while there is also evidence that some *tuğras* were stamped, notably a most interesting *mülknāme* of Mehmed III dated 30 Ramadān 1006/ 6 May 1598 in the collection of Ciğdem Semavi in Istanbul.[20] Here a stamped black outline is clearly visible: quite why it is

out of registration is unclear, since we should have expected it to be concealed by the gold and polychrome gouache of the finished *tuǧra*. Chancery practice certainly evolved from reign to reign, or from Nişancı to Nişancı, but a damaged *tuǧra* of Süleyman in the British Museum (OA 1949.4–9.087) showing a stamped outline under painting in blue suggests that Mehmed III's *mülknāme* may follow a practice instituted already in Süleyman's reign when the enormous number of documents to be authenticated made some form of mechanical reproduction of the *tuǧra* an absolute essential.

Illumination

Illumination, particularly in gold and blue, evidently royal colours in the ᶜAbbasid Chancery, had been the appropriate accompaniment to fine calligraphy from the ninth century AD[21] and the Ottoman craftsmen in the palace studio in sixteenth-century Istanbul had numerous traditions on which to draw – from Tabriz, Herat, Damascus and Cairo and from fifteenth-century Turkey, where Mehmed II[22] notably ordered books for his library bearing illuminated frontispieces in such an individual style that they are almost book plates. In contrast to painting, where the court styles of Herat and Tabriz seem to have been a dominant influence on Süleyman's studio, the indigenous Ottoman style of illumination remains prominent; but probably, also, the illuminated manuscripts from the libraries of the Mamluk sultans Qāyt Bāy and Qānṣūh al-Ghawrī were more influential than the booty of manuscripts and craftsmen from Safavid Baghdad and Tabriz.

Even in the most sumptuous manuscripts the illumination is concentrated on certain pages – principally, a frontispiece, usually double; a head-piece for the first page or pages of text (often called, respectively, *serlevḥa*, from Persian *sar*, 'head', and Arabic *lawḥa*, 'panel', and *ᶜunvān*, 'heading', although they are not used consistently so cannot easily be used for technical terms); the final page of text or of a part of it, which may or not bear a colophon; and section headings, verse stops or marginal indications of the progress of the text – but with particular attention given to the opening pages. The Süleymaniye account books[23] and other documents of Süleyman's reign confirm that only the most precious materials were used – gold leaf which may be tinted and which is often pricked for added luminosity; gold inks of various tints and textures; lapis and other valuable mineral pigments well known from the Islamic cultural traditions; and dyes like carmine[24] which, though Mexican cochineal was known in Europe probably by 1520, was almost certainly lac, the principal crimson dye for silks too. It seems to be rare for gold leaf to be used as the basis for the decoration (in contrast to fourteenth–fifteenth-century Cairo where the gold leaf is often overlaid by translucent varnishes or coloured washes), and most often lapis seems to be the basic colour.

Where frontispieces are present they are more often in the nature of book plates with medallions bearing dedicatory eulogistic inscriptions to their patron than 'carpet' pages like those of the Koran (no. 14) illuminated by Bayrām b. Dervīş Şīr in 930/1523–4. Few ever bear titles, which more often appear in the illuminated opening pages of text. The manuscripts exhibited here show that at the very highest level of book production their disposition was becoming standardised, with small central panels of text, flanking panels and broader panels above and below usually treated as a *tabula ansata* (with sometimes further side- and head- and foot-panels enclosing those). Then comes a border, often with lappets in a counterchange or reciprocal design, with a crenellated edging: in some cases border and edging may have no internal divisions. The edging is decorated with marginal darts usually in blue and often with exquisite minute chinoiserie lotuses or cloud scrolls or enhanced with claw-like cloud clips in gold. As an additional refinement the ground of a written page may be sprigged with flowers (e.g. 53d) or filled with irregularly lobed panels roughly following the outline of the letters and giving the appearance perhaps of clouds (*abrī*).[25]

The filling of these classical Ottoman illuminations is essentially scrollwork: with the exception of interlaces of jointed or noded leafy stems which are more typically Safavid (no. 19, triangular side-pieces), the angular interlacing ornament still popular for Ottoman woodwork (e.g. nos 98, 101), which is so characteristic of Mamluk Koran illumination, is studiously avoided. The scrolls are basically of two types – an arabesque (*rūmī*) which may be merely a fine spiral with minute blossoms but which may also be bold split-palmettes (e.g. no. 21); and scrollwork with chinoiserie lotus and peony flowers or with cloud bands, or clips (*ḫaṭāyī*). Cloud scrolls and split-palmettes (cf. nos 21, 24a) may be so heavily modelled as to appear scaly or imbricated. The two sets of scrolls are sometimes executed together, superimposed, as it were, or in counterpoint (on the ivory hilt of Süleyman's short sword, no. 83, they are literally superimposed), a feature which probably more than any other serves to distinguish the finest Ottoman illumination from that practised at the contemporary Safavid courts at Tabriz or Qazvin. Interestingly, however, there is less direct borrowing from illumination in bindings and the other arts than one might expect: illumination seems to go its own way.

Not surprisingly, perhaps, Koranic illumination in the broad sense tends to be rather conservative. A striking exception is the Ḳarahiṣārī Koran (no. 15a), which shows two important features which were to be characteristic of the work of Ḳara Meḥmed Çelebi or Ḳaramemī (identified in 962/1552–5 (no. 20) as *ser-naḳḳāşān* at Süleyman's court and *ustād al-kutub*, head decorator and, probably, head of the scriptorium) – namely the use of fine blue flowers as a background for inscriptions, and side-panels of rather naturalistic flowering prunus branches rising from leafy tufts. The more generalised adoption of a repertoire of florists' flowers in the industrial arts

of the sixteenth century (for example, in Bursa silks or in Iznik pottery and tilework) cannot at the moment be attributed to any one man and was doubtless a fashion taken up by customers and craftsmen all over the Ottoman Empire, but Ķaramemī's illuminations of the *Dīvān-i Muḥibbī* (no. 31), dated Ṣaᶜbān 973/ March 1566, must be one of the greatest works in the genre.

The sources of this floral style are difficult to pinpoint. In the general context of Ottoman-Safavid court poetry there is a rich vocabulary of floral erotic *topoi*,[26] but in Safavid illumination there is no indication that this was ever transposed from the literary to the visual mode.[27] On the other hand, the Ottoman florists' and gardeners' passion for cultivated flowers is documented as early as 1524, when the floats displayed in the Hippodrome for Ibrahim Paşa's wedding were massed with spring flowers (see p. 10),[28] and is confirmed by Pierre Belon who was in Istanbul in the 1540s and who describes the flower market with hawkers of rare cuttings and bulbs from distant parts of the Ottoman Empire for the passionate horticulturalist. A love of flowers and floriculture, however, may not well explain their appearance in art, and, indeed, the repertory of documented garden flowers is only selectively represented in illumination – the iris is rare, for example, and the Turk's cap lily (*L. pomponium*), ranunculus and Judas tree (*Cercis siliquastrum*) are never shown. This is the difference between the paper-cut gardens in the albums (F. 1426, f. 47a (no. 53) and the Murad III album in Vienna Nationalbibliothek, Cod. mixt. 313) with such rarely depicted species as cyclamen, columbines (*aquilegia*) and *Lychnis chalcedonica*, which are models of botanical illustration, and the famous tile panels of the Mosque of Rüstem Pasa (d. 1561) in Istanbul where a basic repertory of flowers – narcissi, roses, carnations or violets and prunus blossom – has been 'hybridised', with the fantastic lotuses and peonies of the post-Timurid chinoiserie or *ḫaṭāyī* repertoire.

The tendencies to thoroughgoing naturalism[29] which these compositions suggest are almost certainly associated with the transformation completed (*c.* 1550) by European naturalists, particularly Italians like Ulysse Aldrovandini and Matthioli, of the medieval herbal into illustrated botanical works, or works of floriculture. The actual connections are so far difficult to trace, but the appearance in the Iznik floral repertoire of flowers of botanical rather than horticultural importance (for example, gentian stems with their conspicuous axillary flower buds, no. 139) certainly suggests access to them.

Since it is so often repeated that Busbecq introduced the tulip to Europe, it must be said that the description of tulips in Thrace in his *Letters* is a crux; that nowhere in his letters does he mention bringing back tulips to Europe (the drawings of natural history he had made may never have reached Europe); and that, although Clusius states that he received tulip bulbs and seed from Busbecq, that was in 1570 or 1571,[30] long after his return from Istanbul, by which time

many Europeans were sending back botanical material. These bulbs seem to have been a cultivar, possibly *Tulipa versicolor*, which was to be of great importance in the cultivation of European hybrid garden tulips; but wild tulips from Italy, Spain and southern France had been known, described, depicted and cultivated decades before Busbecq's first mission to Istanbul in 1552.

Other dated or datable tile panels show that this florists' repertoire (that is, essentially garden plants not wild flowers, with an emphasis upon cultivars, double flowers and intriguing freaks) was thoroughly established *c.* 1560 so that Ķaramemī was adapting, rather than innovating, in his illumination of the *Dīvān-i Muḥibbī* (no. 31) of 1566 and that it might be misleading to regard it as a hallmark of his style. In fact, much of the illumination of this volume is a repetition of already established tastes like the scrolling counterpoint of the frontispieces which follows those of the *Süleymānnāme* of 1558 (no. 45) and *tuġra* illumination of even earlier date (no. 10), while the double-page opening verses (ff. 2b–3a) have characteristic fine spiral blossom scrolls as a ground for the text, side-panels of polychrome flowering prunus and elaborately floriated marginal darts.[31] The innovations are the vignettes separating the verses in gold and brilliant polychrome in which a repertory of florists' flowers, cloud scrolls, split-palmettes, tiger stripes and other abstract forms is used, often 'hybridised' or in combination and often lengthwise so that recognisable flowers appear as 'trees', in pairs on a long stem. The broad margins, which may well have been stencilled, employ a somewhat different repertory of flowers, in loose or broken sprays sometimes in combination, mostly in gold or silver inks but with carmine or blue accents. The obvious differences in style may be a difference of technique or may result from the absence of the need to compress, but Ķaramemī's signature does not appear on any of them and they could well be the work of a different hand.

Certain features of this highly compressed vignette style recur in the illuminated frontispiece of the album (no. 53b) and in the borders and grounds of later pages of calligraphy; these may suggest that Ķaramemī was also involved (he most probably died soon after Süleyman himself in 1566). Although it is easy to trace certain persistent features from the Ķarahiṣārī Koran of 1546–7 (no. 15a) to the *Dīvān-i Muḥibbī* of 1566 and, although Muṣṭafā ᶜĀlī singles him out for distinction in his *Menāķib-i Hünerverān*,[32] it is scarcely credible that the head of the workshop with considerable administrative responsibilities and working in a compressed miniature style could have been so productive. The ᶜAbd Allāh al-Ṣayrafī Koran (no. 20) and the Hamburg *Dīvān-i Muḥibbī* (see p. 85), both illuminated in 1554–5, are stylistically so different that, but for the signature or the attribution, one would never attribute these to him.

It might appear plausible a priori that a distinguished illuminator who was also head of the scriptorium (*ustād al-kutub*) would have been extremely influential on the decoration

of the other court arts, if only because illumination is so obviously a matter of design without the constraints of its practical or technical applications, a pure rather than an applied art. Yet it is interesting that the treatment of similar motifs even on bindings (e.g. no. 24a–b) is markedly different, and although the *naḵḵāşān* were commissioned to execute wall-paintings, for example, at Süleymaniye,[33] what little of that which has survived is closer to the decoration of bindings than to illumination.[34] Certain characteristic decorative themes, moreover, of the latter part of Süleyman's reign, most notably the *ṣāz* style with its long feathery leaves (cf. nos 35b, 51, 53f and the caftan, no. 106) and fantastic flowers, seem to have developed in independence from the characteristic repertory of illumination. Even, therefore, so centralised an institution as the palace scriptorium allowed for a considerable degree of specialisation.

The influence of illumination was limited by the degree to which mechanical reproduction was possible. Since the pigments are mostly opaque, we cannot tell how much was sketched out and how much was the work of the master: even compass pricks and ruled lines are rare enough to give very little idea of this. Obvious stencilling, like the margins of the *Dīvān-i Muḥibbī* (no. 29), is quite rare and would not lend itself to much of the most minute work. There is a constant temptation to underestimate the capacities of the craftsmen of the time to work freehand so that conclusions based on visual examination are dangerous. It is, however, probable that certain repeated motifs like marginal darts (cf. in particular the corner darts of the Ḳaraḥiṣārī Koran (no. 15a), where a central dart is flanked by half-darts so sharply cut that they could never be freehand) or the darts, scrolling edges and cloud bands of the album pages (no. 53b) were stencilled, as must have been the blue scrolling grounds of much calligraphy (e.g. no. 12). The considerable variation in motifs and their designs shows, however, that if stencils were widely used they must have been very numerous indeed.[35]

An important reason for the differences between Koranic and secular illumination is the latter's role in Chancery documents, which in their more splendid forms complement and set off the grand phraseology and the imposing form of the *tuğra* (see p. 58). To judge from dated documents the illumination seems to have become standardised *c.* 1550, with counterpoints of contrasting spiral scrolls in the horizontal loops of the *tuğra* and prunus branches, florists' flowers and abstract motifs in the cells of the ascenders: it is from this repertory that the illumination of the dedicatory page of the *Süleymānnāme* (no. 45, ff. 1b–2a), and, doubtless, also the Ḳaramemī illumination of the *Dīvān-i Muḥibbī* (no. 31), are drawn. The promulgation of imperial orders was always a matter of urgency, even more than the execution of illuminated manuscripts ordered by the Sultan. Royalty brooks no delay. It must, therefore, have been common practice for illuminators to hurry between the Chancery and the scrip-

torium to augment the forces available at a particular time, and the many similarities between *tuğra* illumination and that of secular manuscripts show how close the contacts were between the two. In much of it the Chancery must have played the prime role, in productivity as well as innovation, although much of the finest illumination is stereotyped. There is thus no need to invoke Ḳaramemī on every occasion that fine illumination is in question.

NOTES

1. ʿĀlī 1982; cf. Dickson and Welch 1981, *passim*.
2. Derman 1970, 269–89; id. 1982; Lowry in Petsopoulos 1982, 169–91.
3. R. Anhegger, in Otto-Dorn 1941, 166, nos 2–3 dated 8 Muharram/21 May and 4 Rabīʿ-1/15 July 1572. Muṣṭafā ʿĀlī, interestingly, ignores the contribution of the Chancery, reflecting the view current at the beginning of Süleyman's reign that it was, anyway, the preserve of the *medrese*-trained *ʿilmiye*, among whom ʿĀlī counted himself. The situation had changed by the end of the reign to the extent that the *kalemiye* was coming to represent a parallel career structure to high office and with this, doubtless, came the emancipation of the Chancery scribes and calligraphers.
4. Minorsky *et al.* 1959, 167.
5. Salmān 1978, 329–34; Minorsky *et al.* 1959, 134–8. The *nastaʿlīq* Koran was then illuminated in 970/1562–3 by Ḥasan al-Baghdādī, the chief illuminator of Shah Ṭahmāsp's studio.
6. Fekete 1926.
7. 'Celālzāde Muṣṭafā', *IA*; Uzunçarşılı 1958, 391–441.
8. Çulpan 1970, 291–9.
9. ʿĀlī 1982, 112.
10. Karabacek 1913, 41–51.
11. Duda 1983, 109–60.
12. Matuz 1971; id. 1974.
13. Tschudi 1932, 317–28; Abrahamowicz 1959; Bombaci 1965, 41–55, and see also Mahmut H. Şakiroğlu, '1521 tarihli Osmanlı-Venedik anlaşmasının aslî metni', *Tarih Enstitütüsü Dergisi* 12 (Istanbul, 1982), 387–404.
14. Kraelitz 1921; Matuz 1974.
15. Ménage 1985.
16. Orgun 1949, 201–20.
17. Wittek 1948, 311–34; Umur 1980, 155–73 for *tuğras* of Süleyman and the Şehzades; 'Tughra', *EI*[1].
18. Heyd 1960.
19. Private communication.
20. Istanbul 1986.
21. Cf. the inscription on the Nilometer of Rawḍa erected by the ʿAbbasid Caliph al-Mutawakkil and altered evidently by Ibn Ṭūlūn later in the ninth century. K. A. C. Creswell, *Early Islamic Architecture* II (Oxford, 1940), 304.
22. For example, Shihāb al-Dīn Suhrawardī's *Ḥikmat al-Ishrāq* (TKS A. 3267) dated 882/1477–8.
23. Rogers, *IJMES* 14 (1982), 283–313; Washington 1987, 288.
24. Gettens and Stout 1966, 110.
25. Ettinghausen 1977, 315–56.
26. E.g. Zand 1977, 463–79.
27. There is no study of Safavid illumination but the richly illuminated borders of the Shah Ṭahmāsp *Khamsa* of Niẓāmī datable *c.* 1540 (British Library, Or 2265) are remarkable for their lack of naturalistic flora. Cf. Titley 1979.
28. Kappert 1981, 116a–117a; Uzunçarşılı 1976, 55–65; Belon du Mans 1588, 458–9.
29. Demiriz 1986; id. 1977, 41–58. The latter article is devoted to a Koran in the Topkapı Saray Library (Koğuşlar 23) dated 954/1547–8 and signed by Muhammad b. Ilyās whose name is not mentioned in the palace

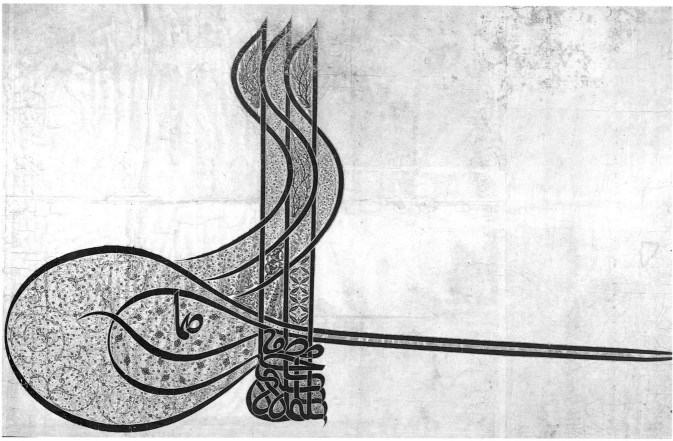

8

registers and who may, therefore, have executed it as a private commission. The illumination took three months and the signature, which is exceptional, must indicate that the illumination was something of a novelty. In its use of naturalistic carnations and tulips it is a modest precursor of works like the *Dīvān-i Muḥibbī* signed by Karamemī (no. 31).

30. Contin 1939, 98–9.

31. Demiriz 1986, 278–303.

32. Demiriz 1986, 117; cf. also Yağmurlu 1973, 79–131.

33. Barkan 1972; 1979, I–II; Rogers, *IJMES* 14 (1982), 299–304.

34. Otto-Dorn 1950, 45–54.

35. This has the immediate consequence of making it virtually impossible to speak of an individual hand or style in illumination, such as Zeren Tanındı has ingeniously endeavoured to trace with the refurbished ʿAbd Allāh al-Ṣayrafī Koran (no. 20), to justify the note on the flyleaf that it was the work of Kara Meḥmed Çelebi *ser nakḳāṣān-i Dergāh-i ʿĀlī ve ustād al-kutub*. His works are too few (cf. Ünver 1951) to trace the development of his style; and in any case, economy of time and labour must inevitably have led to the work in hand being shared out among the craftsmen and their apprentices. Hence the peculiar convenience of stencils in giving the result a homogeneous appearance.

8 *Tuğra* of Süleyman the Magnificent

Ink, gold leaf and gouache on heavy paper
c. 1550–60
164 × 247 cm (in frame)
TKS GY. 1400
Literature: Istanbul 1983, E. 53; Washington 1987, no. 1

The panels created by the sweeps of the tails across the shafts of the ascenders are filled with polychrome prunus branches rising from leafy tufts with tulips, roses or hyacinths at the base; florists' flowers in rows as if in a garden; panels of complex split-palmettes, black, pink and gold on lighter spiral blossom scroll in lapis blue with carmine accents; designs made up of feathery leaves; cloud scrolls and jointed interlaces of Safavid type with floral filling, some on a gold ground as, for example, in the interstices of the letters. The large loops are filled with two different arrangements of superimposed spiral scrolls, combining various of the separate elements noted above with lotus or pomegranate forms.

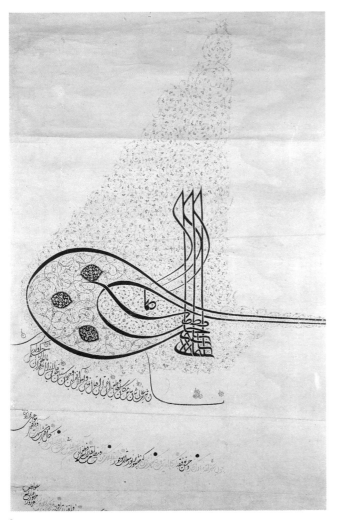

9

Towards the end of line 11 comes a copious series of titles: some of these relate to his position as Süleyman's minister; some to his position as commander-in-chief of Süleyman's armies and the champion, therefore, of the frontiers of Islam; and others to his own magnificence, together with prayers for his success, career and long life as Grand Vizier. The forms seem to have become standardised in the Ottoman Chancery by 1550, but curious formulas, like *ḍirghām-i palang intikām* ('the lion, or sharp sword, of panther-like revenge'), occur already in the *berat* appointing Ibrahim Paşa commander-in-chief (*Serasker*) of the Imperial armies, dated early Şaʿbān 935/ mid April 1529 (Ferīdūn 1274–5/1858, I, 544–6).

10 Ferman

Temlīknāme, or grant of lands together with the farmed revenues from silk rearing (*ḥarīr mukaṭaʿası*) in villages in the *sancak* of Trablus (Tripoli in the Lebanon) to Hürrem Sultan, for her foundations in Jerusalem, dated 21 Rabīʿ II 959/16 April 1552. (Cf. also E. 7816/1, E. 7816/3–11, dated between 22 Zilhicce 957 – early Şevvāl/967/December 1550–June 1560)

Paper scroll, *dīvānī* script, 13 lines in gold and black ink

41 × 168 cm

TKSA E. 7816/2

Literature: Heyd 1960, 143–4; Stephan 1944, 170–94; Taşkıran 1972; Altındağ 1985, no. 102, E. 7816/1–11; Washington 1987, no. 3, has wrongly 19 April

The ferman is headed by the *tuğra* of Süleyman the Magnificent. The inner loop, containing *dā'iman*, has (cf. also no. 8) plants above and braided split-palmettes below; the outer loop has spiralling scrolls, alternately with feathery leaves and with

9 Ferman

Scroll, sized paper, *dīvānī*, 12 lines

c. 1550

42.3 × 164.5 cm

TIEM 2238; acquired in 1916 from the Evkaf Müessesatı, Ilmiye Idaresi

Literature: Bombaci 1965, fig. 7; Washington 1966, no.186; Petsopoulos 1982, no.185; Istanbul, 1986, no.11; Washington 1987, no. 2

The decree is addressed to an unnamed personage, probably Rüstem Paşa, with the titles of a Grand Vizier, the first line in blue with gold dots for the word *Nişān* and vocalisation in blue, with a gold dot at the end of each word in the rest of the line. The remaining lines are in black, or black powdered with gold, with gold Koranic citations and *duʿā*. The lineation is indicated by triple dots in dull blue or grey at the left-hand side of the sheet.

The *tuğra* is enclosed in a right-angled triangle of gold blossom spirals and small blue cloud scrolls. The filling of the inner loop, containing the word *dā'iman*, is of blue blossom spirals: the outer loop has a counterpoint of split-palmettes in blue and gold on dense, fine gold blossom spirals, with three-lobed medallions of symmetrical designs in gold on blue. The illumination is close to that of one *tuğra* in the British Museum (OA 1949. 4–9. 086), dated by Bombaci to the latter part of Süleyman's reign.

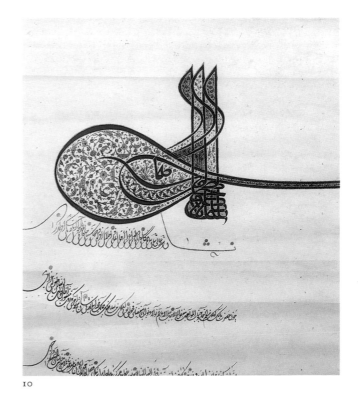

10

blossoms. The cellular compartments of the shafts have cloud scrolls and florists' or illuminators' flowers.

11 Ferman

Summary list, dated 23 Receb 976/12 January 156, of villages granted as *mülk* to the Grand Vizier, Sokollu Mehmed Paşa, in the *sancaks* of Vize (Western Thrace), Paşa (Bulgaria), etc. Described on the back in a good Ottoman hand, as a *temlīknāme* and 2 *mülknāmes* of Sultan Selim, with lists of the *sancaks*, *kazas* and *nahiyes* involved

Scroll, paper, sized and gold-sprinkled, *dīvānī*, 38 lines in gold, black and blue inks

46.2 × 373 cm

TIEM 4125; purchased 1968 from the artist Cemil Aldişen

Literature: Gökbilgin 1952, 508–15; Umur 1980, fig. 128; Istanbul 1986, no. 18; Washington 1987, no. 5

The *intitulatio* is in plain gold, *Huwa Allāh al-ᶜAzīz*. At the foot of the document is a list of witnesses including the *kazaskers*, the three other viziers, the four *defterdars* and the *tawḳīᶜī* or Nişancı.

The *tuğra* is gold and blue, with carmine accents. The inner loop with *dā'iman* has tufted carnations in blue and carmine and a band of interlacing palmettes in gold- and blue-coloured contours. The outer loop has a dense counterpoint of scrolls in black and gold, blue and carmine. The shafts have alternate panels of crimson or black wriggling cloud scrolls, and floral spikes in blue and carmine, and a plume of three spikes of stylised chinoiserie lotus. The top line of the document is in gold with traces of an erased phrase in blue below it to the left. There follow the titles of Sokollu Mehmed Paşa, including *al-ghanī fī sabīl Allāh* ('he who is rich in works pleasing to God'), alluding to his generosity in founding *vakf*, and lists of the lands and their revenues together with the dates at which the grants were made.

The document was more than a formal preliminary to the endowment of a pious foundation by the Grand Vizier, whose legal status in Ottoman eyes was complicated by the fact that though married to Selim II's daughter, Esmahan Sultan, he was the Sultan's slave and as such could not legally found a *vakf*.

The building/foundation for which the grants were made does not appear to be named here, but it was very probably his mosque complex at Kadırga Limanı in Istanbul inaugurated in 1571. Sokollu Mehmed Paşa was a generous founder. Two *vakfiye* documents (Istanbul, Millet Kütüphanesi, ᶜAli Emiri Tarih, no. 933) list his *vakf* lands at Becskerek in Transylvania (very probably seized in reprisal for the pro-Habsburg policy of Bishop George Martinuzzi) and his other foundations. These include waterworks at Medina; a complex at the Azapkapısı in Istanbul; a *mescid* at Balçık, Turkish Thrace; a mosque and Koran school at Kayapınarı, near Sidrekapsı in northern Greece; a mosque and Koran school at Becskerek (dated Rabīᶜ II 961/March 1554); a *medrese* and Koran school at Soklovik, that is, Sokol in Bosnia, the place of his birth; a *mescid* at Büyük Çekmeçe; a mosque, *medrese*, Koran school, ᶜimaret

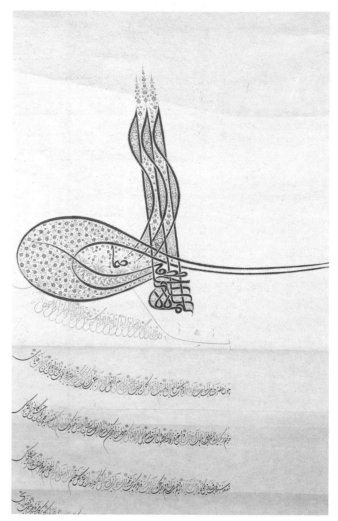

11

('soup kitchen') and an enormous guest house at Lüleburgaz, both on the royal road to Edirne; and in Anatolia a large *medrese*, market and port installations at Payaz near Iskenderun and a complex at Bor, near Niğde.

12 *Vakfiye* of Hürrem Sultan

Dated (f. 72a) 28 Receb 947/28 November 1540, for her complex foundation in Istanbul, a mosque at Ankara, etc.

73 folios, text Arabic, 9 lines per page, carefully pointed *naskhī* with elements of *taᶜlīq*, with gold and black margins, stops in gold, black and red, and with *duᶜā, āyāt* and the names of God in gold

Brown leather binding with medallions, pendants, corner-pieces and border of embossed cloud scrolls on gold; *doublures* filigree in brown on blue

Page 25.2 × 17 cm

TIEM 2191 (entered TIEM in 1919)

Literature: For further commentary and bibliography see pp. 18–20 above; Washington 1987, no. 6, wrongly reads 18 Receb

f. 7a *Tuğra* of Süleyman the Magnificent, blue with gold contours.

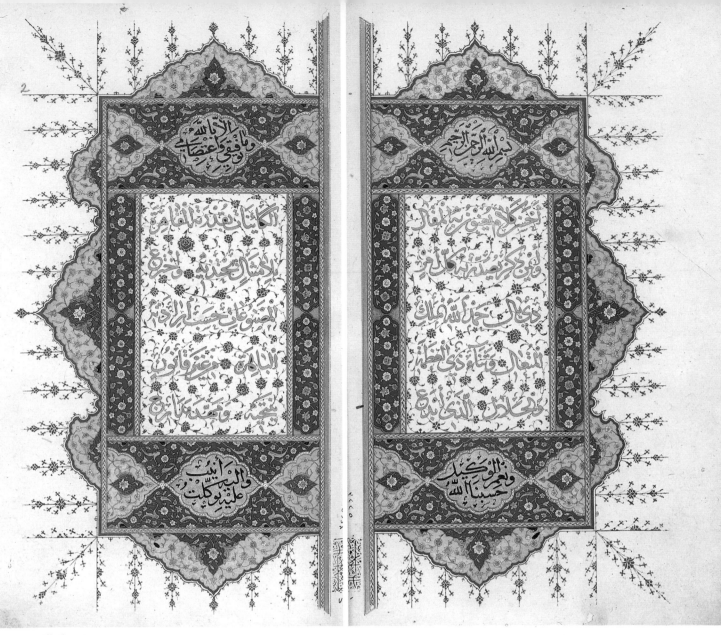

12 (ff. 1b–2a)

f. 7b Deed of *vakf* drawn up by Abu'l-Su'ūd Maḥmūd al-Qāḍī, that is, Ebussuûd, Süleyman's Şeyhülislam. The main text of this page seems to be in his own hand.

f. 21b Titles of Hürrem Sultan, including 'Ā'ishat al-Zamān, Fāṭimat al-Dawrān, al-Sulṭāna al-Zāhira (name left blank), the most honorific title being evidently Wālidat al-Sulṭān Amīr Muḥammad (the mother of Şehzade Mehmed). The titulature is evidently *ad hoc* but is based upon that of a Grand Vizier. It is followed by the formal titulature of Süleyman himself, continuing up to the last line of f. 24b with his name in gold: this, not surprisingly, completely eclipses that of Hürrem Sultan and suggests that her role as foundress may have been considered to be secondary to that of Süleyman – from whom the grants of *mülk* for the *vakf* had to come.

f. 29b Designation of the foundations made *vakf*, including a mosque in the *mahalle* of al-Ḥājj al-Rawwās (that is, Hacı Başçı, probably a Gülşenī dervish) in Istanbul, with a *medrese* opposite it with accommodation for sixteen students, a Koran

school (*maktab al-sharīf . . . li ta'līm al-Qur'ān al-'aẓīm*), and an 'imāret and a kitchen next to the *medrese*; and a mosque in Ankara.

ff. 32b–37b *Endowments*: Ankara mosque (32b ff.); Istanbul complex (34b ff.). The rural endowments (f. 37a–b) include villages in the *kaza* of Ahyolı/Ahyolu in the *liva* of Silistre.

ff. 40b–42a Provision for the upkeep of the foundations, together with specified amounts to be set aside by the *mütevellī* and the *kātib* to be invested on behalf of the *vakf*.

ff. 42a–60a Staff, wages and salaries, and rations for the Istanbul foundations.

f. 60a–b *Occasional duties and benefactions*

ff. 63b–73a *Additional provisions*

f. 63b To the *zaviye* of Tōklu Dede, 20 dirham per month.

f. 65b To the *zaviye* of Shaykh Ḥasan Dede at Karapınar in the *kaza* of Aksaray, 12 dirham per month.

ff. 63b–64a Staff for the mosque in Ankara.

ff. 72b–73a Witnesses (shuhūd al-ḥāl) including the four viziers, the principal defterdars, the Nişancı Celālzāde Muṣṭafā and other chancery officials and courtiers. The names appear to be all in the hand of the same scribe. Below are later attestations of 1224/1809–10, 1226/1811–12, 1228/1813 and 1235/1819–20.

13 Koran

Written by Şeyḫ Ḥamdallāh for Bayazid II at Istanbul
337 folios, muḥaqqaq in black ink, 14 lines to the page with illuminated verse stops, sūra-headings and marginal medallions marking each 10 verses; illuminated frontispieces ff. 1b–2a, 2b–3a and opening page of text
Colophon (f. 337b) dated 901/1495–6
Original warm brown stamped leather binding, the central medallion, pendants, corner-pieces and border heavily embossed and gold-tooled with floral scrolls, cloud clips, split-palmettes and trefoils; doublures of chocolate brown leather similarly stamped and embossed
28.2 × 20 cm
TKS EH. 72
Literature: Karatay 1962–9, no. 798; Washington 1987, no. 7

Şeyḫ Ḥamdallāh was the son of a Suhrawardī shaykh from Bukhara, Muṣṭafā Dede, who studied in the tradition of Yāqūt al-Mustaᶜṣimī and ᶜAbd Allāh al-Ṣayrafī transforming the rounded scripts to Ottoman taste. He was Bayazid II's tutor during his residence at Amasya before his accession and was

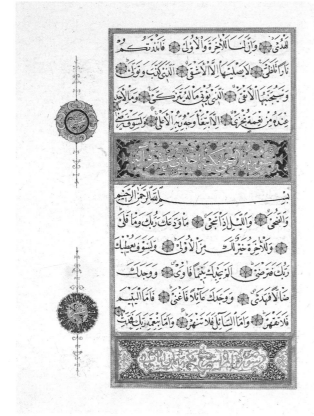

13 (f. 328a)

then installed by him in Istanbul in the palace where, inter alia, he gave the Sultan and his sons instruction in calligraphy. A prolific scribe, he also designed monumental inscriptions, notably those of Bayazid's own mosque (inaugurated 1505) in Istanbul. The opening (ff. 327b–328a) demonstrates that the format, layout of the script, and many of the favourite motifs and devices of illumination of Süleyman's reign had developed from a standardised international Timurid style into specifically Ottoman forms several decades previously.

14 Koran

Made for Süleyman at Istanbul
477 folios, heavy, polished, unwatermarked paper, 11 lines of carefully pointed muḥaqqaq, illuminated verse stops, marginal darts, medallions and sūra-headings
Dedication and colophon (f. 477a–b) dated 930/1523–4, with the names of the illuminator (nakkāş Bayrām b. Derviş Şīr), and the calligrapher (ᶜAbd Allāh b. Ilyās)
Reddish-brown leather binding, stamped with central medallion, corner-pieces and borders; doublures with a gold-tooled border and stamped central medallion with embossed cloud scrolls, ribands and florets
Page 25.5 × 17 cm
TKS EH. 58
Literature: Karatay 1962–9, no. 810; Yağmurlu 1973; Istanbul 1983, E. 5; Washington 1987, no. 8

ff. 1b–2a (opening) The frontispiece is illuminated in blue, polychrome and tones of gold with a field of star and cross design, in tones of gold (somewhat similar in scrollwork to the binding of no. 21), a border of medallions and reciprocal heavy lappets, and long marginal blue darts. The lappet-borders of ff. 2b–3a are similar but they enclose panels above and below the Koranic text.

15a Koran

238 folios, fine muḥaqqaq or naskhī, 15 lines to a page, ruled gold margins, with illuminated sūra-headings, marginal ornaments and 10-verse stops which probably derive from a Koran (TKS EH. 249) made at Baghdad in 705/1305–6
f. 235b signature of al-Ḳaraḥiṣārī min talāmīdh Sayyid Asadallāh al-Kirmānī and date in words 953/1546–7 in characteristic taᶜlīq
Modern binding
Boards 28.6 × 18 cm
TKS Y.Y. 999

ff. 1b–2a open with a double-page illuminated spread of Sura I and the beginning of Sura II. These are panelled, with the basmala and the bottom line written large in gold with black contours on a ground of blue and carmine dianthus with black ḥaraka. Between these is the main text, in a minute naskhī, flanked by pairs of lobed oval panels of interwoven prunus stems rising from a tuft of feathery leaves. Above and below are the sūra-headings and verse counts. The border is edged with an amazing fusion of feathery leaves and composite buds, but the whole composition is a brilliant contrast of panels, motifs and colours prefiguring the finest work of Ḳaramemī (cf. no. 31).

14

سورة البقرة

بسم الله الرحمن الرحيم

الم ذلك الكتاب لا ريب فيه هدى للمتقين الذين يؤمنون بالغيب ويقيمون الصلوة ومما رزقناهم ينفقون والذين يؤمنون بما انزل اليك وما انزل من قبلك وبالاخرة هم يوقنون

وهى ماتتان

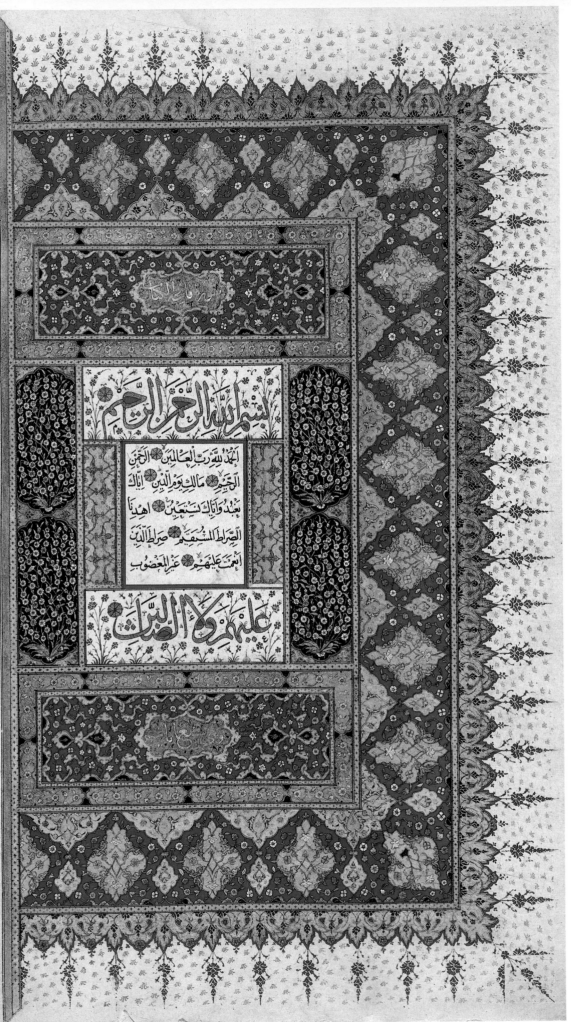

15a (ff. 1b–2a)

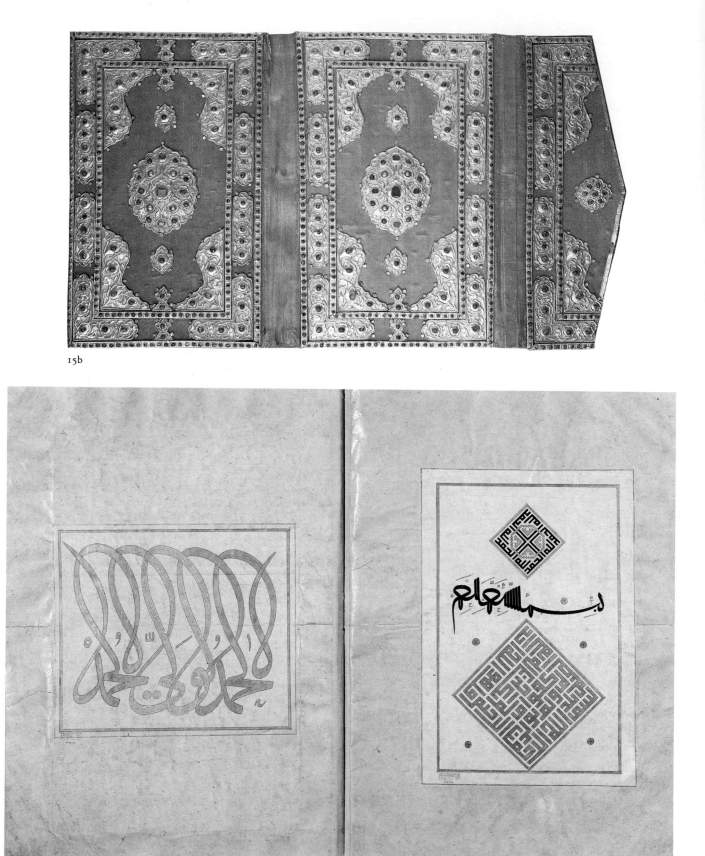

15b

16 (ff. 1b–2a)

15b Binding

17th century
29.3 × 18.2 cm (single board but ignoring spines and flap)
TKS 2/2097
Literature: Istanbul 1983, E. 269; Washington 1987, no. 9b

The binding was a later replacement for the Karahiṣārī Koran (15a). It is of cloth of silver in which the silver thread is mixed with brown silk to give the appearance of gold over cardboard (*mukavvā*). It is decorated with embossed gold plaques with medallions, lobed corner-pieces and borders attached by gold nails and encrusted with rubies, turquoises and pearls in plain collar mounts.

16 Calligraphic specimens

Sūrat al-Anʿām and assorted *ḥadīth*, prayers and extracts from the *Kaṣīdat al-Burda*, written by Aḥmad Karahiṣārī in various swash scripts (signatures ff. 12b, 15a)
15 folios, in gold and black on finely gold powdered polished white paper, pasted on to heavy beige paper
c. 1550
Leather binding, with stamped medallion and pendants with feathery leaf scroll rising from a leafy tuft embossed in beige on gold; *doublures* of heavy yellow paper, heavily flecked with silver
Page 50 × 35 cm
TIEM 1443; transferred from the library of Ayasofya 1914
Literature: Flemming 1977; Istanbul 1983, E. 60; Frankfurt 1985, 1/76; Washington 1987, no. 10

f. 1b *Basmala* in *musalsal* script (cf. TKS Koğuslar, Muḥammad b. Ḥasan al-Ṭībī's collection of alphabets and calligraphic specimens for Qāyt Bāy's library); lozenge with a quadruple *al-Ḥamdu li'llāh* and a large lozenge of square Kufic containing *basmala* and Sura CXII in black and gold.

f. 2a Chain script (*musalsal*) with *al-ḥamdu li-walī al-ḥamd* [*sic*], *al-walī* in black outline with fine dotted running rosettes, and *al-ḥamd* in gold.

The signatures in characteristically quasi-*taʿlīq* script read *Mashq adʿaf al-ḍuʿafā wa turab aqdām al-masākīn al-faqīr Aḥmad al-Karahiṣārī* ('The script of the weakest of the weak ... Karahiṣārī'). The final phrase, *min talāmīdh Sayyid Asadallāh al-Kirmānī*, is minute. The protestations of humility prolong the inscription to considerable length.

The texts and probably the scripts too are indebted to works of pious calligraphy made for the libraries of the Mamluk sultans Qāyt Bāy and Qānṣūh al-Ghawrī, which after the conquest of Egypt mostly found their way to the Topkapı Saray.

17 Album of calligraphy

22 folios, black and gold ink on very finely gold-powdered paper, 3 or 4 lines per page in different rounded scripts, oblong format, reverses of folios blank
ff. 19b–20a signature, in quasi-*taʿlīq* (cf. also no. 12): ... *al-Karahiṣārī min talāmīdh Sayyid Asadallāh al-Kirmānī* and date 960/1552–3 in a surround of Persian distichs in praise of calligraphers and script
Original stamped and gilt leather binding
Page 37.5 × 26 cm/38 × 26.2 cm
TKS A. 3654
Literature: Washington 1987, no. 11

The main body of the work (ff. 3b–18a) consists of alphabetic studies in various rounded scripts, from bold and monumental to minute – first a series of complete alphabets, both separate and combined, and then studies of particular letter forms in combination, in alphabetical order, alternately in gold and black, but sometimes with contrasting contours. Between each line of bold script is a series of pious formulas in *naskhī* or *muḥaqqaq* – the *istiʿādha*, the *basmala, wa bihi nastaʿīn*, etc.

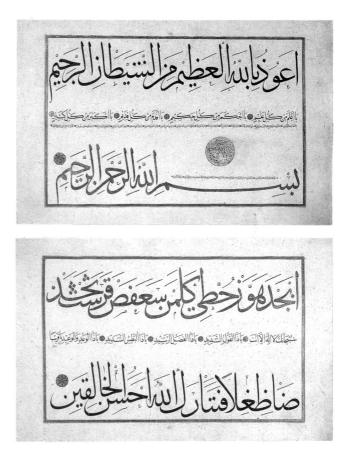

17 (ff. 1b–2a)

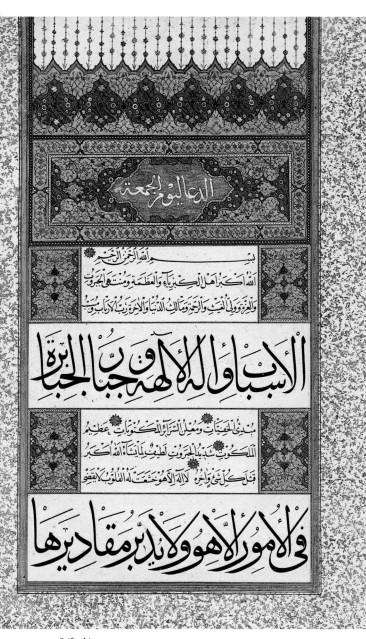

18 (f. 2b)

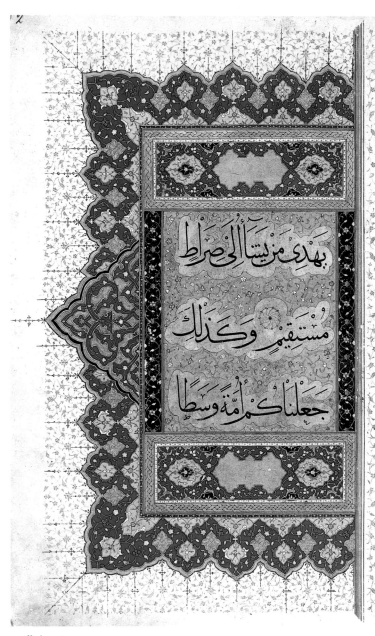

19 (ff. 1b–2a)

18 Prayer book

Written (f. 7a) by Ḥasan b. Aḥmad al-Ḳarahiṣārī in 974/1566–7 (in words)

7 folios, paper with heavily gold-sprinkled margins, black and gold ink, 9–14 lines, in alternating bold and fine scripts, illuminated side panels and headings

Modern binding

Page 36 × 25.5 cm

TKS EH. 1077

Literature: Karatay 1962–9, no. 5636; Derman 1970; Derman 1982, pls 9–10; Washington 1987, no. 12

ff. 1b–2a have illuminated rectangular panels, that on f. 1b with a dedication to Selim II. The illuminated heading of ff. 2b–3a (opening) is strongly reminiscent of the Ḳarahiṣārī Koran, YY 999 (no. 15a) in style.

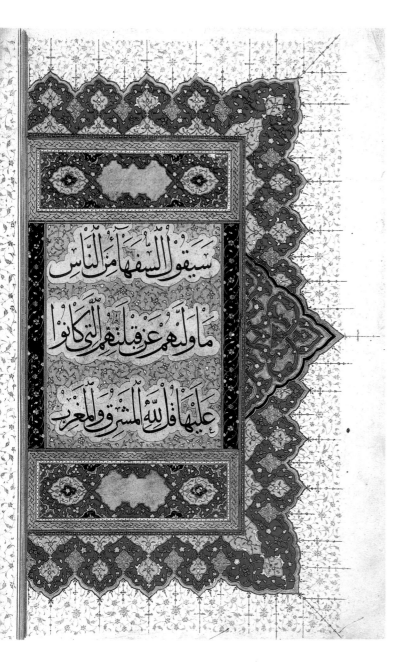

19 Koran fragment

50 folios, 5 lines *thulth*, black ink on paper beginning (ff. 1b–2a) *in medias res*;
text panels of brownish paper inlaid in broad white margins

f. 50a *katabahu Yāqūt al-Mustaʿṣimī*, not in *thulth* of text but in characteristic
quasi-*taʿlīq* used by Aḥmed Ḳarahiṣārī to sign his work, although dated
681/1282–3 (in words); it may, therefore, be an attribution

Reddish-brown leather binding, stamped and tooled with lobed central
medallion and pendants and lobed concave corner-pieces with embossed
scrolling in gold; *doublures* and inner flap have medallions and corner-pieces
of paper or leather filigree painted gold, on panels of green, blue or
vermilion paper

Boards 33.5 × 22.7 cm

TKS EH. 227

Literature: Karatay 1962–9, no. 99; Tanındı 1986; Washington 1987,
no. 13.

The first double-page opening (ff. 1b–2a) has large triangular
projecting side-pieces with typically Safavid interlacing noded
stems, panels above and below which are blank, and long blue
darts in the margins over fine gold flower-scroll filling. The
ground has been filled in to Safavid or Ottoman taste with gold
abrī or cloud ornament.

Korans by Yāqūt and ʿAbd Allāh al-Ṣayrafī are also known
to have been presented to Süleyman on various occasions with
embassies sent by Shah Ṭahmāsp. This raises the possibility
that the illumination is partly Safavid and that the pages were
only later mounted and rebound in Istanbul.

20 Koran

Made for the *ḥizāna* ('treasury', or 'library') of Rüstem Paşa, 964/1556–7

330 folios, in rather squashed *naskhī* or *muhaqqaq*, well pointed, 15 lines per page, inlaid in paper of lighter colour mostly undecorated

Illuminated folios 1a, 1b–2a, 2b–3a, 329b–330a, 330b; a few have conserved their 14th-century illumination, of gold on blue on spiral leaflet scrolls

Colophon (f. 330a) *katabahu ᶜAbd Allāh al-Ṣayrafī fī 745* (in words)/1344–5

Modern binding

Page 22.5 × 15.7 cm (overall)

TKS EH. 49

Literature: Karatay 1962–9, no. 141; Yağmurlu 1973; Tanındı 1986; Washington 1987, no. 14

Pasted on to the flyleaf is a series of librarian's notes in contemporary *siyāḳat* attributing:

1. The binding to Meḥmed Çelebi *ser-mücellidān-i Dergāh-i ᶜĀlī, müsellim al-kutub*, 963/1555–6.

2. The illumination to Ḳara Meḥmed Çelebi (Ḳaramemī) *ser-naḳḳāşān-i Dergāh-i ᶜĀlī, ve ustād al-kutub*, 962/1554–5.

3. The calligraphy to ᶜAbd Allāh al-Ṣayrafī, 745/1344–5.

4. Supplementary texts (*vaṣṣālī*, literally 'patching up') including *sūra*-headings, etc. to the pen of *al-kātib* Ḥasan veled-i Aḥmed al-Ḳaraḥiṣārī.

ff. 3b–4a Among the most interesting illuminated margins are fantastic chinoiserie lotus stems of blossoms and leaves, very close to the *ṣāz*-margins of the Murad III album in the Vienna Nationalbibliothek, but in black and two-toned gold ink.

It must be said that the style of the illumination has little in common with the signed work of Ḳaramemī or of works attributed to him.

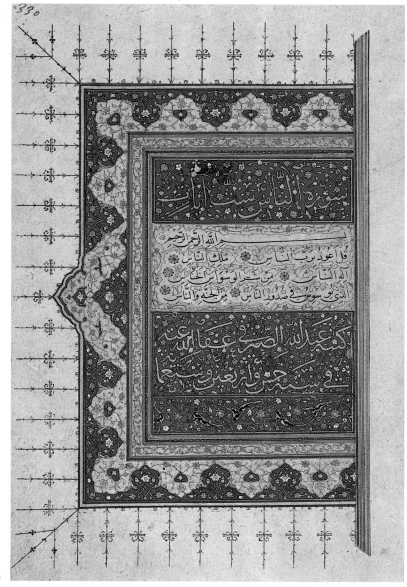

20 (f. 330a)

3 Bindings (nos 21–7)

For bindings the scriptorium of Süleyman the Magnificent called on several rich yet markedly distinct decorative traditions using a variety of different media: Mamluk Egypt and Syria, which in a sense encapsulated the early 'classical' tradition of Islamic bindings and which had a considerable influence on the European Renaissance;[1] Timurid Tabriz and Herat, which drew upon the traditions of Jalayirid Baghdad;[2] and the style of the Ottoman fifteenth century, notably a series of works made for the libraries of Mehmed II and Bayazid II.[3] Yet from all of these the bindings of the high Ottoman period are again stylistically quite distinct, not only from their contemporaries but also from the other arts of the book, in spite of the fact that the non-Ottoman Islamic bindings in the Topkapı Saray, probably the richest collection in the world, must almost all have been there by 1535 or so and would have been accessible to the binders in the scriptorium.[4]

The stamps and tools customarily used by book-binders of the period could circulate independently and, therefore, might have served as patterns in other crafts. Although this may be generally true, there are some remarkable particular instances. Julian Raby[5] has, for example, demonstrated the closeness of both medallion and star Uşak carpets, which had previously been generally believed to owe their designs to Safavid carpet weavers brought to Istanbul after 1514,[6] to the stamped and gilt bindings of a series of volumes made for Mehmed the Conqueror (often, too, with illuminated dedications or frontispieces in highly personalised style) and, in the case of the star Uşaks, to their filigree doublures. The implications for their dating are, thus, interesting. This may, of course, be related to the fact that as early as 1427 a report by the calligrapher Ja'far al-Baysunqurī on current work in Baysunqur's library at Herat states that draughtsmen were making designs suitable for bindings and for tentwork.[7] The great Akkoyunlu, Safavid and Mamluk tents erected as trophies in the Hippodrome (see p. 10) for the great wedding feast of Ibrahim Paşa (1524) or the circumcision feast of 1530 must, thus, have been not dissimilar to the imperial Ottoman tents (otāğ-i Humāyūn) of Süleyman's reign depicted in illustrated chronicles. The Uşak designs, therefore, may have evolved indirectly, via tentwork, as the 'Court' kilim designs of c. 1550–1600 also seem to have done.[8] It is, doubtless, relevant that the lists of craftsmen brought from Tabriz in 1514 do include tent-makers (ḫaymedūz).

Technically speaking the book-binders of Süleyman's reign worked on principles established in the fifteenth century – stamping or tooling leather on boards; lacquering on leather; using cut leather or paper filigree for doublures set over polychrome panels painted blue, yellow, orange or green (but rarely or never over coloured silks, as in Mamluk Egypt; and not apparently continuing the tradition of fine textile doublures recently published from the reigns of Mehmed II and Bayazid II).[9] This technical conservatism was no accident for stamps and blocks were constantly reused, making the evolution of compositions difficult to date, and because certain bindings (cf. the Nevā'ī manuscripts begun in Herat but completed c. 1530 in Istanbul, for example, no. 33) seem to have been bound before all their illustrations were executed and so reflect Safavid taste: such are the lacquered bindings and flaps with peris or animal ornament (no. 33)[10] for which the Ottoman court does not seem to have cared. Two striking features of later sixteenth-century Ottoman binding, the use of heavy gold embroidery with coloured silks on fine leather or sharkskin (no. 25) and of jewelled jade plaques and filigree (no. 26), which involved the skills of jewellers or embroiderers, either separately or in concert with the binders,[11] may also have Safavid precedents, though they harmonise well with the Ottoman tendency to encrust every available surface.

The decoration of the stamped and gilt medallions and corner-pieces, borders and field is particularly important, however, both for its innovation and its continued influence in other media. The wriggling imbricated cloud scrolls on the medallions and corner-pieces of the exterior of no. 24a, for example, are strikingly close in their treatment and disposition to panels of blue and white tiles on the façade of the Sünnet Odası in the Topkapı Saray. The scrolling counterpoint of split-palmette arabesques and chinoiserie floral scrolls on the exterior of the Tafsīr binding (no. 21), which is evidently Safavid work, exploits the contrast of relief as well as of texture and motifs and is, thus, close in effect to the scrollwork, both relief and encrustation, on the ivory hilt of Süleyman's short sword (no. 83), which may also be Safavid work. The relationship between binding decoration and goldsmith's work – possibly because so much of the latter is in repoussé and could, therefore, use the same or similar tools and stamps – is particularly close. On the other hand, marble carving and ivory carving (like the mirrors (nos 79–80)) were as close in the Ottoman sixteenth century as they have been in almost every Islamic culture, yet there is no obvious connection between them.

The distinctive appearance of Ottoman bindings seems to have become standardised by about 1540 – with deeply stamped medallions (şemse) and pendants (salbek), lobed corner-pieces and borders, with embossed relief but sometimes, on borders, small cartouches resembling jewelled plaques (e.g. no. 30). Even when more ambitious decorative techniques were used, like embroidery (no. 25), tortoiseshell (no. 53a) or jewelled hardstone (no. 26), the disposition remains essentially the same. The embossed ornament is mostly counterpoints of spiral blossom scrolls underlying split-palmettes or cloud bands which are sometimes formalised into strictly symmetrical compositions of knotted ribbons or clips, often in contrasting colours to the field or to the gilt ground.

Possibly the most important decorative innovation of Süleyman's reign, the so-called sāz style,[12] a swirling scroll

form with rich feathery leaves, is particularly associated with bindings, although, since manuscripts sometimes remained unbound for a considerable time after they had been written, their colophons are not always an exact guide to the date of the binding.[13] Two forms of it appear in the present exhibition, on the lacquer binding of the *Khamsa* of Nevā'ī (no. 35b, colophon dated 937/1530–1) which, if the binding is contemporary, gives an indication of its first use as a worked-up decorative motif; and on a *sancak* Koran (no. 23, no colophon, *c.* 1550) exquisitely embossed in black on gold with broken stems, rather curiously, however, a mere fragment of a much larger scrolling design: in both cases the leaves are one element in a complex chinoiserie floral repertory of stylised peony and lotus forms, which are often hybrid or composite, enclosing smaller medallions of buds, leaves or pomeganates (e.g. no. 106). *Ṣāz* in western Turkish dialects means 'reed' and these serrated feathery leaves indeed often appear as bunched reeds; but Orhan Şaik Gökyay[14] has observed that in the Oğuz epic, the *Dede Korkud kitabı*, *ṣāz* (to judge from its glosses in the Arabic dictionaries) is used in the sense of 'forest, jungle', the lair of wild beasts. Although reed-beds are often depicted in lion- or boar-hunts in Safavid painting, worked-up drawings of the leaf form as foliage through which dragons or lions writhe or prowl (no. 50d) may well be a play upon its sense as forest. These drawings derived from a tradition of large format brush or pen drawings of foliage and monsters cultivated in fifteenth-century Tabriz or Herat[15] although in these the foliage almost always derives from lotus or vine leaves. The *ṣāz* style is much more characteristic of stamped bindings than of manuscript illumination, although a version of it appears on a ferman dated 1552 (no. 10), and arguably these were the source from which it percolated into Ottoman decoration – textiles (no. 106), pottery (nos 140–1) and tilework, damascening or goldsmiths' work. When used in decoration *ṣāz* leaves appear with animals only once, on the famous blue, turquoise and white tile panels on the Sünnet Odası in the Topkapı Saray,[16] which are probably to be dated *c.* 1560 rather than earlier. These must be from a pounced stencil. However, brilliantly modelled and composed as their design is, it has little to do with the drawings in albums of the mid- and later sixteenth century made for the Sultan, some very much in the Turcoman tradition (cf. no. 50d) of foliage drawing, in which sinuously writhing monsters and animals in combat (no. 53f) are an integral part of the composition. This indicates that these are worked-up versions of standard motifs, not the original drawings from which *ṣāz* designs in the decorative arts derived.

NOTES

1. Chicago 1981. Rather curiously, the influence of later Ottoman bindings on the development of bindings in sixteenth-century Italy and France is far less apparent.

2. Aslanapa 1979, 59–91.

3. Çığ 1971, pls I–IV.

4. Meriç 1954. Cf Washington 1987, 298–9, which traces the careers of some of the palace binders through registers (*mevācib* defters) of the reign of Süleyman. The workshop was dominated by the family of Meḥmed b. Ahmed, who first came into palace service in the reign of Selim I and was head of the workshop from 1545 to 1566. He is credited with the binding of the ʿAbd Allāh al-Ṣayrafī Koran fragment (no. 20) in a note on the flyleaf. His origins are not recorded, but one might have expected some of the staff to be of Persian or Egyptian origin. The register for 965/1557–8 includes a certain Ahmed *ser mücellidān-i kātibān-i Dīvān-i ʿAlī*, i.e. the chief binder to the scribes of the Grand Vizier's office, a clear indication that the rather small palace staff of three or four masters and some pupils was supplemented when necessary from outside.

5. Raby 1986, 177–87.

6. No carpet-weaver appears in the summary list of craftsmen brought from Tabriz after the Battle of Çaldıran in 1514 (TKSA D. 10734). Nor is a single member of the palace carpet-weavers (*kālıçebāfān-i Ḫāṣṣa*) known to have been of Persian origin. Cf. Çetintürk 1963, 715–31. This workshop seems, moreover, to have been singularly inactive and under Ahmed I it was replaced (if that is the right word) by a workshop of turban ornament-makers (*sorguç*).

7. Özergin 1974–5, 471–518. This might at first glance suggest that Baysunqur was using his scriptorium as a centre for designs, but Jaʿfar is evidently being quite precise: bindings and tentwork showed similar compositions of medallions and corner-pieces for their panels.

8. Balpınar 1983, 13–20.

9. Tanındı 1985, 27–34.

10. Tanındı 1984, 223–53.

11. Çağman 1984, 51–88.

12. Mahir 1986, 113–30.

13. Denny 1983, 103–21.

14. Istanbul 1983, 96.

15. Grube 1961, 176–209; id., 1969, 85–109; Mahir 1986.

16. Kurt Erdmann 1959, 144–53.

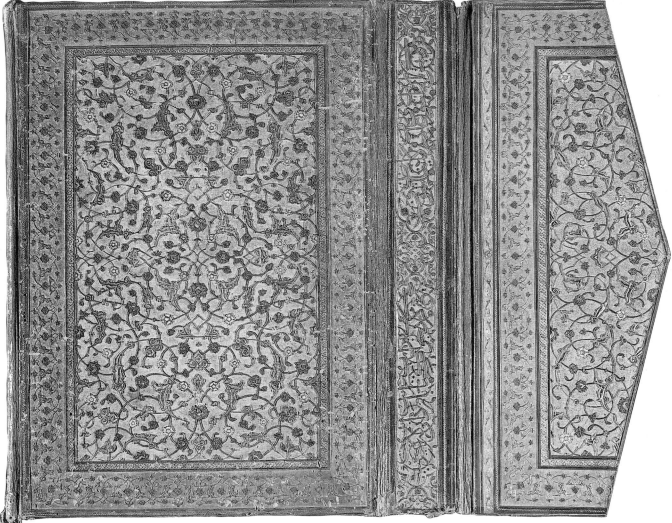

21

21 Binding

Tafsīr-i Ḥusaynī, Ḥusayn Wāʿiẓ al-Kāshifī, 380 folios, Persian text, *nastaʿlīq*,
 27 lines to the page
Written at Constantinople by Rafīʿ al-Dīn Faḍl Allāh al-Tabrīzī, 20 Receb
 925/18 July 1519 (f. 380a)
Boards 32.5 × 24 cm
TKS A. 21
Literature: Karatay, *Farsça yazmalar*, no. 5; Washington 1987, no. 15

The binding is of leather on heavy board with embossed scrolls
in gold, tarnished silver, yellow and white on a finely stippled
gold ground, with a scrolling border and thin bands of zigzag
or meander interlaced. The field is a counterpoint of split-
palmette and lotus scrolls symmetrical about both horizontal
and vertical axes. The *doublures* are of brown leather filigree,
with split-palmettes and cloud scrolls on a panelled ground of
green, gold, deep blue, pale blue and turquoise.

Filiz Çağman points out the indebtedness of the binding to
Herat or Tabriz craftsmanship. With this may be compared a
small *Manṭiq al-Ṭayr* (TKS EH. 1512), dated 25 Muḥarram
911/29 June 1505, evidently completed in Istanbul with
miniatures added *c.* 1530, which shows the influence of
Safavid court arts at the Ottoman court, well before the *sürgün*
of Tabrizi craftsmen after the battle of Çaldıran in 1514.

Technically very similar, and possibly from the same
workshop, is a binding for Saʿdī's *Bustān*, Museum für
Islamische Kunst, Berlin-Dahlem, I 5/72 (cf. Berlin 1986, no.
282).

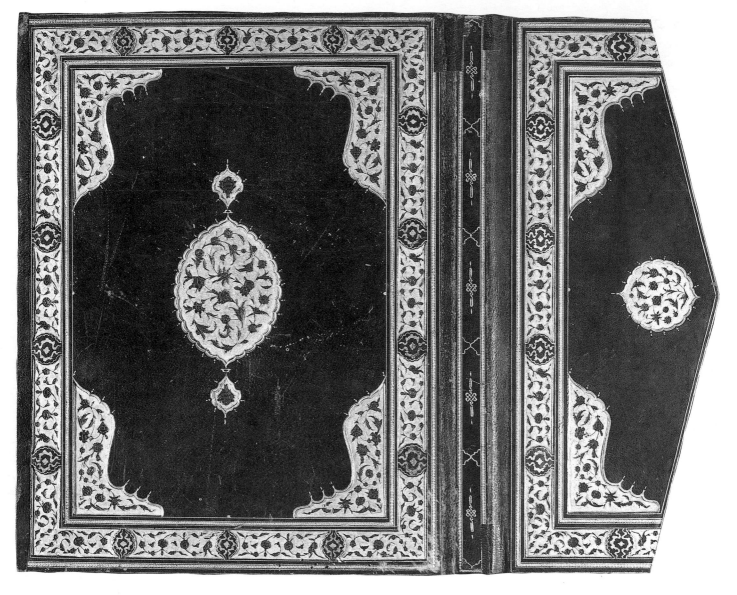

22

22 Binding

Collection of Koranic Suras (I, VI, XVIII, XXIV, XXX) written by the Baghdad
calligrapher, Arghūn al-Kāmilī 706/1306–7, and refurbished in Ottoman
Turkey or Safavid Iran, *c.* 1550

102 folios, heavy laid brownish paper, *thulth*, 4 lines to the page, illuminated
opening for the Fātiḥa and Sura VI. *Basmala* of each *sūra* in gold, but few
with headings. Text panels have faint hachured gold *abrī* with chinoiserie
clouds, foliate sprays, leaves and tightly curved flower stems, possibly
stencilled.

Page 32.5 × 25.8 cm

TKS EH. 222

Literature: Karatay 1962–9, no. 135; Tanındı 1986; Washington 1987,
no. 16

The binding, with flap, is of stamped black leather, decorated
outside with a central medallion, pendants and corner-pieces
and a border embossed with scrolls of feathery leaves and
chinoiserie lotus (cf. no. 20). The *doublures* are reddish-brown
with ruled borders and central lobed roundels of brown-leather
filigree on blue.

23 Small Koran binding

Sancak Koran, written in minute script (*ğubarī/ghubār*) in black on thin,
brownish paper in medallions 4 cm in diameter, 16 lines to the medallion in
a flowing, rather careless hand without verse stops. The first two *sūras*
(ff. 1b–2a) have rather washed-out illumination in the margins

c. 1550–60

5.7 × 5.0 cm

TKS EH. 522

Literature: Karatay 1962–9, no. 638; Istanbul 1983, E. 66; Washington
1987, no. 17

The binding is of cherry-red leather with embossed scrolls and
feathery leaves, part of a large design, in black on gold on the
front, back and flap; the spine is replaced.

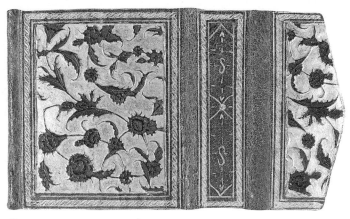

23

24a–b Lacquer binding

40 ḥadīth, text alternately Arabic and Persian, 8 folios of cut-out script,
 alternating panels of nastaʿlīq and taʿlīq in white or pale blue, on deep rose
 or olive-green paper with gold ḥaraka and tashkīl. Margins plain or
 marbled, gold-sprinkled
Richly illuminated almost embossed headpiece (f. 1b) with blue and carmine
 floral darts, punctuation and triangular panels
f. 8b Dedication to Şehzade Mehmed (d. 1543) and colophon with signature of
 the cut-out calligrapher, ʿAbd al-Ḥayy ʿAlī, c. 1540
Boards 24.5 × 15 cm
TKS EH. 2851
Literature: Istanbul 1983, E. 61; Tanındı 1984; Washington 1987,
 no. 18a–b.

The lacquered binding has a central lobed medallion and
pendants and lobed concave corner-pieces which are all filled
with wriggling black cloud scrolls on a dense spiral blossom-
scroll ground in contrasting tones of gold and black. The
doublures and flap (damaged) are decorated with plants of roses,
tulips, prunus, violets, dianthus, iris, the first appearance of
florists' flowers in Ottoman court art, and a dependent cloud,
in blue, red and green, on a talc-powdered gold ground under
an orange varnish. The borders have panels in gold on red.

Similar cloud scrolls decorate panels of blue and white tiles
on the façade of the Sünnet Odası in the Topkapı Saray.

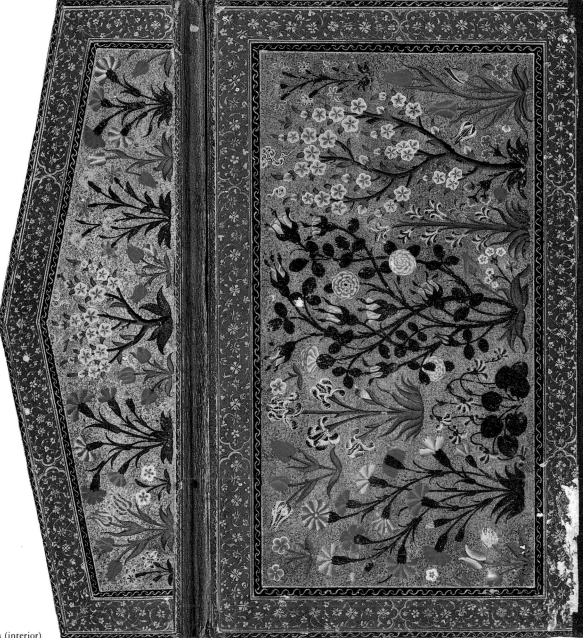

24a (interior)

24a (exterior)

24b (f. 1b)

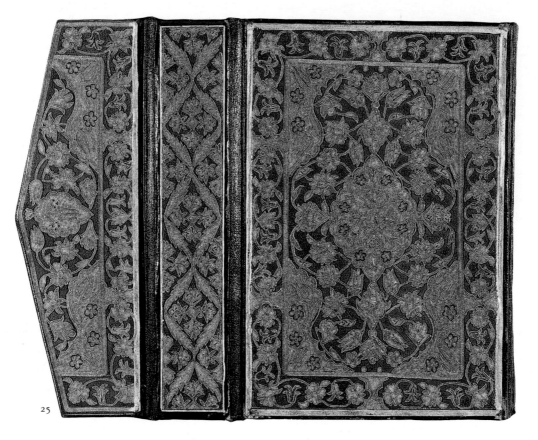

25

25 Embroidered Koran binding

373 folios, small *muḥaqqaq*, or *naskhī*, 15 lines, with double-page
illumination (ff. 1b–2a), illuminated verse stops, marginal 5-verse and 10-
verse stops, *sūra*-headings and medallions to indicate the number of the
cüz'. The point at which each *cüz'* begins is indicated by a thin oblong
illuminated scroll panel heading the page; *eczā'* of irregular length, varying
from 11 to 14 pages each, only a few beginning with a *sūra*

c. 1550
Page 14.4 × 9.8 cm
IUK A. 6570
Literature: Istanbul 1983, E. 181; Washington 1987, no. 19

The *doublures* are deeply stamped with a central medallion and
lobed corner-pieces embossed with *ṣāz*-scrolls in red on gold.
The binding is of grainy black leather (sharkskin), densely
embroidered with gold thread; this is enhanced by bright
turquoise and brownish-black silk with faint touches of
carmine, evidently the core silk of the gold thread, mostly in
satin stitch, although the contours and seams are in a corded
stitch which stands out even when not differentiated by
colour. The central medallion, pendants and lobed corner-
pieces are filled with stylised three-pronged tulips and other
flowers, with a border of scrolling cartouches of stylised
chinoiserie lotuses and hyacinths, and a ground of lotuses,
rosettes and stylised tulips and leaves or bracts similar to those
encrusting later sixteenth-century hardstones, for example, the
jade tankard (no. 72).

 The embroidery technique is comparable to that of the bow
case (no. 95), the portfolio (no. 124) and the sharkskin box
(no. 126).

26 Jewelled Koran binding

Later 16th century
17.8 × 10.8 cm
TKS 2/2121
Literature: Istanbul 1983, E. 200; Çığ 1981, fig. XXXIII; Çağman 1984, fig. 7;
 Washington 1987, no. 20

The exterior of the binding consists of four plaques of pale
green jade in gold mounts and joined by fine gold links. Three
of the plaques are encrusted with emeralds and rubies in collar
mounts in petal surrounds and tracery of gold foliate scrolls so
as to recall the layout of contemporary leather book-bindings.
The stones are all table-cut except the largest rubies in the
centre which are cabochon, and the two above and below these
which are rose-cut. The flap is inlaid with gold arabesques
lying flush with the jade surface. The openwork pierced gold
Koranic inscription plaque on the spine was added later by a
certain Eyüp Paşa when he made the Koran *vakf*.

 Inside, decoration is varied and elaborate. The outer edges
of the two boards have chased foliate scrolls engraved through
a soft black mastic surface. The same technique is used in
reverse on the central oval medallions, so that the floral design
appears in black on gold. The ground is of openwork tracery of
finely chased arabesques over deep-blue paper painted with
tiny gold flowers. One of the flaps bears a cartouche engraved
with a Koranic inscription (Sura LVI, 79) in honour of the
Koran itself.

 Certain features of this binding recall one bearing the name
of Mehmed, the chief court jeweller at the end of the sixteenth
century up to *c.* 1605 (TKS 2/2086). It is possible that this is
another example of his work.

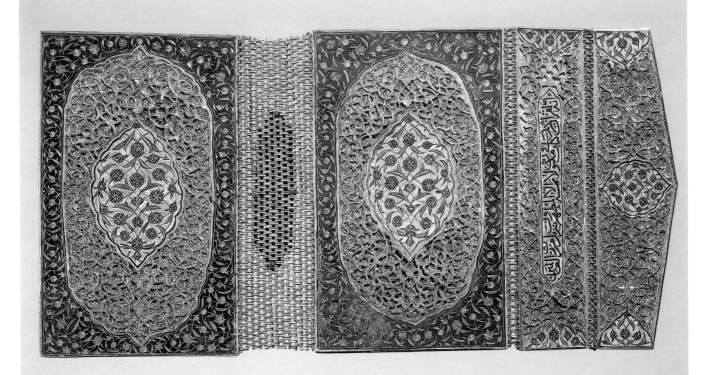

26 (interior)

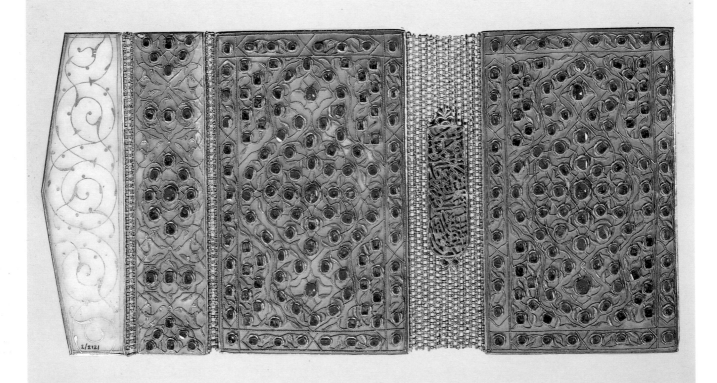

26 (exterior)

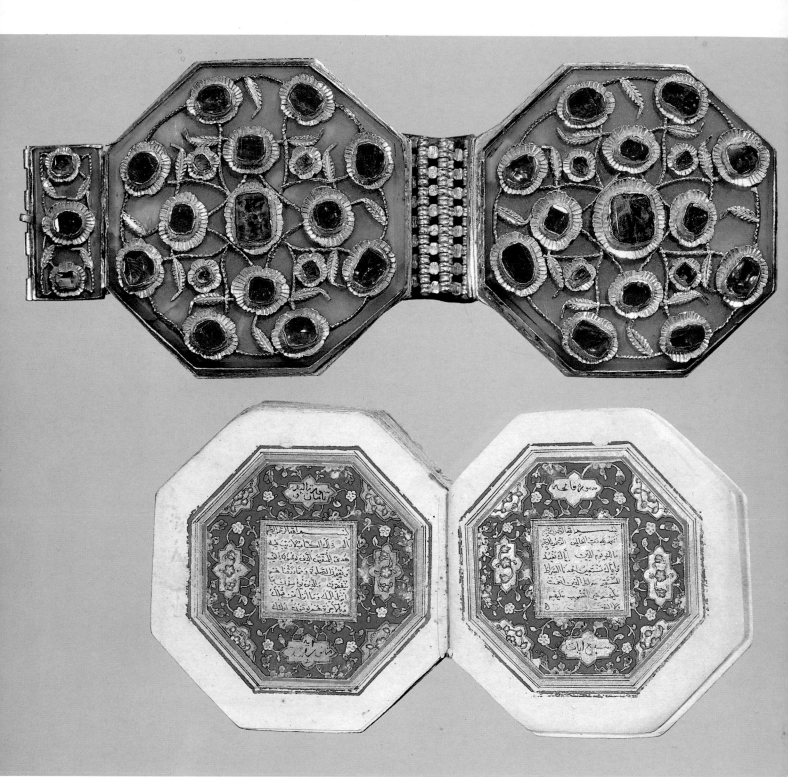

27

27 *Sancak* Koran and binding

Unfoliated, *ğubarī*, *ghubār* script, 7 lines, illuminated double spread (ff. 1b–2a) for the Fātiḥa and the beginning of Sura II, chapter headings and verse stops

Colophon on final page with copyist's name Ibn Halūl Muḥammad Ẓāhir (correcting Washington 1987, no. 21, 'Ṭāhir') and date 978/1570–1, in minuscule script at bottom of page

5 × 5 cm

TKS 2/2896

Literature: Washington 1987, no. 21

The binding is of two hinged green jade plaques and a hasp with gold mounts, encrusted with a tracery of twisted wire and cabochon or table-cut rubies and emeralds in collar mounts with chased petal-like surrounds and small chased feathery leaves. The underside of the hasp is chased with a cypress flanked by florists' flowers; the *doublures* are of reddish-brown leather.

4 Süleyman the poet (nos 28–31)

Gibb in his *History of Ottoman Poetry*[1] has described the sixteenth century as an Augustan age for poetry and its patronage, both for the technical improvements in versification and for the number of fine poets, alive and writing, some of whom reached high rank at the court. One of the most copious among them was Süleyman himself, who wrote in both Ottoman Turkish and in Persian under the pen name Muḥibbī, 'the affectionate one' (and sometimes Muḥibb, Meftūnī or ʿĀcizī).[2] He was not the first Ottoman sultan to write verse (cf. *Dīvān-i Selīmī*, no.32a–b, Selim I's collected verse), but his output, considering his activity as conqueror and administrator, is amazing. This is all the more remarkable in that Ottoman Turkish does not lend itself particularly well to the quantitative prosody of Persian which was the literary model of the time.

In addition to the four manuscripts in the present exhibition, at least twelve manuscripts of his works, the *Dīvān-i Muḥibbī*, have been identified in Istanbul.[3] Not all are dated but they would almost all have been for the palace libraries, either executed at Süleyman's orders, or for presentation to him or, after his death, reflecting his heroic status in the eyes of his contemporaries. The number of his manuscripts is less, therefore, an index of his popularity, than of his or his successors' readiness to pay for them. There is no critical edition of his *Dīvān* to date[4] so that it is impossible to calculate how much he wrote, but one of the four manuscripts exhibited here (no. 30), undated but evidently from the end of his reign, contains 1,000 *ğazels* in addition to other verse. In addition, a recently found manuscript in Hamburg illuminated by Ḳaramemī but dated late Rabīʿ II 961/early April 1554, identified as Volume III of his *Dīvān*, already contains 552 *ğazels*.[5] It is, of course, quite probable that, as with modern books of collected verse, there were periodic revisions or culls, but even so it is extremely likely that Süleyman's total output was well over 2,000 *ğazels*, as well as other verses, and well up to the output of a full-time professional poet.

Among the poets who particularly influenced Süleyman were Persian classics like Niẓāmī and Saʿdī; and Ottoman contemporaries like Zātī (1471–1546),[6] a protégé of Ibrahim Paşa's who suffered accordingly after the latter's execution, and Bāḳī (1526–1600).[7] Bāḳī, who came to court in 1555, is stated to have corrected his verses, and to have written *nazīres* on them (virtuoso exercises involving different words but the same metre and rhyme scheme),[8] while the historian Celālzāde Muṣṭafā copied them out in a fair hand. All but one of the dated Istanbul manuscripts are after Bāḳī's appearance at court, and his *nazīres* might raise the suspicion that poems actually written by Bāḳī or others may have been incorporated into manuscripts of the *Dīvān-i Muḥibbī*. Notwithstanding, the fairly numerous faults of versification show often that verses must have been copied directly from a first draft, which

is good evidence that Süleyman wrote these himself. On the credit side his avoidance of unfamiliar Arabic and Persian words and the simplicity and directness of his verse contrast with the taste of poets like Zātī for bizarre vocabulary and expressions and the florid secretarial style which became popular in the Ottoman Chancery in the latter part of his reign. The contemporary *tezkerecis*, the critics of the period, tactfully refrained, however, from expressing an opinion on his merits.

The prime lyric verse form in Persian and Ottoman Turkish is the *ğazel*, roughly equivalent in length and difficulty of rhyme scheme to the Renaissance sonnet, with the added sophistication of visual puns where words are chosen so that letter forms repeat or imitate one another. The sentiments expressed are conventional – the pains or joys or love, the delights of spring and of nature, intoxication with wine, the burdens of office; the vocabulary is restricted; and stock poetic tropes frequently appear – nightingales and roses, moths and flames, Laylā and Mecnūn, hyacinth locks, rose lips, tulip faces and eyes loosing arrow shafts which wound the heart, tears of blood, etc. – which make translation into English difficult without giving an impression of stale Omar Khayyám. For reasons of metre, moreover, certain expressions and even lines regularly recur.

The problem comes in judging Süleyman's intentions. Spontaneity is often held to be essential to the lyric form, which may even come to be seen as a form of autobiography. What, however, are we to make of the following (rather roughly translated) specimen?

O heart, abandon narcotics; if you would drink, drink tulip-red wine.
The Royal basil has come to the garden and has spread everywhere its leopard-spotted mat.
Come and drink Muscat wine in the garden, do not believe that drunkenness is shameful or against the law.
For a Frankish cupbearer has poured the wine.
Muḥibbī, do not let the occasion pass: let not your hand stray from the tulip-red wine.[9]

However, in the light of his devotion to Hürrem Sultan and Busbecq's testimony that he avoided both wine and boys, the numerous references to drunkenness, passionate beauties and downy-cheeked cup-bearers cannot be autobiographical and must, therefore, be conventional or allegorical, conceivably symbolising the joys of paradise or the union of the soul with God. The occurrence of religious imagery, together with the erotic topoi, indicates that Süleyman was sometimes aware of the allegorical possibilities, but unlike the verse of more obviously mystical poets like Ḥayālī (cf. no. 160), the imagery is not systematically worked out. Most of Süleyman's verse, therefore, cannot have been intended to be serious, any more than much of the lyric poetry of his more eminent contemporaries. It is essentially light, depending for its effect on

topical allusion, and the adroit manipulation of conventional sentiments or imagery. This goes not only for the love lyrics but also for moralising reflections on his position as ruler or the transience of human life. Of course, the effect may be serious and many lines are striking, but accidentally, as it were.

Such was, more or less, the judgement of later Ottoman critics. To us it may sound harsh, but their criteria were somewhat different. Spontaneity of feeling, which may relate to an imaginary object, is perfectly compatible with conventionality of diction. In the context of Ottoman court poetry novelty of expression had always to be balanced by acceptance of the conventions, and adroitness, wit and vividness were all judged in terms of this balance. It makes it difficult for a Westerner, or even a modern Turk, to weigh the merits of different poets when diction, tropes and sentiments are all much of a muchness. However, such is the case with most European Mannerist verse, and it is difficult to think of any Renaissance or Mannerist monarchs who could be deemed Süleyman's superiors.

An important element of poetical output at Süleyman's court was the *kaṣīde* (an ode), generally panegyric or congratulatory in nature, offered to the Sultan on a particular occasion, generally in the expectation of financial reward. The careers of Süleyman's favourite poets, particularly Ḥayālī and Bāḳī demonstrate that flattering *kaṣīdes* appropriately presented were not just a social accomplishment but a means of social advancement, for both were appointed to rich military governorates; and even less distinguished versifiers could hope for financial reward. How far they may properly be considered 'serious' is a matter of judgement, but laments (see above pp.21–2) on the execution of Şehzade Mustafa in 1553 show that there was an undercurrent of seriousness in the poetry of Süleyman's time largely concealed by the *ğazels* and *kaṣīdes* of the poets of his entourage. There also survives one poem by Süleyman[10] which demonstrates that such seriousness was not entirely alien to him – his answer to Şehzade Bayazid's strong protestations of innocence (see above, p.24) reproaching him for his disobedience in a series of quatrains, the refrain of which is: 'Do not protest your innocence but repent my dearest son.' The exchange almost certainly took place after Süleyman had obtained the *fetvā* from Ebussuūd authorising Bayazid's execution, for the burden of it is that Bayazid is in rebellion and pardon either useless or too late. However, the choice of verse and the simplicity of feeling, despite the restraints imposed by metre and vocabulary, bring out the tragic elements in this fratricidal squabble.

NOTES
1. Gibb 1904.
2. Ibid.
3. They include IUK T. 689, 1976, 2885, 5455, 5471, 5758; Fatih, Millet Kütüphanesi, ʿAli Emiri 394 (written by Meḥmed Şerīf and dated 978/1570–1), 393 (written by Ḳāsim) and 392 (written by Ḳāsim and dated

974/1566–7); Süleymaniye Library Ayasofya 3970; TIEM T. 3878; Nuruosmaniye 3873; but others may well remain to be identified.
4. A principal problem is the gross discrepancies between the contents of the manuscripts examined. Few of those in the copy book H. 1132 (no. 28), for example, seem to appear in any other text: they may well have been juvenilia and accordingly suppressed. The printed text, by ʿĀdile Sultān (Istanbul 1308/1890–1), and the transliterated text (Çabuk 1980), both evidently selections from various manuscripts, including probably TIEM T. 1962, do not, however, identify their sources and need full collation with the corpus of manuscripts already located.
5. *Dīvān-i Sālis/Thālith*, Museum für Kunst und Gewerbe, Hamburg. For generously copious information on this important manuscript we are indebted to Professor Claus-Peter Haase of the University of Kiel and to Dr David James of the Chester Beatty Library, Dublin.
6. 'Zâtî', *IA*. He is reported to have written 3,000 *ğazels* although only 1,800 of these have been identified in the extant manuscripts. He was notorious for his wit and his frequenting of riotous company. He always wore spectacles.
7. 'Bâkî', *IA*; 'Bâḳī', *EI²*.
8. TKSA E. 738.
9. Jacob 1903, 69–70, no. 37, and commentary.
10. Turan 1961, 209–10.

28 *Dīvān-i Muḥibbī*

120 folios, polished whitish laid paper, 14 lines of clumsy *nastaʿlīq* to the page, with numerous corrections, in black or gold-powdered ink. Some of the pages water-stained, with odd spots, blotches or doodles of larval or feathery leaf forms in gold ink
c. 1540
Page 21.2 × 14 cm
TKS H. 1132
Literature: Karatay, *Türkçe Yazmalar*, no. 2331; Washington 1987, no. 24

The grounds for the attribution to Süleyman himself are a posthumous note on the flyleaf (f. 1a): *Işbū dīvān-i mübārek cennetmekān . . . neşān marḥūm ve mağfūr ve Sultān Süleymān Ḥān*

28 (f. 94a)

Ğāzī ḥaẓretleriñin kendü mübārek ḫaṭṭlarıdır . . . ve arāya iltiḥāf eylesün. 'Ḫaṭṭları' must refer to the verses rather than the writing.

The notebook was already bound when the verses were copied out: some pages have numbers which are of no obvious significance. Each *ğazel* is preceded by *ve lahu* (as in a properly ordered divan) but also by *yazıldı*, a Chancery formula deriving from the *mühimme defterleri* where it is used to indicate that the text of a ferman has been recorded in the registers. On f. 85a the second half of the first line, written by error at the top of the page before *yazıldı*, has been crossed out and the poem begun properly below. This is conclusive evidence that it was being copied from another manuscript, almost certainly as a series, either an earlier draft, or a properly calligraphed text. The absence of a *basmala* invocation at the beginning of the notebook, the fact that the poems are not arranged in order of rhyme, and, in a very few cases where the poem is known in one of the dated manuscripts of the end of Süleyman's reign, a fuller text all show that the copy text must have been a draft, including doubtless juvenilia which were later suppressed. Süleyman would scarcely have recopied his own poems in this way. The hand, which is of variable clarity, though with occasional *shaddas* and indications of Persian *iḍāfa*, is not that

of a trained calligrapher, which would thus exclude someone like Bāḳī, his poetic mentor. The note on the flyleaf must therefore be misleading. The presence of this copy book in the Topkapı Saray library raises the possibility, however, that it could have been an exercise book for one of the Şehzades, possibly Mehmed, who was a patron of literature and poetry; or possibly Şehzade Bayazid, whose plea to Süleyman under the pen name 'Şāhī' has been noted above (p.24).

29 *Dīvān-i Muḥibbī*

206 folios, *nastaʿlīq* in double columns of up to 6 lines, some pages blank
f. 203a signature of scribe, Meḥmed Şerīf, *bi-dār al-salṭana Qusṭanṭiniyya*, and
 date, mid-Ramaḍān 973/mid-May 1566
Original stamped reddish-brown leather binding with borders, central lobed
 medallion, pendants and concave corner-pieces, all filled with undulating
 cloud-scroll forms, clips and knots
Page 20.4 × 12.5 cm
TKS R. 738
Literature: Jacob 1903; Karatay, *Türkçe Yazmalar*, no. 2330; Washington
 1987, no. 25

The Persian *dīvān* is on ff. 5b–6a–37a. F. 5b bears a finely illuminated headpiece in gold leaf and polychrome, with stencilled margins in gold, pale blue and pink. The headpiece

29 (ff. 39b–40a)

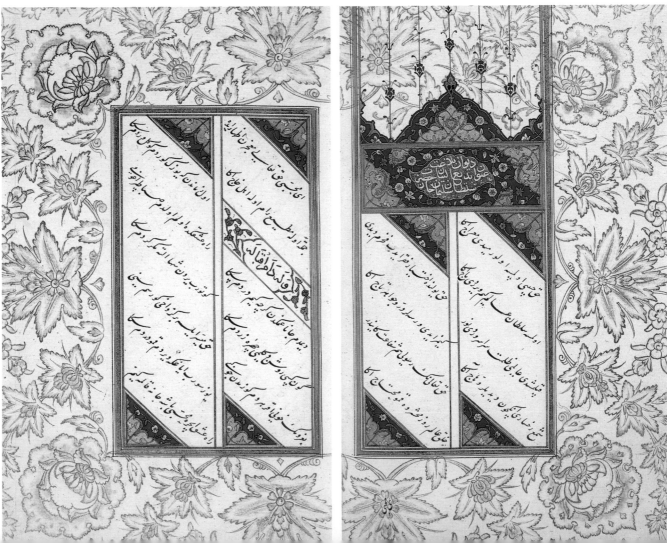

(f. 39a) of the Turkish *dīvān* is similar. Practically all the other margins are stencilled with florists' flowers, palm-trees and cypresses, with the verses on pale-tinted papers of contrasting tone, with gold-illuminated headings and triangular illuminated corner-pieces.

Folios 1b–2a, 2b–3a and 203b–204a bear additional *ğazels* written in black or gold-powdered ink in one or more rounded hands, very different from Meḥmed Şerīf's *nastaʿlīq*: Karatay supposes these to have been entered by Süleyman himself as in a copy book. The volume was evidently bound with blank pages at either end to make such afterthoughts possible.

30 *Dīvān-i Muḥibbī*

252 folios, *nastaʿlīq*; up to 13 lines per page, in double columns, panels of text finely gold-powdered and inlaid in plain paper with ruled margins

Illuminated headings up to f. 76; thereafter in gold ink, or roughly sketched.

 Text consists of 1,000 *ğazels*, 3 *muhammasāt*, 2 *murabbaʿ*, 31 *mukaṭaʿāt* and 52 *mufradāt* (one-liners)

c. 1560

TIEM 1962; transferred from the mosque of Fatih/Mehmed II in 1914

Page 25.5 × 15.7 cm

Literature: Çığ 1959, pls X–XI; Washington 1987, no. 27

f. 1b–2a Double-page illuminated frontispiece on thickened paper with, in panels, *Dīvān-i Pādişāh-i cihān: ḥaẓret-i Sulṭān*

Süleymān Ḥān: dāmit ayyām-i sulṭānahu: ilā ğāyet al-devrān, and elaborate cloud-scroll marginal darts, in blue and carmine.

The binding is of deeply stamped leather, with medallions and pendants, corner-pieces and borders embossed with feathery leaves in gold. The *doublures* are similarly laid out with filigree on faded blue

31 *Dīvān-i Muḥibbī*

371 folios, *nastaʿlīq* in double columns up to 13 lines per page. Paper white or cream, sometimes with the borders or the central (inlaid) panel entirely stained pale carmine

ff. 367b–71b blank but for illuminated borders

Colophon (f. 367a), Arabic, signed by scribe Muḥammad al-Sharīf and dated the last day of Şaʿbān 973/21 March 1566; below that in similar fine blue *naskhī, mudhahhib al-faḳīr Karamemī al-ḥaḳīr*. His signature also appears on f. 365b at the base of a panel with roses

Modern binding

Page 26.2 × 16.5 cm

IUK T. 5467

Literature: Istanbul 1983, E. 62; the present entry corrects that in Washington 1987, no. 26

ff. 1b–2a Double-page illuminated frontispiece with roundels in a rectangular frame bearing the titles of Süleyman, both as ruler (for example, *ḫāḳān ḫawāḳīn al-ʿArab wa'l-ʿAcem*) and as poet (for example, *niẓām aşraf şuʿarā-i mulūk wa'l-selāṭīn wa*

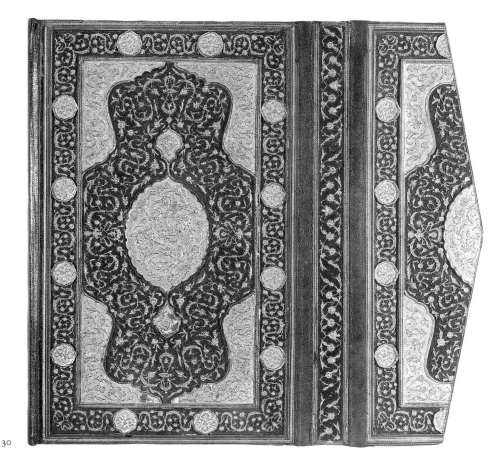

30

31 (ff. 359b–360a)

afṣaḥ bulaḡā-i devrān), on a ground of superimposed arabesques and lotus scrolls.

ff. 363b–366b Post-face in *sac'* with further poetical titulature of Süleyman, praise of his verse and eulogy of the scribe, Meḥmed Şerīf (who evidently composed it himself) and (366b) a *ḡazel* evidently containing a chronogram: *Rumūz-i ḥikmet ve gene ma'ānī* 973.

The verses are separated by brilliantly illuminated panels with lavish stylised foliate or naturalistic floral motifs in polychrome and gold and central cartouches of blue *naskhī*. The motifs include roses, hyacinths, carnations, tulips, tiger stripes, prunus, lotus, cypress, cloud scrolls, split-palmettes, sometimes mixed. There is a certain preference for 'trees' of tulips or carnations and compositions like autumnal kochias. The broad margins are less naturalistically drawn, in gold, with polychrome washes and some silver, mostly with leaf scrolls and foliate or floral medallions, but also with foliate or floral sprays or plants including carnations, tulips, violets, iris, prunus, roses/hollyhocks, marigolds, tiger stripes and cloud scrolls. Probably the finest illumination of all is for the *mufradāt* (one-liners) from f. 349b onwards.

5 Illustration (nos 32–53)

By far the greatest production of illustrated books for the palace library in the Ottoman sixteenth century was not for Süleyman but for Murad III (1574–95), but it was under Süleyman that the foundations were laid, and the styles and preoccupations of the painters. Even in the 1580s, however, it is difficult to be certain of the degree of centralisation, for the historian Muṣṭafā ᶜĀlī[1] was certainly able to recruit a group of illustrators working specially for him for a presentation copy of his Nuṣretnāme, and the privileges of the group of painters associated with Murad III's Şehnameci Loḳmān aroused such discontent among those employed in the palace that on his dismissal in 1596, on Mehmed III's accession, they were sacked with him.[2] It remained generally true that the greatest works were made for the imperial library – because the complication of the operation could best be controlled centrally and because the associated expenses were most easily borne by the Sultan, but the permanent staff of the scriptorium could always be supplemented by recourse to private ateliers, and this was a legacy of earlier reigns.

This was particularly true of Süleyman's reign where increasing interest in portraiture and in topographical illustration demanded not so much professional illustrators as expert or learned copyists. The foremost portrait painter of his time, the sea captain Haydar Reis (Nīgārī), was evidently an amateur, and it is significant that in the Süleymannāme of ᶜĀrifī (no. 45), the first major production of Süleyman's studio, his own personal appearance is considerably less faithfully conveyed. The presentation copy of the Kitāb-i Baḥrīye of Pīrī Reis (no. 40) must also have been the author's own work, for the utility of its illustrations depended upon a tradition of practical naval handbooks notably indebted to Venetian portolans or isolarii ('island books') which he needed to adapt to the needs of Ottoman mariners. Moreover, although the extent of Maṭrāḳçi Naṣūḥ's participation in the illustration of his own Mecmūᶜa-i Menāzil (no. 43) is disputable, the faithful rendering of monuments and topography presupposes eye-witness knowledge of the localities.

It is generally asserted that Naṣūḥ was the copyist of the Mecmūᶜa-i Menāzil[3] but, although the forward-sloping carefully pointed naskhī is evidently the hand of an educated man, it has too many errors resulting from faulty transcription of a dictated text to be admissible as his work; while, if the amateurishly illuminated heading (f. 1b) is his, he did not know his limitations. Many of the illustrations are poor and uninformative and suggest recourse not to nature but to books of shrines such as also appear in compendia like the Bodleian Kitāb al-Bulhān:[4] writers or compilers of guide-books remarkably often prefer to copy each other than see for themselves. The treatment of landscapes, trees, birds, animals, rocks and architecture, as well as differences in colour schemes and the use of gold all argue for several painters, who may, of course, have worked together on various illustrations. Basically there are three groups of illustrations:

1. The views of Kerbela, Najaf, Baghdad, Tabriz and Sultaniye (no. 43b) from which most of the illustrations of the cities on the Tigris and Euphrates derive.
2. The cities of Anatolia, from Istanbul to Kayseri (f. 18b), with details recalling the landscapes of early sixteenth-century Ottoman painting.
3. Aleppo, from which derive some Syrian sites, for example Marj Dābiq (Ṭābiḳ). Most of this group, covering Süleyman's return stages from Syria to Anatolia, must be lost. Aleppo (ff. 105b–6a) in style and the observation of detail is in a way as exceptional as the famous double-page illustration of Istanbul and Galata (ff. 8b–9a, no. 43a), but the most delicate, precise and varied illustrations are group 1, notably the double-page illustration of Sultaniye (ff. 32b–33a, no. 43b), a spring landscape with richly coloured architecture enhanced with gold.

The margins of the volume have been cut down and the paint is too thick to determine what underlying sketches there may have been, but clearly it will not do to ascribe these great differences merely to the diversity of prototypes. The actual sources continue to be disputed, although some must have been sketches made on the spot; but Istanbul and Galata are in a tradition of Italian bird's-eye views of which the Jacopo de' Barbari plan of Venice (c. 1500)[5] remains the most famous; whereas Aleppo is decades in advance of the earliest-known depictions of Aleppo in European printed collections.[6] The rest, however, owe nothing to Italian prototypes, and it is noteworthy that although the Mecmūᶜa-i Menāzil illustrations are commonly said to be in the portolan style neither architecture nor landscape has anything to do with works like Pīrī Reis's important collection of portolan charts, the Kitāb-i Baḥrīye (no. 40), numerous sixteenth-century copies of which are known. For most of the illustrations no prototypes are known. Maṭrāḳçi Naṣūḥ's participation in the manuscript must, anyway, have been limited to overall supervision of a group of painters which, to judge from the sometimes mediocre results, must have been sporadic.

The low profile given Ibrahim Paşa, whose generalship was largely responsible for the success of the Iraq campaign, reflects the fact that the colophon (now lost) was dated 944/1537–8, little more than a year after his disgrace, and the text could have been composed by Naṣūḥ for presentation to the Sultan. However, if this illustrated copy was presented, it was strangely uninfluential. For, despite the frequently noted interest of Ottoman court painters in topography, neither the Süleymannāme of 1558 nor the panegyric chronicles of the reign of Murad III are markedly indebted to it; and, indeed, the Iraq campaign of 1533–5 occupies a very minor place within their pages. This cannot be the only occasion on which a development of the first historical importance was restricted in its

effects: but it must be, at least in part, because the palace studio was to some extent working apart from some of the principal patrons of Süleyman's reign.

Most strangely of all the paintings of the *Mecmūʿa-i Menāzil* had only minimal influence on Naṣūḥ's later illustrated works, like the book of Süleyman's campaigns in 1543–4 (no. 44). Illustrations of Hungarian cities like Pécs and Tata may show some influence from the colour scheme and composition of the views of Bitlis (f. 100a) and the Bitlis gorge (ff. 100b–101a), but the Mediterranean views, like those of the *Tārīḫ-i Sulṭān Bāyazīd Ḫān* (no. 42), are from the sea in a linear style owing much to contemporary European sketches, like those of one of the eye-witnesses to the campaign, Jérôme Maurand d'Antibes, in 1544.[7] Since Naṣūḥ could not have participated simultaneously in Süleyman's Hungarian campaign of 1543–4 and Barbarossa's naval campaign, at least one set of these illustrations cannot be after his own sketches, and his role must have been limited to the collection of appropriate illustrative material. There again, however, the Mediterranean illustrations, which cannot exactly be said to be in the 'portolan' style either, were to be largely ignored in later Ottoman chronicles, in favour of bird's-eye views.

Maṭrākçı Naṣūḥ was, therefore, one of several representatives of a tendency in sixteenth-century Ottoman illustrations towards realism, rather than the prime influence in its development. More influential was the Safavid portraiture which reached Istanbul in the albums sent by Shah Ṭahmāsp as gifts to Süleyman.[8] However, whereas the annals of Süleyman's reign like the *Süleymānnāme* (no. 45), Aḥmed Ferīdūn Beg's account of the Szigetvár campaign (no. 46a) and even vol. II of Loḳmān's *Hünernāme* (TKS H. 1524) made for Murad III take care to show Süleyman both in youth and old age in consistent fashion, except for the depiction of Barbarossa received in audience (no. 45c), which seems to be after Nīgārī's portrait of him, we cannot assume that other viziers or even the Şehzades are portraits. So, somewhat as with the development of works of topographical illustration, we might say that Ottoman court painting under Süleyman and his successors evolved in spite of, rather than because of, these important preoccupations.

An equally important source of Ottoman interest in topography was guides to shrines and the Holy Places of Islam, a literature which comes to the fore in the fifteenth century in Egypt[9] and in Herat.[10] Scrolls attesting pilgrimage by proxy to the Hijaz (the Ottoman sultans were rarely in a position, even as Guardians of the Holy Places, to make the pilgrimage in person, and their pious foundations and restoration works at Mecca and Medina were doubtless compensation for their failure to go there in person), grandly written and properly witnessed, are known by the twelfth century; no more than a century later they are illustrated with the stations of the pilgrimage, relics of the Prophet and the major shrines of Mecca, Medina and Jerusalem. That issued for the late Şehzade Mehmed, dated 951/1544–5 (no. 36), is almost identical with a scroll issued in 836/1432–3 for Amīna (or Maymūna) bint Muḥammad b. ʿAbd Allāh al-Zardalī (British Library Add. 27566),[11] and the stencilled inscriptions and waxed grounds of each suggest that they were mass-produced documents which would, of course, have circulated widely in Islam.

These scrolls became the basis of the illustrations of one of the most popular works of piety of the sixteenth century by the Persian poet Muḥyī Lārī, the *Futūḥ al-Ḥaramayn* (no. 37), on the stations of the pilgrimage to Mecca and Medina, Shīʿī in tenor but no less popular in Turkey – to which most of the illustrated copies extant are attributed – than in Safavid Iran. Apart from the finest copy (British Library, Or. 3633) dated 14 Ramaḍān 951/29 November 1544, illustrated in tones of blue, green and gold, they even follow the colour scheme of these scrolls. In the *Mecmūʿa-i Menāzil* the views of the Shīʿī shrines of Najaf (ff. 64b–5a) and Kerbela (ff. 62b–3a) are stylistically so similar to the shrines of Mecca and Medina on such pilgrimage scrolls that they must be adapted from one for the Ḥaramayn which was to hand.[12] Once again there is little detectable influence from these documents on the illustrated annals of Süleyman's reign, but they add a further dimension to the preoccupation with topography which gives painting of the period such a distinctive appearance.

It is remarkable how much the culture of Süleyman's reign owed to officials who were not from the *medrese*-trained ʿilmiye but soldiers like Naṣūḥ, sailors like Haydar Reis or even corsairs, like Pīrī Reis, whose work was indeed largely inspired by European models – sea charts and portolans or *isolarii*. Pīrī Reis's career as a cartographer,[13] which began with a world map (dated 1513) dedicated to Selim I in Egypt in 1517 (no. 39), continued after a further visit to Egypt in the fleet of Ibrahim Paşa in 1525 with the *Kitāb-i Baḥrīye* (no. 40) presented to Süleyman in 932/1525–6, and apparently came to an end with a second world map presented to him in 1528. Pīrī Reis then evidently returned to naval duties. In 1552 in command of the Suez fleet he captured Muscat and besieged Hurmuz, the principal Portuguese factory on the Gulf, but on his return to Egypt he was believed to have abandoned his command and was tried and executed.[14] His successor in the command was Seydī ʿAlī Reis, the author of one of the most important travel books of the sixteenth century, the *Mir'atü'l-Memālik*, as well as a work on the Indian Ocean, the *Muḥīṭ*, with an important section on the use of instruments in navigation, but no illustrated copy is known.[15]

Although Pīrī Reis's presentation copies to Sultans were appropriately illustrated, their importance for book illustration was less than for Ottoman science and navigation. The 1513 world map, of which only the western half survives, is an adaptation of maps, he claims, of various types, and, indeed, has great historical interest, being partly based on a lost map of Columbus, which must, however, have been obsolete by the time he drew it up.[16] The result is not in the Muslim[17] tradition of cartography like al-Istakhrī's maps, which were

still being copied in the late sixteenth century, but follows the Catalan cartographers,[18] who by 1400 were producing highly decorative maps with illustrations of an orientalising type, after European or Near Eastern books of Marvels of the East. By 1500 these also must have been thoroughly old-fashioned, since sixteenth-century Spanish maps like their Italian counterparts concentrate on proper cartographical matters. Pīrī Reis's *Kitāb-i Baḥrīye*, a practical manual of navigation which was repeatedly copied in the sixteenth century, is, on the other hand, in the appropriate style of north Italian portolans or *isolarii*, although it is not a copy of them, and his autobiographical commentary upon it has unique value both as an account of the Ottoman transformation of the corsairs of the sixteenth century into naval commanders and of contemporary Ottoman geographical knowledge of Europe.[19] We should not expect his work to influence court painting to any great extent, however: maps, like siege plans and harbour charts, in Ottoman Turkey (as in the Spain of the Catholic Kings, who took careful precautions to restrict the circulation of maps based on discoveries in the New World) circulated much more by espionage and spoils of war than they did by publication. Pīrī Reis's work is, thus, the tip of an iceberg of strategic material kept in the Admiralty, the Arsenal or the Grand Vizier's office which was later dispersed or discarded as it became obsolete.

Like the perfect murder, successful espionage or contraband should be undetectable and so far the relations between Istanbul and Venice, the main European map market, are difficult to trace. There is, for example, in the Library of the Topkapı Saray (H. 644) an atlas dated Ṣafar 975/August–September 1567 signed by a certain ʿAlī Macār Reis, to judge from internal evidence partly based on Italian maps drawn before 1542, although it also contains a *mappa mundi* of a type first recorded from Tommaso Porcacchi in 1572. Soucek[20] suggests that it was the work of an expert Italian draughtsman who left the charts blank so that 'ʿAlī Macār Reis' could fill them in, add his own commentary, and evidently decorate it for presentation to Selim II or a high official. Even more significant, however, is a Venetian forgery, a world map of the Onophrius group (first edition 1536), attributed on the title page (dated 967/1559–60) in dubious Arabic to 'Ḥācı Aḥmed'[21] (most probably Michele Membre, the Turkish dragoman of the Signoria of the time), with effusive dedications to both Süleyman and Shah Ṭahmāsp. It reached the Venetian censorship in 1568, when the Ottoman siege of Cyprus was imminent and war fever was rampant, and the blocks were then confiscated from the publisher Marc' Antonio Giustinian. If the forgery was thought worthwhile in the first place on an official level, the demand for contraband maps must have been very considerable indeed.

The large plan view of Lepanto (no. 49) illustrating works there by Kasim Paşa, *vālī* of the Morea in 1540, appears to be much more decorative than explanatory, and for siege plans

sketches made by an Ottoman engineer, a renegade or a prisoner of war must often have been perfectly adequate. Certainly from 1530 onwards, however, Venetian and other European publishers turned themselves to editions of fortress plans, like that of Tunis, which seems to have been in circulation within months of Charles V's capture of it in 1535. Official objections on strategic grounds were, doubtless, overcome by concentrating on Ottoman fortresses or on fortresses which had fallen into enemy hands, like the plans of Szigetvár which fell to Selim II in 1566, which circulated widely and were bound up into Venetian or Roman atlases of the Lafreri type. These were to have considerable effect on illustrated chronicles for Murad III in the 1580s, but a page (no. 46b) in the *Nüzhet esrār al-aḫbār* of Aḥmed Ferīdūn Beg includes a bird's-eye view of Szigetvár which is little more than a coloured-up version of a print by the Venetian draughtsman Domenico Zenoi (or Zenoni), published in 1567.[22] It is interesting, however, that although Mehmed II had asked Gentile Bellini to draw a plan of Venice for him as long ago as 1479–80,[23] and despite the importance of the bird's-eye view of Venice by Jacopo de' Barbari (c. 1500), which had such an effect on European views of Istanbul, too, they only appear to have become popular under Murad III.

In some contrast to the evident originality of these tendencies of painting in the reign of Süleyman is the illustration of poetry, in which genre scenes in an Istanbul or Edirne style which had become established by 1500 or so, with landscapes and rather eclectic architectural forms, seem to have been persistent. To some extent these account for the mysteriously Europeanising appearance of architecture in the *Süleymānnāme* of ʿĀrifī (no. 45). Somewhat curiously, despite the booty of manuscripts and of craftsmen brought back to Istanbul by Selim I after Çaldıran late in 1514 and gifts also brought by the deposed ruler of Herat, Badīʿ al-Zamān Mīrzā, on his visit to Istanbul in the same year, Ottoman illustration of poetry for much of Süleyman's reign is much more directly related to Herati painting than to the court style of Safavid Tabriz.[24] Some painters can be traced via a partial inventory of booty from the Heşt Bihişt palace at Tabriz into palace registers/*mevācib* defters of the early part of Süleyman's reign when most of them appear to have spent a period at Amasya on the way.[25] With the exception of Şāhḳulı we have very little idea of what they could do, but if they were employed on the illustration of poetical works made for Süleyman in the 1530s (e.g. nos 34, 35), the result suggests that few, if any, can have been of the calibre of Shah Ṭahmāsp's own painters who worked on the finest pages of his *Shāhnāme*. This is a clear indication that the customary conscription of local craftsmen practised by the Ottomans was, like loot, a very haphazard method of collecting quality. It is, however, also possible that, just as ʿĀrifī's Persian text for his *Süleymānnāme* was not the high Persian of the Safavid court but a language more to the taste of the Ottoman sultans,[26] so its illustrations, though

somewhat crude and barbaric to high Safavid taste, indicate deliberate selection on Süleyman's part, rather than the unsuccessful efforts of second-rate painters to achieve the effects of Shah Ṭahmāsp's court style. Some evidence that it was, indeed, a matter of taste, not accident, is the neglect of the great albums from Tabriz, sent as gifts to Süleyman, like that made for the Safavid Prince Bahrām Mīrzā in 1544 by Dūst Muḥammad (TKS H. 2154) or an even more spectacular folio album made for Shah Ṭahmāsp (IUK F. 1422) – or, indeed, his *Shāhnāme*, which evidently reached Istanbul in 1567 among the gifts for Selim II's accession: to judge from their lack of effect, they were simply placed in the palace library and forgotten.

Some of the first illustrated manuscripts to arouse Süleyman's interest in the 1520s were of the works of the famous Eastern Turkish poet and vizier, ʿAlī Shīr Nevāʾī (nos 33, 35), mostly written in Herat and partly illuminated there in the late fifteenth and early sixteenth centuries, but carried off by the Safavid Shah Ismāʿīl to Tabriz in 1510, where genre scenes of high quality, also often Herati in style, were added to them. Although the Eastern Turkish dialect (Çağatay) must have given the Ottoman reader some difficulty, the Ottomans were highly conscious of their Central Asian cultural heritage, and this, doubtless, explains their importance in Süleyman's library.[27] Not all were complete and further illustrations and illuminations were added in Istanbul. The works of Persian poets, notably Jāmī, were also illustrated in a similar style.

Süleyman, to judge by the manuscript of the *Selīmnāme* (no. 41), which was probably made in the 1520s for him, was from the first conscious of his dynastic position. This work is a panegyric history of his father's reign. The illustrations are devoted first to Selim I's imperial qualities and briefly cover the events of his youth, notably his defeat of his stepbrothers, the death of Bayazid II, his enthronement and the final battle with his stepbrother, Sultan Ahmed. The later illustrations are devoted to his campaigns against the Kızılbaş and the Turcoman rulers of Eastern Anatolia; his reception of the Timurid prince, Badīʿ al-Zamān Mīrzā from Herat at Istanbul in 1514; the campaign of 1516–17 which resulted in the conquest of Syria and Egypt; the defeat of the Hijazi Bedouin; and, finally, the suppression of a Celali uprising by his general, ʿAlī b. Şehsuvār. The illustrious subject and the fact that the manuscript was for Süleyman explain why neither in the text nor in the illustrations he gained his sobriquet of Yavuz ('the Grim').

Further evidence of Süleyman's filial piety is a manuscript of his father's Persian verse, the *Dīvān-i Selīmī* (no. 32a–b), which in its illuminations, at least, is markedly Tabrizi, particularly in its juxtaposition of spiral scrollwork on one page and a quasi-landscape of trees on the other. It is very comparable to a manuscript of the *Dīvān-i Ḥiṭāʾī* in the British Library (Add. 11388), the poems of Selim's great enemy Shah Ismāʿīl, who, ironically, wrote in Turkish.

Dorothea Duda[28] has published a manuscript of the *dīvān* of Amīr Shāhī Āqamalik al-Sabzavārī, a fifteenth-century Herat court poet and a favourite poet of Selim, with illuminations (though not illustrations) in the same hand. The craftsman's name, ʿAbd al-Ghanī, appears in a register of Süleyman's court craftsmen of 952/1545–6. The lacquered binding showing Ottoman figures (possibly Selim I himself) in a landscape has similarly mannered treatment of the trees and must also be his work: he may, thus, have been a specialist in lacquer decoration, and it is not, therefore, surprising that, among those who offer gifts on the Bayrām of that year, he is recorded as having offered a decorated fan (*bir münakkaş yelpāze*).

Although its purposes were much grander and the enterprise much more ambitious, it was basically in this verse tradition that the *Süleymānnāme* (no. 45) of ʿArifī, who had entered Süleyman's service as court chronicler or *şehnameci* shortly before the arrival of the Safavid refugee Alqās Mīrzā from Tabriz in 1547, was illustrated.[29] Since it was a dynastic monument as well as a literary exercise, bold innovation would have been inappropriate. This matches ʿArifī's rather cautious approach in the text to some of the more controversial events of Süleyman's reign, like the disgrace of Ibrahim Paşa and the execution of Şehzade Mustafa: ʿArifī, an outsider and an émigré, was writing under the disadvantage that his patron was alive and only too likely to be offended by lack of delicacy. The idea of an illustrated annals was, indeed, one of the great innovations of Süleyman's reign, but the illustration of historical literature was left to be fully exploited under Murad III, when lapse of time made it possible to present Süleyman's deeds as a whole, albeit with some prevarication, and acknowledge indebtedness to sources, both pictorial and literary, without embarrassment.

No less than the Safavid and Mughal courts the Ottomans patronised albums, of calligraphy and paintings or drawings, which were regularly compiled for the sultans for presentation on the great feasts of the Muslim year, or on accessions, triumphal returns from campaigns and circumcisions. Since they were largely compilations of whatever there was to hand, their contents were somewhat variable in quality, and, particularly in the later sixteenth and seventeenth centuries, owing to a lack of suitable material the studio seems occasionally to have had to cannibalise earlier albums. An important part of their attraction lay in their illumination, the tasteful mounting on decorated papers of miscellaneous material – portrait studies, genre scenes or abstract ornament – to give a luxuriously balanced effect.

One of the finest of these albums, in a binding of tortoiseshell plaques set over metal foil, datable probably to *c*. 1560 and most probably made for presentation to Süleyman (no. 53), is formed round calligraphy by the famous Safavid calligrapher Shāh Maḥmūd al-Naysābūrī from Nishapur, with two facing *nastaʿlīq* versions of the Fātiḥa, the opening chapter of the Koran (no. 53b) set in exquisite illumination.[30] Further

pages of calligraphy are equally carefully balanced in pairs with matching mounts and illumination, and the album also contains a number of virtuoso calligraphic studies in Safavid style. It is completed by a series of studies of foliage and monsters and an unsigned spring garden of cut paper set under talc of a type attributed by Muṣṭafā ʿĀlī in his *Menākib-i Hünerverān* to the Bursa paper-cut artist, Faḫrī. The pictorial contents are very similar to those of an album in Vienna (Nationalbibliothek, Cod. mixt. 313) made for Murad III (1574–95)[31] a year before his accession, although the quality is not quite so high and suggests that the example set by the Shāh Maḥmūd album was too difficult to follow.

The line drawings in such albums (nos 50-3), of peris, dragons and other chinoiserie monsters and fantastic foliage, are a peculiarly Ottoman treatment of a Timurid and Safavid genre which filled the great albums of Herat, Baghdad and Tabriz painting in the Topkapı Saray Library (H. 2152–3, 2160). These must have arrived in Istanbul between 1473 and 1535 but remained neglected on the library shelves. The court style of Süleyman's reign was moulded by a Tabrizi or Baghdadi Şāhḳulı (actually rather a common Safavid name), whose name first occurs in the list of craftsmen conscripted from Tabriz in 1514, when he is listed as having offered a volume of decorated illustrated stories, a piece of decorated mother-of-pearl and 'an adornment of the night' (meaning unclear),[32] and in palace registers from 1525 onwards. He probably died in 1556. Of disagreeable character – he is said to have circulated bad Persian verses under the Şehnameci, ʿĀrifī's name, in order to discredit him in Süleyman's esteem[33] – he was, to judge from the drawings attributed to him, a virtuoso in the *ṣāz* style, in which stylised chinoiserie lotuses are worked up with feathery leaves into heavily modelled, intricately interlacing compositions, sometimes animate in appearance, even when they do not contain monstrous heads or animals, and compositions of dragons in foliage or of peris as well.[34]

Chinoiserie motifs and feathery leaves were standard Ottoman decorative motifs but, unlike their occurrences on tilework and for textile patterns (no. 106), which may or may not have been from prepared stencils, these drawings by Şāhḳulı and his pupils or colleagues were not designs. On the contrary, they are worked-up versions of stencils or other designs; their brilliant line and minute detail could never have been reproduced in other media with any exactitude; and practically none of them lend themselves to repeating designs. We must conclude that if those in the present Catalogue (nos 50-3) inspired anything at all it must have been a matter of chance.

NOTES

1. For almost a year (Fleischer 1986, 110–11). In his *Nuṣhatü'l-Selāṭīn* ʿAlī cites the excessive wages paid to the twenty calligraphers, gilders and painters employed on the work as a waste of public funds and accuses the gold-beaters of embezzling the gold foil assigned to the atelier.
2. Tanındı 1984.
3. Yurdaydın 1976.
4. Or 133, a compilation largely magical in purpose. There was, therefore, little need for realism.
5. Mazzariol and Pignatti 1963; Schulz 1978, 425–74.
6. Cf. the later sixteenth-century compendia of city views published by Braun and Hogenberg between 1575 and 1615.
7. Paris, Bibliothèque Nationale, MS Latin 8957, evidently autograph, illustrated in Dorez 1901.
8. Notably in the album made for the Safavid prince, Bahrām Mīrzā in 1544 (TKS H. 2154).
9. Notably Ibn al-Zayyāt's *al-Kawākib al-ṣayyāra* and al-Maqrīzī's *Khiṭaṭ* I–II (Būlāq, 1856). Cf. Rāġib 1973, 259–80.
10. Muʿīn al-Dīn Muḥammad al-Isfizārī, *Rawḍat al-jannat fī awṣāf madīnat Herāt*, ed. Sayyid Muḥammad Kāzim I–II (Tehran, 1338–9 solar/1959–60). Gaudefroy-Demombynes 1923, 315–20.
11. Ettinghausen 1934, 111–37; Tanındı, *Sanat Dünyamız* (1983), 2–6; id., *Journal of Turkish Studies* 1983, 407–37.
12. A later scroll, however, demonstrating the existence of such a tradition for Najaf and Kerbela, is in the private collection of Shaykh Nasir al-Sabah of Kuwait: we are grateful to Shaykha Hussa for having drawn our attention to it.
13. 'Pîrî Reis', *IA*.
14. Orhonlu 1970, 235–54
15. Kahle 1956b, 266–77.
16. Kahle 1956a, 247–65.
17. 'Kharīṭa', *EI²*.
18. Winter 1954, 1–12; Campbell 1987.
19. Soucek 1973, 241–55.
20. Soucek 1971, 17–27.
21. Ménage 1958, 291–34.
22. London, British Library, Lafreri atlas I, pl. 53, with a smaller format parallel in the Camocio atlas (British Library, Maps C. b. 41), pl. 79.
23. Angiolello, *Historia Turchesca*, cited Thuasne 1888, 67: 'Volse [il Sultano] che glie facesse [Gentile] Venetia in disegno'.
24. Çağman 1978, 231–59.
25. TKSA D. 10734; Uzunçarşılı 1986, 23–76.
26. Sohrweide 1970, 263–302.
27. Bartol'd 1964, 199–260.
28. Duda 1978–9, 61–78.
29. Woodhead 1983, 157–82. Fleischer (1986, 30, n. 46) observes that, despite the generally held belief that ʿĀrifī arrived in Istanbul in Alqās Mīrzā's suite in 1547, he appears already in a palace expenditure register of Şaʿbān 952/October 1545 as drawing a stipend (BBA Maliyeden Müdevver 17881). He was, however, certainly close to Alqās, who appointed him his Nişancı, or Chancellor.
30. Interestingly, the versions are not identical, and the phrase *mālik yawm al-dīn* appears on the right-hand page as *malik*, a divergence sanctioned in Koranic practice though in the later centuries of Islam invariably indicated by an *alif* above the line. The absence of an *alif* here makes it something of a solecism to be decried by a strict Muslim. The explanation must be that the fame of the calligrapher, or the skill of the illuminator, diverted attention and blame from the actual text.
31. Duda 1983.
32. TKSA D. 10734, 3b: *siyar-i münakkaş-i muṣavver* 1; *ṣadafkārī-i münakkaş* 1; *zayn-i liyāl* 2.
33. Sohrweide 1970, no. 26.
34. Mahir 1986, 113–30.

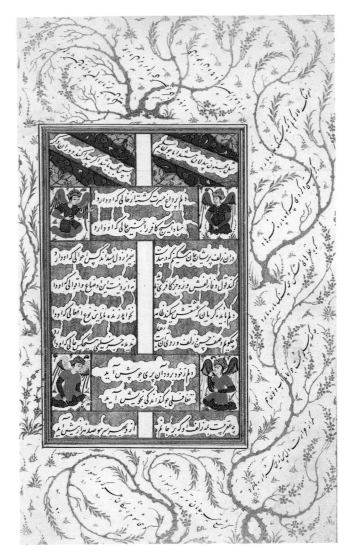

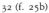
32 (f. 25b)

32a–b *Dīvān-i Selīmī*

Poems of Selim I, 87 folios, Persian, with up to 11 lines *nasta'līq* in 2 columns per page, most pages also with oblique lines of *nasta'līq* in all margins, rather thick paper. Catchwords related not to the marginalia but to the horizontal lines

Colophon undated, signed (f. 87a) '... *akall mamālik al-ḫāḳāniyya Şehsuvār al-Selīmī*' and the seal of Selim I or II. (Şehsuvār was evidently a slave; if, however, he was one of the craftsmen taken from Tabriz to Istanbul in 1514, his name does not appear in the register of craftsmen conscripted from Tabriz after Çaldıran dated 12 Receb 920/2 September 1514 (TKSA D. 10734))

1520–30

Page 19.5 × 11.7 cm

IUK F. 1330

Literature: Istanbul 1983, E. 56; Titley 1978, 292–6; Washington 1987, no. 28a–b

ff. 1b–2a Double-page illumination with gold *abrī* for the verses, margins with gold stencilling of lotus, blossoms and feathery leaves. On subsequent pages the verses are separated by inset couplets, sometimes (but not always) invoking the poet Selīmī or Selim with polychrome vignettes at the sides of peris conversing, mostly seated, in profile or in half profile, for example, ff. 25b–6a. Some margins have illumination of gnarled or leafless prunus, pomegranates or willow-trees, the branches alternating with fine lines of oblique *nasta'līq*.

ff. 5b–6a Double-page illumination with margins of monkeys in trees with a phoenix, a fox, leopards and a rabbit in the background. From f. 61a onwards the polychrome peri vignettes are replaced by monkeys, foxes, gazelles and *bixie* in gold.

The manuscript has two double-page illustrations with illuminated borders and dull gold margins. Folios 27b–8a show Selim riding and reading in his library attended by pages. Behind him are sets of shelves with small tulips in green or blue and white pots, evidently Chinese, although the shapes also include *Humpen*.

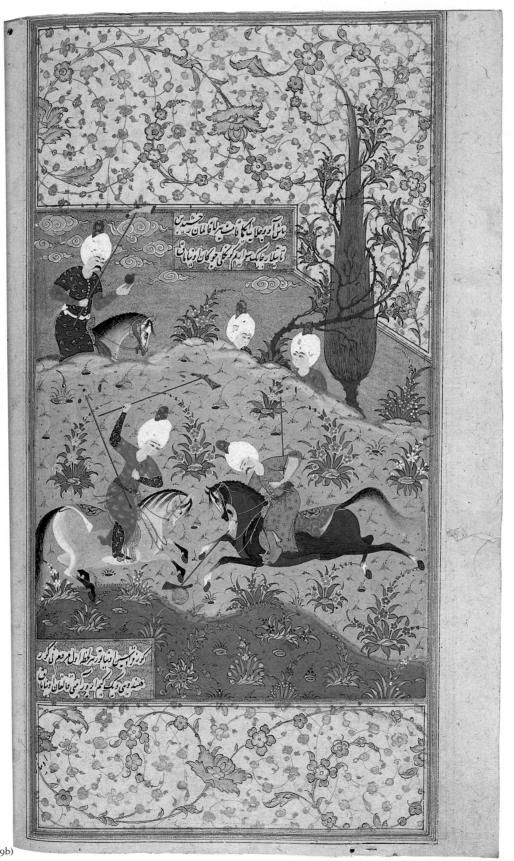

33 (f. 89b)

33 Dīvān-i Nevā'ī

ʿAlī Shīr Nevā'ī, Eastern Turkish (Çağatay)

214 folios, *nastaʿlīq*, 17 lines to the page in two columns, with gold or gold-
powdered *abrī* and with scroll margins, partly stencilled, 8 miniatures of
genre scenes in Tabriz court style, fine illuminated frontispiece and
headpieces

Original stamped, gilt lacquered leather binding with lacquered *doublures* of
feathery leaf scrolls and flying peris

Tabriz-Istanbul, *c.* 1530–40

TKS R. 804

26.5 × 17 cm

Literature: Karatay, *Türkçe Yazmalar*, no. 2293; Sohrweide 1970, 263–302;
Atasoy and Çağman 1974, pl. 4; Istanbul 1983, E. 58; Tanındı 1984, figs
9–10; Washington 1987, no. 29

The treatment of the figures and the landscapes is exception-
ally close to Safavid court art, and in many respects recalls
paintings in the now dispersed 'Houghton' *Shāhnāme* made for
Shah Ṭahmāsp, *c.*1530, which, however, evidently only
reached Istanbul in 1567 as an accession present for Selim II
(1566–74). The scrolling ornament of the marginal illumi-
nations is also characteristic of Persian illumination of the
period 1520–50 with spiral blossom scrolls and undulating
lotuses. More typical of Istanbul taste, however, may be the
treatment of the two different scrolls in which the contrasting
movement gives life and depth to the composition (for
example, f. 89b).

Folio 89b shows a polo match.

34 Shāhnāme of Firdawsī

With Preface, 575 folios, Persian *nastaʿlīq*, up to 25 lines per page. 57
illustrations

f. 575a bears Süleyman's own seal

Original stamped black leather binding, with cartouche borders, central
medallion with pendants and elaborately lobed corner-pieces, filled with
finely embossed Timurid lotus scroll; filigree or inlaid *doublures* filled with
arabesque foliate panels of green, turquoise, black and gold on contrasting
grounds

c. 1520–30

35 × 24.5 cm

TKS H. 1499

Literature: Karatay, *Farsça Yazmalar*, no. 341; Atıl 1980, pl. 18; Washington
1987, no. 32

ff. 1b–2a and 10b–11a Double page illuminations with peris'
faces in panels.

f. 9a Large illuminated medallion, uncompleted dedication
with axial pendants, and peris' faces on stalks inside.

ff. 9b–10a Double page of a sultan enthroned alfresco and a
hunt on stippled dark green ground, with gold sky.

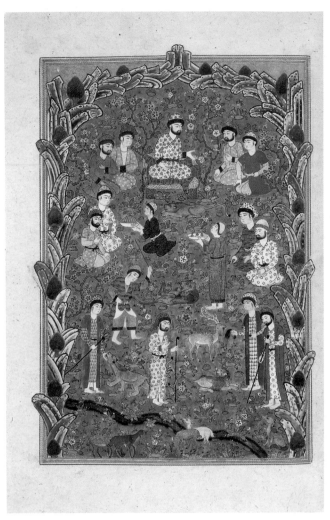

34 (f. 14a)

f. 14a The first ruler Gayūmarth with his viziers clad in wild
animal skins.

The rather naïve style of the illustrations is much indebted to
late fifteenth-century Turcoman Shiraz and Tabriz painting,
although often with gold skies or landscapes: the characteristic
animated rocks of Tabriz painting appear only once in a scene
of Rustam grilling meat (f. 303a), although with a cloud
shown as a coiled dragon for good measure. In fact, the
painters must have thought they were still working for a
Safavid patron, for some figures are shown with the charac-
teristic Safavid red bonnet (*tāc*) which has then had to be
crudely erased.

35a–b *Khamsa* of Mīr ʿAlī Shīr Nevāʾī

Ḥayretüʾl-Abrār, Ferhād-ū Şīrīn, Mecnūn-ū Leylā, Sabʿa sayyāra and *Iskendernāme*
309 folios, *nastaʿlīq*, 23 lines per page in 4 columns, 16 illustrations
Colophon (f. 309b) copied by Pīr Aḥmad b. Iskandar and the date (in figures)
 937/1530–1
Page 18.5 × 29.5 cm
TKS H. 802
Literature: Karatay, *Türkçe Yazmalar*, no. 2299; Atasoy and Çağman 1974, pl.
 3; Grube 1961, figs 14–16; Tanındı 1984, fig. 18; Washington 1987,
 no. 33a–b

The headings are in gold, in *naskhī*, and are up to 6 lines long, but they appear to be in Çağatay, as is the text, and cannot have been easy for the Ottoman reader.

The original lacquer binding is on black leather, with cloud-scroll borders, black on gold, and a field of swirling stems of fantastic lotuses, composite rosettes and feathery leaves impaling them, springing from a leafy tuft, in red, black and gold on black. The lower half of the design is strictly symmetrical but looser than similar patterns on tilework or textiles. The *doublures* are of stamped red leather, with feathery leaf scrolls and lotuses embossed in red.

f. 99a Capture of Ferhād by Hüsrev from *Ferhād-ū Şīrīn*.

35a (binding)

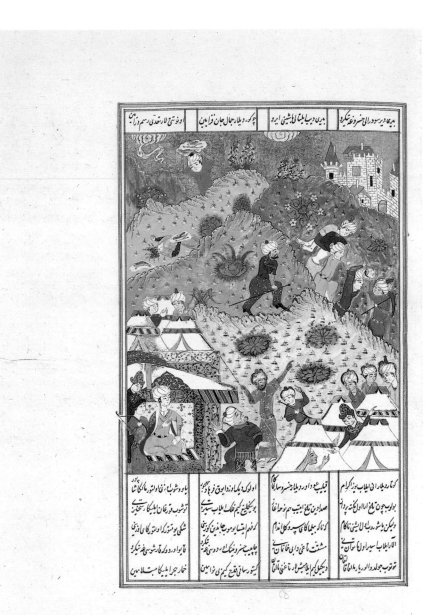

35b (f. 99a)

36 Pilgrimage scroll

Attestation of pilgrimage by proxy (*Hac Vekāletnāmesi*), scroll, heavy paper,
gold and polychrome gouache on waxed grounds, with *nasta'līq* indications
of the sites and monuments (in Ottoman), and with stencilled borders and
horizontal bands of *hadīth* and Koranic verses relating to the *hajj* in
accomplished *thulth*, with many letters written over or above the *ductus*

951/1544–5

TKS H. 1812

524 × 46 cm

Literature: Ettinghausen 1934; Karatay, *Türkçe Yazmalar*, no. 668; Tanındı
 1983; Washington 1987, no. 23

The scroll is arranged as a series of panels showing the
principal stations of the pilgrimage at Mecca, all stencilled
evidently; the shrine at Medina, showing the late fifteenth-
century restorations of the Mamluk Sultan Qāyt Bāy; and the
monuments of the Ḥaram al-Sharīf at Jerusalem, but with the
octagonal Dome of the Rock shown improperly as a ten-sided
structure, and the Prophet's sandals. The first part of the
scroll, with the heading and including the depiction of the
Kaʿba, is missing, and only a few monuments of the Ḥaram at
Mecca survive.

At the end is a short text, dated 951/1544–5, in Ottoman
by three Murshids of the Ḥaram at Mecca – Khusraw, ʿAlī and
Muṣṭafā – and an emir, ʿAlī b. Muḥammad b. Ḥusayn b. ʿAbd
Allāh, in which the Kātib al-ḥurūf Muḥammad Abu'l-Faḍl al-
Sinjārī states that Ḥājjī Pīrī b. Sayyid Aḥmad has made the
hajj by proxy for the late Sultan Muḥammad (that is, Şehzade

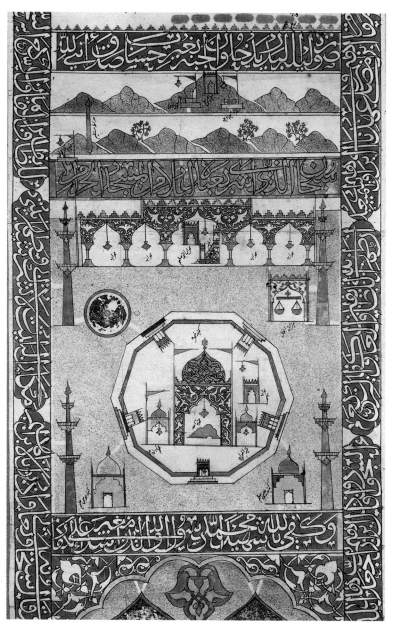

36

The Ḥaram-al Sharīf at Jerusalem

Mehmed, d. 1543) and that he has fulfilled completely the appropriate duties and rites.

The sites and monuments depicted show up some interesting omissions from no. 37, the *Futūḥ al-Ḥaramayn* manuscript (R. 917), including the sandals of Muḥammad, the Ḥaram at Jerusalem, and Süleyman's works there and at Mecca and Medina.

37 *Futūḥ al-Ḥaramayn*

Mistitled *Esrārü'l-Hac*, by Muḥyī Lārī

58 folios, *nastaʿlīq*, 12 lines to the page in 2 columns, laid paper, illuminated
 opening f. 1b; 13 illustrations of the stations of the pilgrimage

Original stamped red leather binding, with central medallion, pendants and
 concave corner-pieces embossed with foliate scrolls, red on gold

c. 1540–50

Page 22.2 × 14.8 cm

TKS R. 917

Literature: Ettinghausen 1934; Karatay, *Farsça Yazmalar*, no. 772; Tanındı
 1983; Washington 1987, no. 22

f. 14a The Ḥaram at Mecca with the outer arcades and the six minarets turning inwards and the inner arcades turning outwards. The various monuments are shown in profile, and the arcade by the Kaʿba indicating the direction of *ṭawwāf* is shown almost in bird's-eye view. All the arcades, the minarets and some of the buildings too are shown with hanging lamps, in gold and gouache on a waxed ground.

The text, wrongly attributed on the flyleaf to Jāmī, is by Muḥyī Lārī (d. 933/1526–7) who dedicated it in 1506 to the Sultan of Gujārāt: it is a general description of the stations and the rites of the pilgrimage, together with the customs and sacrifices etc., somewhat Shīʿī in tone.

There is a second copy in the Topkapı Saray library (R. 916, Karatay, *Farsça Yazmalar*, no. 771), properly attributed and, though colophonless, probably sixteenth century in date. It is, however, padded out with verses by Ibn Yamīn (d. 745/1344–5), and although it has more illustrations, better labelled in the case of Mecca and Medina, these are artless and more fanciful.

38 Horace, *Odes, Ars poetica, Epistles*; Juvenal, *Satires*; Persius, *Satires*

Parchment, 234 folios, rounded Humanist script, illuminated at Florence
 between 1450 and 1470, from the library of Matthias Corvinus at Buda

25 × 16.5 cm

British Library, Lansdowne MS 836

Literature: Kovachich 1798; Kropf 1896, 1–8; Csapodi and Csapodi-Gárdonyi
 1978, no. 69 and pl. XXIII; Schallaburg 1982, no. 394

The volume bears a note that it was brought back from Istanbul (*c.* 1555–7) by Antonius Verantius (Vrančić), Bishop of Pécs (Fünfkirchen), who was a prominent figure in Habsburg diplomacy relating to Hungary in the later years of Süleyman's reign.

The title page (f. 3a) of the Horace is decorated with plain white foliated scrolls with a golden bar in Florentine style

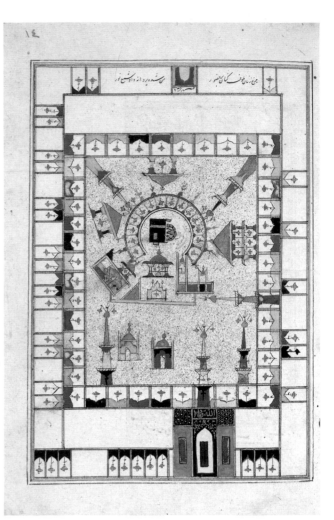

37 (f. 14a)

running through them. Below is a central laurel wreath held by two putti containing the arms of Matthias Corvinus painted over a now indecipherable coat of arms by his 'first heraldic painter'. Opposite (f. 2b) is an unauthenticated half-length portrait of Matthias.

By the 1550s the libraries of Istanbul had acquired a legendary reputation as a repository of the authors of Classical Antiquity which had somehow survived the fall of Byzantium in 1453. It is difficult to see how far this was based on fact, since the palace libraries were inaccessible to visitors, but as a result many European ambassadors brought express instructions to collect whatever manuscripts they could and frequently had scholars attached to their delegations to search them out and appraise them (cf. Charrière 1848–60, I, 440; Busbecq, *Letters*, 242–3). Manuscripts from the Corviniana cannot have been on the open market and were presumably solicited by diplomats like Bishop Verantius/Vrančić as part of the presents customarily given by the Sultan to an envoy on his parting audience.

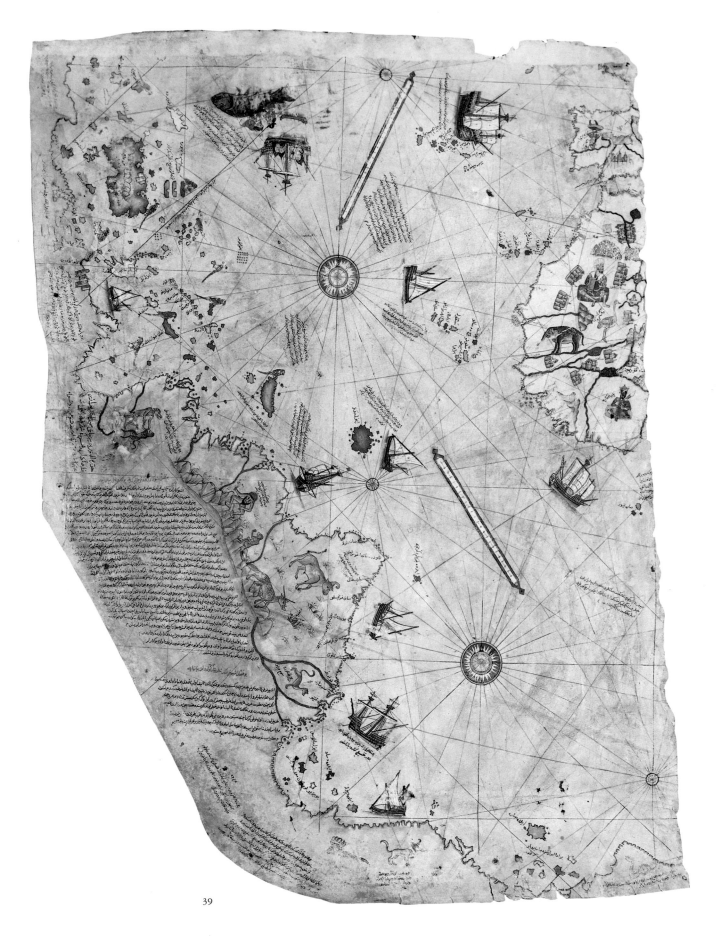

39

39 World map

Section showing the east coast of the Americas, the Atlantic, the tip of the
 Iberian peninsula, the Straits of Gibraltar and the west coast of Africa, with
 scale bars and a graticule of rhumb-lines, numerous figures of ships (mainly
 Portuguese) and fantastic creatures
Ink and gouache on parchment, signed (middle left) Pīr b. Ḥācī Meḥmed,
 'famous as the nephew of Kemāl Reis [=Aḥmed b. Meḥmed al-Ḳaramānī]',
 at Gelibolu (Gallipoli) in Muḥarram 919/March–April 1513 and presented
 by Pīrī Reis to Selim I in Egypt in 1517
90 × 63 cm
TKS R. 1633 (*mük*)
Literature: Akçura 1935; Adıvar 1970, 58, etc.; Kahle 1933; Winter 1954;
 Karatay, *Türkçe Yazmalar*, no. 1408; Istanbul 1983, E. 73; Campbell
 1987; Washington 1987, no. 35

The lavish commentary in Ottoman Turkish contains numer-
ous references to Portugal, which would have figured large on
an Ottoman map of this time because of concern at the
concentration of the spice trade in Portuguese hands.

Among the numerous sources, some pretentious, which Pīrī
Reis claims to have consulted for his map, were four
Portuguese maps and a Spanish slave who had sailed with
Columbus on his three voyages to the New World, a matter of
some historical importance since no surviving Columbus maps
are recorded. Columbus himself seems not to have drawn any
map of his first voyage, but the map of the second was
presented to the Catholic Kings before his departure on his
third voyage. The map from the third voyage unquestionably
existed in several copies, but their circulation was carefully
restricted by the Spanish. The map became obsolete so rapidly,
in view of his successors' discoveries, that there can have been
little point in preserving it. Its survival in the form of Pīrī
Reis's map is ironic, since the New World was one of the few
directions in which the Ottoman empire seems to have had no
inclination at all to expand.

The pictorial sources for the decoration may include the
fantastic creatures of the *ʿAjāʾib al-Makhlūqāt* ('The Wonders
of Creation') or European books of marvels, but another
important source was the floridly decorative charts generally,
though not exclusively, associated with Catalan chart-makers,
many of whom worked in Majorca and who also included long
written explanations to accompany them. There is even a map
of this type, datable *c.* 1375, in the Topkapı Saray collection,
and to this tradition can be attributed vignettes like the boat
with monks in Armenian habits (at the top, upside down),
identified as St Brendan and his companions on their voyage to
the Isles of the Blessed. It should be said, of course, that the
illustrations to late fourteenth-century charts of the Catalan
type are markedly orientalising in style and subject-matter, and
even suggest the painting of contemporary Jalayirid Baghdad.

The Columbus map Pīrī Reis used may well have been,
Kahle considers, that taken by Columbus on his second voyage
of 1498 and by which he set his course, although without the
corrections to the map he had taken on his first voyage, which
contained several ghost islands. These appear on the Pīrī Reis
map with parrots on them, a device which Columbus evidently

used to distinguish them from the islands as he discovered
them: Haiti/Cipango is the only real island on this map on
which a parrot is shown.

The other half of the map, showing China and the Indies, in
which Selim I had a definite interest, is missing, quite
probably because it was the basis for charts for the Ottoman
naval actions in the Indian Ocean in Süleyman's reign and
either wore out or was lost at sea.

40 *Kitāb-i Baḥrīye*

Pīrī Reis, Ottoman Turkish, text worked up in verse by the poet Murādī
421 folios, fair *naskhī*, 15 lines to the page with careful *ḥaraka*. Illuminated
 headpiece and chapter headings in gold. There is a list of maps or plans
Verse colophon dedicated to Süleyman (f. 420a), dated 932/1525–6, final
 couplet giving the versifier as Murādī and chronogram giving 932. (Murādī
 also seems to be the author of the *Ġazavāt-i Ḥayreddīn Paşa*, recounting the
 naval exploits of Barbarossa, sometimes attributed to Sinan Çavuş)
Original stamped leather binding with marbled paper *doublures*
Page 31.7 × 22 cm
TKS H. 642
Literature: Karatay, *Türkçe Yazmalar*, no. 1336, and refs; Yurdaydın 1963;
 Akalay 1969; Soucek 1973; Washington 1987, no. 36

The text contains 215 coloured plates, in wash, black line and
gold, with shallows and sandbanks dotted in red, showing safe
harbours, sources of water, fortresses, inhabited villages and

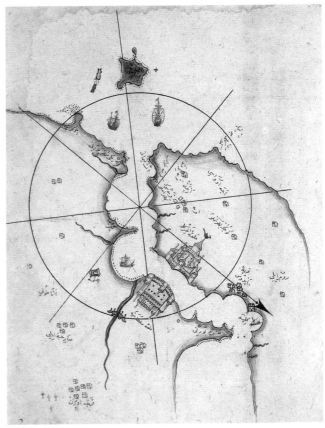

40 (f.44a)

sometimes ancient ruins too. The series starts (ff. 44a, 47a) with the Dardenelles fortresses, *Ḳaľe-i Sultānīye–Kilīdü'l-Baḥr*, and then moves north-west showing islands and fortresses in the Aegean, the Mediterranean, the Adriatic, and in Apulia (Pūlya); Malta; Genoa and the Ligurian coast, the Riviera and Spanish coasts, past Barcelona to Gibraltar (Jabal Fatḥ). The charts then turn back along the African coast to Algiers, Tunis and Alexandria, with a detour up the Nile to Cairo, going up the coast of Palestine and Syria and returning along the southern Turkish coast and Cyprus up to the Dardanelles again.

Pīrī Reis's notes to the plates make it clear that he was writing from personal experience; and, for example, Cyprus (f. 381b), which did not fall into Ottoman hands until the reign of Selim II, and Venice, of which he can only have known at second hand, are much less detailed and realistic than, for example, his survey of the mouths of the Nile, Būlāq, Cairo and Giza (ff. 350b–52a). The plates of the *Kitāb-i Baḥrīye* are, however, not his invention but an adaption of earlier Venetian *isolarii* ('island books'), notably that of Bartolomeo dalli Sonetti/Bartolomeo Turco (Venice, 1485), in their depiction of buildings and land and sea masses as well as following the use of wind roses with an arrow to give north (cf. Skelton 1966, Introduction). Unlike maps and fortress plans

which were strategic material and often only procurable by espionage or violence, these *isolarii* were standard naval manuals for mariners in the Mediterranean.

41 *Selīmnāme*

A versified account in Turkish of the conquests of Selim I (1512–20), from his struggle for the accession and the death of Bayazid II up to his own death and the accession of Süleyman the Magnificent, Şükrī Bidlīsī

277 folios, Ottoman Turkish, *nastaʿlīq*, 11 lines in 2 columns to the page, with 24 miniatures

Binding originally of black lacquer with gold and blue scrolls in counterpoint, stamped medallion, and corner-pieces stamped with embossed lotus scrolls in blue and black on gold; no flap; *doublures* of reddish leather with central medallions and corner-pieces in dull blue with black, filigree-like scrolls

*c.*1525

Page 26 × 18 cm

TKS H. 1597–8

Literature: Karatay, *Türkçe Yazmalar*, no. 639; Çağman 1978, fig. 20; Tanındı 1984; Washington 1987, no. 37

f. 1a The surviving half of a double-page frontispiece shows three figures in a tent, identified as the writer, the scribe and the illustrator of the *Selīmnāme*, a form of the medieval or antique author-portrait.

f. 113a Selim I confronting the Safavids at the battle of Çaldıran (1514).

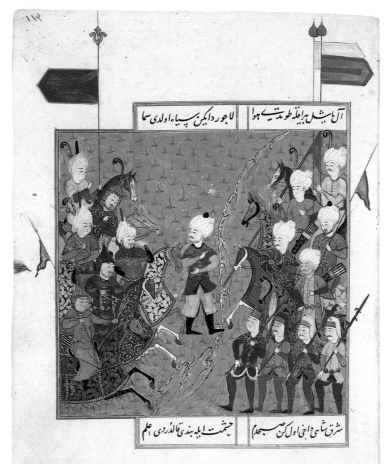

41 (f. 113a)

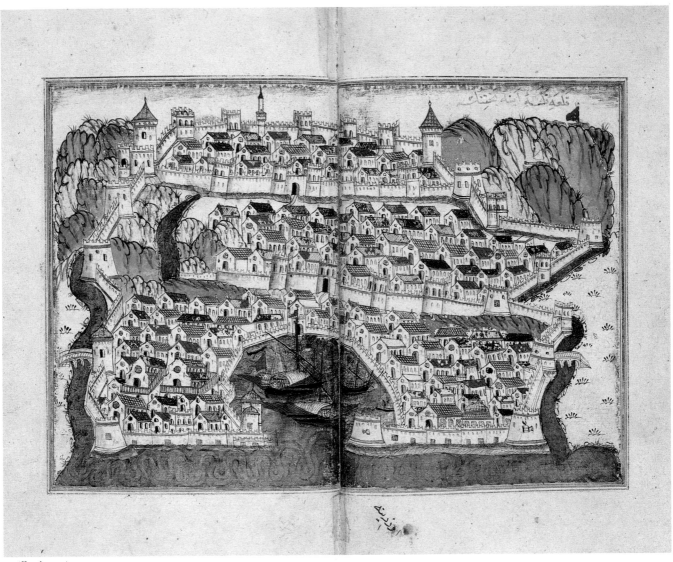

42 (ff. 21b–22a)

42 *Tārīḫ-i Sulṭān Bāyazīd*

Maṭrākçi Naṣūḥ, 82 folios, Ottoman Turkish text with Persian headings,
forward-sloping *naskhī*, 13 lines to the page, with some *ḥaraka* in black
ink, illuminated heading (f. 1b), 10 illustrations, laid paper with numerous
Italian watermarks of *c.* 1530

Absence of colophon and initial *basmala* suggests that it is a section of a
continuous text

Original stamped and gilt brown leather binding, with concave corner-pieces,
medallions and pendants, embossed with cloud scrolls and feathery leaves

Page 26.9 × 18 cm

TKS R. 1272

Literature: Karatay, *Türkçe Yazmalar*, no. 624; Akalay 1969; Yurdaydın 1976;
Çağman and Tanındı 1986, pls 145–6; Washington 1987, no. 38

The illustrations are of Bayazid II's naval campaigns in the
Black Sea and the eastern Mediterranean in the late fifteenth
century, including the capture of the key Venetian fortresses of
Coron and Modon. Folios 21b–22a are a double-page view of
Lepanto/Inebahtı (captured 905/1499–1500). The total ab-
sence of illustrations from the latter part of the volume, on a
whiter paper in a different hand with full *ḥaraka* closer to that
of the Hungarian section of H. 1608 (no. 44), suggests the
take-over of a single source, possibly a portolan or *isolario* for
the less elaborate views, but possibly an early Venetian or
Roman atlas for the rest.

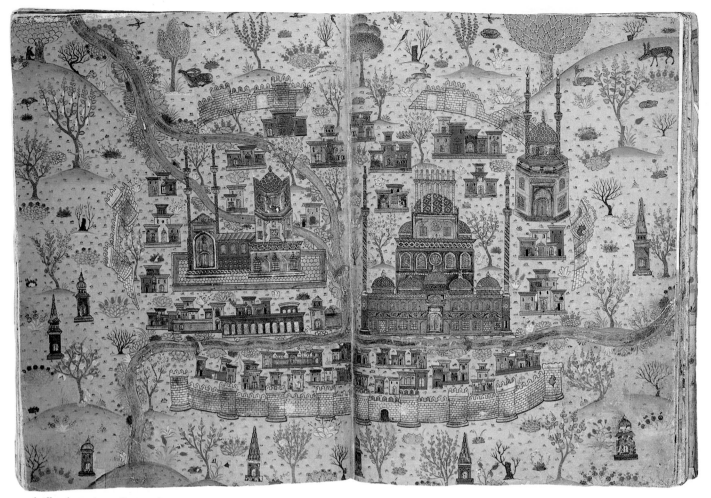

43b (ff. 32b–33a): 43a illustrated on p. 37

43a–b *Mecmū͑a-i Menāzil*

Otherwise known as *Beyān-i Menāzil-i Sefer-i ͑Irāķeyn-i Sulṭān Süleymān Ḫān*, an account of Süleyman's campaign in Iraq and north-west Iran in 1534–5, by Naṣūḥ al-Silāḥī al-Maṭrāķī (Maṭrāķçı Naṣūḥ)

109 folios, ruled panels of 17 lines of rather carefully pointed *naskhī*, heavy whitish paper with various watermarks. Amateurishly illuminated headpiece (f. 1b) with titles

Colophon dated 944/1537–8, now lost

31.5 × 23.5 cm

IUK T. 5964

Literature: Taeschner 1956; Flemming 1968, 168; Yurdaydın 1976; Istanbul 1983, E. 74; Washington 1987, no. 39a–b

130 pages are painted, some of them being double-page spreads but several depicting two or more sites, entirely without human figures, and almost all in thick, heavy rather dull colours, with a tendency for the white to blacken, with gold sparingly used, but some silver used for water. The pages are cut down so that the illustrations have practically no margins.

At some point the volume was wrongly rebound and folios were lost or misplaced. Substantial sections, particularly for the later stages of Süleyman's return, have no illustrations at all, and may, indeed, never have been illustrated. The correct order has been established by reference to the account of the campaign in Ferīdūn's *Münşeātü'l-Selāṭīn* and to a recently discovered unillustrated work by Naṣūḥ on Süleyman's Persian campaign of 955-6/1548–9 (Marburg Staatsbibliothek Hs. Or. Oct. 955), which he evidently also envisaged in illustrated form (Yurdaydın 1976, 173).

The treatment of the ground, trees, birds and animals, rocks and architecture, not to mention differences in colour schemes, use of gold, etc., make it very clear that several painters were involved, some of them of mediocre abilities. Yurdaydın has pointed out (1976, pp. XVII, XXII) that the numerous dictation errors in the text virtually preclude the possibility that it was Naṣūḥ who wrote it. Nor is there any evidence that he did any of the paintings himself.

The styles are noticeably unindebted to contemporary Safavid Iran, but show concern for natural history (birds and animals), as well as topography, and include some intriguing, inexplicable details like a minaret at Baghdad (f. 47b) inside the walls with a millstone tied just below the balcony, and peculiar 'umbrellas' in sockets and a third empty socket outside the citadel of Aleppo (f. 105b).

ff. 8b–9a Istanbul-Galata.

ff. 32b–3a View of Sultaniye, double-page illustration.

44 *Tārīḫ-i fetḥ-i Şikloş ve Usṭūrġūn ve Usṭunībelgirād*

Maṭrākçi Naṣūḥ, 146 folios, good, sloping *naskhī*, 13 lines to the page, black ink in ruled margins with gold punctuation and black, red and gold for emphasis, 32 illustrations

No colophon, but note on flyleaf (f. 1a) gives the scribe as Muḥammad *ḥāfiẓ al-Kur'ān al-mashhūr bi-Ṣarfzāde*

ff. 145–6, both a and b, are portolan or *isolario* fragments

*c.*1545
page 26 × 17.5 cm
TKS H. 1608
Literature: Karatay, *Türkçe Yazmalar*, no. 667; Deny-Laroche 1969; Istanbul 1983, E. 72; Washington 1987, no. 40

The work is an account of Süleyman's campaign in Hungary in 1543 and of Barbarossa's Mediterranean campaign of 1543–4. The record of stages in the European campaign has large blanks, evidently for illustrations which were never undertaken. Those which were are bird's-eye views neatly drawn, showing towns, bridges, castles, wells and encampments, some with a gold ground.

The remaining illustrations are of Mediterranean ports temporarily occupied or sacked by Barbarossa's fleet, mostly from the sea, but with details of architecture and fortifications showing familiarity with them and possibly therefore by a renegade siege engineer or prisoner of war. The style is hybrid with schematic landscapes somewhat similar to work in the *Mecmū'a-i Menāzil* (no. 43), but with townscapes with considerable cross-hatched detail suggesting that European topographical prints may have been adapted for this purpose. An autograph manuscript of Jérôme Maurand d'Antibes's voyage to Istanbul in 1544 (Paris, Bibliothèque Nationale Lat. 8957) contains numerous sketches of Italian ports, Eastern Mediterranean islands and fortresses and views of Istanbul, either in the Italian *isolario* tradition or in a somewhat similar style to the Naṣūḥ illustrations here. He may or may not have been the source, but one of his companions on their voyage could well have been.

ff. 32b–3a Genoa.

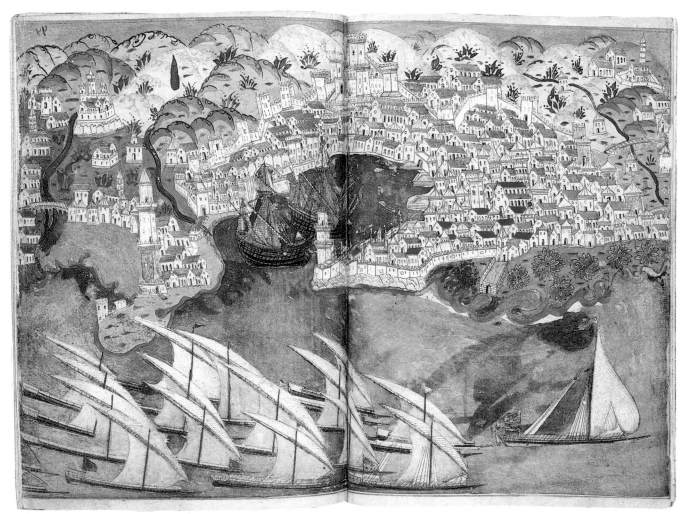

44 (ff. 32b–33a)

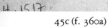

45c (f. 360a)

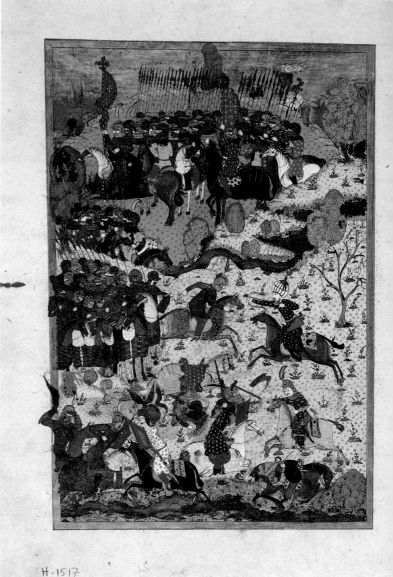

45b (ff. 219b–220a); see also cover

45a–d *Süleymānnāme*

ʿĀrifī, 617 folios, Persian *nastaʿlīq*, 15 lines to the page, in four columns in
 ruled panels of finely gold-powdered whitish paper, 69 illustrations,
 including 4 double-page spreads

Colophon (f. 617b) states that the work was completed by ʿAlī b. Amīr Beg
 Şīrvānī in mid-Ramaḍān 965/early July 1558; illuminated titles and panels

Black leather binding with central medallion, pendants and corner-pieces of
 gold-embossed feathery leaf scrolls rising from a single tufted base; *doublures*
 of warm brown leather with medallions, pendants and concave corner-
 pieces, all similarly embossed with cloud scrolls

Page 37 × 25.6 cm

TKS H. 1517

Literature: Karatay, *Farsça Yazmalar*, no. 160; Sohrweide 1971; Istanbul
 1983, E. 70–1; Atıl 1986; Çağman and Tanındı 1986, pls 152–4;
 Washington 1987, no. 41a

ff. 1b–2a have medallions containing the genealogy of Süley-
man back to Ertoğrul on gold leaf on a dense spiral scrolling
ground in gold and blue with carmine accents.

ff. 2b–3a Double-page frontispiece with panels of *nastaʿlīq* in

2 columns. Basically, but for the *nastaʿlīq* script, a larger
version of the frontispiece of Y.Y. 999 (cf. no. 15a).

45a (ff. 108b–109a) Süleyman before Belgrade in flames,
double-page illustration.

45b (ff. 219b–220a) The battle of Mohács, double-page
illustration.

45c (f. 360a) Süleyman, receiving his admiral Barbarossa,
Hayreddin Paşa.

45d (f. 367a) Süleyman arriving at Qaṣr-i Shīrīn in Iraq.

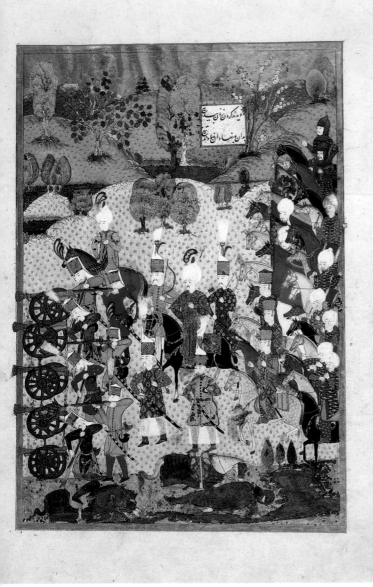

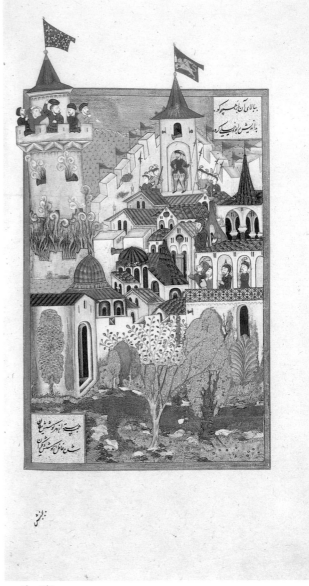

45a (f. 108b)

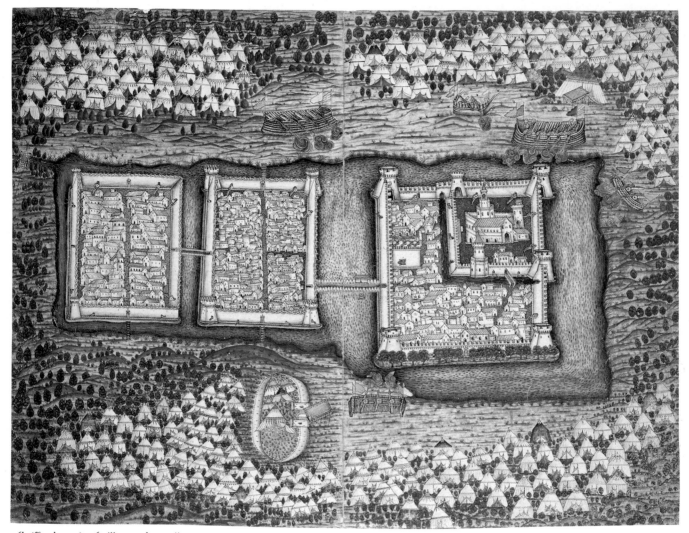

46b (ff. 32b–33a); 46a illustrated on p. ii

46a–b *Nüzḥet esrār al-aḫbār der sefer-i Sigetvār*

Aḥmed Ferīdūn Beg, 305 folios, fine *ṇaskhī,* 15 lines to the page in 4 columns

Illuminated opening page (f. 1b). Headings in gold with summaries of chapters given generally with full *ḥaraka,* 20 illustrations, some in the style of Nakkaş ʿOsmān

Colophon (f. 305a) dated 13 Receb 976/2 January 1569. Folios beyond that are ruled but left blank

Modern binding

Page 39 × 25 cm

TKS H. 1339

Literature: Karatay, *Türkçe Yazmalar*, no. 692; Istanbul 1983, E. 172; Washington 1987, no. 42a–b, and refs; cf. British Library Maps C. 22a.3, Lafreri atlas, pl. 53, by Domenico Zenoi 1567; Camocio atlas (Maps C. B. 41), pl. 79

The illustrations are in a simpler and grander style than those of the *Süleymānnāme* of 1558 (no. 45). They cover the death of Süleyman, the capture of Szigetvár by Sokollu Mehmed Paşa, Selim II's accession, and his triumphant return to Edirne to receive the congratulations of ambassadors. There are no fewer than three views of Szigetvár, that on ff. 32b–33a (no. 46b) without margins, being a coloured version of Venetian bird's-eye views of the fortress by Venetian draughtsmen like Domenico Zenoi or Zenoni, published within months of its capture. No. 46a (f. 16b) shows Süleyman receiving John Sigismund ('Stephen') Zápolya his vassal in Transylvania.

47 Brass dish

By Nicolò Rugina of Corfu, perhaps made in Corfu or Venice, c. 1540–60
DIAM. 43.4 cm
BM, MLA 1855.12–1.3
Literature: Ralph Bernal Collection sale catalogue, Christie's, 5 March–
30 April 1855, lot 1227

The surface of the dish, which is gilt, with silvered details, is engraved front and back with concentric bands of decoration. On the front are five bands articulated with staggered architectural columns: (1) in the centre, a shield of arms: *a fess impaling a bend fusilly* beneath a sideways helm; (2) interlace with panels representing Justice, Temperance, and Fortitude; (3) interlace and scrolling foliage incorporating ovals showing the Judgement of Paris, the Three Fates, and three Classical deities (?); (4) on the sides, interlace and scrolling foliage; (5) on the rim, interlace and scrolling foliage incorporating hunting scenes, birds, romping figures and monstrous heads; in ovals, scenes representing the heroism of Mucius Scaevola, the sacrifice of Iphigeneia (?), and an unidentified temple scene.

On the reverse are five bands: (1) in the centre, a shield of arms: *a dexter and a sinister arm jointly holding a halberd, in base bendy of six*; on a scroll the signature .NICOLO.RVGINA.; (2) a band of scrolling foliage; (3) a continuous bird's-eye view of Corfu, with the tents of the Turkish encampment opposite the twin-castled fortress; galleys and sailing ships at sea; (4) on the sides, a band of scrolling foliage; (5) on the rim, the Triumph of Caesar: Caesar on a chariot, preceded by captive kings, soldiers with banners and models of captive towns, a chariot with booty, a unicorn, elephants, musicians, oxen, and the Coliseum in Rome.

One of the most strategically and commercially important islands in the Venetian Empire was Corfu, and the strengthening of the island's defences was a preoccupation of the Venetians throughout the sixteenth century (Concina 1986). In 1537 hostilities flared up between Süleyman and the Venetian Republic. Süleyman moved his encampment to Butrinto, on the mainland opposite Corfu, and the Ottoman admiral known as Barbarossa invaded the island with a large force. The fortress of Corfu, however, defended by a garrison of Venetian and Corfiote soldiers, stood firm; after thirteen days the Turks abandoned the siege, but left the island devastated. Corfu remained a Venetian stronghold until the Venetian Republic was dissolved by Napoleon in 1797. There are accounts of the siege of Corfu from the Corfiote point of view by the eye-witness Noukios Nikander (Nicandre de Corcyre

47 front

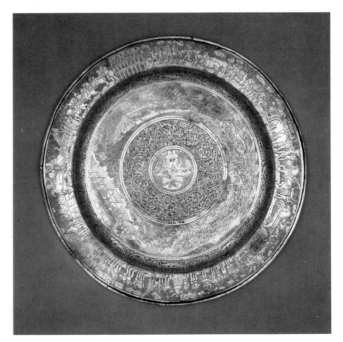

47 reverse

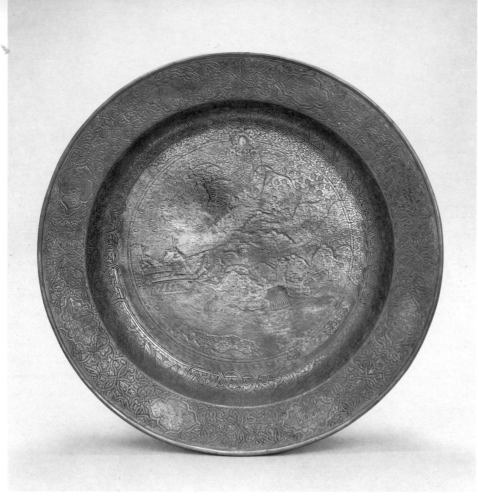

48

1962, book 3, chs 83–6) and the historian Andrea Marmora (1672, book 6).

The dish juxtaposes the siege of Corfu with Classical images of triumph and heroic virtue. The Triumph of Caesar is derived from woodcuts by Jacobus Argoratensis, for which see Massing 1977, 42–52.

The specific references to Corfu on this dish and no. 48 (cf. a dish with a scene of Corfu sold at Sotheby's, Zurich, 27 November 1980, lot 96) suggest a particular association of work in this style with Corfu; but little is known of Nicolò Rugina. The only other recorded signed work is a dish with arabesques in the Österreichisches Museum für angewandte Kunst, Vienna, inv. G0.81, illustrated by R. Lightbown (1981, tav. 331, 332). It is signed NICOLO.RVGINA GRECO.DA CORFV FECCE. 1550. In the centre is a shield of arms incorporating a bend sinister fusilly, recalling the arms on the British Museum dish. It has been suggested (Thieme-Becker, s.v. Rugina) that he is identical with a 'Nicolo Greco orpellaro' recorded in Papal inventories as working in Rome in 1542. The documents cited (Frey 1909, 148; Bertolotti 1884, 50) leave this identification open to doubt. His signed works seem transitional between the so-called 'Veneto-Saracenic' metalwork made by Islamic craftsmen in the fifteenth and early sixteenth centuries (most of this now seems unlikely to have been made, as once thought, in Venice; see Huth 1970, 58–68) and the unequivocally Italian Renaissance style of Orazio Fortezza of Sebenico. T.H.W.

48 Brass dish

Venice or Venetian empire, possibly Corfu, c. 1540–70
DIAM. 42.3 cm
Private collection
Literature: Catalogue of the Special Exhibition of Works of Art of the Mediaeval, Renaissance and more recent periods on loan at the South Kensington Museum, June 1862, London 1863, no. 6596 (the property of R. Curzon, Jun.); Exhibition of Works of Art, Arms and Armour, Howard Ricketts Ltd, London 1972, no. 10

This dish is engraved on the front: (a) in the centre, a map/bird's-eye view of part of the island of Corfu during the siege of 1537; on the left is the fortress flying Venetian flags; to the right, separated from the fortress by a canal, is the town of Corfu with part of the coast; at the bottom, Turkish galleys entering harbour; at the top, a defaced shield of arms; (b) on the sides, interlace and continuations of the central scene, two showing countryside, and two showing Turkish tents, one of them with three cannon; (c) on the rim, interlace incorporating dogs hunting birds and rabbits; the inset panels showing Turkish and Christian soldiers apparently represent incidents during the siege of Corfu. On the reverse are some engraved doodles. The engraving is worn.

For a list of comparable printed maps of Corfu see Tooley 1939, 25. The Corfiote connection has suggested an attribution to Rugina, but the style seems distinct from no. 47. Some of the vignettes on the rim, such as the flooding caused by a cloudburst, and sorties by the defenders catching the Turks off guard, correspond to incidents described by Nikander; others do not obviously do so. T.H.W.

49 Plan of the fortress of Lepanto

Opaque pigments on stout paper

Undated, but the state of the fortifications, which reflect works carried out by
Kasim Paşa, Vali of the Morea in 1540, but evidently predate certain
monuments described by Evliya Çelebi, suggests that it may have been
executed *c.* 1550

57.5 × 75.5 cm

TKS 17/348

Literature: Istanbul 1983, E. 75; Washington 1987, no. 44

From left to right The fortifications at the mouth of the gulf have
walls and towers attributed to Ḳāsim Beg: there are houses
outside the fortifications. Outside the moated fortress are
suburbs (*maḥalle*) of single-storeyed brick dwellings. The
fortress is in five tiers rising from the Arsenal guarded by
towers and with a chain across it with walls and a landing-
stage (*iskele*), and linked on both sides to the land by wooden
bridges. To the right of the Arsenal are more houses, a
caravanserai with chimneys, an aqueduct and a series of water-
mills (*āsiyāb*) attributed to Muṣṭafā Paşa.

The lowest tier of the fortress contains a double bath and
fountains, each with an outflow channel evidently supplied
from the waterworks outside the walls. In the next enceinte
above is a mosque with *mehterler* inscribed on a tower,
evidently the janissary bandstand. The fifth tier is the cliff
behind the fortress but enclosed within the defensive walls.

By the later sixteenth century these plan-views of fortresses
were evidently a standard genre. Esin Atıl (Washington 1987,
97, n. 90) notes that there is a plan-view of Belgrade in the
Topkapı Saray collections. J.-L. Bacqué-Grammont has pub-
lished a seventeenth-century plan-view of the fortress of Van,
and a list of furniture of the royal box in the mosque of Sultan
Ahmed in Istanbul (Barkan 1972–9, no. 580) includes a
picture (*taṣvīr-i ḳalʿa-yi Eğri*) of the Hungarian fortress of
Eger/Erlau.

The interest in representing and labelling watercourses,
however, recalls the plans and maps of the waterworks of
Süleymaniye in Istanbul, one known in two copies dated 1584
(Istanbul, Fatih, Millet Kütüphanesi 1291/2352; TKS H. (gift
of Nuri Arlasez), and an earlier two-page illustration in the
Chester Beatty *Süleymānnāme* of 987/1579–80 (Ms 413 H.
22b–3a). Cf. Çeçen 1986.

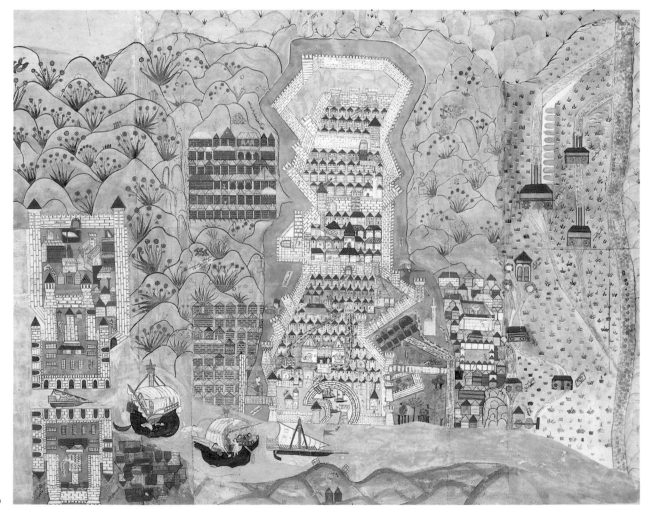

49

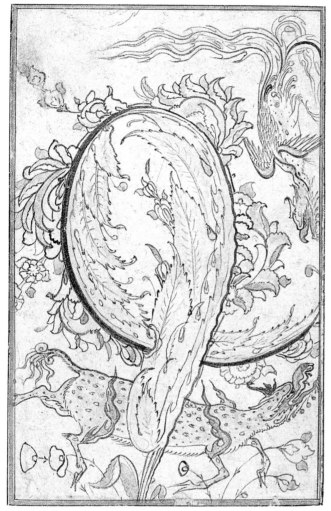

50a (f. 21a)

50b (f. 22b)

50a–d Album leaves

From an album of 32 folios, with paintings and drawings, including
calligraphic specimens by (f. 5b) Dervīş Ḥasan, dated 1004/1595–6, and
cut-outs (ff. 11a, 22a) by Faḫrī Burūsevī and (f. 12b) Dervīş ʿAbdī, 1021/
1612–13. This gives a terminus for the compilation of the album in the
reign of Ahmed I

Later 16th century

Page 30.2 × 20.5 cm

TKS H. 2147

Literature: Grube 1961b; Grube 1969; Denny 1983; Washington 1987, no.
45a–d

50a (f. 21a) Phoenix attacking a *qilin* with a coiled *ṣāz* leaf
between. The theme recurs in the tiles on the front of the
Sünnet Odası, which themselves seem to repeat a textile
copied by Jacopo Bellini (cf. Degenhardt-Schmitt 1984).
Brush drawing, black and gold ink and coloured wash on
paper.

50b (f. 22b) *Ṣāz* spray in black and gold on paper finely
sprinkled with gold. Two of the three leaves are broken or bent
back, one of them poking through a hole in the third. The
minute details are ingeniously used to set off the border line.
Brush drawing, black and gold ink and coloured wash on
paper.

50c (f. 23a) Large composite lotus, with a further composite
tuft above and serrated *ṣāz* leaves rising from a spiral holder
with smaller *ṣāz* leaves and a further composite tuft. Brush
drawing, black ink on paper, faintly blotched with gold.

50d (f. 32b) Dragon in mortal combat with a lion in swirling
spiral scroll of composite lotus and leaf buds, with broken
serrated, stylised lotus leaves and bristly tailed birds. Black
ink and gold wash on paper.

50d (f.32b)

51 (f.10b)

51 Album leaf

From an album of 43 folios, with ṣāz compositions, ff. 6a, 10b, 15a
(attributed Velīcān); f. 18b, with cranes (attributed Velīcān), birds, figure
studies and animal studies in line or colour. Safavid, Bukhara and Ottoman,
with various attributions to Maḥmūd Mudhahhib, Velīcān and Bihzād
Later 16th century
Page 35.4 × 22.4 cm
TKS H. 2168
Literature: Mahir 1986; Washington 1987, no. 47

f. 10b Collage of ṣāz compositions, line and coloured wash:
1. looping foliage on paper; 2. broken leaf spray on paper;
3. peri in leaf hat, bust rising from ṣāz volutes with small
birds, on gauze. This has been extended, perhaps by the same
hand, into 4. on paper. 1. has also been extended into 3.

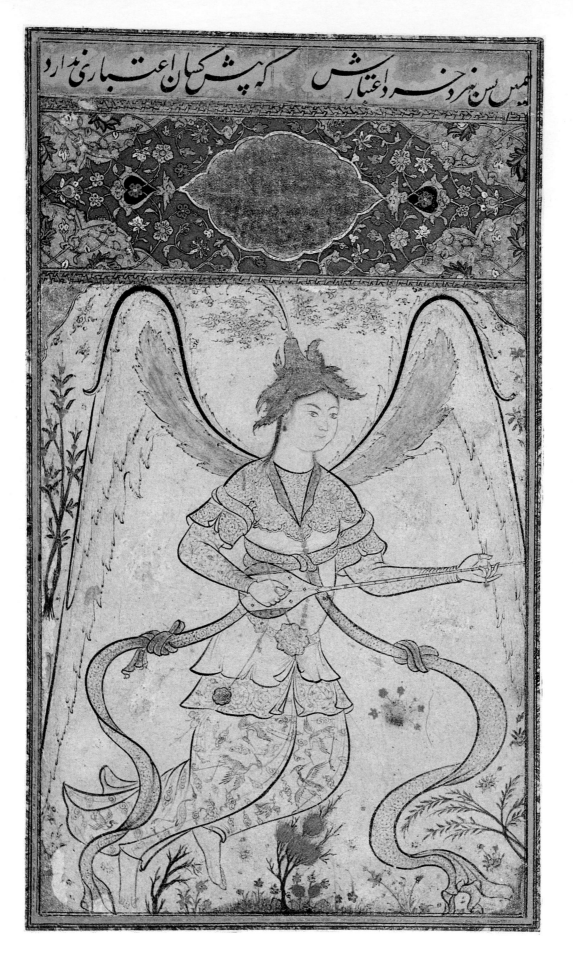

پیش کسان اعتباری ندارد کہ پیش کسان اعتباری ندارد

52a (f. 9a)

116

52a–b Album leaves

From an album of 34 folios, mainly Safavid and Ottoman paintings, arranged
roughly in groups, for example, peris; Isfahan portrait studies; composite
animals; camels and their drivers, etc. Attributions include Bihzād, Mānī
and Velīcān, the first two quite implausible and casting doubt on the third.
Terminus for composition of album seems to be a study of Isfahan type
dated 1082/1671–2

Page 36.2 × 25 cm

TKS H. 2162

Literature: Washington 1987, no. 48 a–b, and refs

f. 8b Peri, with a long trailing knotted stole across her arms
and chest, in black line and wash on whitish-buff laid paper
finely powdered with gold. There are gold details, together
with touches of pink for lips, cheeks and a ruby earring. There
is a bold attribution: *qalam-i Velīcān* (Velīcān worked in
Istanbul in the last decades of the sixteenth century).
18 × 9.1 cm (within margins).

f. 9a Peri, with stringed instrument, in line and wash, with
touches of gold and carmine on buff laid paper. She has a long
trailing knotted stole across her arms and chest with fine scroll-
work as on the collar and sleeves of her tunic and trousers or
skirt, which are minutely decorated with cranes, and cloud

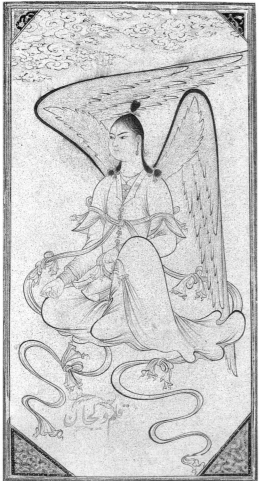

52b (f. 8b)

scrolls, and a lavishly jewelled belt. The coloured florets and
trees suggesting a landscape were doubtless touched in when
the album was made up for presentation. 12.9 × 10 cm
(within margins).

53a–f Album

49 folios, mostly *nastaʿlīq*

c. 1560

Binding 35.5 × 23 cm

IUK F. 1426

Literature: Mahir 1986; Istanbul 1983, E. 63–4; Washington 1987, no. 49a–f

53a The binding is of contrastingly grained sheets of tor-
toiseshell on metal foil with cloisons of silver wire, with
cartouche borders and a central medallion. The *doublures* are of
deep red stamped leather with gilt and embossed *ṣāz* and lotus
scrolls.

The title page reads 'Muraḵḵaʿāt-i Ṣāh Maḥmūd-i Niṣābūrī'
[*sic*]. The central dedication medallion is blank. The opening
flyleaves form a double-page spread on sky-blue paper of *ṣāz*
and lotus-scroll composition, similar to but rather looser than
the caftan (no. 106), in gold and polychrome with conspicuous
cinnabar reds, symmetrical both vertically and horizontally,
giving four repeats to the page. The dimensions of the design
are thus about 16.9 × 11.4 cm, which is a fair approximation
to the proportions of a loom piece of Bursa silk.

ff. 1b–2a Two facing illuminated *shamsas* with long blue
darts, with inlaid panels of appliqué lobed blue corner-pieces.

53b (ff. 2b–3a) Double page of illumination for two panels of
bold *nastaʿlīq*, each with the Fātiḥa in ruled panels, line by
line, with very fine, possibly stencilled, sprigged blossoms,
suggesting illumination by Ḵaramemī (no. 31): f. 2b is signed
ʿabduhu al-faqīr Shāh Maḥmūd al-Nīshābūrī; f. 3a is signed
katabahu al-ʿabd Shāh Maḥmūd. The text on f. 2b has *malik* for
mālik. Above and below are lobed triangular projections with
prunus branches rising from tufts, with pricked gold stems.
Long marginal darts with stylised foliate motifs in blue
alternating with minute red tulips are surrounded by a border
of dense lotus scroll with brighter gold-pricked cloud bands,
both evidently stencilled.

53c,d Subsequent pages of *nastaʿlīq* bear the signatures of
Shāh Maḥmūd in other forms (-i Nīshābūrī, al-Nīshābūrī, al-
Naysābūrī), Sulṭān ʿAlī al-Mashhadī, ʿAlī al-Kātib (dated 946/
1539–40), Sulṭān Muḥammad Nūr, Pīr Muḥammad, ʿAbd al-
Karīm al-Khwārazmī, Mīr ʿAlī, and Shams al-Dīn Muḥam-
mad al-Kirmānī. Practically all are in matching double-page
spreads in single or double columns, inlaid into broad margins
of contrasting colour, and generally with matching illumi-
nated corner-pieces, vignettes of florists' flowers or sprigged or
scrolling grounds. The borders when illuminated also gener-
ally match.

ff. 39b–45b include a series of bold *nasta'līq* practice alphabetic inscriptions in postcard format, with ʿAlī, Ḥasan Ḥusayn, etc., possibly Shīʿī, although these letter combinations are appropriate to Arabic alphabets.

ff. 46a–46b Shīʿī inscription in the form of a roaring lion, with gold and polychrome on blue, cut out and stuck to a panel of pink card. Opposite, brilliant overlapping *thulth*, *tawakkalt bi-maghfır [at] ilayhim: Huwa al-Ghafūr Dhu'l-Raḥīm [sic]*, in black and blue: the letters are illuminated with polychrome flowers, on a gold ground with sumptuous *tashkīl*.

f. 47a Paper-cut (8.8 × 19.6 cm, inside borders), stuck down under talc, of a garden border, including *Lilium candidum* and

L. pomponium, hyacinths, narcissi, iris, carnations, daisies, double roses, single yellow or red roses, cypress, fir, poplar, vines, double peach, double pomegranate, citrus, oleander and jasmine.

53e (f. 47b) *Ṣāz* composition, in ink on paper, with waxed red and blue details. The border is of undulating and symmetrical *ṣāz* scroll. 18.7 × 12.8 cm (including borders).

53f (f. 48a) Dragon in *ṣāz* leaves and flowers, in ink, wash and gold. 12.3 × 19 cm.

In general the composition of the album and its arrangement suggest an even more luxurious and richer version of the Murad III album in Vienna (Nationalbibliothek, cod. mixt. 313).

53a (binding, exterior)

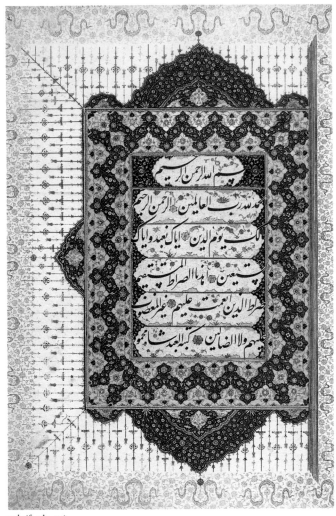

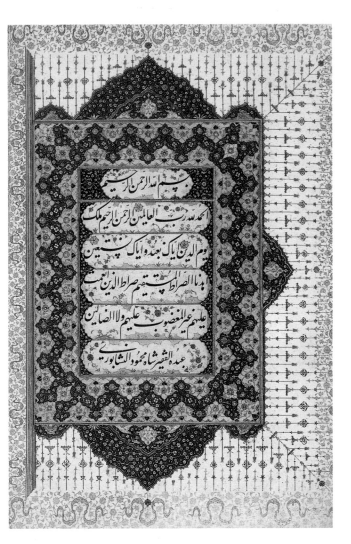

53b (f. 2b–3a)

53f (f. 48a)

53e (f. 47b)

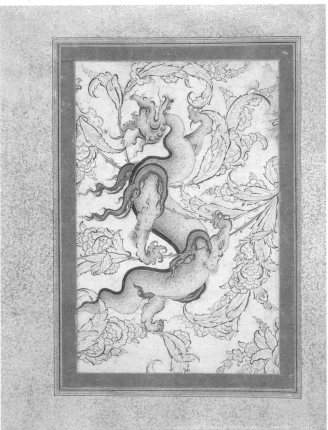

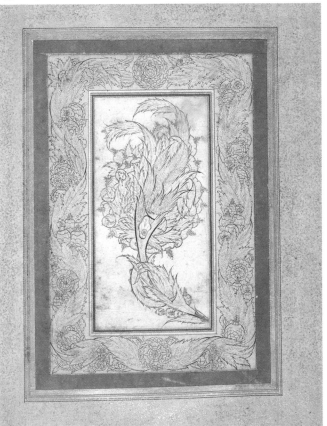

6 The palace craftsmen (nos 54–96)

The first palace scriptorium organised as a unit, with specialised craftsmen working together to make fine manuscripts, appears to be the studio (*khizāna*) of the Timurid ruler Baysunqur at Herat in the 1420s.[1] We do not really know how far this was a model for the organisation of other court craftsmen – armourers, swordsmiths, jewellers and goldsmiths – but in later fifteenth-century Tabriz and under the early Safavids the palace craftsmen were organised into workshops.[2] Some of these craftsmen were probably captured by Mehmed II and taken to Istanbul following his victory in 1473 over the Akkoyunlu ruler Uzūn Ḥasan at Otluk Beli, probably to become the nucleus of palace workshops created by Bayazid II. Giovanni Antonio Menavino, who from 1505 to 1514 was a slave at Bayazid II's court, states that he had seventy jewellers in his employ – masters, sub-masters and apprentices, one group 'Persian' (that is, most probably by style and workmanship) and the other the Sultan's slaves – who were paid a daily wage but were paid in addition for the work they did for the Sultan: their responsibility was to execute all his orders for silver and for goldsmiths' work.[3] This is a fair description of the organisation of the palace workshops under Süleyman, except that Menavino adds that they had their shops, evidently in a closed market, at the centre of Istanbul. They must thus have been like the royal warrant-holders today, first and foremost purveyors to the palace, but conceivably able to take on private commissions, time permitting.

As with other craftsmen there was a strong tendency for crafts to run in families, but jewellers and goldsmiths required exceptional skill and high finish, and considerable capital reserves. Inevitably they were not responsive to sudden increases in court demand. The great economic power of sixteenth-century Istanbul as a consuming centre certainly exercised an attractive force on able craftsmen from the provinces, but the only other solution to labour shortages was conscription (*sürgün*) of foreign craftsmen, along with booty from cities sacked or conquered. Selim I's sack of the citadel of Cairo was followed by deportations of skilled craftsmen[4] to Istanbul (although many of them returned to Egypt a few years later). A short inventory associated with ʿAlī b. Şehsuvār, Selim's general on the Çaldıran campaign (TKSA D. 10734, dated 12 Receb 920/2 September 1514), headed 'Belongings of Shah Ismāʿīl taken from the Heşt Bihişt palace at Tabriz', contains valuable loot, including jades and other hardstones, gems, porcelains, textiles and furs, but also things as valueless as a chest of salt, and is plainly haphazard, in no sense a complete inventory of the palace furnishings. This document also includes a list of craftsmen conscripted and taken off to Istanbul – both court workmen, as well as useless individuals such as an astrologer – and some objects offered by them, which may have been masterpieces, or credentials of their capacities.

The list by crafts (if it was not mere 'impulse buying') shows that the demand for skilled workers was considerably wider than Menavino's report might suggest: damasceners (*zerniṣānān*), goldsmiths, armourers or shield-makers, tailors, marquetry-workers, diamond-cutters (*ḥakkākān*), tentmakers, embroiderers in gold thread (*zerdūzān*), binders, weavers of fine silks (*ābānībāfān*) and a group of decorators and painters, including the head of a Tabrizi workshop, Shāh Manṣūr Tabrīzī. It must, however, be said that the list has the somewhat indiscriminate character of the booty, for the personnel also included flute-players, fiddlers and singers or reciters (*gūyandegān*), sugar-candy-makers (*qannādān*), as well as the astrologer.

There are significant discrepancies between the list of craftsmen and another list of conscripted craftsmen (D. 9784, possibly to be dated *c*. 920, although the evidence for that is so far not forthcoming), which has been published in part;[5] and the *mevācib* defter (or register of palace craftsmen) of Rabīʿ II 932/January–February 1526. In one way this is not surprising, since the craftsmen brought by *sürgün* could have died or retired or returned in the twelve-year interval, or their workshops could have been suppressed. Certain individuals in the 1526 *mevācib* defter, however, are stated there to have been brought from Tabriz by *sürgün* but do not appear in the earlier documents cited above. This shows, at least, that D. 10734 and D. 9784 are probably complementary, and there may, of course, have been other lists as well, drawn up by others of Selim's generals and divisional commanders on the Çaldıran campaign. Alternatively, and more probably, perhaps by oversight some were not listed anywhere.

Many of the Persian craftsmen enrolled seem to have spent a period of time at Amasya, before taking up employment at the Ottoman court. Süleyman does not appear ever to have resided there before his accession, but they may have owed their position in Istanbul to service in his household before he came to the throne. In some cases their sons appear to have accompanied them, although there is little evidence that they moved out of their fathers' craft and they may already have been thoroughly specialised by the time they reached Amasya.

The importance given to goldsmiths and damasceners reflects the indebtedness of Ottoman taste in the earlier sixteenth century to Persian models (e.g. no. 87), but skilled craftsmen were obviously similarly enrolled when Süleyman occupied Buda in 1526, and the palace register[6] of that year, which at first sight is comprehensive, is much more Balkan and Anatolian in complexion.

The 1526 *mevācib* defter contains: (a) armourers and associated crafts – makers of shields, maces, bows, arrows, muskets and swords, scabbard-makers, cannon-founders and miscellaneous ironworkers, steelsmiths and locksmiths; (b) artisans in the sumptuary crafts – painters and decorators, binders, goldsmiths, silver-wire drawers, diamond-cutters, embroiderers, damasceners, inlayers in metal, an amber-worker, marquetry-workers (possibly joiners), workers in

beaten metal, makers of decorative hanging globes (*dimişķīgerān*), lute-makers, carpenters, tile-cutters, mould-makers; (c) cloak-weavers, brocade-weavers, carpet-weavers, furriers, bootmakers and glovers, but although embroiderers are mentioned in (b), no tailors are listed at all; and (d) launderers (thirteen with three apprentices) and surgeons (forty-six with five apprentices), altogether more numerous than all the craftsmen put together. One group is problematic, the inlayers in metal (*kūftçūyān*, cf. Arabic *kaffātīn*), whose work in Mamluk Egypt and Syria, like that of the Azziministi in northern Italy, is documented in hundreds of pieces – but not a single one from Ottoman Turkey. It may be, for example, that just as *damascening* in medieval and Renaissance Europe is a vague term covering various sorts of metal inlay, *kūftkārī* is not a specific term at all and the workers took their name from the particular objects they happened to offer. A short list of miscellaneous occupations (e) includes two scribes, a sweet-meat-maker, a maker of instrument strings (?) (*yūnqārī*), a balance-maker, a chainmaker, two tentmakers, a glazier (*cāmger*), a saddler and a foil-setter (*fōyager*, for gems, tortoiseshell, etc.). These, with their apprentices, somewhat increase the scope of the register, but one glaring omission seems to be saddlers, who would have made the parade saddlery needed for Süleyman and his viziers or for gifts to foreign embassies.

From an inspection of the lists of presents[7] periodically offered to the Sultan by craftsmen from the palace workshops it is possible to gain a clearer idea of their specialities. Thus in metalwork the *kazğānciyān* (literally boilermakers) seem to have made table vessels and utensils in silver and copper, evidently beaten but possibly engraved too. The *zerneşānciyān* (damasceners) evidently worked on steel, inlaying it in gold, but they may also have done fretwork or relief carving on steel, as on the short sword of Süleyman (no. 83). The *çilingīrān* (locksmiths) also made lanterns, and possibly fretwork too, candle-snuffers and bits for horses, which could then be inlaid or damascened or not, as the case may be. The *ķuyūmcuyān* were goldsmiths setting jewels too and working in enamel, but the diamond-cutters (*ḥakkākān*) not only seem to have cut jewels (mostly simply table-cut) but also engraved seals and worked tough materials like jade, hardstones, and mother of pearl for inlay, being skilled enough to know when the material might crack. The armourers, swordsmiths and probably the file-maker (*eğerci*), sawmaker (*desterreci*) and the razor-maker (*uşturacı*), who offered files and a razor, evidently all worked steel, so their work must have been interchangeable.

Relatively few of the craftsmen are identified as from Tabriz, although most of these are the more highly paid. Most otherwise came into palace service under Bayazid II (whose initiative in creating the Ottoman court workshops may well have been of fundamental importance), and may or may not have been slaves. Quite a lot of the others were, indeed, slaves,

either presents to the Sultan from private individuals or from the palace at Edirne, or else slaves of Grand Viziers (including Yunus Paşa, Hadim Sinan Paşa and Hayin Ahmed Paşa), who had fallen to the State on their death, disgrace or confiscation. This is a further indication of the lavish scale on which these viziers lived, training master craftsmen who could then hope for court employment. Some were *pencik* slaves, that is, from the Sultan's fifth of prisoners of war which were his by right and some were *gebr* (non-Muslim foreigners) and free – Georgian shield-makers, Italian or French diamond-cutters, a Jewish foil-setter, etc. Relatively few of them are stated to have been conscripted by Süleyman himself, although among these are a few Hungarians (Üngürüs) and 'Russians' (Rūs): these, however, entered his service well before the Buda campaign of 1526.

Relevant to the status of these craftsmen is a further series of palace registers (*mevācib* defters), periodic lists of those on the palace strength, with their daily wages, their apprentices, their social status and sometimes brief biographical details. As the 1526 list above[8] shows, the craftsmen might have been numerically inferior to surgeons and launderers, and by no means all of them were employed on producing luxury objects for the palace. There are several such registers for Süleyman's reign, which allow us to trace the careers of his craftsmen and fluctuations in the strengths of various workshops. Related to these are registers of wages and salaries of a much wider circle of state employees (*nafaķa* defters), which have to date been less well published but which are essential for evaluating the status of the palace craftsmen *vis-à-vis* those working on the 'open market'. There are two other important series of registers: registers of presents offered to the Sultan by the palace craftsmen,[9] and by some casual visitors or employees, on the great feasts of the Muslim year, and their rewards for them; and monthly registers of palace expenses (*in'ām* defters) for visiting embassies, members of the imperial family, their spouses and children, 'boon' companions (buffoons or entertainers), musicians, dwarfs, poets, pastry cooks, astrologers and spies, with some payments to the heads of workshops – goldsmiths, damasceners, locksmiths, dagger-makers, tailors, button-makers, cannon-founders, etc. These last, which survive in some numbers for Süleyman's reign, have so far only been published in extracts[10] and are better known from the late Ömer Lutfî Barkan's work on the *in'ām* defters of Bayazid II's reign.[11] Registers of this type owe their importance to the possibility they offer of evaluating the relative privileges of the various crafts and the status of craftsmen *vis-à-vis* other court employees.

The *in'ām* defters for the latter part of Bayazid II's reign show that the privileged groups were from those paid on a monthly stipend (*cemā'āt-i müşaḥereḥōrān*), including poets, a number of provincial *'ulema*, fashionable dervishes, dwarfs, musicians and, above all, spies. The emphasis upon entertainment and espionage strongly recalls an Italian Renaissance

court. The Chancery scribes are also well rewarded, but for the completion of a series of carefully specified tasks, and neither the Ottoman authorities nor they themselves would have viewed these as in any way artistic. The records of payments, as usual, cover a variety of cases: occasional rewards or payments to the regular craftsmen for gifts, some offered by outsiders; seasonal gratuities of a standard nature; and, possibly, rewards for outstanding merit, although in this last case, as in many other honours systems, the honour seems primarily to have been related to the craftsman's rank or employment, and the merit element is difficult to detect or may be largely absent. The system did not preclude extraordinary or unsolicited gifts from the court craftsmen in Istanbul. Whether they received payments for work done or rewards for their thoughtfulness is not easy to say. The amounts are considerably larger than the Ramaḍān gratuities, but the relation between the product, the materials, the labour and the craftsmen's wages is obscure. Such occasional payments must, however, have been considered as adequate by the authority and, if they were arbitrary or capricious, then at times that must have been to the advantage of some of the craftsmen.

What emerges from the 909/1503–4 *In'ām* defters is that even the heads of the workshops were excluded from the group of Müşāhereḥōrān, who received for their seasonal gratuities robes of honour of Bursa silk and, generally, over 2,000 *akçe* each: practically none of the craftsmen received a robe of honour, and the gratuities even to heads of workshops (and to their employees in descending order of rank) were considerably less. Among the Ramaḍān gratuities the craftsmen best represented were armourers and weapon-makers (muskets, bows, arrows, daggers, swords), followed by goldsmiths and damasceners, but the list is short and far from comprehensive; and conspicuously the best rewarded were the cannon-founders (*ṭōpçu*) and smiths (*ḥaddād*).

The separate lists of seasonal presents offered by the craftsmen from the court workshops are similarly rather incomplete. Very probably not all were commissioned or expected to produce presents for every festival, or not all of them were ready. They are also somewhat problematic in that many of the objects offered, such as knives with damascened blades, inlaid fish-tooth handles and jewelled sheaths, would have been the work of several specialists: which particular craftsman finally presented the object therefore may have had very little to do with his own specialisation. But a list of presents offered on the ʿĪd 963/November 1556[12] suggests that under Süleyman there was some improvement in the financial rewards. On this occasion, moreover, the heads of certain workshops, the painters, goldsmiths, bow- and armour-makers, metal-beaters (*kazǧānciyān*), furriers, sword-smiths, bonnet-makers and bootmakers received robes of honour. But the only other workshops represented (copyists of manuscripts, embroiderers, damasceners, marquetry-workers, gold embroiderers, shield-makers, locksmiths, decorators of

hanging ornaments (*dimişkīgerān*), dagger-makers, and a candle-maker (?) (*çirāǧī*), a binder, an amber-carver, a carpenter, a scabbard-maker and two glaziers) by no means exhaust the luxury industries under Süleyman. This selectivity is inexplicable, but evidently employment in the palace workshops was not even a guarantee of regular seasonal gratuities.

In the *mevācib* defters of Süleyman's reign these craftsmen are known as the *ehl-i ḥiref* (literally, 'tradespeople', 'crafts-men', 'artisans') possibly implying that they belonged to guilds or corporations (*eṣnāf*),[13] but probably without the restrictive practices and artificial demarcation lines, or even control of quality, of guilds in contemporary Europe. Some were slaves, some were from the janissaries and some were non-Muslim and free. Entry into the palace workshops does not seem to have changed their legal status, since quite a few of those listed in the 1526 register are stated to have been slaves in the households of viziers and other officials. However, as we have seen, by no means all the workshops seem to have been active all the time and, indeed, the *kāliçebāfān-i Ḥāṣṣa* (the court carpet workshop) does not appear to have presented a single carpet to Süleyman.[14] Many of the staff may be traced through successive palace registers of his reign, but the number of workshops certainly varied from reign to reign; while the inclusion in each register of a 'Miscellaneous' category of craftsmen, and razors, saws, balances and other rather *outré* objects presented to Süleyman in lists of seasonal gifts suggests that certain craftsmen may have been only occasionally employed.

The system of double payments noted by Menavino involved a daily stipend, and payment of reward for commissions actually executed which we must presume to have been commensurate with the craftsmen's labour. The daily stipends, which were comparatively low even in Bayazid II's reign, ranged from 10–12 *akçe* for a master to 2–3 *akçe* for an apprentice and did not increase significantly even after the serious inflation of the 1580s. It is doubtful that the apprentices would, in fact, have been able to live on their stipends even with regular seasonal gratuities. If the stipends were in the nature of retainers they cannot have been of much use, and the palace would have taken it for granted[15] that it would have first call on their services. However, there is evidence, for example, in the diaries of Stephan Gerlach[16] and Salomon Schweigger,[17] who frequented the Greek merchant families during their time in Istanbul, that they had access to the court jewellers. This seems to have been particularly the case with the imperial saddlers, whose absence from the *mevācib* defters of Süleyman's reign is so puzzling and who, Michel Baudier writes, were concentrated at Saraçhane in Istanbul:[18]

[At] the Sellerie or the place where they make Saddles, & rich Caparisons for Horses of Service and Pompe, some set with great round Pearls upon the Saddle of an Arabian Horse out of

the Grand Vizier's stable: Others fasten a Bitt of Gold to Reines of rich red Leather of Russia, some doe fit stirrop Leather to stirrops of Gold, enriched with a great number of Turkishes of the old Rocke: Others fasten upon a large Croupe a great number of precious stones. In another place you shall see a rich Saddle cast forth a thousand flames, the numbers of Diamonds wherewith it is enricht make it inestimable: The Bitt & Stirrops of Gold covered with Diamonds, the Tassels of Pearls which are at the Reines, and at the Trappers of the Crouper, & the other beauties of this Royall harnesse, ravish the eyes of such as look on it with admiration of their wonders . . .

This was evidently open to the public, in fact to anyone who could afford it.

The attachment of the palace craftsmen to the palace was, therefore, somewhat loose and their privileges rather moderate. It is even less clear that the *ehl-i ḥiref* were an aristocracy of talent. This is partly because, apart from manuscript colophons, there are so few objects with craftsmen's signatures known from the sixteenth century, and virtuoso pieces like the short sword of Süleyman (no. 83) made by Aḥmed Tekelü or the mirror made for him (no. 79) by Ghanī are by craftsmen who do not appear in the registers. Almost certainly those recruited from Istanbul underwent a process of selection, while craftsmen of *devşirme* origin were doubtless chosen for their aptitudes. Recruitment by *sürgün* was, however, rather haphazard, since craftsmen anxious for court employment must have offered their services in the confidence that their credentials would not be subject to examination. This seems particularly to be the case with painting under Süleyman, where the influence of Shah Ṭahmāsp's finest court painters is little apparent and certain Europeanising elements suggest that painters may have been recruited at Buda in 1526 after they had falsely pretended to experience in the library of Matthias Corvinus. This is not, by any means, to decry the quality of workmanship under Süleyman but to suggest that, in the light of what we know at present, the reason for the existence of the *ehl-i ḥiref* was not their artistic or technical pre-eminence, but the control of the materials they worked.

The craftsmen listed in the registers are exactly the sort of people one would expect to find in attendance upon any great court, not only to provide necessary luxuries but also because the very high capital cost of the basic materials made it difficult for them to make their living without the patronage a court could offer. This was not merely an Ottoman problem: the more independent goldsmiths of Augsburg and Nuremberg[19] found relations with their Habsburg patrons excessively difficult, since they, on the contrary, had to wait for payment and might be driven to bankruptcy by a ruler's temporising. The Ottoman solution was to issue materials to the craftsmen from the Palace Treasury, which was a great storehouse not just of artefacts but of raw materials – gold, unworked jade,

uncut gems, ebony and other exotic woods, ivory and tortoiseshell – as well as of objects which could be reworked or cannibalised at demand: these would then be issued to the craftsmen, by the head of the Treasury, as required in the course of a commission. Hence the system of double payment, with the principal amount being paid only when the work was complete; this was a guarantee that the craftsmen would not slack, while the strict control exercised in the issue of precious materials was meant to minimise loss through pilferage.

This attitude applied no less to the scriptorium, which similarly consumed large amounts of precious materials. Of the bill for the *Süleymānnāme* (no. 45), totalling 21,056 *akçe*, more than a third went on the materials, while, of the total 88,489 *akçe* for the Korans presented for the inauguration of Süleymaniye (executed from late 1552 to late 1556), more than a quarter went on the paper alone.[20] A more detailed account for the completion of an unfinished Koran written by Aḥmed Ḳaraḥiṣārī and illuminated for Murad III (992–1001/1584-92)[21] (now TKS EH. 5) demonstrates the way in which gold, precious pigments and even pens and paper were doled out in small amounts every ten days or so. This must have been unconducive to smooth progress, but it is possible that the head of the studio hoarded materials and thus was able to avoid too many hiccoughs in production. All systems are imperfect, but arguably the craftsmen were not excessively hampered by central interference. It is difficult to be less lukewarm about the *ehl-i ḥiref*. On the evidence of the registers the palace craftsmen owed the palace their first loyalties and otherwise competed with craftsmen catering for the general public. Certain scarce materials like fish tooth, jade, rock-crystal or amber were probably bought up by the Treasury whenever they came on the market so that the palace effectively had a monopoly in working them, but the authorities do not seem to have made any persistent attempts to centralise the luxury trades. This seems to have been true even of the scriptorium, the largest of the workshops and, very probably, permanently occupied with the production of manuscripts and albums for the Sultan: craftsmen from it were set to work on manuscripts for viziers like Rüstem Paşa (for example, no. 20); while other manuscripts presented to the Sultan, like the *Kitāb-i Baḥrīye* of Pīrī Reis (no. 40) and the *Mecmūᶜa-i Menāzil* (no. 43), may have been worked up by their authors or illustrated by painters they themselves supervised.[22]

The number of craftsmen in the scriptorium (now generally known as the *nakkaşhane* in the literature) and their variety of specialities have suggested, however, that it was not merely the main centre of book production but the nerve centre of the whole system of palace workshops, drawing out patterns for all sorts of different media and imposing an extraordinary unity on the court arts of Süleyman's reign.[23] In stronger or weaker versions this theory is now more or less generally believed but it is largely conjectural, exaggerates the resemblances, and must be based upon misunderstanding of the rather inadequate

evidence at our disposal. The stylistic unity of the arts under Süleyman is very much a matter of individual judgement, but even within the scriptorium there are pronounced differences in the motifs used in binding, illumination and illustration and their treatment; and illumination, unexpectedly perhaps, seems to have had practically no influence on any of the other arts. As for the claims that designs for textiles or tile panels were drawn in the scriptorium and sent to Bursa or Iznik, they have no substantiation in fact. Silk design in particular was a matter for specialists in contemporary Florence[24] and it is scarcely probable that anyone in the scriptorium would have had the time or expertise to understand what the Bursa weavers would make of his designs in the weaves they manufactured. If the Bursa weavers were capable of manufacturing the materials, they were certainly capable of employing their own designers. It is surely relevant that there is practically nothing in the Topkapı Saray Library or archives from the reign of Süleyman which could be seen as a pattern.

In the case of Iznik we do not know how the potters were organised, the relations of the various workshops or even how the tastes of their clients affected what they made. In fact, too little is yet known of the internal workings of the Ottoman *Kunstindustrie*, although much can be deduced from practice in contemporary Germany or Italy.[25] The Ottoman authorities have contributed to the confusion by their attitude to Bursa and Iznik[26] which they consistently treated as if they were court industries, although they were not. They were, doubtless, their largest customers but they shared no inclination to capitalise them, and their peremptory orders for their always pressing requirements must often have been ineffective. The orders published relating to the Iznik potteries in the sixteenth century are unspecific and appear to deem it sufficient for control of *quality* to appoint a legal official, usually the local *kadi*, to disburse the funds and, occasionally, to obtain raw materials, an interesting misapplication of the Mannerist belief that, *pro tanto*, expensive art was better art. There is not a single record of an attempt to control quality by controlling the potters. One must thus conclude that centralised control was at best an ideal incompletely realised but that if the authorities had seriously wished for centralisation of production there was a great deal more they could have done.

This distinctly *laissez-faire* attitude, while perhaps less true for the palace workshops, was characteristic of the authorities' attitude to other luxury industries. It is remarkable how localised the luxury industries in general were: carpets in Cairo,[27] in the province of Karaman and in western Anatolia in the Uşak area; silks and other brocades in Amasya, Aleppo, Damascus, Kaffa/Kefe as well as Bursa; pottery at Iznik and Aleppo; goldsmiths' work in Trebizond (Trabzon) and Diyarbekir; mohair at Ankara and at Tosya;[28] woollens at Salonike. The court reaped enormous advantage from the tax-farms of such localised industries and it was generally content to compete for their products with the Italian, Russian, Polish,

Syrian and Persian merchants who flocked to Aleppo, Bursa, Damascus and even Cairo. Even when an increase in demand for tiles for the imperial and vizieral foundations of 1557 onwards in Istanbul and Edirne led to shortage of supply from the Iznik potters, the authorities' solution was the bureaucrat's (that is, no solution) to issue periodic orders that they comply, rather than taking active steps to exclude outside competitors. On the evidence of administrative documents of the later sixteenth century, the authorities attempted to concentrate certain luxury industries in Istanbul,[29] notably brocades and other silks, possibly carpets and probably jewellery and goldsmiths' work; but this seems to have been an afterthought. It is difficult or impossible to identify the products of these concentrated industries.

NOTES

1. Gray (forthcoming); Özergin 1974–5, 471–518.
2. Akimushkin 1981, 5–20. The term used in the Ottoman registers is *cemāʿat*, 'group'; the modern sense anachronistically suggests an organised society of craftsmen.
3. *I costumi et la vita de' Turchi* (Florence, 1551), 121, Capitolo 19, 'Degli Orefici Argentieri': Similmente tiene il gran Turco settanta huomini chiamati Ciumgeler [Kuyumcular]; cio è, orefici, con provisione di dieci aspri, quelli che sono maestri, & i sotto maestri vi & i garzoni tre: di questi una parte sono Persiani [sc. ʿAcem], et l'altra schiavi del signore [sc. *kapıkulları*, though not necessarily all slaves], i quali lavorano tutte le cose del Signor, d'oro, & d'argento, che fa fare & sono pagati di lavori oltre al salario & hanno le oro botteghi in mezo di Costantinopoli, & hanno tutte le spese & cavalcature del gran Turco à loro piacere.'
4. Ibn Iyās 1960, 173, states merely that they were specialised without saying what they did. Other craftsmen included masons, carpenters, marble-workers and smiths.
5. Aslanapa 1958, 15–17.
6. Uzunçarşılı 1986, 23–76.
7. Cf. Meriç 1963, 764–86. Evliya Çelebi's list almost a century later (trans. Hammer 1844, 188–94) suggests that there may have been even greater specialisation among the jewellers and goldsmiths. They may have had little to do with the palace workshops, however, and it seems to be the case that Evliya's groupings were less professional than fiscal.
8. Meriç 1963, no. 6.
9. Meriç 1963, no. 7.
10. These have been most recently exploited for the information they give on Ottoman court patronage of poets, cf. Erünsal 1984, 1–17.
11. Barkan, 1979, 296–300. He publishes only the register for the year 909/1503–4, but the series goes up to 917/1511–12. Cf. Erünsal 1977–9 (Istanbul, 1980), 213–22.
12. TKSA D. 4104; cf. Meriç 1963, no. 7, 775–8.
13. For a recent study of the goldsmiths' guilds in sixteenth-century south Germany cf. Schnörer, Nuremberg 1985, 71–85.
14. B. Çetintürk 1963, 715–31.
15. Ö. L. Barkan (1972, 93–107) has suggested that, for example, the masons and carpenters conscripted for the construction of Süleymaniye were regarded as free, too, to take on what outside work they could find when unseasonable weather held up work on the site. But would they have found any?
16. *Stephan Gerlachs des Aeltern Tagebuch* (1674).
17. Schweigger 1608; cf. Göyünç 1963, 119–40.
18. Baudier 1635, 151b.
19. Pechstein, Nüremberg 1985, 57–70.
20. Barkan 1979, 69 (L); 69–70 (M); Washington 1987, 288.
21. Meriç 1953, no. 66, TKSA D. 9628.

22. Notably Fleischer 1986, 10–11, the copy of Muṣṭafā ᶜAlī's *Nuṣretnāme* (now TKS H. 1365) completed Receb 992/mid-July 1584 for presentaiton to Murad III. The expenses were evidently borne by the palace since ᶜAlī complains in his *Nuṣhatül'-selāṭīn* of the excessive fees paid to the twenty calligraphers, illuminators and painters employed, and of the peculation attendant upon it. There is independent evidence of irregularities in the palace scriptorium but ᶜAlī's book of counsel for sultans was an attempt to gain Murad III's favour and he possibly exaggerated his criticisms to show his zeal for rectitude and economy.

23. The strongest version of the argument to date, which presents the court of Süleyman virtually as a prefiguration of Colbert's mercantilist reorganisation of the French luxury industries at the court of Louis XIV, is Washington 1987, 29–36.

24. Edler de Roover 1966, 223–85.

25. Particularly suggestive are Goldthwaite 1980; and id., 1984, 658–74.

26. Commentary to documents published by R. Anhegger in Otto-Dorn 1941.

27. Erdmann 1938, 179–206; 1940, 55–81; 1961, 65–105.

28. Faroqhi 1980, 61–83; 1986, 1246–84.

29. Halil Inalcık convincingly argues ('Ḥarīr', *EI²*) that the reason for concentration of silk manufacture in sixteenth-century Bursa was basically fiscal and derived from its status as the entrepôt for raw silk imported from northern Iran and re-exported to Europe. If attempts were periodically made to regulate silk manufacture there, because of the fundamental role in the Ottoman honours system of robes of honour of Bursa silk, there was no systematic control of either quantity or quality of production.

Ottoman jewellery (nos 54–61)

The Ottoman sultans and their courtiers were restrained in their use of jewellery. During the sixteenth century manuscript illustrations depict men occasionally wearing turban ornaments, belts and rings, but most frequently they wear no jewellery at all. In this they stand in contrast with their neighbours and rivals to the east, the Safavids of Persia, and also to the various courts of Europe to the west. However, given their passion for encrusting everything else with gold and gems, from Chinese porcelains to jade, and from bookbindings to furniture, this must preclude an aversion to jewellery on religious grounds, and the unpopularity of male jewellery at the Ottoman court in the sixteenth century may simply have been a matter of taste. The sultans' respect for the rather strict sumptuary laws of Islam was further limited by the splendour of the silk and brocaded textiles they wore, which were condemned out of hand in the *ḥadīth*.

It is impossible to know whether or not this restraint extended to Ottoman women. Court ladies do not appear in miniatures, and were not seen by the chroniclers of the period, and the females of lower estate depicted, for example, by Nicolas de Nicolay, although shown, doubtless fancifully, wearing textiles as splendid as any in this exhibition, are not bejewelled.

Belts (nos 54–6)

The Ottomans are unusual within the Islamic tradition for not treating the belt as a symbol of martial power and prestige. Belts are rarely shown in paintings of court scenes before the seventeenth century. Sixteenth-century miniature paintings depict men in loose flowing caftans, or gathered at the waist by sashes (see nos 120–2). If belts were worn under caftans to hang small objects such as seals or purses, they were not treated as a conspicuous part of court dress. They did exist, however: Süleyman included gold belts with the gifts that he sent Shah Ṭahmāsp of Persia, shortly before the execution of his son Bayazid.[1]

By the seventeenth century belts consisting of gold and jewelled plaques mounted on leather become more commonplace in miniature paintings of court scenes. However, surviving examples include a group of belts from the tomb of Ahmed I (early seventeenth century), which are not of the quality that one would expect of court dress, and were probably used in hunting or in a similarly functional context.

The three belts in the exhibition are from a group of ivory or mother-of-pearl belts with particularly delicate carving and decoration. Their lightness and fragility suggest that they may have been worn by the women of the royal household.

1. Uzunçarşılı 1960, 103–10.

54 Belt

Later 16th century
L. 78.8 cm
TKS 2/539
Literature: Istanbul 1983, E. 87; Washington 1987, no. 76

The belt is made of lobed polished ivory plaques, with ivory links between each. It has a counterpoint of gold scroll

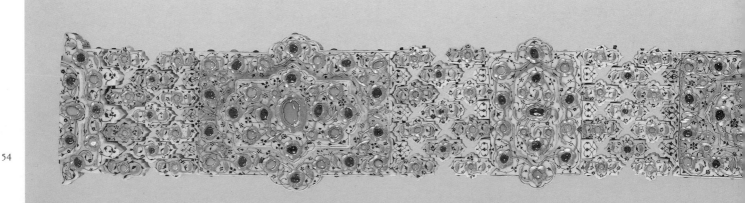

set with small cabochon turquoises and rubies in collar mounts over fine arabesques inlaid with black mastic. The buckle is made from two half plaques, secured by a gold pin through gold hoops attached to their outer edges. The top and bottom edges of the plaques are also decorated.

55 Belt

From the tomb of Selim II at Ayasofya
Later 16th century
L. 65.4 cm
TIEM 482
Literature: Washington 1987, no. 77

The belt is made of square polished ivory plaques, with ivory links between each. The plaques have a raised central disc and a finely chased gold split-palmette scroll set with turquoises and rubies in floral gold mounts, superimposed over a fine blossom scroll inlaid with black mastic. The links are decorated with single rubies or carved turquoises, in gold floral mounts between gold palmettes, also finely chased and inlaid in black. The buckle is missing.

56 Belt

Later 16th century
L. 91 cm
TKS 2/575
Literature: Istanbul 1983, E. 120; Washington 1987, no. 78

The belt, of alternating oval and concave-sided plaques of mother-of-pearl, is decorated with engraved floral motifs filled with black mastic and multi-petalled gold florets and tiny gold discs. The plaques are set in silver, and are mounted on red leather by loops on their backs. An oblong plaque encases one end of the leather. A loop attached to the mount of one oval plaque would have been used for the suspension of small objects. There are several other very similar belts in the Topkapı Palace Treasury which must have been made in the same workshop. Indeed, this belt is made up with plaques of two or three different types: the two plaques with bold tulips and the plaques bearing delicate spiralling blossoms must have been for different belts, especially as the tulip plaques are not set with tiny gold discs.

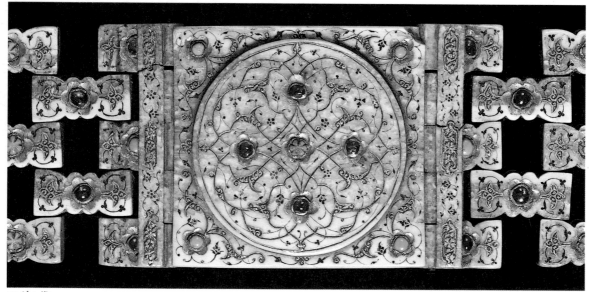

55 (detail)

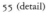

Turban ornaments (nos 57–61)

Seventeenth-century Western sources frequently, if implausibly, state that the sultans matched the number of the turban ornaments they wore to the number of kingdoms under Ottoman control – hence the four tiers to the crown made by Venetian jewellers for Süleyman, which were evidently intended to represent the kingdoms of Asia, Greece, Trebizond and Egypt (no. 6). However, if it was ever true that the Ottoman sultans shared the European obsession with number symbolism, this was not the case under Süleyman who despite his vast conquests rarely wore more than one turban ornament at a time.

Early turban ornaments seen in miniatures are bud- or tulip-shaped (nos 58–60). This shape retained its popularity during the sixteenth and beginning of the seventeenth centuries. Flat medallions, often linked by chains to two other subsidiary ornaments and all encrusted with gems, became common only in late seventeenth- to early eighteenth-century miniatures. A miniature of the burial of Süleyman (Chester Beatty Library MS 413, fol. 115b) shows the massive turban of the Sultan adorned only with two tulip-shaped ornaments. Jérôme Maurand (1544) describes Süleyman as wearing a great gold medallion on his turban, with a sparkling round ruby as big as half a hazelnut on it. This suggests something not too dissimilar to the medallion ornament (no. 61).[1]

One of the ornaments (no. 58) comes from the tomb of Hürrem Sultan, but it is hard to imagine how the court ladies, who did not wear turbans, could have worn them without the thick padding of a turban in which to insert the prong. The ornaments were used to contain aigrettes of peacock feathers, or ostrich plumes, but the most highly prized were black heron feathers (Tavernier 1684, 4), which have mostly rotted with time. No. 57, however, gives an idea of their splendour when the feathers are in place.

1. Dorez (ed.) 1901, 216–17.

57 Turban ornament

Late 16th century
H. 14 cm; with feathers 33 cm
TIEM 438
Literature: Washington 1966, no. 213; Tapan 1977, 150; Istanbul 1983, E. 216, 242; Washington 1987, no. 79

The gold ornament, which is shaped like a flattened tulip bud, has a prong and chains for attaching it to a turban, and two cylindrical sockets to either side for additional feathers. The front of the gold ornament is decorated in relief with a bold chinoiserie lotus and a stylised pomegranate at the centre superimposed over a lobed medallion, both with finely chased floral ornament. The ground is finely stippled to give a matt effect. The reverse is of thin gold sheet lightly incised with floral motifs in diamond shapes formed by leaves, markedly

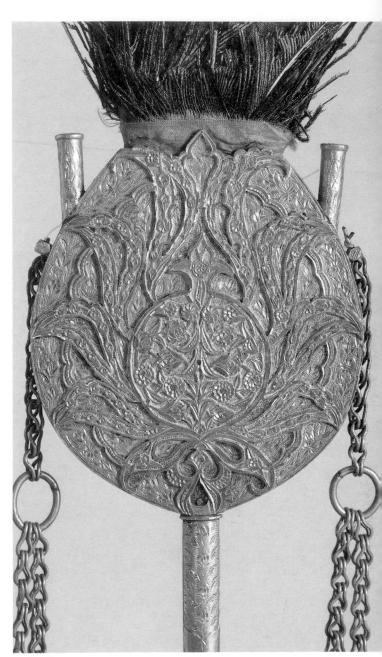

57 (detail)

similar to the thin gold sheet base of the rock-crystal box (no. 69), laid over the feathers and transfixed by two nails to hold them in place. The peacock feathers are wrapped in brown silk, with extra support from a hard wooden core. The TIEM museum register states that the ornament came from the tomb of Ibrahim Paşa at Şehzadebaşı. This has wrongly been understood to refer to Süleyman's vizier, executed in 1536, who was in fact buried in the Canfeda Zaviye at Tophane ('Ibrāhīm Pasha', *EI²*). It must actually refer to the tomb of (Damad) Ibrahim Paşa (d. 1601) at Şehzade, built in 1603 by Mehmed III's court architect Dalgıç Ahmed Çavuş.

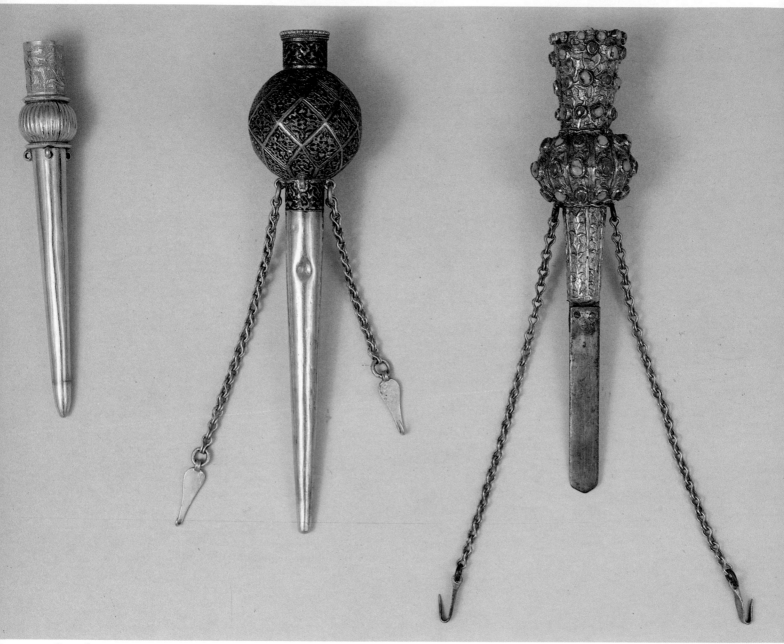

58, 59, 60

58 Turban ornament

Mid-16th century

H. 12 cm

TIEM 419

Literature: Washington 1987, no. 80

The gold ornament has a ribbed knob and collar decorated with a scroll of tulips and feathery leaves on a punched ground, with loops below for chains to secure the ornament in place. It was found in the tomb of Hasseki Hürrem Sultan at Süleymaniye, although it is difficult to see how it could have formed part of her head-dress.

59 Turban ornament

From the tomb of Selim II at Ayasofya, mid-16th century

H. 16.5 cm

TIEM 421

Literature: Washington 1987, no. 81

The gold ornament has a hollow pin, faceted knob and collar to hold an aigrette, and is decorated with chased split-palmettes and cloud clips on a mastic ground. At the base of the knob are four loops, two of which have chains of unequal length to attach the ornament to the turban.

60 Turban ornament

From the tomb of Selim II at Ayasofya, later 16th century
H. 14.5 cm
TIEM 416
Literature: Washington 1987, no. 82

The gold ornament has a spherical knob and tall everted collar, still containing stubs of feathers. It is chased with a floral design and set with alternate cabochon rubies and turquoises in applied collar mounts. Two chains attached to loops at the base of the ornament secured it to the turban. The tip of the pin is a later replacement.

61 Turban ornament

Late 16th century
H. 16 cm
TKS 2/2912
Literature: Washington 1987, no. 83

The gold ornament, with hollow pin, consists of a flat lobed medallion and knob with a socket for plumes behind. All these are incised with floral motifs on a black mastic ground or with black motifs on a gold ground. The ornament is thickly set front and back with alternate cabochon rubies and turquoises, set in repoussé petal-like collar mounts. The central feature of the front of the ornament is a large table-cut sapphire. This is surrounded by four table-cut diamonds which must be later, probably seventeenth-century additions: their undersides are rose-cut. Chains, each set with a turquoise, secured the ornament to the turban.

On the evidence of the jewellery in the Topkapı Saray collections the Ottomans were not fond of sapphires, but this may be misleading. For example, Marino Sanuto (*Diarii*, LV (1899–1900), 232) records Hungarian presents in 1531 to Ibrahim Paşa of a sapphire costing 15,000 ducats, and to Süleyman of a sapphire and a spinel in a magnificent gold vase.

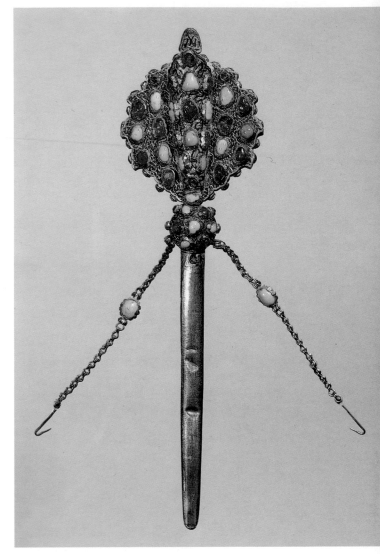

61 (reverse); detail of front illustrated on p. 30

Goldsmiths' work and hardstones (nos 62–73)

62 Silver tray

Mid-16th century
DIAM. 29 cm
TKS 23/1625
Literature: Istanbul 1983, E. 94; Washington 1987, no. 50

The tray is beaten and spun, and parcel gilt. The base has an assay mark and the Arabic numerals 383. The central medallion is engraved and lightly stippled with a scroll counterpoint of stylised Chinese peonies and lotuses. The stamp (upper right), which is not in *tuğra* form, reads *Suleymā[n]sh[ā]h Ḫ[ān] m[uẓ]affer d[ā'iman]*. The rim profile and size are very similar to a series of flat Iznik dishes, with narrow vertical rims, flattened at the top (cf. no. 156).

63 Gold flask

c. 1560
H. 28 cm
TKS 2/3825
Literature: Petsopoulos 1982, no. 28; Istanbul 1983, E. 206; Köseoğlu, 1987, pl. 49; Washington 1987, no. 54

The flask, with a squashed pyriform body on a flaring foot, has a narrow neck and stopper attached by a fine chain, dragon spout and chain mesh handle. The body is decorated in repoussé with palmettes in relief. These, like the background, are decorated in low relief with fine floral scrolls, and set with table- or rose-cut emeralds and rubies in collar mounts with petal-like surrounds. On each side is a central milky-grey jade plaque inlaid with a symmetrical floral scroll in gold, the flowers of which are table- or rose-cut rubies and emeralds in collar mounts with petal surrounds. The domed stopper covered with rubies and emeralds in square mounts, with a large rose-cut ruby on top, is later in style than the body of the flask. The plunger is engraved and features medallions with gold scrollwork on a niello background.

On the shoulders of the flask are two dragons' heads. One, holding a pearl in its mouth, bears the numerals 640; and a word which has been read as *tecdīd* ('renewal'). The numerals evidently give the weight in dirhams (the official Tabrizi dirham = 3.072 gm), making a weight of 1,966.08 gm (almost 2 kg). However, the word may read not *tecdīd* but *taḥrīr*, a Chancery term for the registration or drawing up of a document. Its force here is unclear. The unusual shape of this gold flask derives from leather drinking vessels (cf. a flask presented by Murad III to the Emperor Rudolph II in 1581, Vienna, Kunsthistorisches Museum, C. 28). Such gold flasks were used for the drinking-water of the Ottoman sultans and frequently appear in miniature paintings, carried by one of the Sultan's attendants.

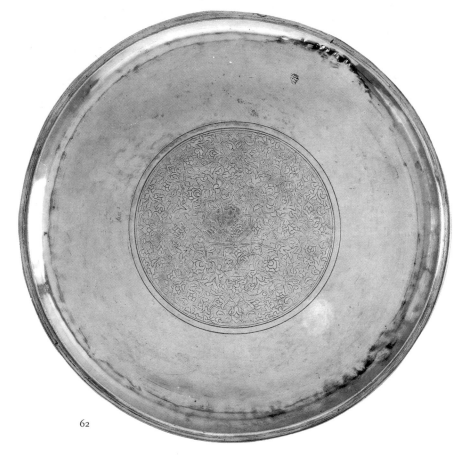

62

63

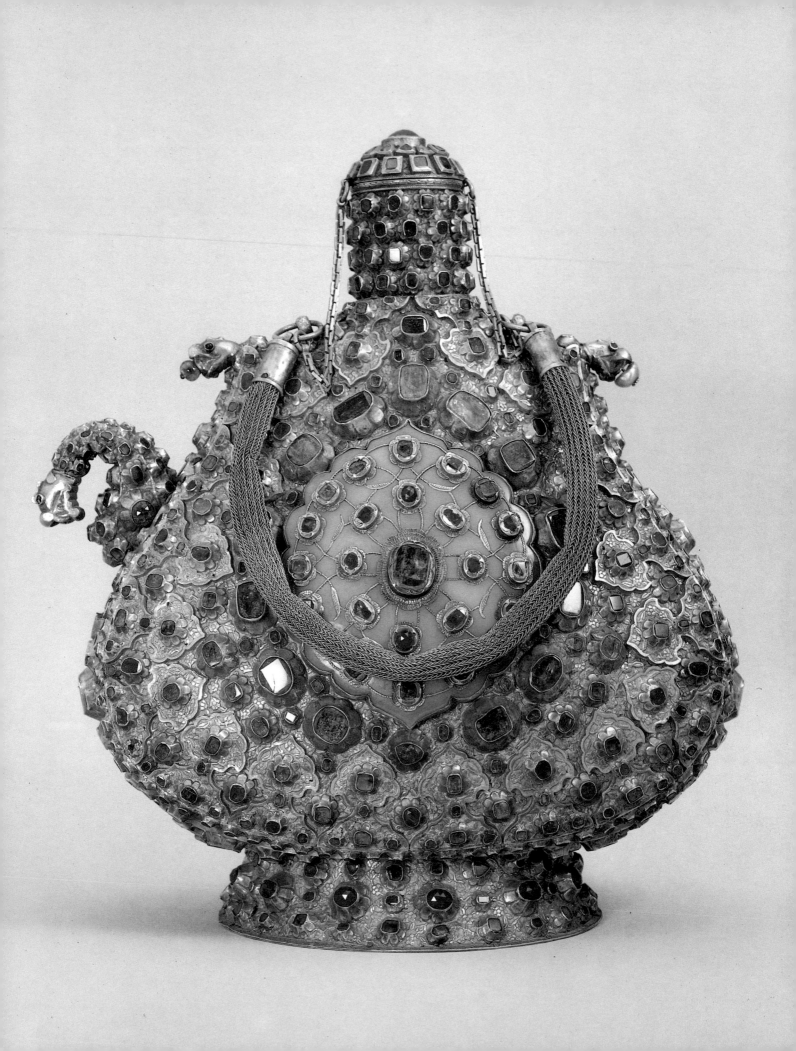

64

64 Padlock

Dated 973/1565–6

L. 75 cm

TKS 2/2274

Literature: Istanbul 1958, no. 67; Sourdel-Thomine 1971, no. 16;
 Washington 1987, no. 55

The padlock of gold-plated silver is decorated with an inscribed finial with a dedication to the Ka'ba by Süleyman, dated in words 973/1565–6, in rounded script with foliate or floral sprigs on a ring-matted ground. The key is missing.

Such ceremonial locks were in Ayyubid, Mamluk and Ottoman custom presented on a sultan's accession to symbolise his protectorate over the Holy Places of Islam. Süleyman had earlier in his reign undertaken works at Mecca, although he was far more active in Jerusalem and he never made the pilgrimage himself. They included the provision of a water-spout for the Ka'ba in solid gold (Gaudefroy-Demombynes 1923, 40), but the presentation of the key seems to have been another initiative altogether not documented in the sources.

65 Globular jug

Mid-16th century

H. 13.5 cm

TKS 2/2873

Literature: Istanbul 1983, E. 96; Washington 1987, no. 56

The jug, of cast zinc, has an applied handle with thumb-piece and a flat lid. It is inlaid with a gold scrolling floral design, the flowers of which bear small turquoises, cabochon rubies or emeralds and pearls in claw mounts, and openwork medallions set with turquoises and cabochon rubies, held by claws in collar mounts. The zinc ground to the medallions is stippled and painted green. The lid is decorated in a different style and may be from another vessel: the gold inlaid design of clouds and sprays of flowers is in relief, not flush as on the body of the jug. The knob on the lid is gold and is set with a turquoise.

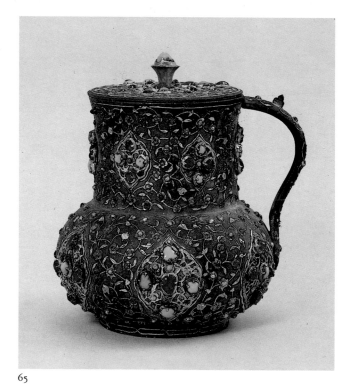

65

66 Globular jug

Mid-16th century
H. 18 cm
TKS 2/2856
Literature: Washington 1987, no. 57

The jug, of cast zinc, has a tall neck, applied handle and domical lid with a flat rim, attached to the handle by a chain. The body is elaborately inlaid with chased gold medallions and floral scrolls on a finely stippled matt ground, and set with turquoises and cabochon rubies in collar mounts with small claws; there is a table-cut diamond set at the centre of each of the four medallions. Inside the neck is a filter of open-work gold scrolls finely chased and set with turquoises and rubies.

67 Oval cup

Central Asia, *c.* 1420-40
L. 20.5 cm
BM, OA 1959.11-20.1(36), Brooke Sewell Fund

The cup, of dark green Siberian jade (nephrite) with a handle in the form of a stylised chinoiserie dragon and foliage below, bears an inscription in the name of Ulugh Beg (d. 850/1447), grandson of Tamerlane and ruler of Samarkand, for whom it was evidently commissioned. Rim damage has been replaced by a filling of tarnished silver bearing an inscription in careful Ottoman rounded script: *Karam-i Ḥaḳḳa nihāyet yōḳdur* ('The generosity of God is infinite').

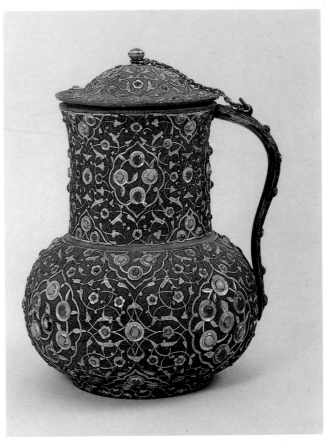

66

67 detail

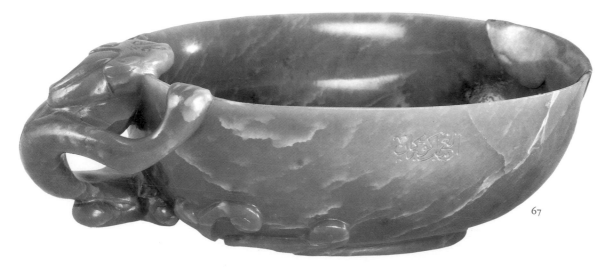

67

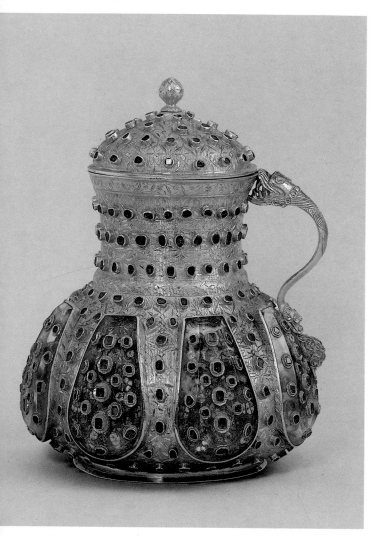

68

68 Repoussé gold jug

Later 16th century
H. 20 cm; DIAM. (max.) 15.5 cm
TKS 2/8
Literature: Istanbul 1983, E. 211; Tokyo 1985, 31; Türkoğlu 1985, 12;
Köseoğlu 1987, pl. 52; Washington 1987, no. 61

The jug, which has a bulbous body, flaring neck, domical lid and cast dragon handle, has been damaged and now sags over its foot-rim. The most striking feature is the eight bevelled lappets of rock-crystal encrusted with table-cut emeralds and rubies in flower-like surrounds, set into gold mounts on the body, over paper painted with floral motifs in gold, white, red and yellow on a blue background. This unusual combination of gold, rock-crystal, gems and painted paper is also seen in the penbox (no. 69). The gold surface and lid are engraved with interlaced leaves on a stippled ground, and set with table-cut rubies in collar mounts at regular intervals. The base, possibly a replacement, is a separate piece of gold set into the foot-ring and engraved with a six-pointed star and rosette.

69 Gold penbox

Late 16th century
L. 40 cm
TKS 2/22
Literature: Washington 1966, no. 222; Istanbul 1983, E. 209; Türkoğlu
1985, 13; Köseoğlu 1987, pl. 42; Washington 1987, no. 62

The penbox is set with convex oval and circular plaques of rock-crystal laid over white paper painted with blue and red flowers and scrolling gold arabesques. The plaques are fixed by bands of gold and set all over with rose- or table-cut emeralds and rubies in gold collar mounts. Those on the crystal have a petal surround. The central emerald on the lid is a cabochon. The inset base is lined with thin gold sheet, chased with large medallions of simple floral decoration, not unlike medallion designs for Ottoman silks.

Inside, the lid of the penbox is lined with plain gold sheet. The body is lined with wood painted in black and gold with sprays of tulips and a central lobed medallion of cloud bands. A fixed silver-gilt tray encrusted with rubies and diamonds at the left-hand end of the penbox houses covered pots for ink and sand. It bears a counterpoint of engraved arabesques and a minute nielloed blossom scroll.

Another removable silver-gilt tray, attached to the penbox by a chain, was added at a later date. It is engraved with naturalistic floral decoration.

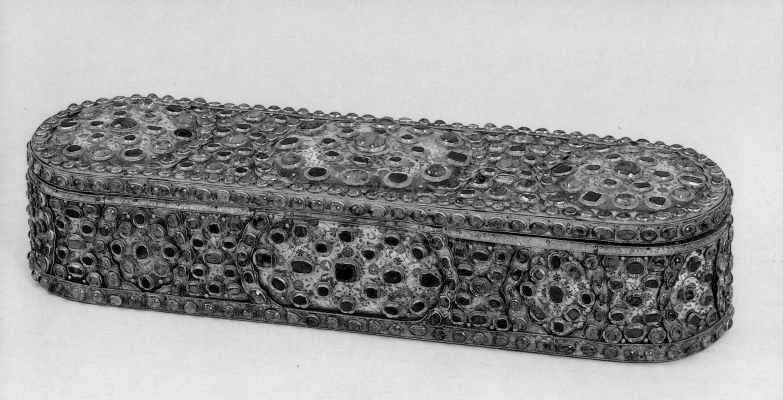

69 closed (*above*), open (*below*)

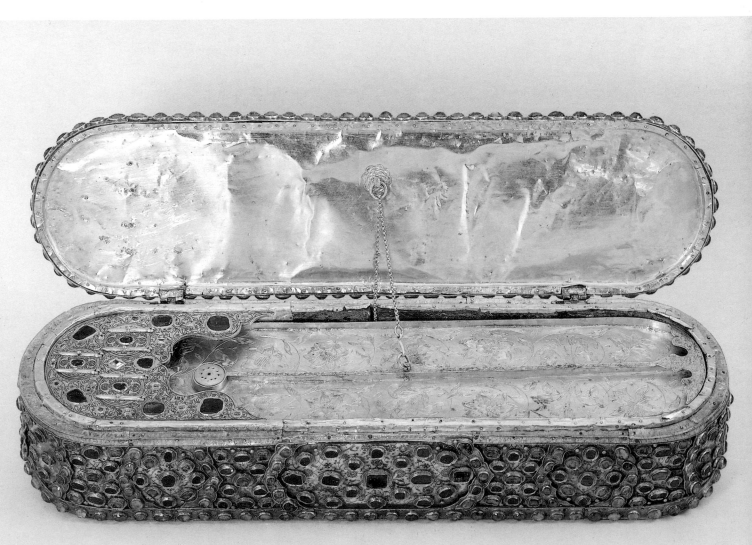

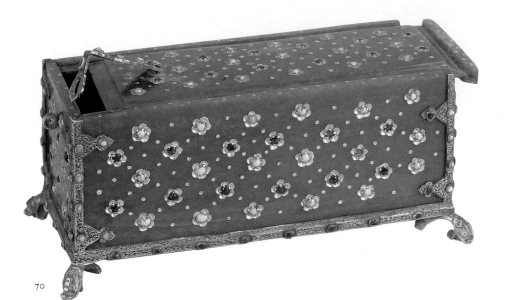

70

70 Jade box

c. 1530–50

L. 14.8 cm

TKS 2/2085

Literature: Washington 1987, no. 63; cf. Milan 1987, no. 286, and Tokyo
1985, no. 313 (illustrating TKS 2/2084)

The box, of dark green jade, with sliding lid, has a silver-gilt
frame, with engraved and nielloed decoration, on cast-gold
dragon-headed feet which have been applied separately. Both
silver-gilt mounts and jade plaques are encrusted with
turquoises and cabochon rubies held by claws, in collar mounts
with petal surrounds. They are arranged in straight lines, and
alternate with small gold discs carved with spirals. There are
several similar boxes in the Topkapı Saray collection (Istanbul
1983, E. 82).

71 Hardstone jug

Late 16th century

H. 19 cm

TKS 2/3831

Literature: Washington 1966, no. 219; Skelton 1978, fig. 1; London 1983,
ref. enamelling; Tokyo 1985, 2/32; Türkoğlu 1985, 14; Köseoğlu 1987,
pl. 50; Washington 1987, no. 64

The covered jug, with dragon-headed handle, is carved from a
single piece of stone (possibly black chalcedony or obsidian)
and encrusted with table-cut rubies, some of them inferior
replacements, in flower-shaped collar mounts linked by chased
gold stems and leaves. Simpler gold inlay is found on the rim,
inside the lid and on the base of the jug. The base of the lid
and the body of the jug have gold mounts. These are decorated
on the outside with *basse taille* enamel, in dark and light green
and blue, and with opaque white and yellow too. The lid has
fine tulips and hyacinths, although these would not have been
seen with the lid in place. The foot is gold openwork,

decorated with green, blue and white enamels. Inside the jug
is a thick gold filter carved with a radial Koranic inscription
(LXXVI, 21), 'and their Lord shall give them to drink a pure
draught', and a central rather coarsely nielloed arabesque
medallion set with a turquoise.

There are references to enamelling in Edirne, in the market
ordinances of Bayazid II (1481–1512), but little concrete
evidence for Ottoman enamelling before the seventeenth
century. The decoration of this jug in fact suggests a late
sixteenth-century date, and the quality of the enamelling
around the lid, which is unlikely to have been a later addition
as it is barely visible, suggests that the technique was already
well established.

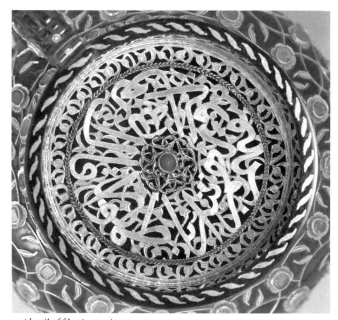

71 (detail of filter); *opposite* 71

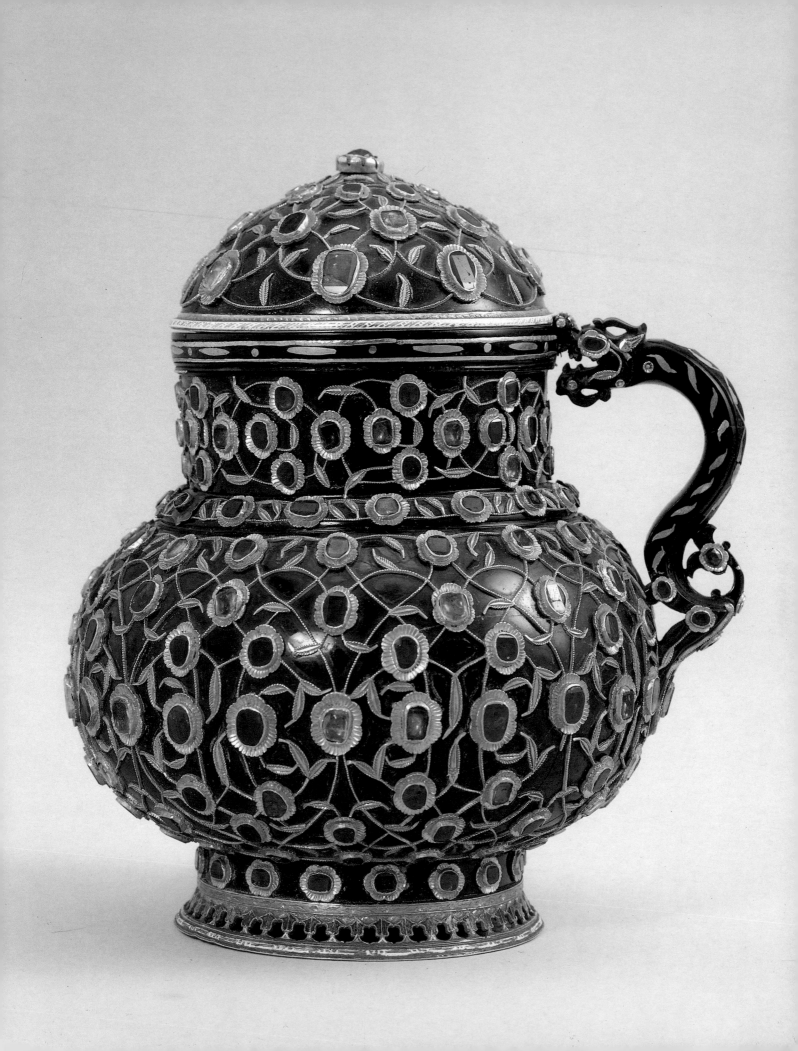

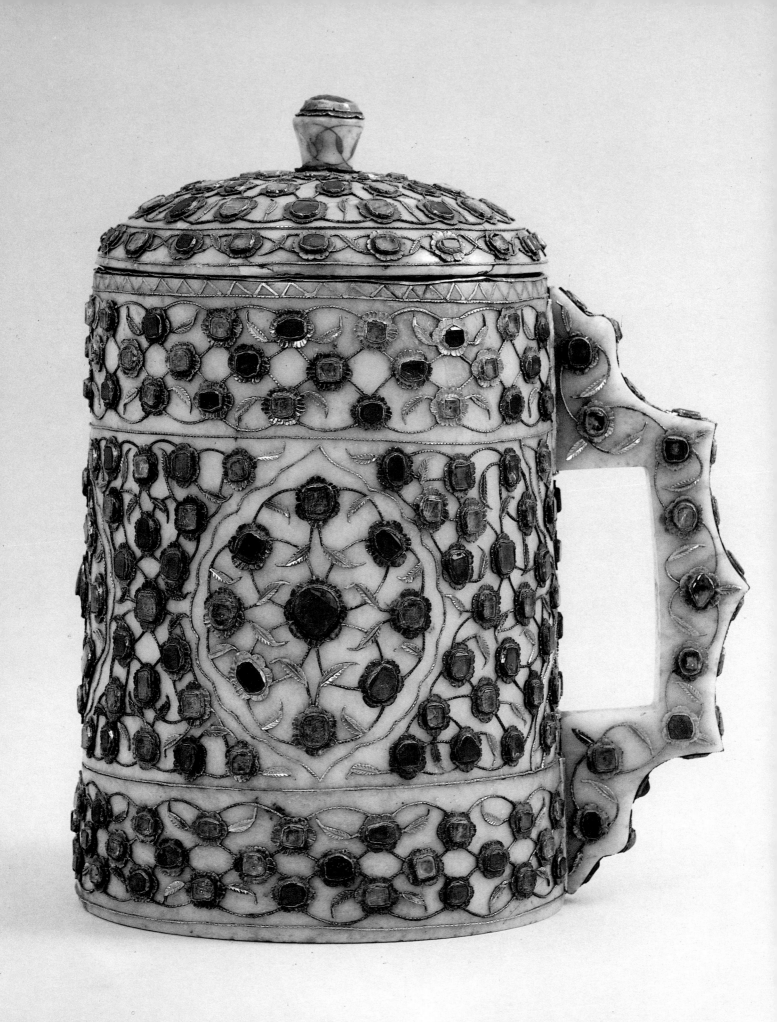

72

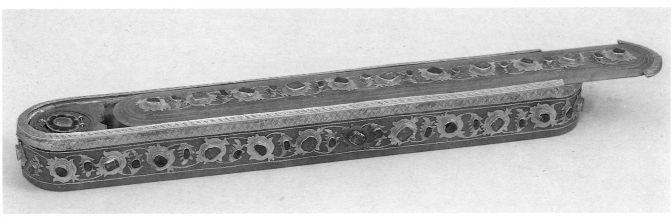

73

72 Jade tankard

Late 16th century

H. 17.7 cm

TKS 2/3832

Literature: Istanbul 1983, E. 207, and illus.; Köseoğlu 1987, pl. 53;
 Washington 1987, no. 66

The tankard, with an angular handle, is made from a single piece of pale green jade and has a knobbed domical lid. The outside is thickly encrusted with alternate rubies and emeralds in gold collar mounts with petal surrounds and chased gold stems and leaves to create a floral scroll. All of the stones are table-cut except the large central rubies in the medallions which are rose-cut.

The interior is lined with plain gold sheet. The underside of the lid and the inset base are covered with finely chased gold tracery of interlaced arabesques about a central ruby in a collar mount. The shape of the tankard and its angular handle derive from leather prototypes. It is frequent in pottery, and a blue and white 'Abraham of Kütahya' tankard in the Çinili Köşk shows that it was already popular by the early sixteenth century. Many pottery tankards even have imitation stitching down the side of their handles, making their debt to leather models quite clear.

73 Penbox

c. 1600

L. 27 cm

TKS 2/2111

Literature: Istanbul 1983, E. 205; Washington 1987, no. 67

The penbox, which is small and oblong with a sliding lid in a finely chased gold frame, is of greenish-brown stone, probably agate or jasper. It is encrusted outside with a frieze of scrolling lotus and feathery leaves in gold, with chased details, each set with a table-cut emerald or ruby in a collar mount. The lotus and leaf surrounds to these mounts are unusual and are mostly restricted to Ottoman decoration for Chinese porcelains, for example, no. 75. At one end of the penbox is a tray holding in place an ink-pot of base metal fitted with a gold lid set with a table-cut emerald amid eight petals filled with translucent red enamel in *basse taille*.

Encrusted porcelains (nos 74–7)

To judge from pieces datable by Chinese reign marks in the Topkapı collections the extant inlaid or encrusted porcelains are mostly of the late sixteenth or early seventeenth century, and many of the mounts are far later.[1] There are practically no references to them before the palace inventory of 1680–1,[2] but increasingly frequent mentions in eighteenth-century archival documents may indicate not an increase in their manufacture but their fall from imperial favour, which made them acceptable gifts to the royal ladies on their marriage, for example. It was the rule that their dowries would return to the palace, but it was obviously safer to send out of the palace only objects which were not the most highly regarded.

The Ottomans seem to have been the only later Islamic dynasty to have mounted or encrusted porcelains. There is no literary evidence that they were to either Mamluk or Mughal taste, and the extant pieces in the Ardebil collection are all innocent of such sophistication.[3] There are a few pieces of Iznik pottery which must have had mounts or armatures too,[4] but the reason why porcelains were almost invariably selected for this treatment is that their hardness and brilliance brought them closer to hardstones in Ottoman eyes. Moreover, if most of them were made by Süleyman's successors, their appearance was largely determined by earlier encrusted jades or rock-crystal. The parallel with Renaissance and Mannerist Europe is striking, although Spallanzani[5] has properly remarked that in the general context of the luxury crafts at the Medici court what porcelains there were were held to be of such minor value that the mounts were essential to bring them up to the standards of the more splendid creations of jewellers and goldsmiths like Cellini. The relatively high survival rate in the attics and lumber-rooms of Europe of Chinese porcelains stripped of earlier mounts is testimony that the porcelains were regarded as of much less value, for the mounts could at least be

melted down. However, although it is indisputable that in many cases the Ottoman mounts, in actual fact as well as in intention, enhance Chinese porcelains of mediocre appearance or importance, the approach is very different, and it would be difficult to trace any connection between the attitudes of, say, Murad III and Rudolf II or Süleyman and his Medici contemporaries.

1. Julian Raby and Ünsal Yücel, 'Chinese porcelains at the Ottoman Court' in Krahl 1986, 27–54; Ünal 1963, 674–714.
2. TKSA D. 12a, 12b.
3. Pope 1956.
4. The mounts have been removed, of course. For a sawn-down flask with drilled holes for a gold armature, or possibly for individually set gems in gold mounts cf. Istanbul 1983, E. 165; and for a flask in the Godman Bequest in the British Museum with drilling which has now been filled in cf. Rogers 1984, 24–35.
5. Spallanzani 1978, 126.

74 Porcelain penbox

c. 1500 (porcelain); Ottoman, late 16th century (workmanship)
L. 27 cm; W. 7.7 cm; H. 7.5 cm
TKS 2/894
Literature: Hobson 1933–4, pl. IX; Ünal 1963, pl. 9; Krahl 1986, no. 666; Washington 1987, no. 68

The oblong penbox, with a slightly domed lid, not originally hinged, is based on a fourteenth-century Islamic metal shape and is decorated with a frieze of scrolling lotus flowers with wave and rock scroll borders (cf. penbox of similar date painted with different lotus scroll, Tokyo, Idemitsu Art Museum, 1981, pl. 837). The outside is encrusted with chased gold wire and small leaves following the lotus stems, and table-cut rubies in collar mounts with petal surrounds in the centre of

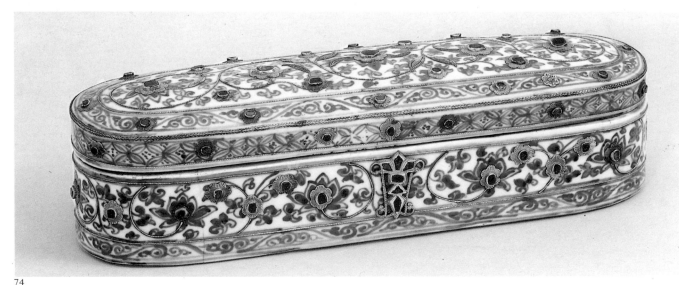

74

each lotus. A gold hasp set with emeralds and rubies is probably of later date. The mount missing from one lotus on the front of the penbox reveals a deep circular drilled hole to which the gold mount was fixed.

The interior is divided into compartments for writing utensils, with Ottoman fittings for a sand pot, with pierced domed jade lid, of gold sheet engraved with floral motifs; a companion pot for silk floss (to mop up surplus ink), also of engraved gold sheet, but with a hinged gold lid set with rubies; and a large ink-pot with a grey-green jade top in lotus-bud shape, inlaid with gold arabesques, and a small central hinged lid set with a ruby.

The underside of the lid is painted with heavy gold tracery of floral arabesques at the ends and in the centre over painted blue and red dots. The closest porcelain mounts in style are on a small blue and white cup (TKS 15/2887, Krahl 1986, no. 1828) of the late sixteenth century.

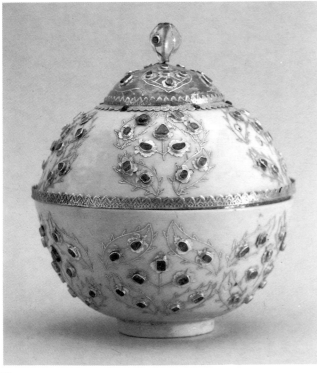

75

75 'Box' formed of two bowls remounted together

1550–1600 (porcelains); Ottoman, late 16th century (mounts)
DIAM. 15 cm; H. (overall) 17.5 cm
TKS 15/2767
Literature: Istanbul 1983, E. 214; Krahl 1986, no. 1784; Washington 1987, no, 69

The interior of the lower bowl with a square character mark, *Jing zhi* ('exquisitely made'), datable 1550–1600, is plain but for a peony medallion with a white bloom among blue leaves in the centre with traces of gilding (cf. Krahl 1986, no. 1255),

and is probably Ottoman. The interior of the upper bowl, which is late sixteenth century in date, has a landscape medallion at the centre with fishing boats under an overhanging willow-tree; its sides are relief-moulded with lotus medallions.

The exteriors of the bowls bear foliate medallions inlaid in chased gold wire set with rubies, the lower bowl also bearing traces of gilding round the rim and foot. The upper bowl has a scalloped gold rim and a finial, inlaid with gold and gems, composed of a faceted knob and a convex rock-crystal disc overlying paper painted in gold, red and blue.

76 Ewer

Early 15th century (porcelain); *c.* 1600 (mounts)
H. 33 cm
TKS 15/2944
Literature: Krahl 1986, p. 24, no. 633; Washington 1987, no. 70

The ewer, which is pear-shaped, has a curved spout joined to the neck by a cloud-shaped strut and a curved handle with a lug above. It is plain white and incised with a scrolling hollyhock and *lingzhi* ('magic mushroom') around the neck and above the foot. (Cf. ewer of similar shape and date but with the hollyhock design in underglaze blue (TKS 15/1368, Krahl 1986, no. 617).)

The gold Ottoman rim mount and hinged domed cover are

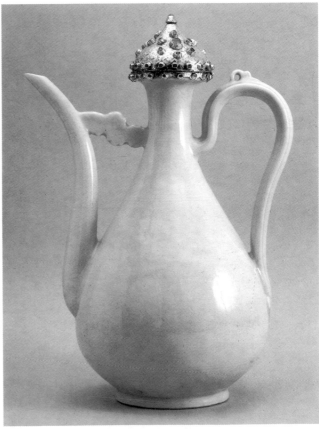

76

engraved with fine feathery leaves and encrusted with rubies in collar mounts. There is a separately worked finial set with a turquoise (cf. the rock-crystal and gold jug, no. 68, *c.* 1600). The neck of the ewer has a silver-gilt lining into which the cap fits tightly by means of a hollow cylinder.

77 Ewer

14th century (porcelain); *c.* 1600 (mounts)
H. (incl. stopper) 20.5 cm
TKS 15/663
Literature: Istanbul 1983, E. 131; Krahl 1986, no. 219; Washington 1987, no. 71

The ewer, which has a pear-shaped body and two flattened circular sides, is decorated on one side with Xi Wang Mu mounted on a flying crane in clouds and a boat on waves on the other. A ewer decorated in a similar relief technique belonging to the Cultural Conservation Committee, Nanjing, was excavated from a tomb of 1418 outside Nanjing (cf. *Longquan qingci* 1966, pl. 65).

The handle, spout and cover are missing; the neck has been cut down, the ewer being converted into a flask (*matara*, *maṯhara*) by the addition of two engraved curved silver-gilt spouts and a domical stopper with a coral-bead finial. Chains linking the spouts and the stopper end in a hook.

Mirrors (nos 78–80)

78 Mirror

c. 1520–30
H. 30 cm; DIAM. 14 cm
TKS 2/1801
Literature: Istanbul 1983, E. 81; Washington 1987, no. 72

The circular mirror is set in a fine scalloped iron or steel surround, and mounted on a faceted dark green jade handle with a bulbous fluted knob and flower finial at the tip. The border around the mirror has gilt decoration set with alternate turquoises and cabochon rubies in claw mounts. The metal back of the mirror is damascened in gold with medallions, cartouches and lobed triangles, radiating from a central six-pointed star, all filled with cloud-band motifs, on a ground of damascened arabesques. Cabochon rubies and turquoises, set in collar mounts with small claws, punctuate the surface. The border is of panels of somewhat narcissistic Persian *nastaᶜlīq* verse (kindly read by M.I. Waley of the British Library) comparing the mirror to the haughty beauty who ravishes the soul of whoever looks upon it.

There is a steel mirror with very similar decoration in the Metropolitan Museum of Art, New York (Berlin 1982, no. 109) which may perhaps be from the same workshop.

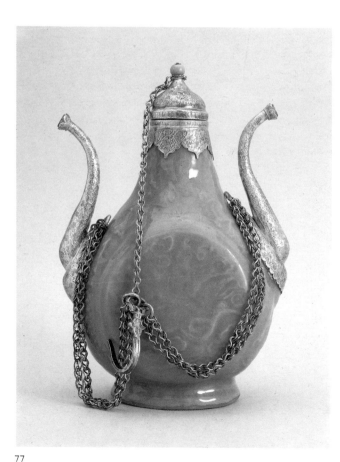

77

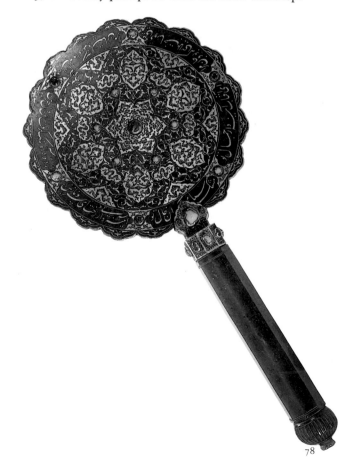

78

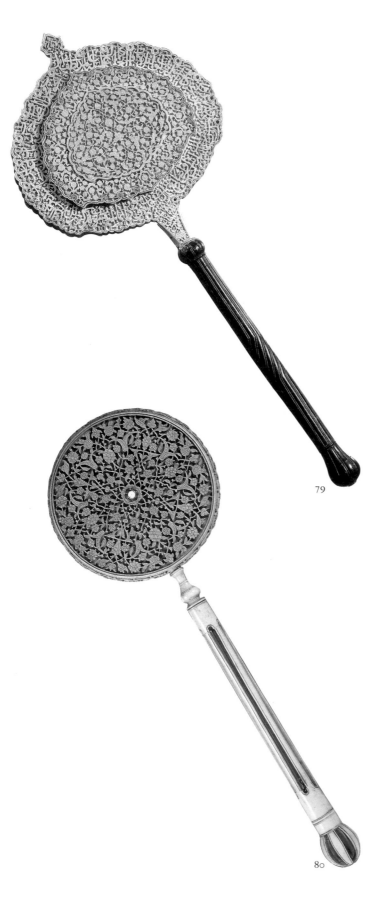

79

80

79 Mirror

Dated 950/1543–4

TKS 2/2893

H. (overall) 30.2 cm; mirror 14 × 12.2 cm

Literature: Paris 1953, no. 188; Istanbul 1958, no. 73; Washington 1966, no. 216; Istanbul 1983, E. 88; Köseoğlu 1987, pl. 117; Washington 1987, no. 73

The glass mirror is set in ebony and held in place with ivory plaques, secured by small gilt nails. The border around the mirror is inlaid with looped gold wire. The long handle is of carved and turned fluted ebony. The back of the mirror is made up of superimposed plaques of ivory, all with bracketed borders, fixed by gilt nails. The carved decoration is on three levels: a central formal interlace of chinoiserie flowers; a surround of scrolling flowers and cloud bands; and a carved inscription border with three couplets of Ottoman verse, a dedication to Süleyman, by the craftsman, Ghanī (Ǧanī), and the date 930/1533–4, all on a scrolling ground. Each of the bracketed borders has thin edging of organic paste, green or dark blue.

80 Mirror

Later 16th century

H. 31 cm; DIAM. 10 cm

TKS 2/1804

Literature: Istanbul 1983, E. 89; Frankfurt 1985, no. 10/1; Washington 1987, no. 74

The ivory frame is carved with interlaced arabesques. The ivory back is deeply carved with a formal interlace of flowers, leaves, lotus blossoms and split-palmettes radiating from a central rosette set with a turquoise in a gold collar mount with a petal surround. The long hollow ivory handle and knob contain remains of small links, which suggest that there was once a carved ivory chain strung between them. The inset glass is now missing.

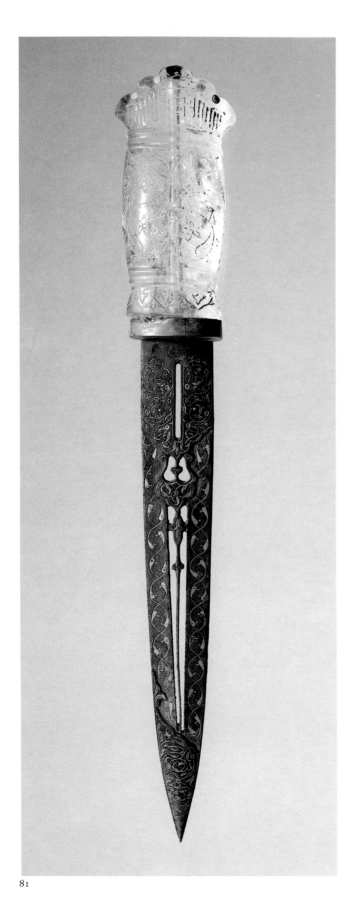

81

Arms and armour (nos 81–96)

81 Dagger

Dated 920/1514
L. 31.5 cm
TKS 2/254
Literature: Washington 1966, no. 237; Istanbul 1983, E. 80; Washington
1987, no. 91

The dagger has a rock-crystal hilt, engraved and inlaid with gold floral decoration, and blued-steel blade, finely damascened with gold arabesques and floral scrolls, and was originally set with eight turquoises and a ruby. Both sides of the pommel bear an inlaid square and inscriptions. On one side are the words *tārīḫ sene* ('the date is the year'), with a square beneath it, divided four by four with each line containing one of the letters Ş K R T. In *abjad* these letters give the numerical total 920. To either side of the square is *mālik al-mulk* ('possessor of the kingdom') in mirror script. On the other side of the pommel are the words *fatḥ-i ʿAcem* ('[of] the conquest of Persia'), with a similar square beneath it, containing the letters A L L H, giving the *abjad* total 66, and *mālik al-mulk*, again in mirror script. On top of the pommel are three letters M Y M, also in mirror script, with the numerical value 90. *Tārīḫ sene-[i]: fatḥ-i ʿAcem* is an evident reference to Selīm's victory over the Safavids at Çaldıran (920/1514), and the dagger hilt was therefore ordered to commemorate it. Otherwise the interpretation of the inscriptions and letters is unclear. The letters of the two Ş K R T:A L L H squares may have been intended to recall a formula of 'thanks to God', properly *al-shukr li'llāh*, in which case the number 66 is a red herring. M Y M is, however, completely obscure.

82 Mace

Late 16th century
L. 72 cm
TKS 2/715
Literature: Washington 1987, no. 85

The mace, which is cast-iron with a long handle and bulbous head, is entirely covered with gold sheet with floral scrolls, and set with turquoises and cabochon rubies (the cut rubies are probably replacements). The gold sheet has been applied in section previously beaten over a mould; flattened gold wire outlines the decoration and disguises the joins. The stones are set in petal-like collar mounts. The top of the mace is decorated with thin sheets of turquoise in gold cloisons (*fīrūzekārī*), a technique derived from Safavid Iran.

Maces are shown carried by senior officers in war and on the hunt, and by Süleyman himself in illustrations to the *Süleymānnāme* (no. 45). They were also ceremonial, and bejewelled maces like this one must have been primarily for show.

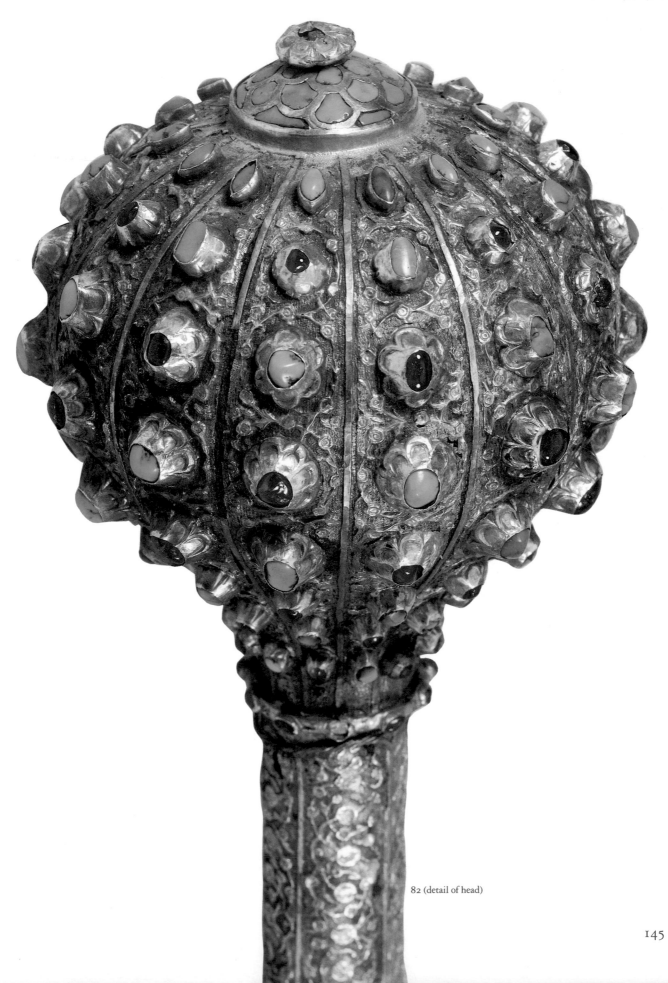

82 (detail of head)

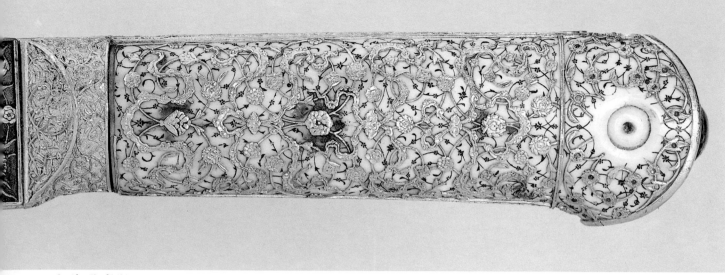

83 (detail of hilt)

83 Sword of Süleyman the Magnificent

Dated 933/1526–7
L. 66 cm
TKS 2/3776
Literature: Munich 1910, no. 148; Istanbul 1958, no. 69; Ünsal Yücel
1964–5; Istanbul 1983, E. 85; Köseoğlu 1987, pl. 82; Washington 1987,
no. 86

The hilt is of ivory engraved with a scroll of blossoms inlaid with black mastic, overlaid by a chinoiserie flower scroll and cloud bands in gold. The pommel is lacking the central gem, but the delicate lotus scroll is set with tiny rubies: on top is a silver-gilt boss set with a large turquoise. The guard is gold, worked in repoussé.

The steel blade bears a damascened relief *thulth* inscription continuing over both sides with an Arabic dedication to and Chancery titulature of Süleyman (given in full in Istanbul 1958, no. 69), and the date 933/1526–7; intermediate decoration consists of finely chased lotus scroll and arabesques or animated scroll with the heads of lions, dragons, monkeys,

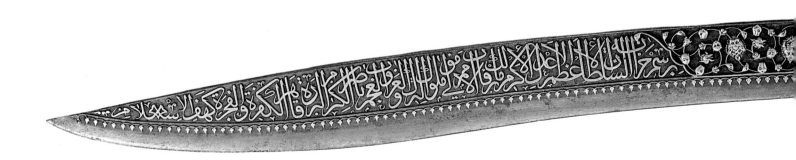

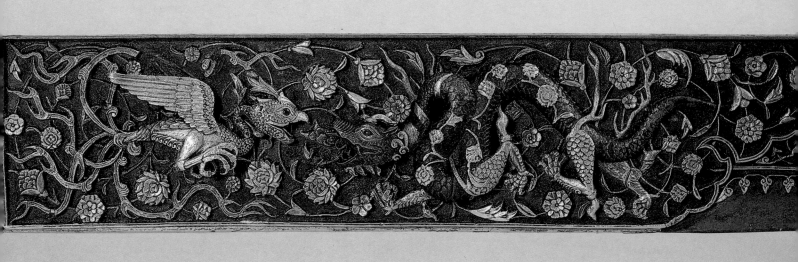

83 (detail of blade)

etc.; and, nearest the hilt, a phoenix and dragon in combat, different on each side of the blade, set over encrusted forms of finely chased Timurid chinoiserie lotus scrolls. The two pairs of creatures are iron or steel, blued or parcel-gilt, and were evidently cast or forged separately, set with rubies for their eyes, then nailed to the blade – virtuoso work of unparalleled complexity in Ottoman and Safavid art. Curiously, on each side the phoenix and dragon combat is upside down with respect to the inscription.

The spine of the blade bears Persian verses in *nastaʿlīq* and the signature of the craftsman, Aḥmed Tekelü. Karabacek (1913) has plausibly argued that his *nisba* associates him with the Teke Turcoman, part of the Kızılbaş confederation, who in the early sixteenth century were established near Meshed, and that he must have been one of the craftsmen brought back from Tabriz by Selim in 1514, although his name does not appear in any of the extant registers. The sword anyway gives a good idea of what Süleyman's 'ʿAcem' goldsmiths must have been making for him in the early part of his reign.

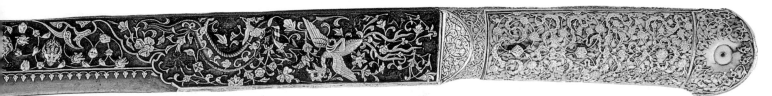

83

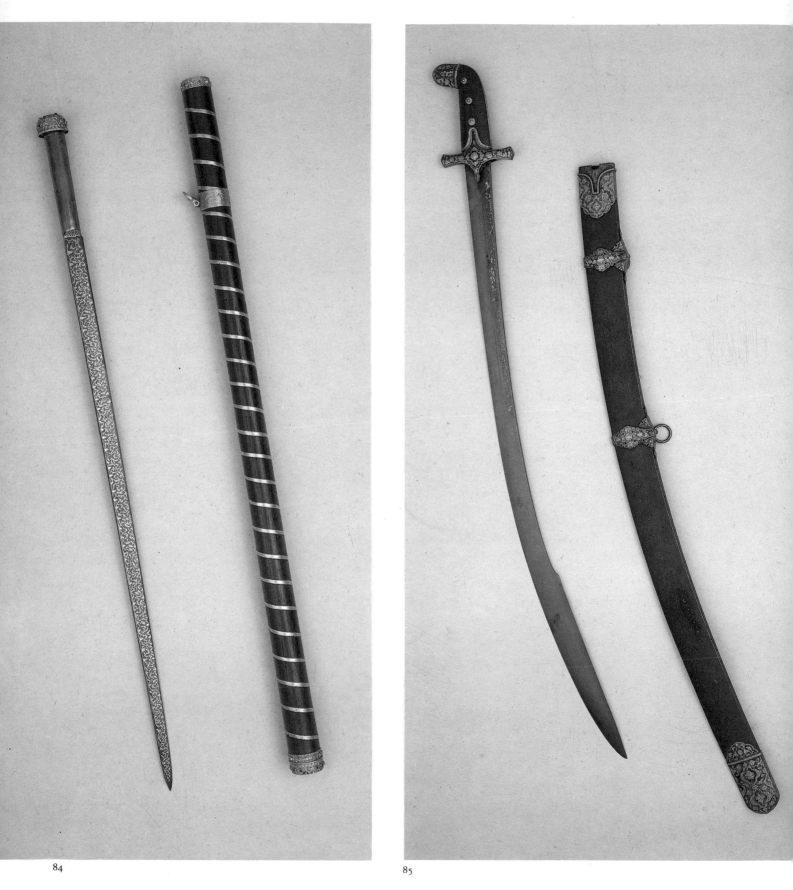

84 Sword

Dated 938/1531–2

L. 73 cm; scabbard 73.5 cm

TKS 1/74

Literature: Paris 1953, no. 51; Washington 1987, no. 87

The sword (*meç*) has a narrow, straight, steel blade, gold-damascened on one side with cloud bands, and inscribed on the other with Koran LXV, 2–3, other prayers (*du'ā*), and a dedication for the treasury of Sultan Süleyman in Constantinople in 938/1531–2. The spine of the blade bears gold floral motifs. The cylindrical steel hilt is plain but for damascened arabesques and cloud bands in reserve where it joins the blade. The gold pommel, decorated in repoussé with a palmette frieze around the sides, and with a six-petalled star on top, is finely chased and set with cabochon rubies and turquoises in collar mounts. The sword has a cylindrical wooden scabbard, wound with a thin strip of gold, and a simply chased sling mount. There are jewelled gold mounts at the tip and the collar of the scabbard to match the pommel.

85 Sword

c. 1550

L. 93.8 cm; scabbard 87.8 cm

TKS 1/463

Literature: Istanbul 1958, no. 51; Washington 1987, no. 88

The sword (*kılıç, kılınc*) has a curving steel blade, with gold-damascened inscriptions on each side, from Koran LXV, 2–3 (cf. no. 84), and a dedication to Sultan Süleyman. The hilt is faceted and its leather covering is secured by three gold rosette studs down each side. The pommel, of blackened steel faceted like the hilt, is damascened with gold cloud and floral scrolls slightly in relief and finely chased. The quillons are similarly decorated. The scabbard is of wood, leather-covered with blackened steel chapes and sling-mounts damascened in gold to match the pommel and quillons of the sword.

86 Sword

c. 1550

L. 93.8 cm; scabbard 87.8 cm

TKS 1/294

Literature: cf. Zaky 1979; Alexander 1983; Washington 1987, no. 89

The sword (*kılıç, kılınc*) has a curving steel blade and is gold-damascened with a badly abraded inscription, now illegible. The hilt is faceted and its leather covering is secured on each side by a fish with gold scales held in place by two small nails, one of which is its eye. The pommel is of blackened steel edged with openwork, faceted like the hilt, and gold-damascened with arabesques, cloud scrolls and four inscription cartouches with a Persian distych in *nasta'līq* set with turquoises. The quillons have gold-damascened cloud bands and arabesques on each side, above a finely damascened lotus and peony scroll, flush with the steel. The leather-covered scabbard has steel chapes and pierced sling-mounts, with damascened cloud bands and arabesques to match the hilt. The fish recur on swords of the period, but their symbolism is unclear.

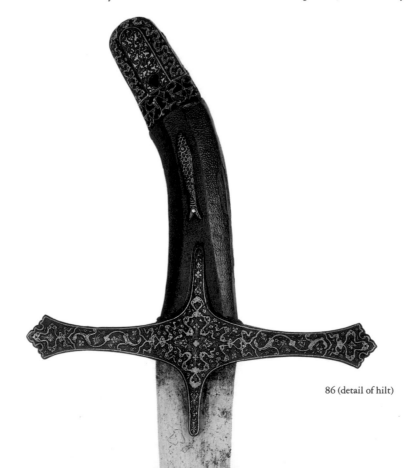

86 (detail of hilt)

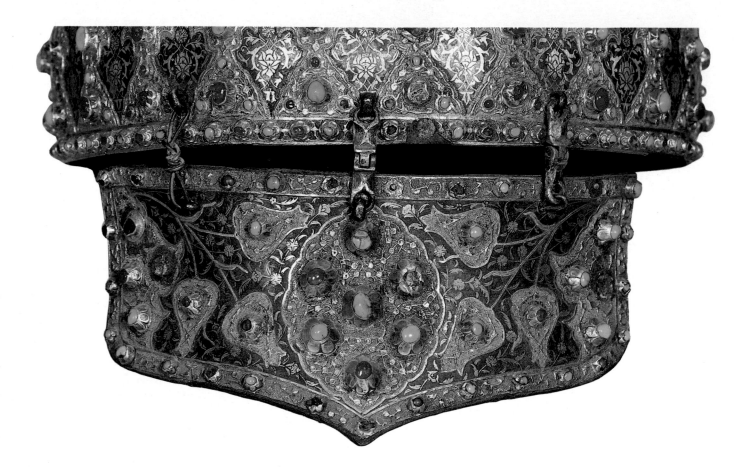

87 Parade helmet

Late 16th century

H. 28 cm

TKS 2/1187

Literature: Tezcan 1975, p. 22; Istanbul 1983, E. 219; Köseoğlu 1987, pl. 37;
 Washington 1987, no. 84

The conical helmet, with nasal, visor and neck guard, is of
iron or blackened steel, lavishly embellished with gold, and
encrusted with turquoises and cabochon rubies. The gold
medallions and palmettes appear to have been beaten into a
mould to produce their repoussé floral scrolls, before being
applied to the iron surface, which was first roughened to hold
the gold more securely. The damascened ground is of fine
sprays of blossoms, lotuses and cloud scrolls, with sprays of
tulips on the neck guard. The helmet is uninscribed. (For a
helmet from Schloss Ambras in the name of Sokollu Mehmed
Paşa, *c.* 1570–1, in the Vienna Waffensammlung cf. Grosz
and Thomas 1936, 96, and Sacken 1855, 210–11.) The
helmet is closely related in technique and decoration to the
mace (no. 82).

87 (detail of neck guard);
whole helmet illustrated on p. 12;
opposite 87 (detail)

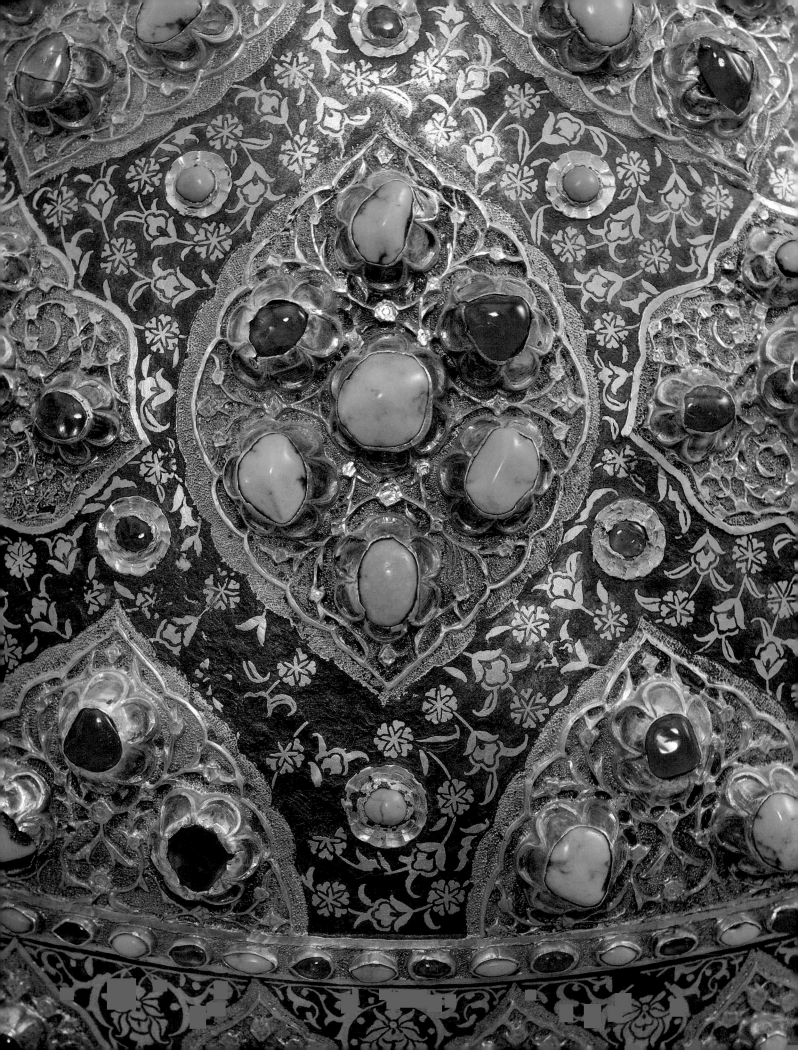

Thumb-rings (nos 88–9)

Archers' thumb-rings were for the thumb of the right hand, to enable the archer to make a cleaner shot with the bow, allowing the maximum force behind the arrow. When released, the string would slide smoothly off the jade surface, with minimal friction. Archers' thumb-rings have a long history, but some of the most elaborate and finely decorated were produced for the Ottoman court. They were as much for show as function, and were worn or hung from the belt during ceremonial occasions. Tavernier (1684, 57) mentions that they could also be used when executing disgraced officials to tighten a handkerchief wound round the throat.

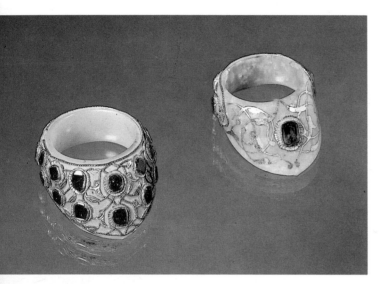

88 (left), 89 (right)

88 Thumb-ring

Later 16th century
DIAM. (max) 4 cm
TKS 2/74
Literature: Istanbul 1983, E. 217; Washington 1987, no. 95

The thumb-ring is of white jade, encrusted with a chased gold floral scroll, the flowers of which are table-cut rubies in collar mounts with petal surrounds. At the rear is a cabochon emerald.

89 Thumb-ring

Later 16th century
DIAM. 4 cm
TKS 2/83
Literature: Istanbul 1983, E. 218; Washington 1987, no. 96

The thumb-ring is of pale green jade, inlaid in front with gold arabesques flush with the surface of the jade, and a table-cut emerald in a collar mount with a petal surround. At the rear is a gold floral scroll in relief, with table-cut rubies in collar mounts with petal surrounds.

Shields (nos 90–4)

These shields are made from successive hoops of wicker bound with different coloured (silken) threads. They radiate out from a central wooden disc covered on the outside by a steel boss. The inside lining is of stuff glued to the wicker. Studs pierce the shield to secure the handgrip and shoulder straps, the former backed by a cushion to buffer the hand against a direct blow to the shield. The decoration, which can be elaborate and colourful, may be enhanced by metal thread, either gold or more often silver (now tarnished) over a yellow silk core. The steel may bear sun motifs or spiral flutes. The most elaborate example shown here (no. 90) is covered with repoussé gold sheet and encrusted with gems, and was evidently a parade shield. However, such decorated shields appear in battle scenes in illustrated manuscripts of the Timurid, Akkoyunlu, Safavid and Ottoman periods. Despite their flimsy appearance they were highly effective: the central boss would cause arrows to glance off, while the wicker was the only efficient way of stopping direct hits from the composite bow which could pierce steel and which for most of the sixteenth century remained a far more efficient weapon than firearms.

90 Shield

c. 1530–50
DIAM. 59.5 cm
TKS 1/2466
Literature: Washington 1987, no. 98

The shield is decorated with triple-spotted cloud bands and Persian *nasta'līq* verse cartouches, in coloured silks and metal thread. The steel boss is gold-plated, with an omphalos, and worked in repoussé with medallions containing floral scrolls and animals on a stippled ground, and encrusted with turquoises and cabochon rubies in collar mounts. The rich decoration bespeaks the work of a Safavid master. The lining is purple velvet, and the handgrip is strung with green-yellow cord. The edge of the shield has a leather guard underneath.

91 Shield

Later 16th century
DIAM. 59 cm
TKS 1/1930
Literature: Arseven, fig. 592; Paris 1953, pl. 8; Istanbul 1983, E. 104; Washington 1987, no. 99

The shield has an outer wide band of interlocking palmettes, alternately black and white, filled with a lotus and peonies in silk and gold thread. An inner band contains a stilted *naskhī* Koranic inscription (XLVIII, 1–3), divided by eight quatrefoils containing the word 'Allāh'. The metal boss has a spirally fluted design with alternate flutes gold-damascened. The other flutes are silvered, and have regular roughened patches (probably left by the mounts for encrusted gems). The studs are of gilt steel, and the lining is of violet velvet.

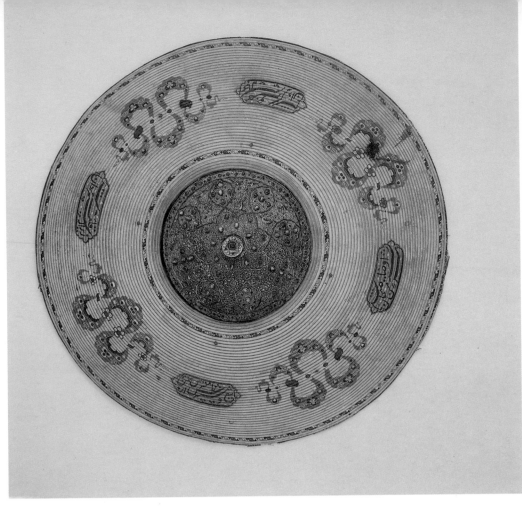

90

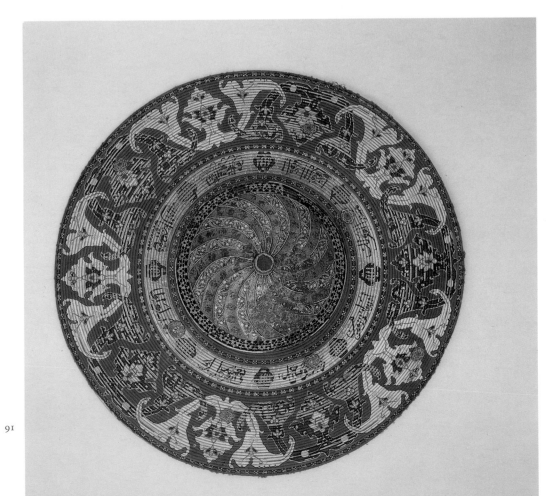

91

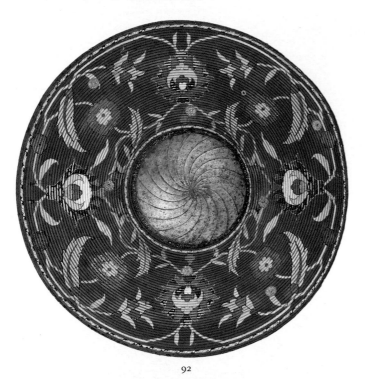

92

92 Shield

Later 16th century
DIAM. 62 cm
TKS 1/2441
Literature: Istanbul 1983, E. 105; Washington 1987, no. 100

The shield is decorated with lotus flowers and feathery leaves in coloured silks and metal thread. The steel boss is spirally fluted, bordered with a small *naskhī* Koranic inscription (II, 255) and originally bore gold damascening all over. The lining is of red velvet.

93 Shield

Later 16th century
DIAM. 64 cm
TKS 1/2571
Literature: Washington 1966, no. 234; Mackie 1980, illus. 220; Istanbul 1983, E. 227; Washington 1987, no. 101

The shield is decorated with alternating carnations and tulips in coloured silks and gold thread. The steel boss, which was originally gold-damascened, has a raised central ten-pointed sun motif. Eight gilt-metal studs in the form of rosettes help to secure the lining of dark red velvet.

94 Shield

c. 1550
DIAM. 62 cm
TKS 1/2597
Literature: Istanbul 1983, E. 226; Washington 1987, no. 102

The shield is decorated with three large lotus blossoms in coloured silks and silver thread, alternating with spotted cloud bands on a field of triple spots treated as crescents. The steel

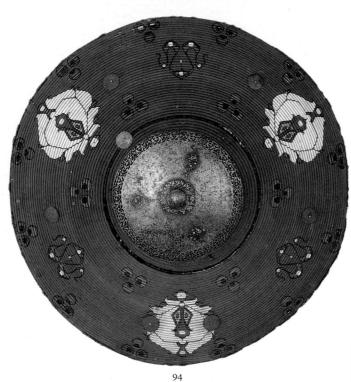

94

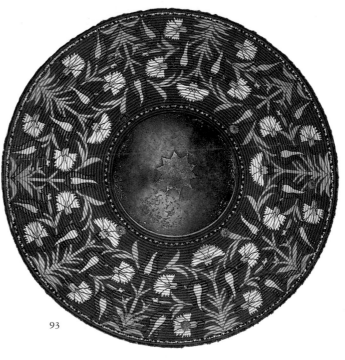

93

boss has a central omphalos and openwork arabesque border, originally with an all-over gold-damascened decoration of which only a frieze of gilded arabesques and three pointed medallions around it survive. The lining is pink silk decorated with medallion rosettes and triple spots in silver thread (which has been wound around yellow silk to give the appearance of gold) and coloured silks.

95 Bow case

c. 1550–70
74 × 34 cm
TKS 1/10989
Literature: Paris 1953, no. 23; Tezcan and Delibaş 1986, pl. 92; Washington 1987, no. 103, and refs

The red leather bow case is covered in dark red velvet with appliquéd embroidered decoration of arabesque medallions. Triple crescents scattered over the red velvet ground and a border of triple crescents are similarly treated. Straps are attached by silver-gilt studs worked in repoussé.

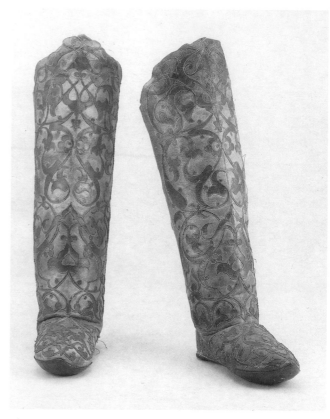

96

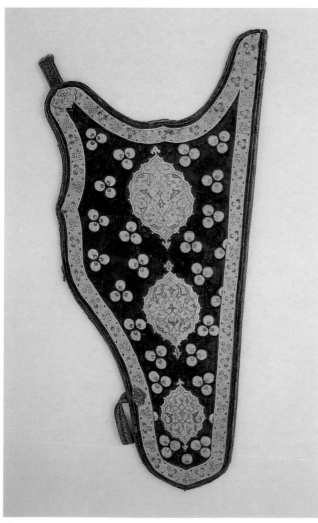

95

96 Boots

c. 1560
H. 53 cm
TKS 2/4447
Literature: Paris 1953, no. 448; Atasoy 1969, p.6, fig 1; Denny 1981, no. 137; Istanbul 1983, E. 108; Washington 1987, no. 106

The boots, of light brown leather, lined with faded pink silk, are decorated with an appliqué mosaic of arabesques and palmettes in red leather bordered with oversewn twisted silver threads. The seams run up the inside leg and around the ankle. The boots would have come over the knee in front, where the leather is cut higher. According to the palace registers they belonged to Selim II (d. 1574).

This leather appliqué was evidently a speciality of the palace shoemakers who number nine in the *mevācib* defter of 1545. There is a pair of very similarly decorated boots, though with armoured heels and toe-caps, shown along with Ottoman saddles, weapons, a long pipe and similarly appliquéd bow cases in an anonymous print at the end of the *Actiones* of Sigismund von Herberstein (Vienna 1560), who had just returned from a mission as Habsburg ambassador to Istanbul. They were evidently gifts presented to him by the Sultan or the viziers. Herberstein was proud enough of them to have them illustrated, differently arranged, in his *Commentari della Moscovia*, the Italian translation of his memoirs of his Russian travels (Venice 1560).

7 Furniture and woodwork (nos 97–101)

The solid forms and brilliant surfaces of Ottoman furniture in the age of Süleyman the Magnificent represent a high point in the history of woodwork. Its origins are somewhat mysterious. Anatolia, being rich in wood, had an ancient tradition of woodworking, though, in contrast to medieval Syria and Egypt, rather than joinery or turned wood screenwork (*mashrabiyya*), it was customary to use solid fine hardwood panels. Yet, while the favourite angular interlacing strapwork, the so-called Mamluk *Kassettenstil*, was much employed for shutters and door panels even in Süleyman's reign, there is a clear break between Seljuk and Ottoman woodwork in both style and workmanship.

Part of the problem is that there is relatively little extant material to enable us to trace technical or stylistic evolution. The Ottomans had, in general, less need of furniture than their European contemporaries, with their tables, chairs, desks, chests and beds, the apparatus of Carpaccio's *Dream of St Ursula*, for example, but it would be easy to exaggerate this, and the illustrations, for example, to, the *Süleymannāme* (no. 45) or the Shah Ṭahmāsp *Shāhnāme* demonstrate that their palaces were far from empty.[1] Clearly much must have been destroyed in the periodic fires which swept the palaces, so that what has survived is mostly in mosques or mausolea, either carpentry like the doors of Süleymaniye with substantial remains of boxwood and ebony inlay or the combined cenotaph and canopy still in place in the mausoleum of Şehzade Mehmed at Şehzadebaşı in Istanbul dated 950-1/1543–5, or else liturgical furniture like the preacher's chair (*vāʿiẓ kürsüsü*) in Süleymaniye with conspicuous vase-shaped finials like the knob of the domed Koran chest from the tomb of Selim II (no. 101). The rest of the original furniture of Süleymaniye has not survived, and the splendid *minbar*, although much indebted to wooden forms is in Proconnessian marble, as was Ottoman Imperial custom.

The most important form of liturgical furniture was probably the Koran-chest, one which was particularly developed in Mamluk Egypt and which is now especially associated with imperial mausolea. The earliest chests appear to be early fourteenth century, of inlaid brass, and are associated either with a number of ancient Korans much revered as having been written (or so it was believed) by the earliest Caliphs and which were, thus, famous relics; or with Korans written in parts (*juz', ajzā'*), generally either seven or thirty, associated with the standard instructions to Koran readers who were generally appointed to the staff of funerary foundations to read so many *juz'* per day or month for the dead founder. This largely explains their shape, as well as their generally elaborate decoration: they were not intended to be boxes for assorted books, which would have been housed in wall-presses in the usual way. Technically, moreover, although the materials used in Mamluk woodwork were of much lower quality, Ottoman craftsmanship owed much to it. A tall Koran chest and hexagonal Koran box from the mosque of Umm al-Sulṭān Shaʿbān in Cairo[2] (founded in 770/1369),[3] with inlay in ivory, bone, ebony and other woods and metal wire, are very similiar to a tall Koran chest in the Türk ve Islam Eserleri Müzesi (no. 4669) from the tomb of Çoban Mustafa Paşa at Gebze, who was governor of Egypt for a few months in 1522. His foundation was inaugurated the following year, and the chest must either have been made for him in Egypt or have been an antique which he brought back with him. He was married to a daughter of Selim I and was thus a stepbrother-in-law of Süleyman, and may well have used his social position to make use of the services of the Egyptian craftsmen deported by Selim to Istanbul in 1517 before their return to Cairo.

Although the Egyptian Mamluk connection was to remain of importance in the evolution of sixteenth-century Ottoman chests, technically speaking the Ottoman tradition was already established in the superlative hexagonal walnut chest for a thirty-part Koran for Bayazid II made in 911/1505–6 by a maker of musket stocks, Aḥmed b. Ḥasan-i Kālibī. The exterior was veneered with ebony and encrusted with carved ivory panels and insets of fine marquetry work of boxwood, ivory, ebony and metal wire.[4] This is the earliest dated piece of furniture in Ottoman style, but a walnut quiver, probably contemporary, is similarly veneered and richly inlaid.[5] The craftsman's specialisation tells us a great deal, for it suggests that the style of inlay was derived from fine weaponry, or from musical instruments, which in Ottoman Turkey and Safavid Iran, no less than in Renaissance Europe, were the object of the finest craftsmanship, even if little of either survives from the sixteenth century and their achievements can only be deduced from the work of their successors.

Much of this woodwork is decorated in a combination of veneer and inlay, the interlocking designs being set into plaques, like the ebony decorative motifs inlaid in ivory plaques on the Koran stand (no. 98). This is more wasteful and presupposes no shortage of fine materials, but the result is less likely to warp. Even complex angular interlacing designs were simpler to carve and lay than the cursive designs, which may explain their increased popularity during the second half of the sixteenth century. The maker of the Koran box (no. 99) actually resorts to a paste filler, painted to blend with the wood, for the more intricately curved inlaid elements. The pieces were fixed with glue. On some early pieces, such as the Koran box (no. 99), nails or dowels were also used; these were either disguised, being made of the same material as the veneer they were securing, or made of contrasting material to appear as decorative dots on the surface of the object. This technique seems to have been used to hold down the edges of the thinner veneers, which had a greater tendency to warp.

Minute marquetry of tiny pieces of wood, natural or green-

stained ivory, brass and silver, was not generally used for all-over decoration but was usually inset into the veneer in small hexagons or lozenges. However, borders of continuous Y-shapes, or meanders made of thin strips of wood, ivory and brass and silver wire, are regularly used to contain decorative fields.

The veneers were mostly on cores of walnut, although pear and other fruitwoods are documented. Walnut was later widely used for musket stocks but its fine qualities as a veneer wood do not seem to have been appreciated. Among the easily identifiable woods ebony was evidently the most popular, although Semiz ʿAli Paşa's request to Busbecq on his farewell audience for bird's-eye maple or 'other woods such as we use for inlaying tables' from Austria,[6] suggests that inlays and veneers may have been more varied even than on surviving pieces. For the compartments inside to take the Korans, sandalwood was often used (nos 99, 100) for its rich fragrance, although the interiors of domes were mostly painted. Among the materials for inlay ivory was initially pre-eminent and was also used as a veneer (see above, no. 98) both natural or dyed green or painted deep blue (for example, the inscription plaques of no. 99).

Other documented common inlay materials were boxwood (şimşīr), which was often reddish, Brazil-wood (baḳḳām, which was an important dyestuff too), mother-of-pearl, tortoiseshell, silver or gilt brass wires, and a variety of compositions or pastes, sometimes reddish, sometimes tinted to match other inlay, but sometimes glistening as if talc had been added, as on the meander-borders of the Koran chest (no. 101). Not all were used simultaneously. Tortoiseshell, although documented by Pierre Belon in Istanbul in the 1540s, who found daggers with sheaths of fine golden tortoiseshell plaques at about a ducat each,[7] does not seem to have become popular until after 1550; while mother-of-pearl is similarly late in its appearance, although by the later sixteenth century it had largely displaced ivory in importance. Inlay in tortoiseshell and mother-of-pearl is almost exactly similar to their uses in jewellery; tortoiseshell is laid over metal foil to give it lustre (compare nos 99 and 53a), while mother-of-pearl plaques are frequently inlaid with black mastic and encrusted with gems in gold mounts (e.g. no. 101), exactly as if they were belt plaques (cf. nos 55–6). This may be because they were considered to be more valuable when they were first introduced; or their lustrousness, which gave a different quality to Ottoman woodwork, may have seemed to need yet further lustre; or it could be sheer conservatism or lack of imagination on the part of the craftsmen, who were more concerned to borrow than to adapt.

The very substantial forms of this furniture and its use of solid ivory or veneered turned-wood vase-shaped finials (e.g. nos 97, 99) and architectural forms like the throne back with its ingeniously profiled and inlaid crenellations (no. 97), have no parallels in the Islamic tradition; the brilliance of its

carpentry and joinery may suggest borrowings from late fifteenth-century Italy, although much High Renaissance furniture was already far too Classical in appearance for its decoration to have had much effect on Ottoman Turkey. Certainly the veneer and intarsia with their brilliance and finish are of a quality to compare with wooden intarsias in north Italian cathedrals, for example, the work of Cristoforo da Lendinara in the Cathedral at Parma (1488–91), while the marquetry and its materials are sometimes closer to the products *alla certosina* of the Embriachi workshops of north Italy than to their joint prototype in Mamluk Egypt. However, if the workmanship is very comparable, the actual effects are quite different, and it will not do simply to attribute these Ottoman pieces to renegade craftsmen without considerably more information.

In any case, at least in the late sixteenth century, we know that domed Koran chests were often the work of architects, including two of Sinan's successors as Hassa Miʿmar or Court Architect, Dalgıç Ahmed Çavuş, who in addition to building the tomb of Mehmed III (d. 1603) made the inlaid doors and a Koran chest[8] for it; and Mehmed Ağa, the architect of the mosque of Ahmed I (inaugurated 1026/1617), who also executed the doors and a wooden lectern (raḥle) for it. The association here seems to be not the architecture but the working and inlay of mother-of-pearl (ṣedefkārī, or possibly of fine inlay in general), at which both were expert and which, according to Mehmed Ağa's own *Risāle-i Miʿmārīye*, was actually a necessary preliminary, since, presumably by means of angular interlaces, it provided the necessary basis of geometric expertise.[9] This may well be a romantic overstatement, but it emphasises that this rather improbable connection was held to exist at the time.

There is a closer connection to our eyes, namely the strikingly architectural appearance, at least at first sight, of these Koran chests, distinguished by their cubiform bases, domes and often polygonal transitional zones. Their Mamluk prototypes are, it seems, invariably flat-topped, not domed, but contrary to what is often asserted, the domes in question are not at all Ottoman but relate to the chevron mouldings and hastate palmettes (cf. no. 99) and even the all-over lozenge-patterns of the stone domes of fifteenth-century Mamluk Cairo, a similarity which is all the more extraordinary for being most probably unconscious. The architectural appearance is only superficial, for, with the finial or knob in place, the lid looks much less like a dome and, even when there is an exterior drum as on no. 101, there is no corresponding squinch or pendentive inside; but, like the interior painting, which shows many similarities to Mamluk and Ottoman dome decoration, the profiles seem to have been chosen deliberately.

The obvious but still partly conjectural explanation is that one of the requirements for the post of Court Architect was an ability to construct models, either experimental, to test the possibilities or structural stability of a particular system of

domes and supports, or for show, to demonstrate to the sovereign how the building would actually look. Much of the architecture of the period was structurally simple, safety factors were very high, and Sinan would certainly have been capable of working from a plan. However, during the seven years which Süleymaniye took to build (1550–7), he needed a model to show the Sultan, who was, doubtless, impatient for the foundation to be completed, or any other distinguished visitors. In the case of Süleymaniye we actually know what it looked like, for it is shown in the *Süleymānnāme* of Loḳmān (987/1579–80)[10] and also in the *Sūrnāme* depicting the festivities for the circumcision of Murad III's sons in 1582, carried in procession by the staff of the Court Architect's office. To judge from an entry in the Süleymaniye account books,[11] it was of heavy paper, painted and gilt on a wooden frame, and possibly this is how such models were.[12] But it is also possible that, like Italian *modelli* in contemporary Florence and Venice, some were of wood, and would have been appropriately veneered and inlaid for the Sultan. That would then explain the need for the Court Architects to be capable joiners, as well as explaining the architectural reminiscences in the Koran chests they made.

NOTES
1. Sadan 1976.
2. Cairo, Islamic Museum, 449, 452.
3. Kühnel 1938, 20 and pl. 19.
4. TIEM 3, Istanbul 1983, E. 9; Frankfurt 1985, 8/2.
5. TKS 1/10463, Istanbul 1983, E. 18.
6. Busbecq, *Letters*, 231.
7. Belon du Mans 1588, f. 375.
8. TIEM 19, Istanbul 1983, E. 151.
9. Gökyay 1976, 128–30.
10. Dublin, Chester Beatty Library, MS 413, f. 119a.
11. Rogers, *IJMES* 14 (1982), 290–2; id., Frankfurt 1985, 320–4.
12. Necipoğlu-Kafadar 1986, 224–43.

97 Campaign throne

Probably *c*. 1560
H. seat 50 cm; back 129 cm; W. 163.5 cm
TKS 2/2879
Literature: Istanbul 1983, E. 77; Frankfurt 1985, no. 8/1; Washington 1987, no. 107

The throne, which dismantles into five pieces, is of walnut, painted and veneered or inlaid with ebony, ivory, mother-of-pearl and marquetry work. It has a triangular back with a crenellated profile ingeniously emphasised by ivory leaf motifs, strikingly similar to the triangular pediment above the entrance façade to the Süleymaniye mosque. The seat is painted yellow with black tiger stripes; the underside is painted with red lead (*sülügen*). The front and back have large medallions of palmette interlace, inlaid on the front in mother-of-pearl, with a central turquoise set in gold, and on the back in ivory, the central stone missing. The use of mother-of-pearl for the main design in front suggests that it was more fashionable. The flanking medallions are of interlaced circles with palmette finials and triple-spot motifs, all in ivory. The low sides to the throne are decorated inside with linked arabesque rosettes and oblongs, and outside with angular interlace panels with a central twelve-pointed star. The screen panels below the seat and below the rear finials all have cloud bands in ivory. The four vase-shaped finials (two are later replacements) at the corners of the throne and the covering of the arms of the throne are solid ivory. The edging and borders are of ivory beading, minute marquetry meanders, or small inlaid marquetry lozenges or polygons.

Palace records state that the throne was used by Sultan Murad (that is, Murad IV (1623–40)) on the Baghdad campaign; but the throne must be sixteenth century. It could possibly have been made for Murad III (1574–95) but more probably was for an earlier sixteenth-century sultan, for example, Süleyman, and used later by Murad IV.

98 Folding Koran stand

From the mausoleum of Hürrem Sultan, mid-16th century
82.3 × 28.8 cm
TIEM 127
Literature: Çulpan 1968, fig. 11; Washington 1987, no. 108

The wooden stand (*raḥle*) is made of a single piece of hardwood, veneered with ebony and ivory, and with marquetry. The upper surface of the book-rest recalls a contemporary book-binding, with a central medallion of intersecting circles and palmette finials, corner-pieces and a marquetry meander border. The spine of the book-rest is painted with triple spots in cusped arches. The undersides and main panel of the supports have an angular interlace radiating from a ten-pointed star inlaid with ebony, ivory and red wood, and a meander border which also frames the other fields of decoration. Between the feet is a thick ivory plaque with lobed profile, veneered and inlaid with ebony in triple spots and curly skeletal palmettes, giving an interesting positive-negative effect. The inner side of the Koran stand is painted with black arabesques on a yellow ground.

In technique and decoration this stand is very similar to the Koran box (no. 101) and the throne (no. 97), and must be of the same date and studio.

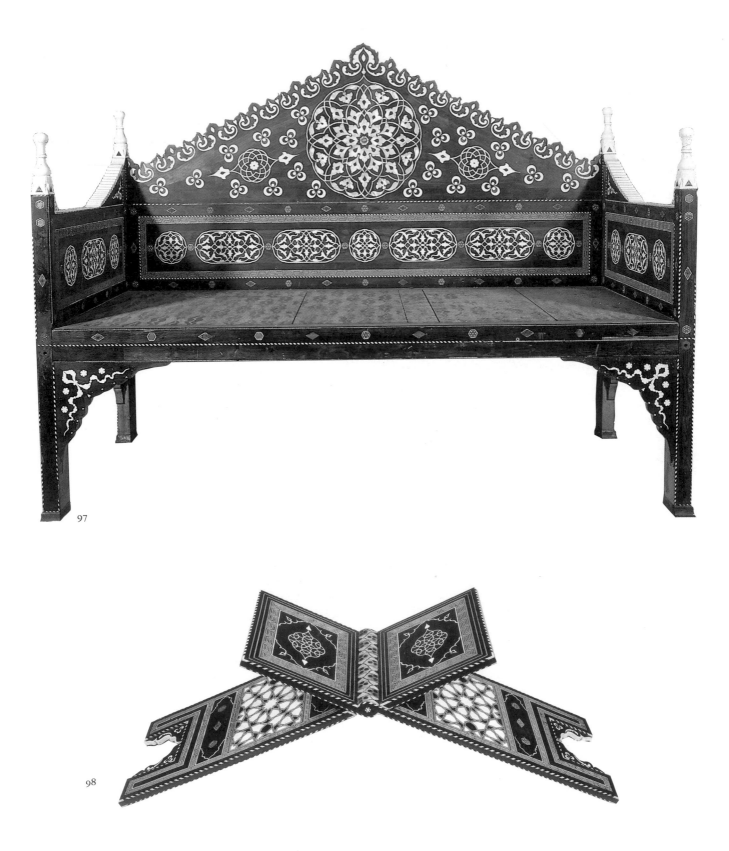

97

98

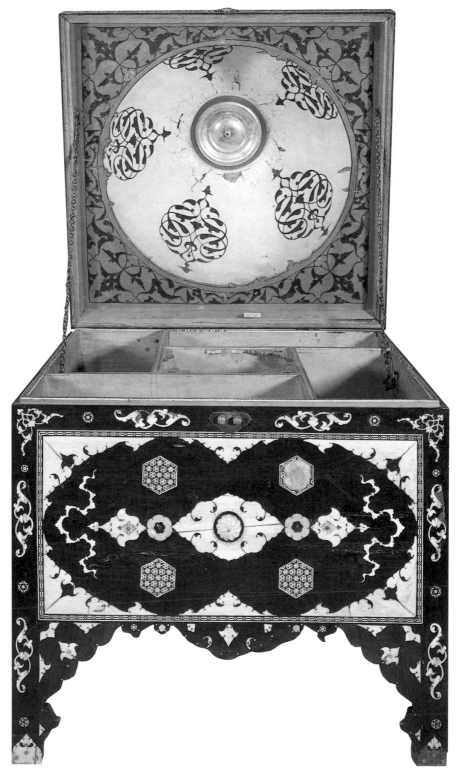

99 (open)

99 Koran box

From the Library of Ayasofya built by Mahmud I (1730–54), *c.* 1525
H. 86.5 cm; W. 50.7 cm
TIEM 5
Literature: Istanbul 1983, E. 76; Washington 1987, no. 109

The truncated cubiform Koran box, on four legs, has a domed lid, originally with a finial. The four sides of the box, which resemble contemporary book covers, have ivory corner-pieces and a central medallion, set with a fluted ivory knob, which is flanked by mother-of-pearl and ivory finials and ivory cloud bands. Four marquetry hexagons of silver, ivory and dark wood are set into the wood above and below the central medallion. Around this rectangle and down the legs arabesque scroll motifs alternate with small marquetry hexagons. The lobed profile of the wooden screen between the legs echoes that of the ivory corner-pieces. The sides of the lid are set with ivory panels carved with a Koranic inscription (II, 255), and prayers (*duʿā*) on a blue-painted background, separated by carved ivory arabesque medallions comparable in style to the

ivory panels of the Koran box dated 1505 (TIEM 3). The domed lid is decorated with chevron bands of wood and ivory. A frieze of palmettes and hexagons decorates the top of the dome above a scalloped band of tortoiseshell, possibly an adaptation from European cabinet-making. The finial is missing.

The interior is lined with sandalwood and divided into five compartments with ivory and wood marquetry edgings; the central unit has a carved wooden fret-board. The interior of the lid is painted with oil-based pigments on a composition base with five arabesque medallions on the dome and an arabesque scroll surround. The painting, like the domical form of the lid, suggests that it was inspired by architectural forms. The ivory inlay is not up to the intricate curves of the pattern which may derive from some other medium, not only book-bindings but also, for example, leather appliqué work. The palmettes and the ring and dot nails resembling stitching are similar to those decorating a leather canteen in Vienna (Kunsthistorisches Museum C.28; illustrated Washington 1987, no. 105).

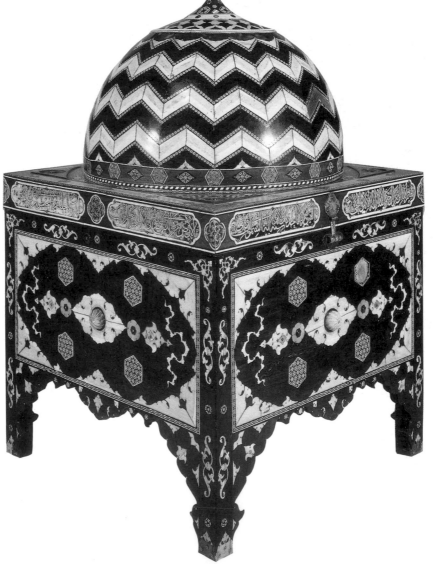

99 (closed)

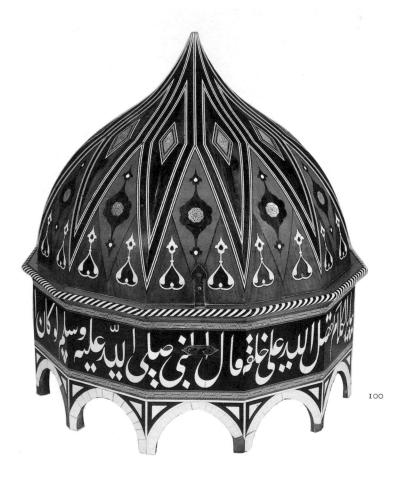

100

100 Koran box

From the tomb of Mehmed III (d. 1603) at Ayasofya, built by Dalgıç Ahmed
 Çavuş
H. 76 cm
TIEM 13
Literature: Istanbul 1983, E. 148, and cf. E. 151; Washington 1987, no. 110

The dodecagonal Koran chest, on arcaded feet with a hinged
pointed domical cover, is of hardwood veneered with ivory,
dark woods and mother-of-pearl. The sides have a *nastaˁlīq
ḥadīth* inscription on the virtues of the Koran. The domed lid
is divided into lozenge or half-lozenge panels veneered in
contrasting colours, with decoration in registers of ivory half-
palmettes with palmette finials; ebony medallions and finials
with central mother-of-pearl rosette, inlaid with black scroll-
ing blossoms and a gold mount for a gem (now missing); and

similarly decorated mother-of-pearl lozenges, with marquetry
borders.

The interior, which is sandalwood, is divided into four
compartments, lined with green silk, three rectangular and
the centre triangular. Inside the dome is painted red on a
fabric foundation with a black twelve-pointed flower and radial
palmettes, and a central gilt boss which must originally have
secured an ivory finial outside.

The pointed dome, arcading, top-heavy proportions and
inscription frieze of this Koran box relate it to another box
from the same tomb, inlaid with mother-of-pearl and tor-
toiseshell and actually signed by the architect Dalgıç Ahmed
Çavuş (TIEM 19).

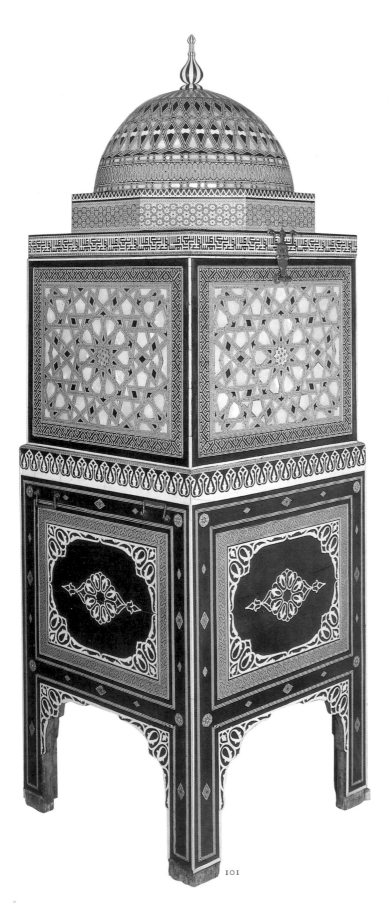

101

101 Koran box

From the tomb of Selim II (1566–74) at Ayasofya

H. 166 cm

TIEM 2

Literature: Istanbul 1983, E. 149; Frankfurt 1985, no. 8/4; Washington
 1987, no. 111

The Koran box, which is cubiform on a tall stand with a
domed lid on a low octagonal drum, is of hardwood veneered
with ebony, ivory and mother-of-pearl, and a marquetry of
these and reddish boxwood, yellow metal and silver wire. The
sides of the box are decorated with an angular design radiating
from a ten-pointed star, and inlaid with mother-of-pearl and
ebony between a strapwork of red wood with chequerboard
inlay of ivory and ebony. The central ten-pointed star bears
gold scrolls originally encrusted with gems. The sides of the
lid have square Kufic *basmala* in repeating panels of two lines.
The dome is inlaid all over with lozenges, with a marquetry
meander band at the base, in mother-of-pearl, ivory, red wood
and ebony. The octagonal drum has an all-over star and
hexagon pattern, similarly inlaid. The dome is surmounted by
a vase-shaped finial with bi-coloured veneer. The rectangular
sides of the stand are inlaid in ebony and ivory with interlace
medallions and spreading corner-pieces, repeated in ogival
screen panels between the legs.

The interior of the chest is divided into four compartments
around a central square with a false top. The inside of the
dome is decorated with gold and black arabesque medallions
and cloud bands on a red ground. There is a pair to it in the
Türk ve Islam Eserleri Müzesi.

8 Textiles (nos 102–27)

During the sixteenth century there was an unrivalled level of production of luxurious fabrics woven and embroidered from silk and metal threads, many with complex decorative designs such as those exhibited. References to various types of textiles appear in archival documents, but frequent inconsistencies in their use make it difficult to match them with surviving materials. However, because these terms are often used in descriptions of Ottoman textiles it may be useful to give a brief summary of their generally accepted interpretations.

Aṭlas (no. 102): monochrome satin; when moiré, *muḥayyer*; shot silk, if made, does not seem to have any technical designation. Linings and hems of caftans often bear impressed patterns.

Kemḫā (no. 106): a general term for woven polychrome silks, many also with metal thread. The metal thread, for reasons of economy, is usually brocaded: it covers only the area of the pattern where it shows on the obverse. The coloured design is usually a supplemental twill weave.

Serenk (Persian 'three-colour') (no. 103a–b): woven polychrome silk, not necessarily of three colours but without metal threads. The conspicuous use of yellow may be a deliberate replacement for gold thread which was periodically banned by edict.

Serāser (no. 108): cloth of gold, or silver.

The metal thread was usually silver, or silver-gilt, wound around silk thread for greater economy, strength and glitter, either with a white silk core for a silvery effect or with a yellow or brown silk core to look like gold. Sometimes, under magnification, the metal can be seen to have been flattened before being wound around the silk thread (for example, on the portfolio, no. 125).

Kadife (*Kaṭīfe*): velvet. It is so far very difficult to distinguish Ottoman and Italian velvets.

Kadıfe-i dū ḥāvī: pile on pile velvet (Italian *alto e basso*).

Çatma: velvet of particularly high quality, sometimes with metal thread.

Costumes and accessories: dating and attribution

Specialists in textiles are attempting to evolve technical criteria for the dating of silks (although, it must be said, it is still practically impossible to distinguish, in general, Italian from Bursa silks). However, the total absence of dated silks, the concentration of datable fabrics in the final decades of the sixteenth century,[1] and the probability that technical changes in fabrics were not sudden, but evolved gradually over decades, make technical analysis of all the Topkapı fabrics laborious. We have absolutely no idea of the rate of change in Bursa textile designs and there is some evidence that earlier designs, though possibly not techniques, were revived periodically in the seventeenth century – or, possibly, unused bolts of cloth were periodically cleared out of the stores and made up by the Court tailors.

The archival documents – Treasury inventories, *in'ām* defters, records of the Kadis' courts, market regulations, and fixed price registers (although nothing earlier than 1640 has so far been published with mentions of silks in it) – abound in references to textiles, but the standard mentions, for example in the 1505 Bayazid Treasury inventory,[2] 'a gown of black Italian pile on pile velvet with roses, lined or trimmed with cotton and with sable furs', even at their most detailed are still far from adequate to give a proper idea of their appearance. This is not merely a defect of textiles; mentions by pattern are always rare and probably the earliest such mention is the 'grape' tiles from Iznik (tiles with vine scroll) or with tulips ordered for the Topkapı Saray in 1591–2.[3] It is difficult to envisage dated lists of this sort in which identifiable patterns are described in sufficient detail (for example, even the 1640 price list mentions patterns but only in very generalised terms), but, even if something like this were to appear, it would not date more than a handful of silks; so that for the moment there is nothing much better than stylistic criteria derived from other materials to go by.

There are, however, two other available means, both connected with Ottoman funerary practices. On the death of a sultan or a prince, or even of a vizier who was related to the Sultan, or whose belongings might have been sequestered on his death, it was customary for them not to be sold but to be wrapped up in bundles in the wardrobe or Treasury. It was some of these bundles which were discovered in the stores when the Topkapı Saray was turned into a museum and which were then revealed to the amazed public as the caftans or garments of sultans like Bayazid II (no. 106) – to give a notoriously unconvincing example. Lamentably, but not wholly unsurprisingly, some of the labels have since been lost, and some of them may have been tied back to the wrong bundles; but not all the labels seem to have been as old as they should have been. In 1680–1[4] when the first comprehensive Treasury inventory seems to have been compiled, and in the inventories of the mid-eighteenth century which contain references to the wardrobes of former sultans, the bundles also seem to have been untied and inspected, giving further possibilities of confusion. It is also clear that existing labels were made more detailed, doubtless misleadingly: for example, the brief lists they give (which can never have been comprehensive) show a tendency to attribute garments to the earliest or most famous sultan bearing the name Murad, Mehmed, Selim, etc.[5] This means that such evidence must be taken extremely cautiously, for the work of Tahsin Öz in the early 1950s which exploits these Treasury registers on a fairly

systematic scale shows the traps into which even experienced scholars can fall.[6]

There is also important evidence from the imperial tombs in Istanbul which were cleared of considerable accumulated furniture in the period 1875–1914, much of which went into what is now the Türk ve Islam Eserleri Müzesi. This is because of the custom, not peculiar to the Ottomans but characteristic of the tomb of Tamerlane in Samarkand shortly after his burial in 1405[7] and more generally in Mamluk Cairo,[8] of garnishing the tomb with the belongings — weapons, garments and jewellery — of the dead Sultan as well as with furniture, book stands (e.g. no. 98), cenotaphs, lamps and ornamental hangings, illuminated Korans and other manuscripts. For males it was customary to crown the cenotaph with enormous turbans, which may also have been personal possessions, and these were appropriately decorated with gold turban ornaments which they would have owned. Many of the objects in the present exhibition are from royal tombs, and it may appear that the Ottoman custom guarantees the date and provenance of their furnishings. Here, however, one has to concede that this is only more or less true, partly because new furnishings may have been added when the tomb was periodically done out, and partly because practically all these tombs in Istanbul were used for multiple burials, of some of a sultan's children, for example, and quite possibly grandchildren too. This explains the frequently documented children's garments in the tombs of adult, even aged, sultans. It would probably not do to take it for granted that they were garments worn by the Sultan as a child.

This state of affairs has led to exaggerated optimism, and pessimism, regarding the possibilities of the evidence. On the whole it is fair to say that taken by itself the evidence from palace inventories or even from the imperial tombs is so open to misinterpretation that it had better be ignored. Occasionally, however, it is possible to see that the various types of evidence, taken in combination with stylistic criteria, support one another, so that, even if it is never possible to be dogmatic, one may reasonably attribute garments or accessories to one sultan rather than another. Such is the case with practically all the caftans shown in the present exhibition, although the grounds vary somewhat from piece to piece. Moreover, even when the wardrobe labels appear to be utterly implausible, one may see ways in which they may be squared with the facts as we know them. The splendid caftan (no. 106), which Öz attributed, impossibly, to Bayazid II (1481–1512), may indeed have belonged to Bayazid, but to the Şehzade of that name, Süleyman's ill-fated son, who was killed in 1561. The original misunderstanding is all the more plausible in that it was common practice in the sixteenth century for princes to take the title *Sultan* long before their accession — if they ever came to accede. A companion piece to this 'Bayazid' caftan, with the same splendid design but in different colours on a cream ground, has been associated, probably for similar reasons, with Mustafa Sultan, again not Mustafa I (d. 1623) or still less Mustafa II (d. 1703), but Süleyman's son Şehzade Mustafa, who was strangled in 1553. It does not follow that both caftans were woven simultaneously, but their appearance fits well with the 1550s, and the pattern, which must be given the earlier terminus, must, therefore, have been drawn soon after 1550.

If the situation is still not entirely satisfactory, however, it is far from hopeless and it represents the most economical approach to the quality of the evidence available. It also takes account of the fact that the scribes engaged in the checking and registering of the Sultan's treasuries were often expert, if not learned, that they must often have had notebooks at their disposal no longer extant but giving information on the collections, and that often there must have been persistent traditions still circulating for which there is now no corroboration, but which they would have been in some position to evaluate. The one thing they were not there to do was to provide learned attributions in the absence of specific data. To that extent what testimony they give deserves some respect, and the most careful emendation when that seems necessary, rather than outright rejection.

NOTES

1. This is mostly in the collections of the Armoury of the Moscow Kremlin when from 1580 onwards Bursa silks were regularly made up into liturgical vestments. These decades coincide with a series of Ottoman documents on the fur trade (Tezcan and Delibaş 1986, 42–5) indicating that state merchants financed their purchases with bales of Bursa silks; but it is recognised that some of these vestments were probably made up of discarded Tsars' garments and could, therefore, have reached Muscovy ten or twenty years earlier. The most recent catalogue of this material, with references back to earlier publications is Moscow 1979, but, probably, much more work remains to be done.
2. TKSA D. 10026.
3. Barkan 1979, 275.
4. TKSA D. 12a, 12b.
5. Tezcan and Delibaş 1986, 11–14.
6. Öz 1950.
7. Bartol'd 1974, 65–87.
8. K.A.C. Creswell, *The Muslim Architecture of Egypt* II (Oxford, 1959), 193.

Caftans (nos 102–9)

The Ottomans were fairly conservative in the tailoring of their dress: it was the quality of the material which was intended to impress, although the majority of surviving caftans are of plain material, so that those exhibited have probably exaggerated the relative quantity of patterned fabrics worn. They were usually cut straight, or slightly tailored to the waist, flaring out over the hips and then more gradually down to the hem. They generally have round necks, sometimes with a small stand-up collar. Usually they have buttons down to the waist, either jewelled or covered in the same fabric as the caftan and fastened through loops, and often frogging in a similar material across the chest.

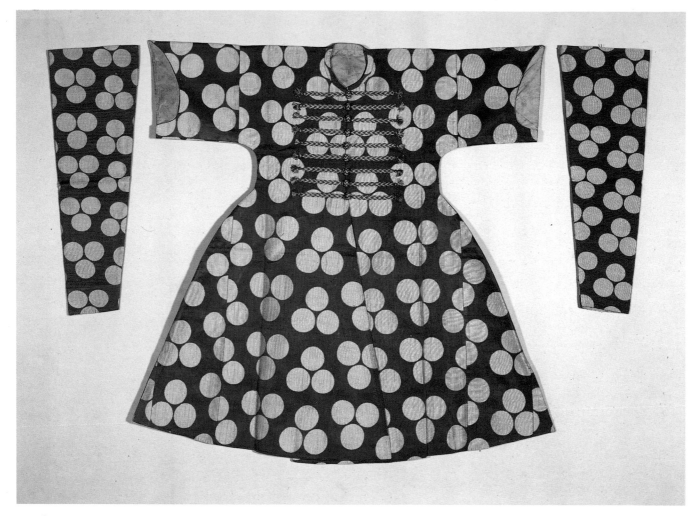

103a–b

Sleeves are short, wrist- or ankle-length. Short-sleeved caftans often had matching wrist-length sleeves which could be attached by buttons to the inside of the shoulders of the caftan. Ankle-length sleeves were purely decorative, hanging empty behind, and were always worn on an outer garment. The Sultan and his ministers would frequently wear three caftans – one with wrist-length sleeves under another with short (or detached) sleeves, under another with decorative ankle-length sleeves, so that their contrasting fabrics could all be seen and admired.

A description by the Venetian emissaries who went to visit the Commander of the Ottoman fleet at Preveza in 1533 indicates that the costumes shown in Domenico de' Franceschi's print of Süleyman in procession (no. 3) were not artistic licence:

The commander is a youngish man of about thirty-eight or less, with reddish moustaches and a handsome appearance. He wore a turban of the finest cloth; he was seated cross-legged in the Turkish manner. Over his shirt he wore a gown of yellow satin (*raso*) and over that one of damask with great flowers in gold thread. Over that he had one in scarlet.[1]

In many caftans, particularly those that were quilted or fur-lined, or those with long sleeves intended to be worn as over garments, there are two slits in front at the hips, although there is no pocket attached. They would have allowed access to items, such as purses, hung from the belt of the under-caftan. Layered clothing enabled the wearer to adapt easily to most weather conditions; but caftans were made with linings of various weights, from thin cotton or silk suitable for summer, to quilting or fur against the appalling Istanbul winter.

Caftans were usually full length, but shorter caftans for practical reasons were worn for sport or battle. The *Süleymān-nāme* (no. 45b) depicts foot-soldiers on campaign wearing knee-length caftans, while Süleyman and his attendants are shown hunting on horseback in knee-length caftans worn over baggy trousers.

1. Marino Sanuto, *Diarii* LVI (1900–1), 742.

102a–b Child's caftan and trousers

L. caftan 72 cm; trousers 70 cm
TKS 13/93; 13/92
Literature: Washington 1987, 112a–b

The green satin child's caftan and matching trousers are lined with white cotton and faced with brown silk. The caftan is close-fitting to the waist, where it flares out over the hips. With a round neck, small stand-up collar and short sleeves, it crosses over in front and is fastened by buttons. The trousers, made from the same green silk, have a waistband and attached feet of cream coloured silk. There is an illegible ink stamp on the cotton lining. The garments are thought to have belonged to Süleyman as a child.

103a–b Child's caftan and sleeves

L. caftan 72.5 cm; sleeves 47.3 cm
TKS 13/1015
Literature: Washington 1987, 113a–b

The red satin child's caftan, faced with blue silk and lined with brown cotton, is decorated with dramatic triple spots in yellow. There is no obvious way of attaching the matching sleeves, which probably therefore were never used. The caftan has a round neck and cross-over front, which is fastened to the waist by buttons and loops. The garment is thought to have belonged to Selim I (r. 1512–20) as a child, but if a *Selim* is in question it is more probably Selim II (r. 1566–74).

104 Sleeves

L. 95 cm
TKS 13/72
Literature: Washington 1987, no. 115

The long sleeves are cotton-lined and faced with green silk, of dull pink and yellow silk stuff with silver thread giving a golden sheen where it mixes with the coloured threads. The sleeves were attached to the inside shoulders of a matching caftan by the buttons. Three similar buttons and loops are placed along the cuff, to tighten the sleeves around the wrists. There is a pattern repeat every 16 × 9 cm of composite lotus and *ṣāz*.

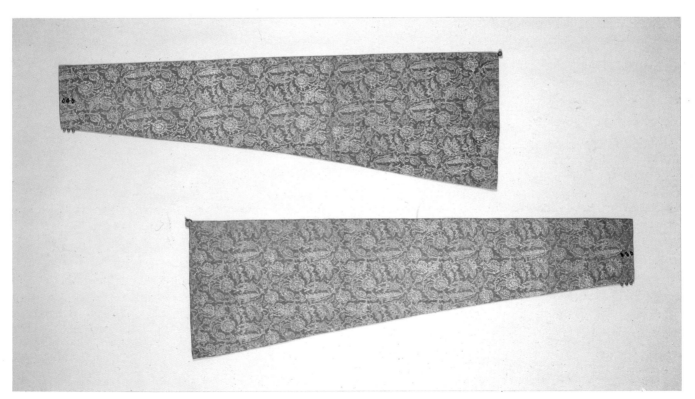

104

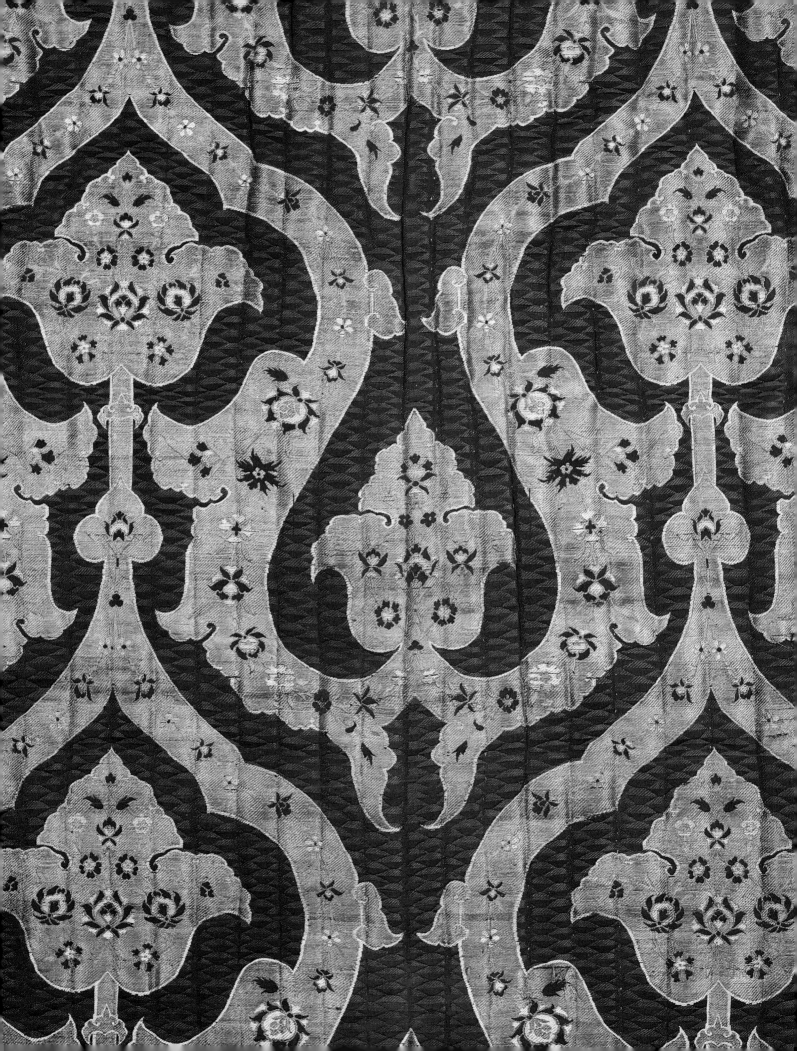

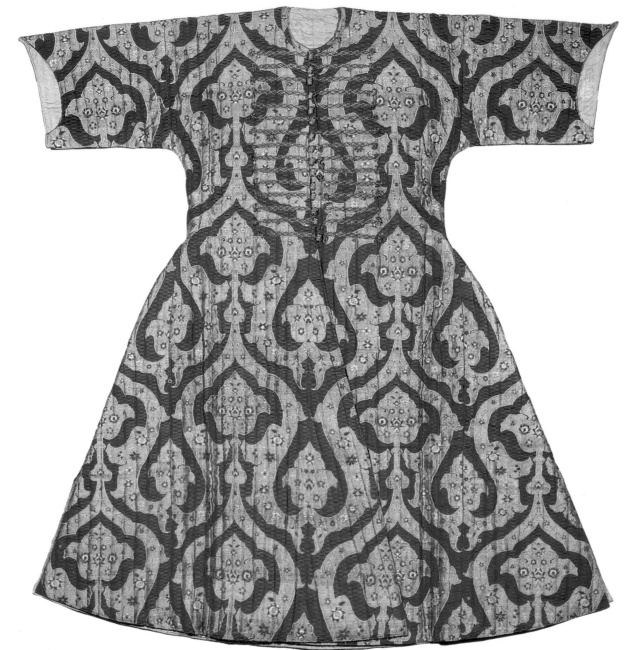

105; detail *opposite*

105 Caftan

L. 138 cm

TKS 13/46

Literature: Mackie 1980, illus. 201 and pl. 60; Istanbul 1983, E. 102; Tezcan
and Delibaş 1986, pl. 7; Washington 1987, no. 114

The three-quarter length caftan is of polychrome silk stuff
with gilt-metal thread on brown silk, with a woven diaper
effect, lined with apricot-coloured cotton and faced with lime-
green silk. With a round neck and short sleeves, it is open to
the waist and is fastened by buttons and loops attached to
frogging across the chest. From the waist it flares out over the
hips. The wide girth of the waist (100 cm) is partly the result
of the quilting. The pattern of the textile is symmetrically
arranged and is cut so as to run across the front of the garment
without a break. It is of large interlinked palmettes, the stems
and buds of the palmettes filled with an additional floral scroll
of lotus and other flowers. The caftan has been stated to have
belonged to Selim I (r. 1512–20), but stylistically the pattern
must be later sixteenth century.

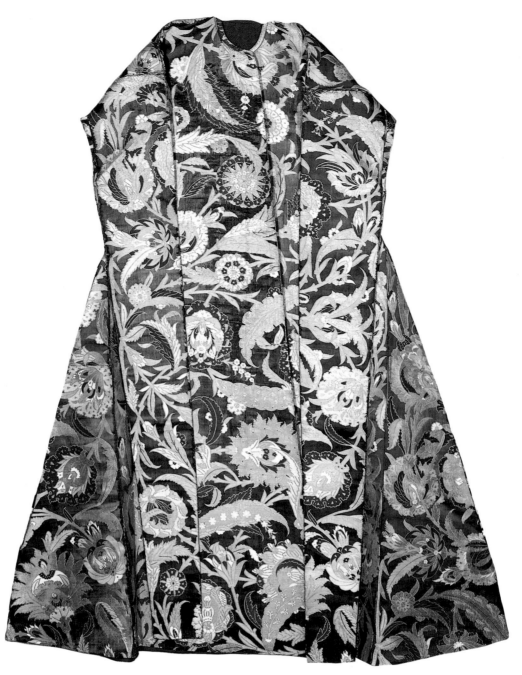

106; detail *opposite*

106 Caftan

L. 147 cm; sleeves 117 cm

TKS 13/37

Literature: Tezcan and Delibaş 1986, pl. 36; Washington 1987, no. 116, and refs

The caftan, which is full-length with ankle-length decorative sleeves and pocket slits, is of polychrome silk and gilt-metal thread on a brown silk core. It has a round neck crossing over without any means of fastening, and is shaped to the waist and flares out over the hips. The scrolling pattern of chinoiserie lotus and peonies, feathery leaves and other flowers without a repeat is one of the most elaborate seen in Ottoman textiles, but the material is so cut that there is no break in the pattern across the front. The side panels are also carefully cut, so that the pattern is not broken by the seam. The caftan is lined with yellow silk and faced with red silk which has been impressed with parallel lines. There are blue appliqué squares at the front corners with square Kufic reading *Muḥammad*, perhaps the name of a court tailor. The caftan was probably made for Şehzade Bayazid (killed 1561).

There is another caftan in the Topkapı Saray collection (13/529) made of a similarly patterned fabric on a cream ground, with similar linings and the same appliqué panels of square Kufic. It is now generally attributed to Şehzade Mustafa (killed 1553), which may suggest that both caftans are similarly dated, *c.* 1550. (For the question of provenance see above, pp. 164–5.)

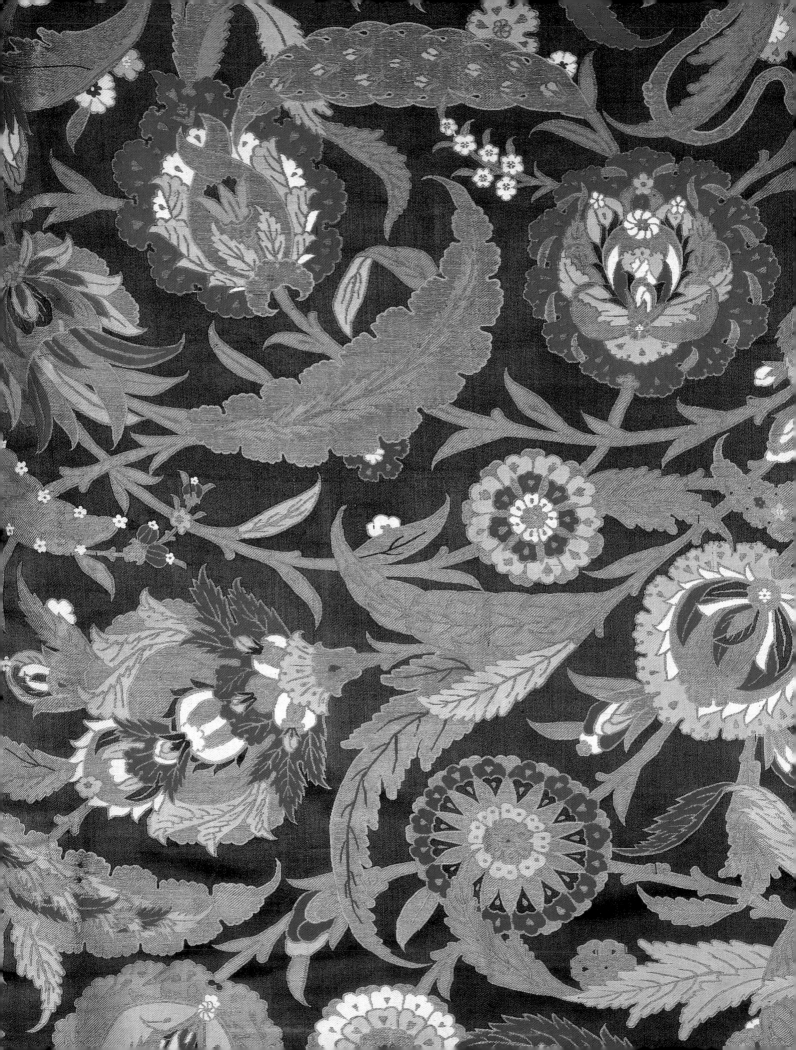

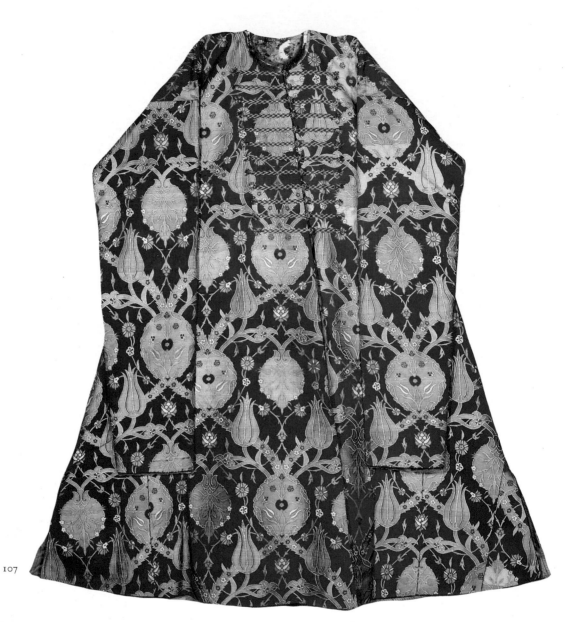

107

107 Caftan

L. 137 cm; sleeves 93 cm

TKS 13/932

Literature: Washington 1966, no. 205; Istanbul 1983, E. 106; Washington 1987, no. 118, and refs

The full-length caftan, of polychrome silk faced with lime-green silk and lined with fur, has ankle-length decorative sleeves and pocket slits. It has a round neck and is fastened to the waist by buttons and loops on braided frogging across the chest. The fur lining indicates that it was intended as an over garment for winter use. The design is an ogival repeating pattern of large oval medallions with a variety of naturalistic (tulips, pomegranates, hyacinths) and fantastic flowers. The owner of the caftan is unknown, but in pattern the fabric resembles that worn by Selim II in his portrait by Nīgārī (TKS H. 2134/3).

108 Caftan

L. 157 cm; sleeves 135 cm

TKS 13/9

Literature: Mackie 1980, illus. 210 and pl. 60; Frankfurt 1985, no. 5/2; Tezcan and Delibaş 1986, pl. 48; Washington 1987, no. 119

The caftan, which is woven from silver (over white silk), gilt-metal (over yellow silk) and pink and green silk thread, is lined with white cotton and faced with red silk, with ankle-length decorative sleeves and pocket slits. It has a round neck and cross-over front, buttoned to the waist, and flares out over the hips. The pattern of the fabric is cut to continue across the front of the caftan without interruption. It is of large pointed ovals on a gold ground, filled with carnation heads, in pink and green silk on a silver background.

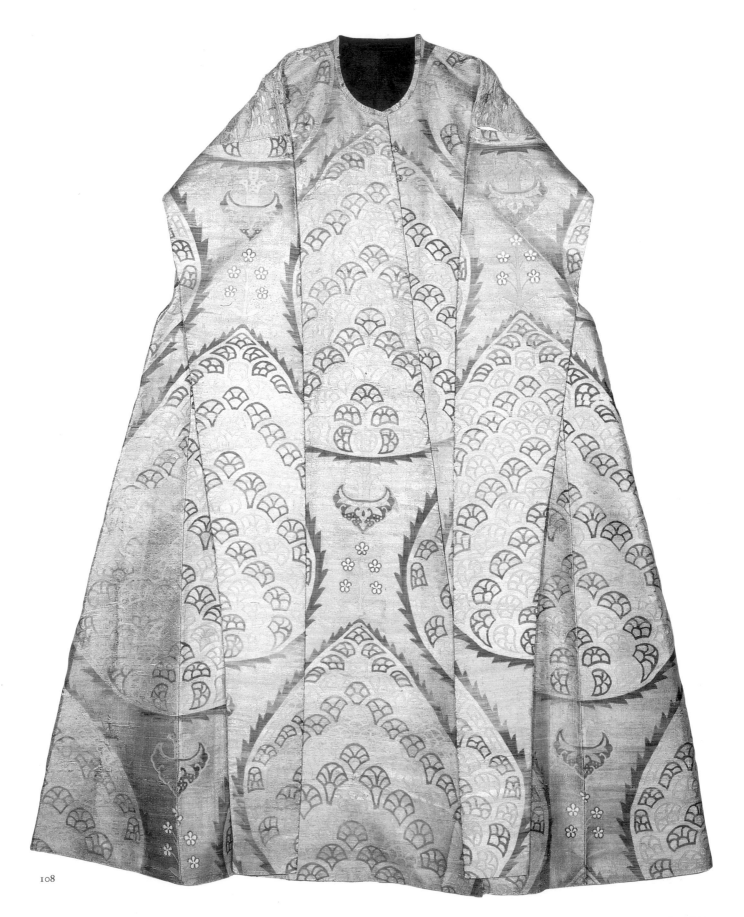

108

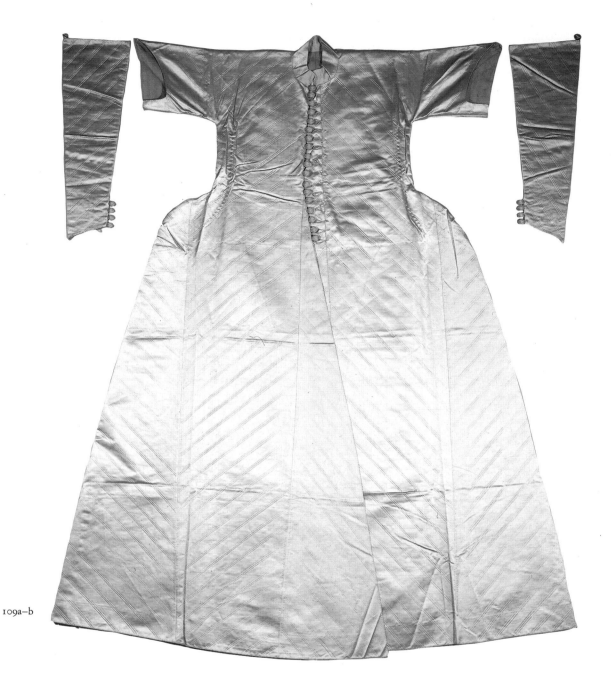

109a–b

109a–b Caftan and sleeves

L. 146 cm; sleeves 49 cm

TKS 13/100

Literature: Washington 1987, no. 121a–b

The full-length short-sleeved caftan, of cream satin with impressed triple lines, is lined to the waist with white cotton and faced with lime-green silk decorated with impressed quintuple lines. With a round neck and small stand-up collar, it is cut tight, and buttoned to the waist, then flares out over the hips, and more gradually down to the ankles. The separate wrist-length sleeves should be attached to the caftan by a button on each shoulder, but they could not, however, have

been used, for the matching loops inside the shoulders of the caftan are missing. The sleeves have more buttons and loops at the wrists. There is a circular stamp on the hem, with an illegible inscription in blue ink. Stamps dating from the seventeenth century and later are mostly triangular or hexagonal; those few which are legible refer to tax payable on the material not to the workshop or conditions of manufacture.

The caftan is thought to have been made for Süleyman (Jérôme Maurand (1544) describes Süleyman as wearing white satin). The condition of the fabric and lack of button loops for attaching the sleeves, however, suggest that the caftan was never worn.

Talismanic shirts (nos 110–11)

The numerous talismanic shirts (*tilsimli gömlek*) in the Topkapı Saray have Koranic verses, prayers, their numerical equivalents and numbers of other significance written in Arabic letters or numerals and exceptionally the name of an Ottoman sultan or prince, mostly in squares or other figures subdivided into smaller units.[1] There have always been strong numerological, grammatological or onomastic tendencies in popular Islam (or, indeed, in the European Renaissance, through the works of the mystagogue Cornelius Agrippa von Nettesheim), and there is a large literature on such magic squares – which, it has been observed, have a steadily increasing proportion of errors the larger they are.[2] These squares generally take either Koranic *āyas* or one of the 'Ninety-nine Names of God'[3] as their base, and are generally *abjadī*, using letters with numerical values, with certain standard operations so that the squares 'work out'.[4] Some squares with letters of the alphabet may be meaningful, like the simple square on the dagger of Selim I (no. 81) which not only gives the date 920 but approximates to a formula giving thanks to God.

The contrast between the quality of the shirts and their decoration is striking. The garments are usually made from white linen or cotton, cut like a tabard and loosely sewn. Their decoration, on the other hand, is both time-consuming in its detail (a shirt for Prince Cem took three years to complete – 30 March 1477–29 March 1480 – Istanbul 1983, E. 25) and extravagant in its use of gold and silver. They may have been worn as undergarments so that their decoration would have been in aid of their talismanic potency rather than their visual effect; but they are so loosely cut that they could have been worn over chain-mail.

The decipherment of these shirts is a wearisome business and was certainly never intended. Any interpretation of their inscriptions must be extremely tentative; but the prominence of the Sura of Victory (Koran XLVIII) does not entirely accord with their generally accepted *protective* function: victory is something more ambitious altogether.

On each of the shirts exhibited the entire *sūra* is written in the inscription border around the edge of the garment. On no. 110 it also appears in a large square on the back of the shirt, which is subdivided into 144 small squares, each containing one word from the *sūra*. The square on the chest of no. 111, subdivided into 1600 smaller squares each containing a number, bears an inscription in Persian above it stating that the *sūra* was written 'for the sake of victory', and may represent the *sūra* in numerical form.

There is a most interesting letter from Hürrem Sultan to Süleyman, undated but evidently before her daughter Mihrimah's marriage to Rüstem Paşa in 1539:[5] a holy man had come from Mecca to Istanbul bringing a shirt inscribed with names (*esmā ile merḵūm*), which he had made in response to a command by the Prophet in a vision, to be worn in the holy war (*ġazā*). He searched through the city and brought it to Emre Koca, some Istanbul saint, who sent it to Hürrem

Sultan. She sent the shirt to Süleyman, who was evidently out of Istanbul on campaign, with the urgent request that he wear it for her sake, for *it had sacred names woven in it and would turn aside bullets*.

A puzzling feature of several of these shirts is that they are in such good condition that they can scarcely have been much used, and certainly not in active battle. The shirt made for Prince Cem has not even had the opening for the head cut. One explanation could be that they were unsolicited gifts, presented (doubtless for a large reward) to the Sultan or his family. It would be a bold sultan who could refuse, particularly a shirt made by a holy man on instructions given by the Prophet in a vision.

1. The earliest study of these interesting textiles is by de Hammer (Hammer-Purgstall) 1832, 219–48. There is a second shirt in Vienna in the Arsenal in which Kara Mustafa Paşa was buried at Belgrade (1687 or slightly later); cf. id. 1829, 122–36. The most recent study is Gökyay 1976, 93–112.
2. Ahrens 1922, 157–77; Schuster 1968, 290–37.
3. 'Al-Asmā al-Ḥusnā', *EI²*.
4. Herklots 1921, 247–63.
5. Uluçay 1960 35–6; V.L. Ménage, private communication, 1987. The Turkish transcription is defective and the final italics have been omitted by Uluçay.

110 Talismanic shirt

Later 16th century
L. 125 cm
TKS 13/1150
Literature: Istanbul 1983, E. 54; Washington 1987, no. 122

The shirt, which is of white linen, lined with white cotton and faced with pink silk, is open down the front, with a plain neck and elbow-length sleeves. It is painted with numerous Koranic verses (principally XLVIII, but also XVIII ('The Cave'), XXXVI (*Yā-sīn*), XLVI (*al-Aḥqāf*), etc.), often in scrolling or medallion designs entirely composed of variously coloured minute scripts and illuminated panels. The only square is a large one on the back, subdivided into smaller squares each containing a word from the Sura of Victory (Koran XLVIII). Numerals and *abjad* letters are entirely absent, which suggests that the artist was a calligrapher-illuminator, rather than a specialist in talismanic calculations. Indeed, much of the decoration resembles contemporary illumination. The garment was painted before the front and back were sewn together. Preliminary sketches in pale grey are visible in places.

111 Talismanic shirt

Dated 972/1564–5
L. 107 cm
TKS 13/1133
Literature: Gökyay 1976, 101; Washington 1987, no. 123

The shirt is made from one piece of white linen, lined with red silk, with an opening and a slit for the head and short sleeves.

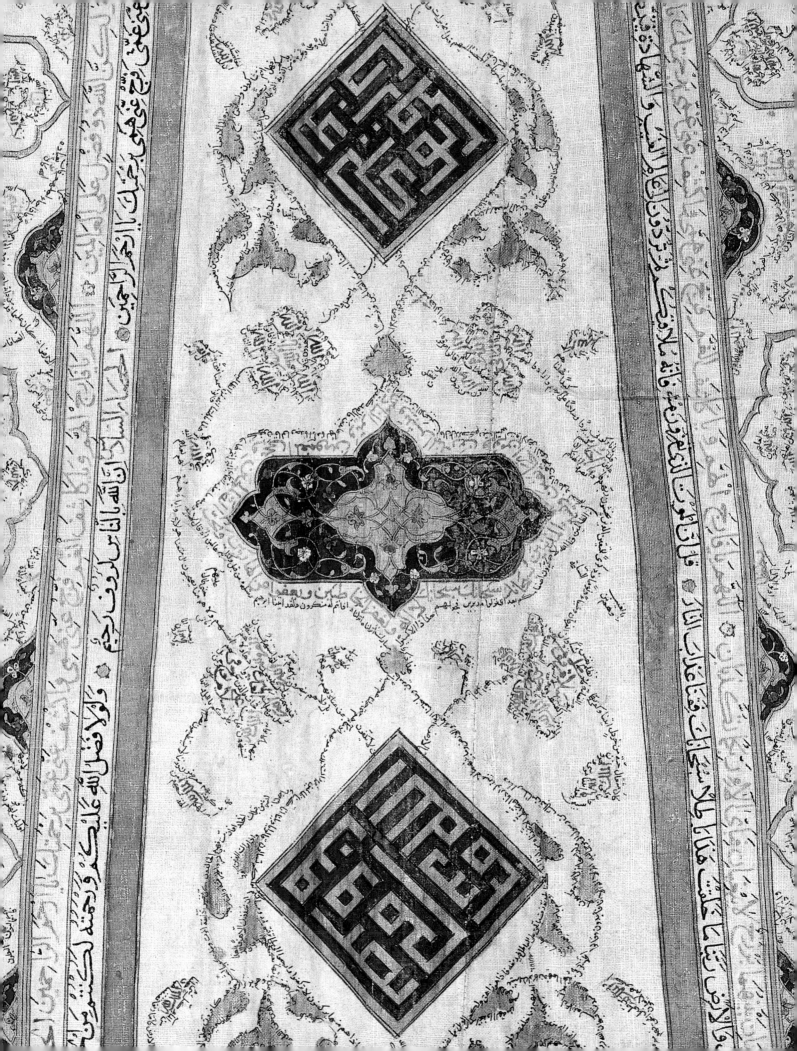

It is covered front and back with magic squares, both of numbers and letters. An inverted gold triangle beneath the neck opening bears an Arabic inscription for Şehzade Selim: *bi-rasm al-sulṭān al-aᶜẓam/waʾl-khāqān al-muᶜaẓẓam mawlā/mulūk al-ᶜarab wal-ᶜajam/mawlānā al-sulṭān ibn al-sulṭān/ al-sulṭān Selīm khān/ibn al-sulṭān Sulaymān khān/khallada Allāh mul-kuhummā/ilā yawm al-qiyāma*. The Şehzades commonly took the title of 'Sultan', but although Selim only acceded in 1566, he is named here as a joint ruler with Süleyman. The second dedicatory inscription omits Süleyman's names and titles altogether.

Two six-pointed stars to either side of the neck opening are divided into smaller triangles. Selim's name reappears on these arranged so that one letter appears in each small triangle of the top side of three of the 'points' of each star. The maker's name Dervīş Aḥmed ibn Süleymān and the date 972/1564–5 appear in red ink in a square at the bottom of the back of the garment, and are repeated elsewhere.

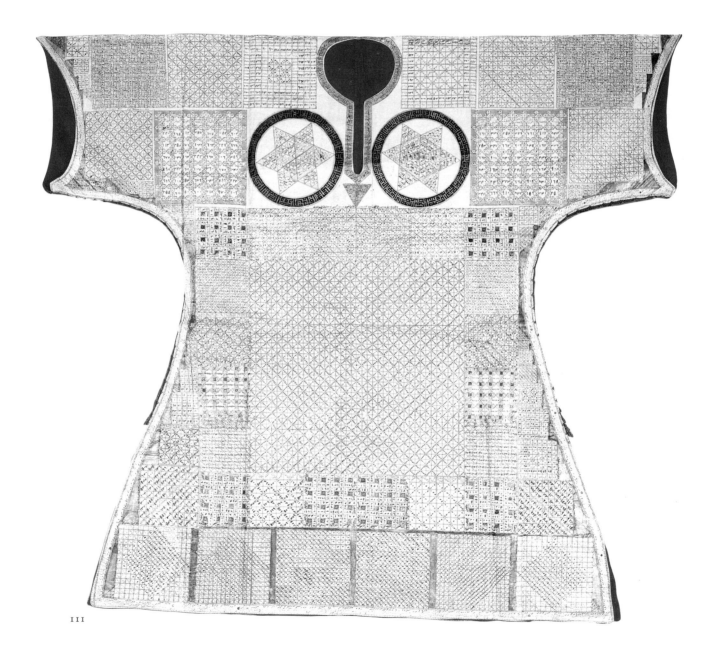

111

110 (detail)

Embroideries (nos 112–16)

To judge from the numerous pattern books which circulated all over Europe, there is little except certain favourite designs to distinguish Ottoman work from embroidery in contemporary Italy, France or Germany. Such fine embroidery was, however, used on a much wider scale, and there is an undated archival document which is often cited to demonstrate this. Seven quilt covers, each 5 *endāze* long (1 *endāze* = approximately 65 cm), had been ordered from ten women (probably from the Harem), with an allocation of 450–500 dirhams (more than 1.4 kg) of embroidery silk to each. The commission, however, could not be fulfilled for the designs were too minute.[1] Washington 1987, no. 137, follows Istanbul 1983, E. 144, in suggesting that this refers to the sheet (no. 123), but the embroidery techniques are far simpler and not at all as fine, and it may well be that no artisan ever succeeded in making anything as fine as the handkerchiefs (nos 112–16) on such a large scale.

Another important type of embroidery which was far more spectacular in its results was *zerdūzī* (that is, work in *zer-i dūḫte*)[2] – roughly, if not wholly accurately, couched gold thread – which may have been brought into Turkey by craftsmen brought from Safavid Tabriz, but which was anyway produced by a workshop attached to the court. Because of the weight of the thread it was normally executed on tough silk, usually satin over some form of stiffening, which would then be sewn on to whatever it was to decorate – sashes (nos 120–2) or a bow case (no. 95) – but which could alternatively be laid down directly on to leather (nos 25, 126). It was not only grand and brilliant, but when built up in successive layers of colour or embroidered on the gold it could produce a variety of three-dimensional effects.

1. Tezcan and Delibaş 1986, 160–1.
2. Ibid, nos 92–5.

Handkerchiefs (nos 112–16)

Handkerchiefs were often placed in tombs. For that reason, and because of their customary dark colours, they are often known as 'mourning handkerchiefs'. In fact this is a romanticisation (cf. no. 1); handkerchiefs were as important in the living culture of the Ottomans as they were in other Islamic societies or in contemporary Europe. Sultans and courtiers are often depicted holding handkerchiefs. They were favourite gifts, particularly as prizes.

The handkerchiefs are made from linen squares, edged for strengthening with silk and metal threads. Gold thread was also used in a technique known as *tel kırma* ('broken thread'), in which it was knotted around the linen threads appearing as small glittering dots in the overall design. This gave the impression of luxury but without the weight of thicker gold embroidery, thereby lessening the risk of tearing the fine material. The embroidery uses counted thread stitch, and is so

fine that it can be looked at from either side. It is also used to create a lace effect in selected areas by pulled thread work (particularly striking in no. 116). Motifs appear more spidery than in other media, but they are basically very similar – tulips, carnations, flowers in vases, triple spots or pseudo-inscriptions in cartouches.

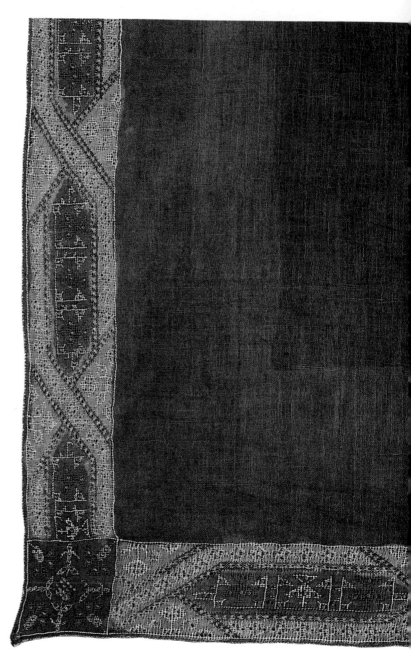

113

112 Handkerchief

From the tomb of Şehzade Mehmed (d. 1543)
55 × 53 cm; border 4.5–5 cm
TKS 31/58
Literature: Barışta 1981, no. 12; Berker 1978, nos 48, 49; Istanbul 1983,
E. 98; Washington 1987, no. 124

The cinnamon-coloured handkerchief is printed dark grey in
the centre and in the octagons of the border interlace, and
embroidered in coloured silks and gold thread with conven-
tional motifs.

113 Handkerchief

From the tomb of Şehzade Mehmed (d. 1543)
52 × 51 cm; border 3.5–4 cm
TKS 31/60
Literature: Istanbul 1983, E. 99; Tezcan and Delibaş 1986, pl. 88;
Washington 1987, no. 125, and refs

The cinnamon-coloured handkerchief is printed dark grey in
the centre and in the hexagons and corner squares of the
border, edged with gold and embroidered with cartouches of
spidery pseudo-Kufic with cruciform motifs and stylised
carnations at the corners. In one corner there is an unread word
embroidered in pale blue thread, which may be the mark of
the embroiderer.

114 Handkerchief

From the tomb of Şehzade Mehmed (d. 1543)
52 × 51 cm; border 5.8 cm
TKS 31/59
Literature: Istanbul 1983, E. 97; Tezcan and Delibaş 1986, pl. 88;
Washington 1987, no. 126

The cinnamon-coloured handkerchief has a border of lobed
medallions and bulbous long-necked vases in reserve on a dark
grey printed background, embroidered in coloured silks and
gold thread with tulips and carnations.

115 Handkerchief

From the tomb of Şehzade Mehmed (d. 1543)
53 × 54 cm; border 4.5 cm
TKS 31/61
Literature: Washington 1987, no. 127, and refs

The cinnamon-coloured handkerchief is printed in dark grey
with triangles in the border design leaving a serpentine line
and the four corner squares in reserve. It is embroidered in
coloured silks and gold, with plant motifs and triple spots, a
chain of rosettes, and cruciform designs in the corners.

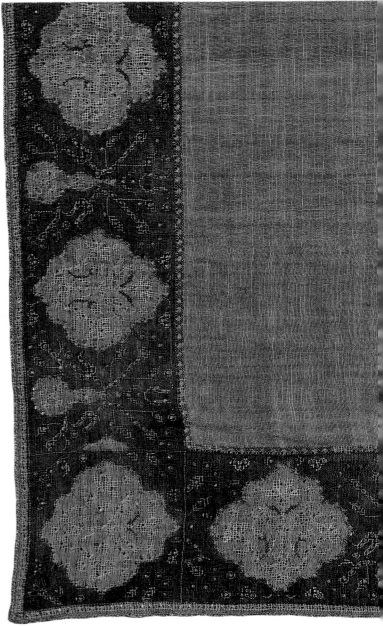

114

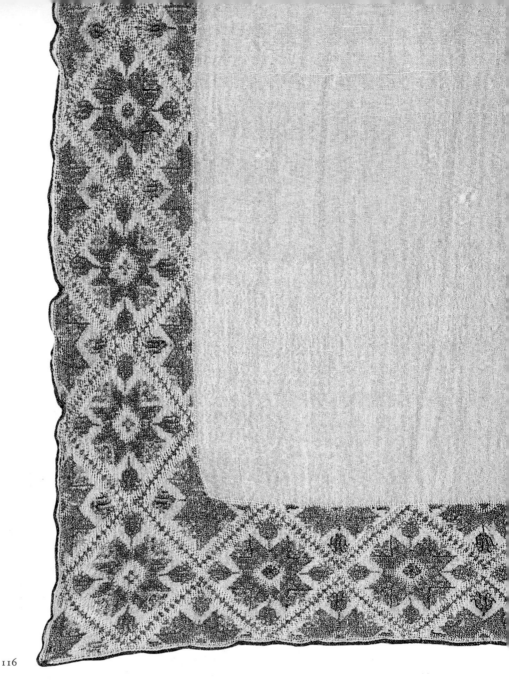

116

116 Handkerchief

From the tomb of Hürrem Sultan (d. 1558)
52 × 52 cm; border 4.5–5 cm
TKS 31/1473
Literature: Tezcan and Delibaş 1986, pl. 90; Washington 1987, no. 128, and
 refs

The cream-coloured handkerchief is embroidered in coloured
silks and gold, and edged with gold wound around beige silk
threads. The lozenge border is filled with eight-pointed stars
with four axial tulips.

Headbands (nos 117–19)

Two of these bands were found in the tomb of Hürrem Sultan
and were evidently part of her head-dress. It is somewhat
difficult to see where they were worn, however: sixteenth-
century representations of Ottoman ladies are mostly by
Europeans, for example, Melchior Lorchs, who can have had

little opportunity to study the details of their costume (cf. no.
4b), and are thus unreliable. They employ the same stitches as
the handkerchiefs, but coloured silks and gold thread are used
more lavishly, possibly because the headbands are one-sided
and have cotton backing which also protected them from
sweat, grime or wear.

117 Headband

From the tomb of Hürrem Sultan (d. 1558)
L. 55.5 cm
TKS 31/1478
Literature: Berker 1973, figs 18a–b; Istanbul 1983, E. 100; Washington
 1987, no. 129, and refs

The headband (the cotton backing is missing) is embroidered
in coloured silks and silver, and edged with gold thread, with
bands of four- or eight-petalled rosettes on a gold ground.

118 Headband

From the tomb of Hürrem Sultan (d. 1558)
Total L. 56.5 cm; without loops 50 cm
TKS 31/1480
Literature: Frankfurt 1985, no. 5/7a; Washington 1987, no. 130, and refs

The headband, with cotton backing, is embroidered in coloured silks and gold, edged with silver thread, and decorated with a frieze of interlinked squares with cruciform fillings and stylised tulips.

119 Headband

From the tomb of Murad III (d. 1595), possibly belonging to his consort, Safiye Sultan
L. 60 cm
TKS 31/1477
Literature: Frankfurt 1985, no. 5/7b; Washington 1987, no. 131

The headband, with cotton backing, is embroidered in coloured silks over the silver and gold ground with octagons containing whirling rosettes and flowers.

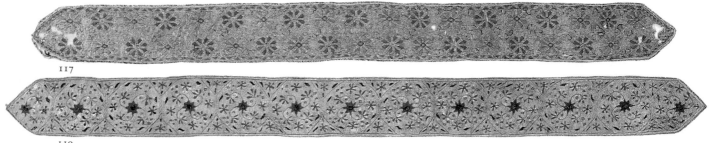

117

119

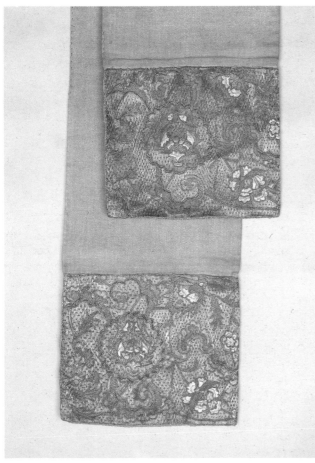

120

Sashes (nos 120–2)

120 Sash

From the tomb of Şehzade Mehmed (d. 1543)
L. 174 cm; embroidery 12 cm
TKS 31/50
Literature: Istanbul 1983, E. 109; Washington 1987, no. 132

The linen sash has embroidered end panels, with gold embroidery (*zerdūzī*) on stiffened yellow satin, in coloured silks with chinoiserie lotus blossoms, cloud bands and feathery leaves. The technique and the design are both very similar to the embroidery of caftans also made for Şehzade Mehmed (TKS 13/1144, 1147; cf. Tezcan and Delibaş 1986, nos 86–7). The sash has been folded over and seamed; this must always have been so for a single layer of linen would not have been strong enough to support the weight of the heavy embroidered panels.

121 Sash

Attributed to Şehzade Mehmed (d. 1543)
L. 216 cm; embroidery 12 cm
TKS 31/49
Literature: Istanbul 1983, E. 110; Washington 1987, no. 133, and refs

The sash has embroidered end panels with gold embroidery (*zerdūzī*) on yellow satin over a double layer of linen with stiffening, in coloured silks with a cypress, date palms in pots, flowers in long-necked vases and triple spots. Signs of stitches down the seam suggest that the sash was intended to be folded once more, thus giving both sides of the sash embroidered decoration.

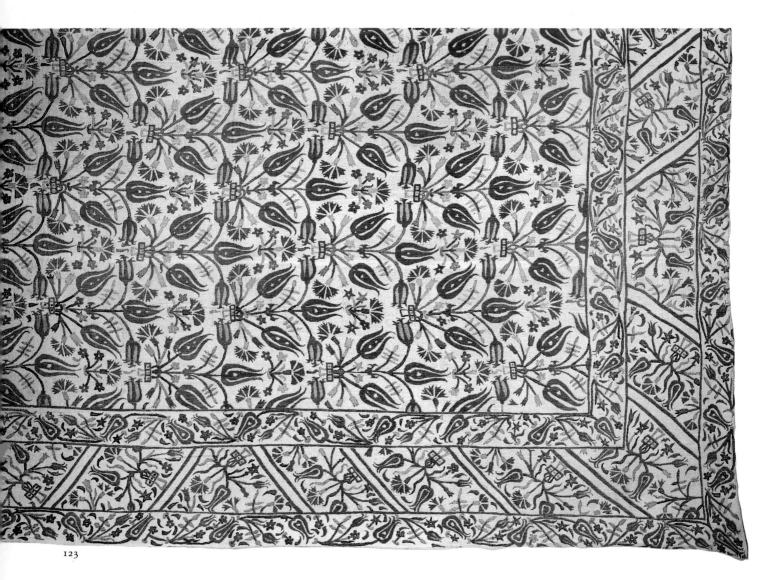

123

122 Sash

From the tomb of Sultan Ahmed (d. 1617)
L. 512 cm; embroidery 15 cm
TKS 31/1475
Literature: Washington 1987, no. 134

The linen sash has embroidered end panels, with gold embroidery (*zerdūzī*) in coloured silks with friezes of cypress trees, hyacinths and tulips on red satin, which is used to some effect in the design, as a strong colour accent. The gold is applied in a finer and smaller version of the basket-weave stitch used on other sashes. In places it is wound around the coloured threads, creating a subtle change of tone and adding sparkle. Of the three sashes in the exhibition this one is in the best condition, and may never have been used: the panels are much less flexible; it is not folded, and there is no sign of stitches down the side, although it would have hung clumsily, and pulled the linen material if used without being doubled.

Other embroideries (nos 123–6)

123 Sheet

Early 17th century
232 × 170 cm
TKS 31/4
Literature: Istanbul 1983, E. 144; Washington 1987, no. 137, and refs

The large and loosely woven linen sheet, or quilt cover, is embroidered in coloured silks in darning-stitch, with repeating bunches of tulips, carnations and other flowers in stylised vases. The decoration draws upon motifs widely exploited at Süleyman's court in the latter part of his reign but is very probably several decades later.

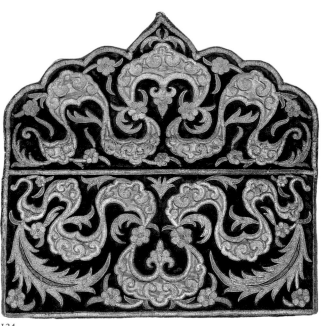

124

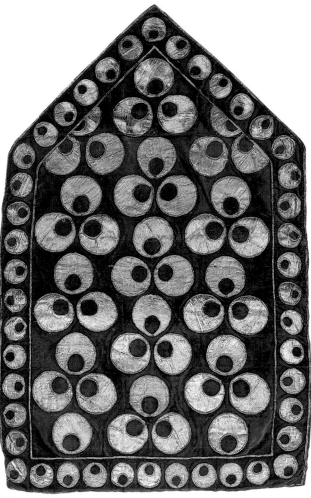

125

124 Portfolio

c. 1550
H. 39.5 cm; closed 19 cm
TKS 31/168
Literature: Istanbul 1983, E. 122; Washington 1987, no. 138

The red velvet portfolio or Koran case, with lobed flap, is lined with yellow satin and decorated with appliquéd embroidery, edged with coiled silver or gold thread, of chinoiserie cloud bands, feathery leaves and rosettes in gold, silver and coloured silks. The silver and gold threads are laid and couched over a padding of beige silk, so that they appear in higher relief than the coloured silks.

It was also customary to store or to send papers in embroidered cloths, but since these would mainly have been scrolls, they were mostly in bags, like those now in the Swedish Royal Archives. Cf. Geijer and Lamm 1944.

125 Portfolio

Later 16th century
H. 112 cm; closed 59 cm
TKS 13/1891
Literature: Istanbul, E. 123; Washington 1987, no. 139

The red velvet portfolio or case for a Koran is lined with red Italian damask and decorated with appliquéd crescents of cloth of silver arranged in groups of three with a border of smaller crescents. They are laid over stiffening covered in silk, and held down by thickly coiled silver threads, which were originally gilded.

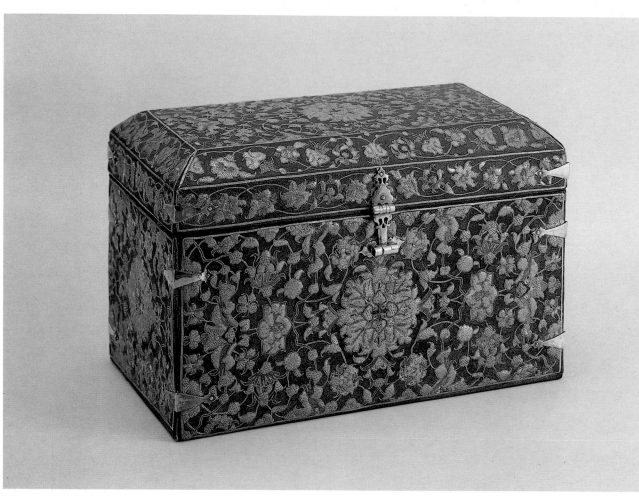

126

126 Embroidered box

c. 1550–80

17 × 27 × 14 cm

TKS 31/268

Literature: Istanbul 1983, E. 117; Tezcan-Delibaş 1986, pl. 94; Washington 1987, no. 140

The box is covered with finely grained dark grey shagreen, lined with red satin inside and underneath with gold hinges, corner-pieces and a clasp. The sides and top of the box are embroidered in relief with chinoiserie floral scrolls around large central cruciform rosettes. The bevelled edges of the lid are decorated with scrolling lotus. The embroidery is in layers: red or blue on the bottom, then pale green, and finally gold on the top. Each layer picks up threads from the layer beneath, thereby adding accents of a contrasting colour to the surface of the design. The different patterns used create a great variety of textures on the surface of the gold. Thickly coiled gold thread is used to outline every part of the design. There is also an embroidered tankard in the Topkapı Saray (Tezcan-Delibaş 1986, pl. 93), less well preserved but from the same workshop. Compare also the embroidered leather binding (no. 25).

127 Floor covering

Later 16th century

400 × 300 cm; original L. 800 cm

TKS 13/1783

Literature: Istanbul 1983, E. 235; Washington 1987, no. 150

The floor covering, woven in red and blue silk and gold and silver thread, consists of three loom widths joined together, originally with three lobed medallions of carnations, stylised tulips and rosettes, corner-pieces of quarter medallions and borders of scrolling lotus blossoms.

This enormous textile, which was later cut in half, is in the Near Eastern tradition of precious silks to strew the floor in royal progresses. Although the Treasury inventories of the reign of Bayazid II (1481–1512) list carpets in the palace collections, these are few and are far exceeded by brocades and other heavy silks for the floor.

127

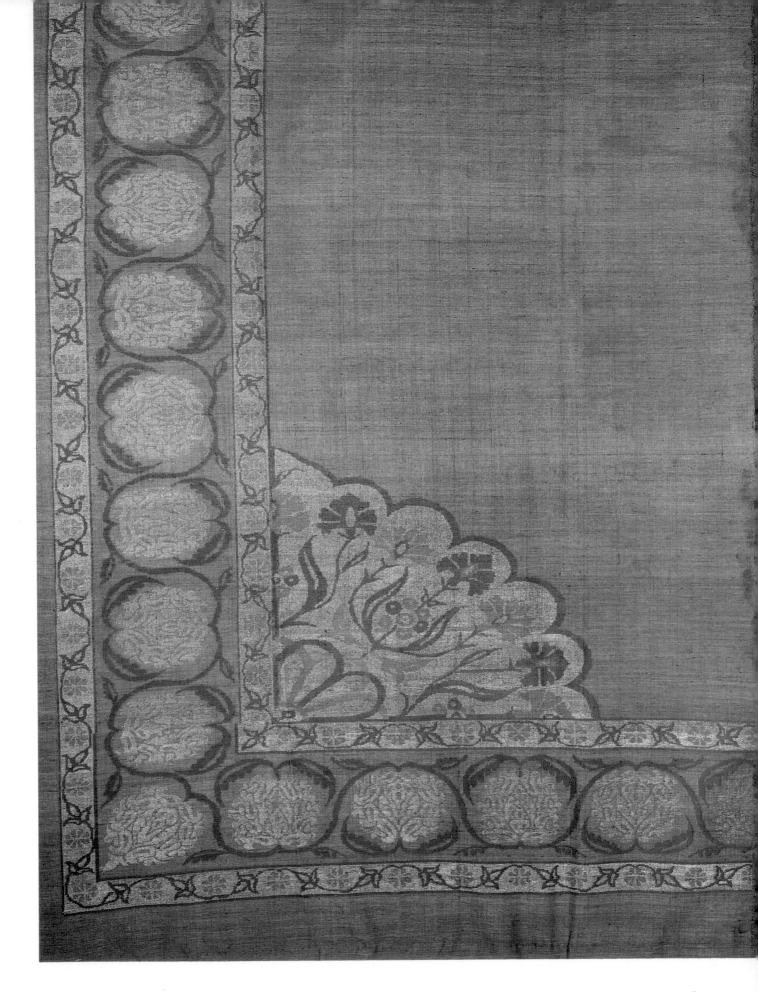

9 The Iznik potteries (nos 128–64)

There is evidence, direct or indirect, for the import of Chinese blue and white porcelains into the Middle East from the later fourteenth century onwards,[1] but its first appearance in bulk is associated with the brief opening of early Ming China to foreign trade and tribute in the first decades of the fifteenth century. These years culminated in the great naval expeditions of the admiral Jengho along the coasts of South-East Asia and across the Indian Ocean, *c.* 1430, to the Gulf when, it has been conjectured, quantities of porcelain were brought as ballast for the enormous Chinese junks and warships.[2] All sorts of fifteenth-century blue and white wares, doubtless locally manufactured, excavated in Samarkand and Merv demonstrate that, at least periodically, the land route to China taken by the Timurid embassies to China between 1400 and 1430 remained open,[3] but the main source of supply was by sea. Chinese porcelains had always been admired in the Middle East for their hardness, durability and above all size, while celadons were believed to detect, or even neutralise poison. They were avidly collected in Egypt in the late fifteenth century and by, for example, the Akkoyunlu rulers of Tabriz, and some even reached the states of northern Italy.[4]

Fifteenth-century Muslim taste for Chinese blue and white remained fixated on the magnificent products of the Yuan and early Ming kilns, to the extent that in the later fifteenth century the Chinese took to reviving their designs especially for export, and it may be that even in the sixteenth century Chinese export wares for the Middle East were relatively old-fashioned. But they also stimulated numerous mass-produced local imitations, in Egypt[5] and to a lesser extent in Syria and Iran. Many of them have little but their decoration, which is often artless, to connect them with the Chinese originals, but particularly in fifteenth-century Fustāt, immediately to the south of modern Cairo, the potters boldly experimented with glazes to produce a vast range of imitation celadons and masses of blue and white, often crude in execution but boldly inventive. In the later fifteenth century a series of potters' workshops, which persisted over several generations, produced ranges of pottery which they signed.[6] Some of the most important among them have Syrian or Persian *nisbas* (notably *al-Tabrīzī*/from Tabriz), although whether this indicated their place of birth, their place of training or the greater popularity of blue and white with a Persian provenance has yet to be established; while far too little fifteenth-century Persian blue and white has been excavated to suggest that the pottery was Persian in style. To judge, however, from the Chinese prototypes he used, the workshop of one of these 'Persians', al-Hurmūzī (from Hurmuz), continued in production after the Ottoman conquest of Egypt.[7]

From this scene of extensive Chinese imports and locally concentrated mass production later fifteenth-century Ottoman Turkey stood apart. Access to the Gulf and even to the Red Sea

was blocked by worsening relations with Akkoyunlu Tabriz and with Mamluk Egypt, and Mehmed II and Bayazid II were relatively far less well placed than Venice or Florence. This is reflected in the minute holdings of Chinese blue and white in the earliest Ottoman palace inventories of the 1490s and 1500s. The only recourse was locally produced pottery, and it was the achievement of the potters of Kütahya and Iznik, which were, doubtless, chosen for their deposits of fine clay,[8] to effect a technical revolution in the production of finely glazed and decorated, if still relatively low-fired, pottery. The earliest reference to Iznik blue and white (*çīnī-i Iznīk*; confusingly, *çini* in modern Turkish means 'tiles', decorated in any way whatsoever) for the court is in the kitchen accounts of Mehmed II at Bursa from 1469 to 1473.[9] To judge from the Iznik blue and white datable to the early sixteenth century, its decoration was lavish chinoiserie, peony, lotus and cloud scrolls – with arabesques and knotted interlaces, more or less characteristic of the 'International Timurid' repertory which had swept Western Asia in the early fifteenth century and which was developed in various forms at courts from Herat to Istanbul to Cairo. These early Iznik blue and white wares (cf. mosque lamps, nos 129–30) were vastly superior to their Muslim competitors, and may indeed constitute a technological revolution.

Where did this all come from? If early Ottoman Turkey had a tradition of fine pottery before Mehmed II, nothing is known of it. Nor is the treatment of the decoration, in brilliantly contrasted tones of cobalt giving a modelled effect,[10] easily to be derived from ornament of the reign of Mehmed II. The technical mastery presupposes a tradition of experiment with glazes and bodies best guaranteed by the mass production of Mamluk Egypt or Syria with which it has some important features in common, although the characteristic glaze compositions seem to be radically different. Moreover, the ornament, particularly the use of knotted interlaces and certain forms of pseudo-Kufic, has a Mediterranean feel to it reminiscent of, if not wholly comparable to, decoration and illumination under Qāyt Bāy (d. 1496), the Mamluk Sultan of Egypt. The political situation and geographical proximity of Syria, with which the fifteenth-century blue and white tiles in the Mosque of Muradiye at Edirne are now generally associated, also make it probable that the potters were trained in a Mamluk tradition.[11] Two recently published dishes fired on cockspurs from the Madina collection with bracketed rims, of off-white ware, with painting of a dragon on a ground of clouds and a *qilin* on a foliate scroll ground, in smudgy greyish cobalt under a greenish rather crazed glaze, are unlike much of the fifteenth-century blue and white from Fustāt: they represent conscientious attempts to reproduce Chinese originals. Their drawing suggests an analogy with Iznik blue and white, although in physical appearance Iznik blue and white wares are vastly different, with a white, more highly fired, body, close-fitting glaze which rarely crazes and brilliant sharp painting making

full use of varying tones of cobalt to give depth and variety to their decoration.

Iznik blue and white is often for convenience grouped round the sole dated piece, a small ewer with dragon handle and curved spout, with an Armenian inscription under the glaze with a potter's name, 'Abraham of Kütahya', which, from the terms in which it was written, must have been made at Kütahya[12] not Iznik.[13] In its shape (which has somewhat implausibly been associated with Islamic metalwork but which may, in fact, imitate a north Italian ceramic form) as in its place of manufacture it can scarcely be considered a typical piece of early Ottoman blue and white. Fragments of 'Abraham of Kütahya' wares, in which a scroll with a teardrop-like leaf disconcertingly reminiscent of a tadpole appears conspicuously, have recently been found in some quantity in excavations at Kütahya[14] and may indicate that it was a local type; for comparison with the large pieces – basins, mosque lamps and penboxes in the present exhibition – suggests that they are in several styles, not one.

The volume of production is difficult to estimate, but sherd finds at Aleppo, Fusṭāṭ, Budapest and in the Crimea, and patent imitations of it from Fusṭāṭ, suggest that the court may have done little more than buy from the market to supply its needs. More specialised pieces like the series of mosque lamps evidently ordered for the tomb of Bayazid II in Istanbul (d. 1512) (cf. nos 129–30); tiles like those on the Sünnet Odası in the Topkapı Saray[15] in Istanbul; great footed bowls (cf. no. 131); or a series of jugs and pitchers, of which one with a schematised landscape recently excavated at the Çarşı Kapı in Istanbul[16] is a brilliant example, must all, however, have been court commissions. Their lavish and brilliant decoration suggests that they were to cater to unsatisfied court demand for Chinese porcelains, although few show the slightest acquaintance with Chinese prototypes. The situation changed with Selim I's booty from Tabriz in 1514 and from Aleppo, Damascus and Cairo in 1516–17, vastly augmented by booty from Süleyman's own campaigns in Iraq and north-west Persia which must suddenly have filled the Sultan's treasury with porcelains. This radically affected court demand for Iznik blue and white and by 1540, if not earlier, close imitations (cf. nos 132–4) of Yuan or Ming pieces from the Treasury began to be made at Iznik.

There was, doubtless, far greater diversity even than the already considerable number of intact pieces now suggests. Sherd material from the site in Istanbul where the foundations of the Post Office were dug in 1905, and now in the Benaki Museum in Athens, suggests a wide range of experimental wares in addition to standard pieces of the 'Abraham of Kütahya' repertory – fragments after Xuande scrolling prototypes (cf. no 132), in dull greyish blue as well as in bright cobalt; similarly diverse blue and white using chinoiserie motifs not derived from Chinese prototypes; blue and turquoise wares, mostly cups or small bowls with marguerites and

'willow' scrolls; as well as opaque-glazed fragments and fragments which in drawing and glaze decay are typical of Cairene and north Syrian manufacture. In rather smaller quantity are represented the characteristic pieces with spiral scrolling known as 'Golden Horn' wares from this convenient find spot, and for which a single dated piece, again with a dated Armenian inscription of 1529, gives a context of c. 1529 (BM, OA, G. 1983.16, Godman Bequest).

It is generally, if unwarrantedly, assumed that this spiral scroll decoration, deriving from illumination and even from the *tuğras* of Süleyman's fermans, superseded 'Abraham of Kütahya' blue and white. However, there is little conclusive evidence so far that it was actually patronised by the court; and, on the contrary, it is remarkable for its Italianate shapes (cf. the flask, no. 136, which copies a common Venetian glass shape). This piece and other 'Golden Horn' pieces have well-established Italian provenances; Venetian maiolica of the period 1525–46 shows indebtedness to it to a degree unparalleled in any other group of Iznik; and it looks as though much of it was exported, if not actually made to foreign taste. Variants in colour, in blackish green and even underglaze red, also indicate that it continued to be made over several decades. Although like the earlier blue and white wares, it is mostly monochrome, accents in turquoise blue are common, and it would probably be mistaken to suppose that the Iznik potters took any time to graduate from single to multiple blue and white wares. Besides, there is plenty of evidence for the continuing manufacture of blue and white throughout the sixteenth century.

The evolution of Iznik pottery is very difficult to chart, and the use of the very few dated pieces known does as much to hinder the matter as help it. Certainly, for much of the time the standard groups must have been made simultaneously by different workshops for different groups or classes of client, so that variations would have been numerous and innovation must have been somewhat haphazard. However, the brilliant 'Damascus' wares (so-called because a century ago they were thought to have been made there), which as pottery have a claim to be the finest of all Iznik, with brilliant glazes, probably the largest range of underglaze colourants in the whole history of ceramics and with extraordinarily varied designs exploiting high Ottoman fashion as well as brilliant repertories of florists' flowers,[17] must have been deliberately commissioned and strictly controlled. The earliest evidence for their manufacture is a mosque lamp dated 1549 from the Dome of the Rock in Jerusalem (no. 148), which may or may not be associated with Süleyman's restorations at that shrine, which reached a high point in the 1540s, but which is fairly clearly evidence for court initiative somewhere. The 'Damascus' group is not invariably vividly polychrome, some of its most virtuoso effects being produced in blue and turquoise or blue, turquoise and grey, but its concentration on dishes, the virtual absence of Italianate shapes, the brilliant drawing, and

the lavish use of botanically exact florists' flowers suggest close contacts with the court arts, particularly the fashions of the latter part of Süleyman's reign (cf. *Dīvān-i Muḥibbī* of 1566, no. 31).

What caused the decline of pottery at Iznik? The general view is that it was superseded by wares with underglaze red, produced by Armenian bole (*kilermeni*), an earth much used as a base for gilding, which under certain firing conditions gives a tomato red; but the conditions are exceptionally difficult to realise and led to an unacceptably high proportion of rejects. However, as an answer that is far too simple. Part of the transition relates to changes in fashion for wall decorations in Ottoman architecture, which from the early fifteenth century had been famous for its tilework. This was very largely in *cuerda seca*, with a range of colours in which opaque yellow and leaf-green were conspicuous and which, in the case of the Green Mosque at Bursa (inaugurated 1421), was signed by craftsmen from Tabriz. The tile revetments of Selim I's tomb at Selimiye in Istanbul, and even of the tomb of Şehzade Mehmed (d. 1543),[18] are in the tradition they established, although the latter is outstanding in excellence and balance of colours. Julian Raby has recently identified the work of Persian craftsmen in tilework for Süleyman's restorations to the Dome of the Rock in Jerusalem, which suggests that the *cuerda seca* tilework of these Istanbul monuments may have been Tabrizi too. It is interesting that the tradition should have so well withstood competition offered by blue and white pottery of the 'Abraham of Kütahya' and 'Golden Horn' types, and from the 'Damascus' group in which practically no tiles were ever made.

The tiles at Süleymaniye (inaugurated 1557) were something different: it was the grandest monument of Istanbul and the embodiment of Süleyman's power as well as his piety; and, by chance or not, these tiles make use of underglaze bole-red. A new fashion was set, and for more than twenty years every imperial foundation, from the mosque of Rüstem Paşa (d. 1561) to Murad III's restoration of the Harem apartments in the Topkapı Saray in 1575[19] (cf. no. 164), ordered similar tiles in enormous quantities, turning the Iznik potteries virtually into an imperial tileworks. It may be that differences in firing conditions, too, made it impossible to fire the bole-red and the polychrome colourants of the 'Damascus' group together in the same kiln, although some tiles in the Rüstem Paşa group make considerable use of manganese-purple and even of the charac-

teristic 'Damascus' sage-green (a misnomer because some greens are almost leaf-green in colour, not glaucous) in combination with bole-red. The crucial factor was, doubtless, that it was not 'Damascus' tiles but the new bole-red tiles which were high fashion. With so overwhelming a demand for tiles and the skilled labour supply inelastic, the Iznik potters no longer had time to devote themselves to the careful control of standards which the manufacture of the 'Damascus' plates and dishes entailed, so they were sacrificed. This was to be the case with Iznik pottery in general. Although it often escapes notice, the marked superiority of, for example, the Murad III tile panels to even the best pottery with bole-red is enough to show that both tiles and pottery could not have been simultaneously produced to standards which satisfied the Ottoman court.

NOTES

1. Julian Raby, 'The porcelain trade routes', in Krahl *et al.* 1986, 55–63.
2. Mills 1970; Carswell, Chicago 1985.
3. Fletcher 1968, 206–24.
4. Spallanzani 1978, 126.
5. These observations are much indebted to John Carswell and Helen Philon's forthcoming work on the later Islamic pottery in the Benaki Museum, Athens.
6. Abel 1930.
7. We are grateful to Helen Philon for her observations on this potter.
8. Raby 1976, 149–88.
9. Barkan, 1979, 187–280.
10. Cf. the observations in Raby 1986, 177–87. Raby ingeniously demonstrates the debt of Uşak carpet designs to book-bindings made for the library of Mehmed the Conqueror (d. 1481).
11. Riefstahl 1937; Carswell 1978, 269–96; id. 1979, 15–22; id., Chicago 1985, nos 66, 68.
12. Carswell and Dowsett 1972; Rogers, *Halı* 26 (April–June 1985), 50–7, 92.
13. The traditional stylistic categorisations – 'Abraham of Kütahya', 'Golden Horn', 'Damascus' and, in the older literature, 'Rhodian' – are all fairly inadequate, particularly since although they have often been regarded as sequential, the chronology of Iznik based upon the handful of dated pieces allows of no definite conclusion. But the stylistic groupings are more or less homogeneous and the classification is, therefore, retained here. Cf. Lane 1957, 247–81.
14. Şahin 1979–80, 259–86.
15. Kurt Erdmann 1959, 144–53.
16. Istanbul 1983, E. 39.
17. Rogers, *The Burlington Magazine* CXXVII (March, 1985), 134–45.
18. Yenişehirlioğlu 1980, 449–56.
19. Sakisian 1939, 959–63.

128 Penbox

Early 16th century
6.3 × 29.6 × 6 cm
BM, G. 1983.7, Godman Bequest
Literature: London 1976, no. 11; Frankfurt 1985, no. 2/3; Washington 1987,
no. 168; cf. Chicago 1985, nos 36–40

The penbox is blue and white with pseudo-Kufic inscriptions on a spiral scroll ground, the rounded ends decorated with arabesques. The upper surface has more arabesque decoration and a Koranic inscription, part of LXI, 13, in rather childish *naskhī*. The underside bears a bold cloud scroll. The moulded ink-wells, which now have tarnished silver caps, were fired with the box. The hinged silver cover bears a stamped *tuǧra*, *Selim*, that is, evidently Selim III (1789–1807).

The penbox reproduces the shape of inlaid or engraved brass penboxes from Egypt and Syria and from Timurid Iran but not known from Ottoman Turkey, but is copied from an intermediary version, in blue and white porcelain of the early Ming period, and as such would have had a cover. There is no early Ming example now in the Topkapı Saray collections, but the Iznik version may have been commissioned to replace the broken original.

The sixteenth-century Ottoman Sultans' overwhelming preference for Yuan and early fifteenth-century Ming, which of course was by then no longer on the market, left them no recourse but to capture it from their enemies. In the period after 1500, when Chinese porcelains were in more plentiful supply in the Middle East, pieces bearing inscriptions in Arabic characters were made, although probably in fact for the local Muslim population rather than for export. The inscriptions, if not illegible, are often illiterately executed. It might therefore be that the unimpressiveness of inscriptions in Iznik blue and white resulted from misplaced zeal in copying Chinese originals of the Zhengde (1506–21) or Jiajing (1522–66) period; but the decoration of early sixteenth-century Iznik blue and white is otherwise not markedly Chinese at all.

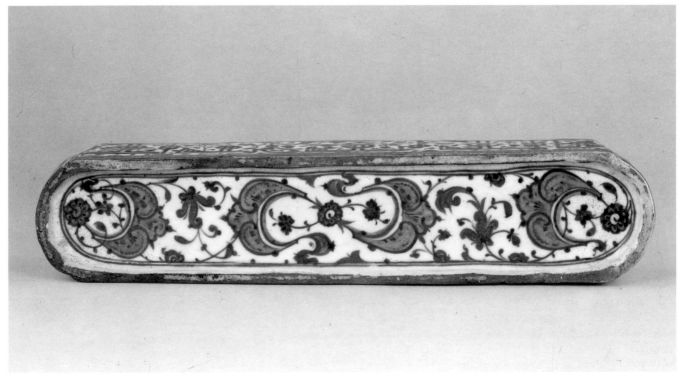

128

129 Mosque lamp

Early 16th century
H. 27.6 cm; DIAM. (max) 18.2 cm
Çinili Köşk 41/2
Literature: Washington 1966, no. 262; Washington 1987, no. 166, and refs

The mosque lamp is blue and white, painted with lobed medallions and *tabulae ansatae*, and bristly cloud scrolls or split-palmette arabesques on a ground of triple spots. There are traces of gilding at the neck and handles. The lutes at the neck and the foot bear meanders or chain bands, while the underside has a radial design. The dotted ground of the medallions indicates that a pounced stencil was used for the naïve *naskhī* inscriptions of the *tabulae – Allāh Muḥammad ʿAlī* – with poorly legible plaited Kufic inscriptions below, possibly ejaculatory prayers.

Of the ten lamps of this type which still survive four are from the tomb of Bayazid II (d. 1512) in Istanbul. The present one, from the mosque of Sokollu Mehmed Paşa (inaugurated 1571), must be from the same group: Sokollu Mehmed Paşa, to judge from his own buildings, was a patron of considerable taste. Despite the *general* similarities the shape, size and the decoration of the ten lamps are extraordinarily diverse and no two are exactly alike. One common feature, however, is the form and content of the inscriptions, not one of which is relevant to the function of the lamps, an astonishing break with Muslim tradition. Those in Kufic, with knotted ligatures and decorative ascenders, are mostly pseudo-inscriptions with repeating groups of letters. Those in *naskhī*, on the other hand, are naïve to the point of illiteracy and may well be the work of potters ignorant of Arabic.

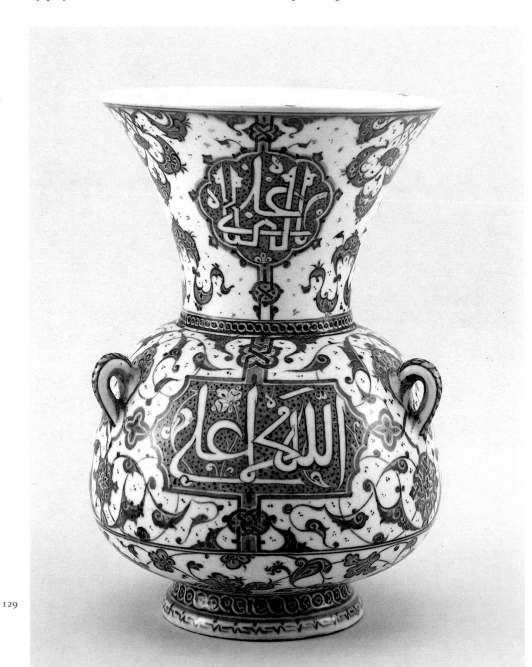

129

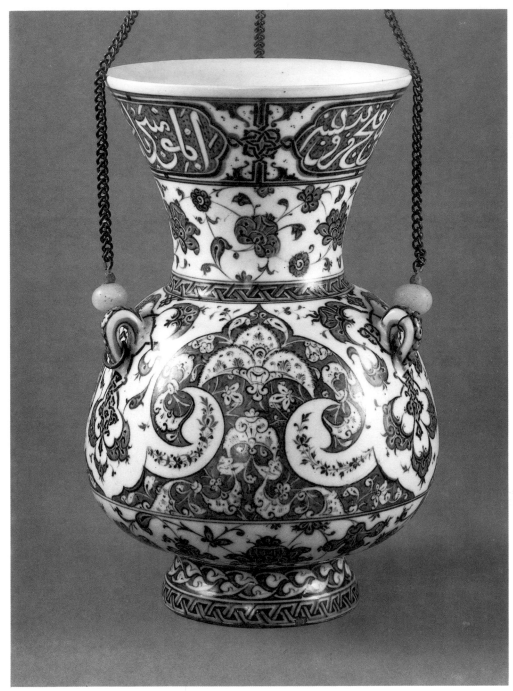

130

130 Mosque lamp

Early 16th century
H. 28.5 cm
BM, G. 1983.4, Godman Bequest
Literature: London 1976, no. 409; Frankfurt 1985, no. 2/7

The mosque lamp is painted underglaze blue, with floral scrolls, cable bands, and a counterchange of bold palmettes filled with scrolls and cloud bands, fine trails of blossoms and bristly cloud-scroll compositions with knot patterns. At the rim are three oblong panels separated by a knotted pseudo-Kufic device, with stencilled inscriptions in naïve *naskhī*: part of Koran LXI, 13; *yā Muḥammad*; and *Allāh, Muḥammad, ʿAlī*. The underside of the foot bears a rosette.

This mosque lamp is one of the group of lamps associated with the mausoleum of Bayazid II (d. 1512) in Istanbul, and has one of the richest decorative schemes.

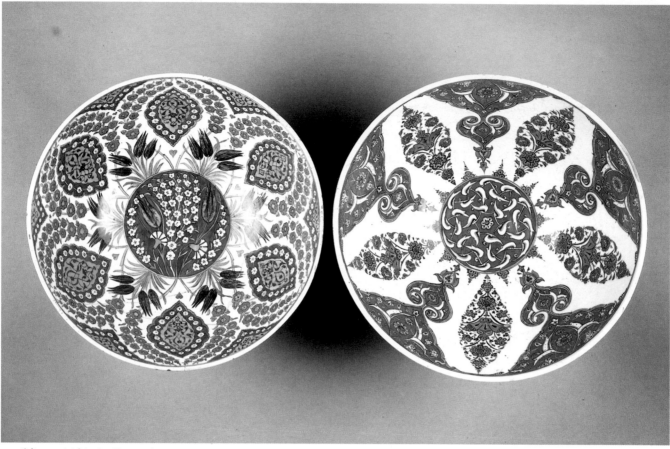

143 (*left*), 131 (*right*); also illustrated on p.34

131 Basin

Iznik, early 16th century
H. 28.5 cm
BM, G. 1983.8, Godman Bequest
Literature: Rogers 1983, 23–7; Rogers 1984, fig. 2

The large basin, which has a high foot, is painted underglaze
in cobalt blue with exquisitely drawn stylised chinoiserie lotus
and 'tadpole' scrolls. Inside are touches of turquoise and of
grey with floral medallions and lavish swags, with a centre of
heavily modelled arabesques. The split-palmettes, which
resemble those of sixteenth-century silver phiales, mostly from
the Balkan provinces of the Ottoman empire, appear deliber-
ately to recall the swimming fish of fourteenth-century Syrian
and Egyptian inlaid brass basins. A blue and white truncated
flask with similar decoration now in a private collection in
Kuwait may well have been a companion piece.

In the partial inventory of the Treasury of Bayazid II, dated
1505 (TKSA D4), there is a reference to eleven *ayāḳ ṭāsı* ('foot
basins' – not, as might appear more appropriate, 'footed
basins' – perhaps therefore for washing the feet). In technical
perfection this bowl would certainly have been for the palace,
but its decoration seems more evolved than the date that the
Bayazid inventory would suggest.

132 Dish

Later 16th century
DIAM. 36.5 cm; H. 9.4 cm
Çinili Köşk 41/155
Literature: Istanbul 1983, E. 33; London 1984, fig. 163a–b; Chicago 1985,
 no. 22; Washington 1987, no. 170

The dish, which is blue and white, has a bracketed rim and
fluted cavetto, the upper surface with lotus- or peony-scroll
designs after an early Ming prototype.

The painter has well suggested the radial treatment of the
central scroll (in contrast with the vertical axis of the greater
majority of Iznik dishes), but its symmetry is far from perfect,
and the cavetto bears thirteen floral sprigs rather than the
standard six, eight or twelve which Chinese taste would have
favoured.

Near Eastern and Ottoman taste favoured almost exclusively
Yuan and early Ming Chinese blue and white, to the extent
that in the late fifteenth century the Chinese began to export
revivalist pieces, which are well represented in the collections
of the Topkapı Saray. Iznik imitations of the Chinese
porcelains are largely confined to early Ming dishes with peony
scrolls or vine clusters (which were still sufficiently common in
the Near East in the sixteenth century for palaces to have sets

or services of them). They were intended either to make up larger services (for example, at the celebrations in 1582 of the circumcision of Murad III's sons when Iznik pottery was bought to supplement porcelains from the palace), or for a wider clientele who had neither the means nor the opportunity to acquire the Chinese originals. This may explain the rather free treatment of the original Chinese designs.

133 Dish

16th century
H. 7.6 cm; DIAM. 38.9 cm
BM, G. 1983.33, Godman Bequest
Literature: Rogers 1985a, fig. 11; Washington 1987, no. 181

The dish is painted underglaze in black, pale cobalt, sage-green and manganese, with motifs from early Ming blue and white porcelains. The ten sprigs in the cavetto admirably balance the dense undulating scrollwork of the flattened bracketed rim. The centre has transformed the essentially radial design of the Ming original into the favourite Iznik design of floral stems rising from a leafy tuft.

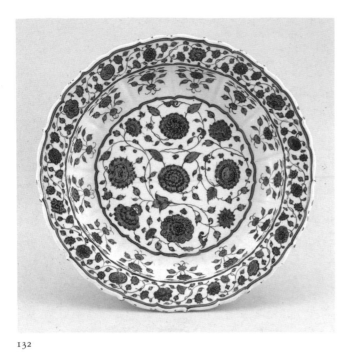

132

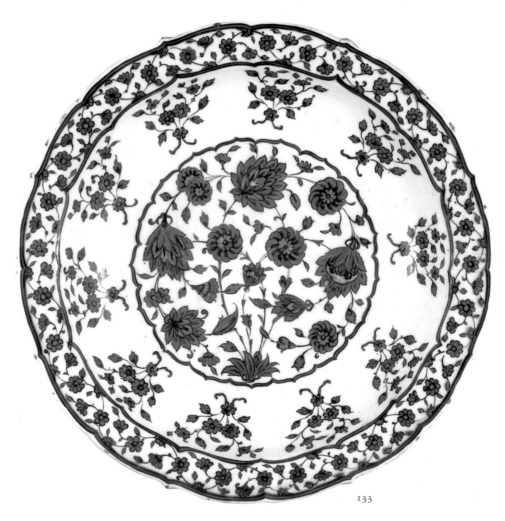

133

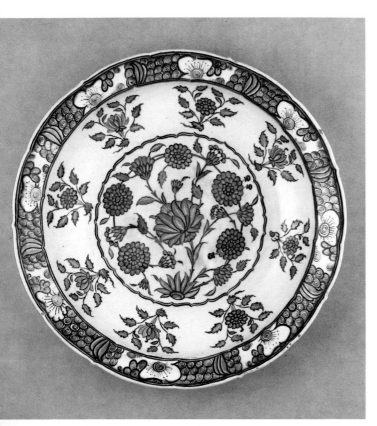

134

134 Dish

16th century
DIAM. 42.5 cm
BM, OA 1969.7–21.1, Brooke Sewell Bequest
Literature: Rogers 1985a, fig. 9

The dish, with bracketed rim, is painted in underglaze cobalt with a wave and rock scroll, triglyphs at the rim, and chinoiserie compositions after early Ming prototypes at the centre (on a vertical axis, however) and in the cavetto.

135 Dish

c. 1530
DIAM. 33 cm
BM, OA 87.6–17.9, gift of Sir Augustus Wollaston Franks

The dish, which has a bracketed rim, is 'Golden Horn' ware painted underglaze in bright cobalt with an undulating scroll at the rim, and a central roundel of dense scrolling, sketchy cloud bands and lozenge cartouches with a whirling rosette at the centre in a cusped surround. The underside has six small spirals.

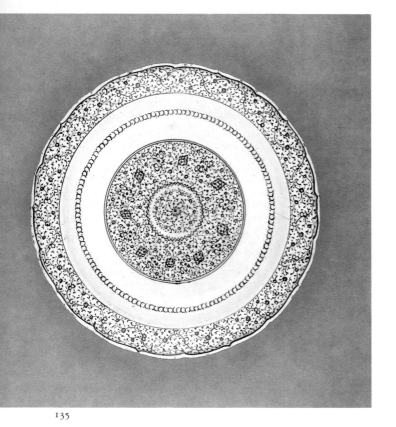

135

136 Bottle

Iznik, or Kütahya, *c.* 1530

H. 43.5 cm

BM, OA 78.12–30.519, Henderson Bequest; acquired in Italy by the
connoisseur and collector, Eugène Piot

Literature: Carswell 1982, pl.73; Istanbul 1983, E. 41; Rogers 1985c, 53;
Washington 1987, no. 178

The bottle, which is 'Golden Horn' ware, has a pear-shaped
base, a graceful neck with a central boss and a flaring mouth.
It is decorated underglaze in cobalt and turquoise with spiral
blossom scrolls and lozenge-shaped panels with split-palmettes
and cross-hatching. The sharp break between the neck and
body decoration may very probably be intentional, to make
room for a gold mount.

There is a single fragmentary tile of this type painted in two
tones of blue (Berlin-Dahlem, Museum für Islamische Kunst,
I.5614). Like other 'Golden Horn' pieces, including *tondini*,
lidded ewers, and an oenochoe in the Museo Civico, Bologna,
its form is Italianate and imitates a common Venetian glass
form. The spiral scrolling on Venetian maiolicas of the period
1525–46, which is also thought to derive from 'Golden Horn'
wares, may thus indicate that a considerable number of them
were made for export.

The cut down 'Golden Horn' ware bottle (BM, G. 1983.16)

bearing Armenian inscriptions under the glaze (dated 978
Armenian/1529) must be attributed to Kütahya but may be an
exception. Pieces with scroll decoration in greenish-black and
even underglaze red show that 'Golden Horn' ware continued
to be made sporadically into the later sixteenth century.

137 Seven hexagonal tiles

c. 1525–50

DIAM. (av.) 17.5–18.5 cm

Çinili Köşk 41/515 and 41/1121; purchased 1943

Literature: Paris 1977, no. 588; Istanbul 1983, E. 44; Washington 1987,
no. 180, and refs

The tiles are painted underglaze in cobalt and turquoise. The
designs are freehand variations upon a six-pointed star (most
clearly shown upper right), filled with split-palmettes and
chinoiserie lotuses, with a small central star and an edging of
feathery half-lotuses, somewhat similar to the central tile
medallions of nos 150 and 151. The tiles have been sawn down
but are in pristine condition and may well have been intended
to have plain or gilt cobalt triangular tiles between them.

There is a group of these tiles in position on the façade of the
Sünnet Odası in the Topkapı Saray.

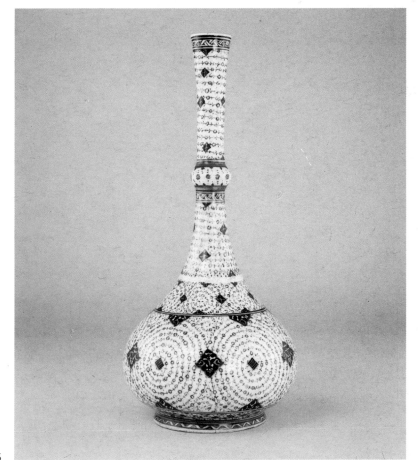

136

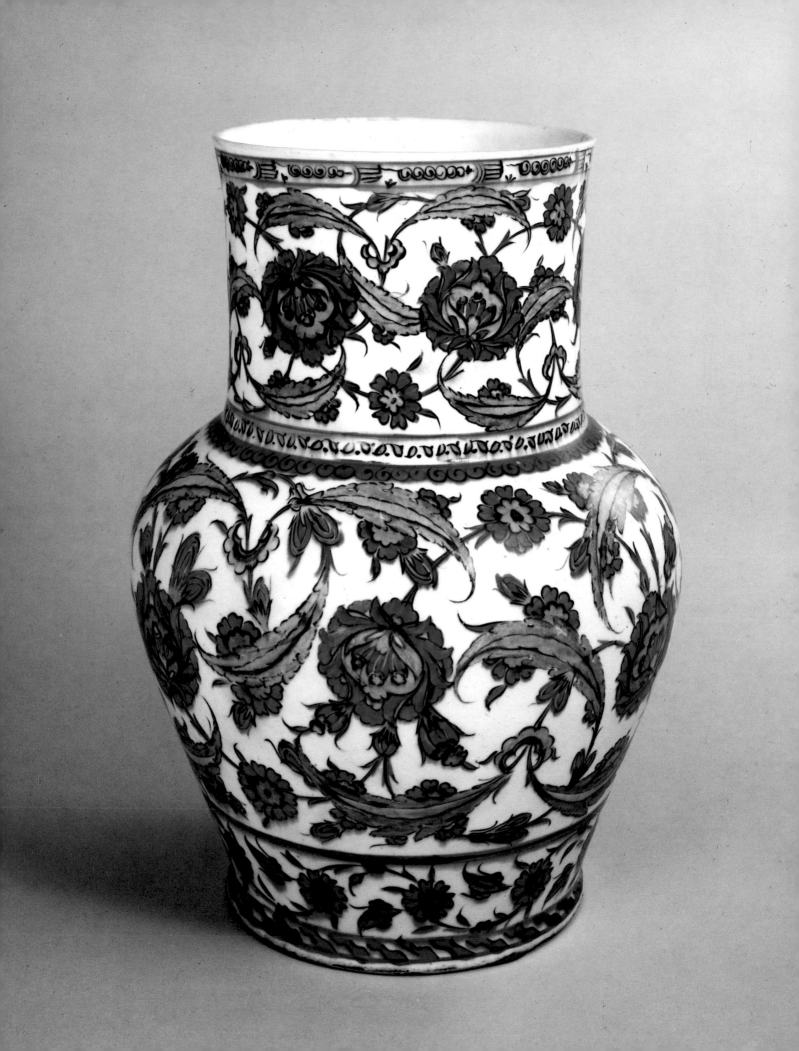

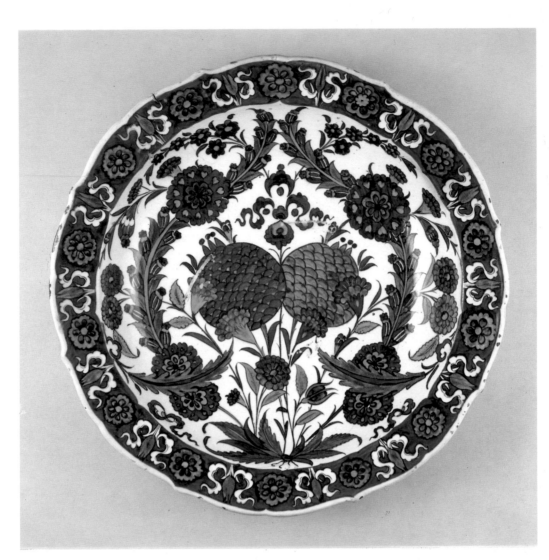

139

138 Wide-mouthed jar

c. 1550–70
H. 33.5 cm
BM, OA 78.12–30. 513, Henderson Bequest
Literature: Washington 1987, no. 183

The jar is decorated in underglaze blue, black, turquoise, green and pale manganese with composite chinoiserie lotus scroll, rosettes, feathery leaves and cloud clips, with narrow friezes at the foot, shoulders and rim. The neck bears a more compressed version of the same design.

Interestingly, whereas early blue and white – both 'Abraham of Kütahya' and 'Golden Horn' wares – exhibit a wide range of successful closed shapes, those of the 'Damascus' and bole-red groups are few and often perfunctorily decorated. This piece is a conspicuous exception.

138

139 Dish

c. 1550–70
H. 7 cm; DIAM. 38.8 cm
BM, G. 1983.48, Godman Bequest
Literature: Rogers 1985a, fig. 4; Washington 1987, no. 186

The dish, which has a bracketed rim, is painted in black, cobalt, turquoise, manganese-purple and green with a pair of scaly pomegranates at the centre wreathed with gentian stems and stylised roses, all rising from a leafy tuft.

The filling of the ground with sprays of prunus and other florists' flowers, feathery leaves and cloud scrolls gives the whole composition a swirling appearance which does not crowd the effect, despite the heavy rim with its stiff lyre-shaped cloud scrolls recalling the treatment of the motif on some Uşak carpet borders. The gentians, which do not seem to have been cultivated in Turkey or in Europe in the sixteenth century, with tight buds in the axils of their leaves, show unexpectedly precise botanical observation.

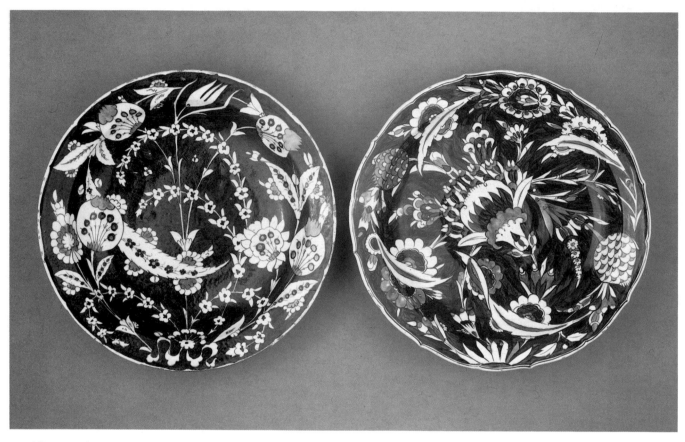

140 (left), 141 (right)

140 Dish

c. 1550–70
DIAM. 39 cm
BM, G. 1983.32, Godman Bequest
Literature: Rogers 1985a, fig. 7

The dish is painted underglaze in black and turquoise with composite pomegranates, slender prunus stems, tulips, marguerites and feathery leaves on a brushed cobalt ground. The stems are tied at the base by a ribbon-like cloud scroll. Iznik dishes on which the central design occupies the whole area are much in the minority and are restricted entirely to the 'Damascus' group.

141 Dish

c. 1550–70
H. 6.5 cm; DIAM. 38.3 cm
BM, OA 78.12–30.531, Henderson Bequest
Literature: London 1983, no. 112

The dish, which has a bracketed rim, is painted underglaze in black, turquoise and brushed cobalt with swirling sprays of scaly pomegranates, feathery leaves, stylised rose-buds and daisies, and a central composite artichoke blossom terminating in serried rose-buds, all rising from a leafy tuft.

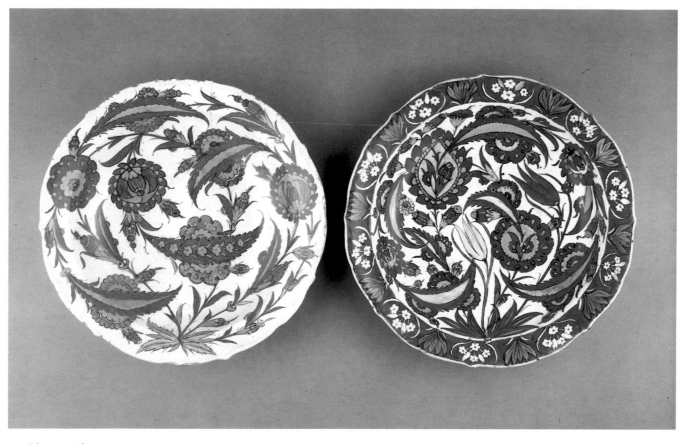

142 (*left*), 147 (*right*)

142 Dish

c. 1550–70
DIAM. 38.5 cm
BM, G. 1983.37, Godman Bequest
Literature: Rogers 1985a, fig. 23

The dish, which has a bracketed rim, is painted in cobalt, sage-green and turquoise, with swirling sprays of stylised chinoiserie lotuses and rosettes, rose-buds and feathery composite leaves rising from a leafy tuft. The design occupies the whole of the surface of the dish. It is a considerable but recognisable simplification of the textile design in no. 106.

143 Footed basin (illustrated on p. 192)

c. 1550–70
H. 27.3; DIAM. 44.1 cm
BM, G. 1983.66, Godman Bequest
Literature: London 1976, no. 413

The basin is painted underglaze in black, tones of cobalt, purple, dull green and turquoise – outside with exuberant scrolls of composite chinoiserie lotuses and feathery leaves with bands of tulip buds at the base, and inside with pointed lobed medallions filled with arabesques and wreathed with prunus blossoms and branches. At the centre is a composition of prunus branches, carnations and speckled tulips or fritillaries with sharply pointed petals around it. From the rim hang triangular swags, also filled with arabesques.

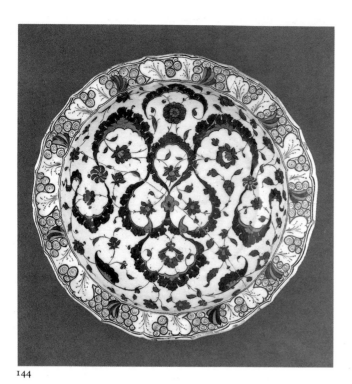

144

144 Dish

c. 1550–70
DIAM. 35.9 cm
BM, G. 1983.39, Godman Bequest
Literature: Rogers 1985a, fig. 5

The dish is painted underglaze in black, tones of cobalt and brown (probably a misfired sage-green) with a wave and rock scroll at the rim and a frilly cloud-scroll composition at the centre on a ground of stylised chinoiserie lotus blossoms.

145 Dish

c. 1550–70
DIAM. 36.2 cm
BM, G. 1983.49, Godman Bequest
Literature: Rogers 1985a, fig. 19

The dish, which has a bracketed rim, is painted underglaze in black, tones of cobalt, turquoise, sage-green and manganese-purple with a central feathery composite lotus wreathed by hyacinth stems and flanked by stylised roses, tulips, fritillaries and other flowers, all rising from a leafy tuft. The rim is a wave and rock scroll enhanced with plume-like triglyphs.

The naturalistic floral decoration seems to include muscari

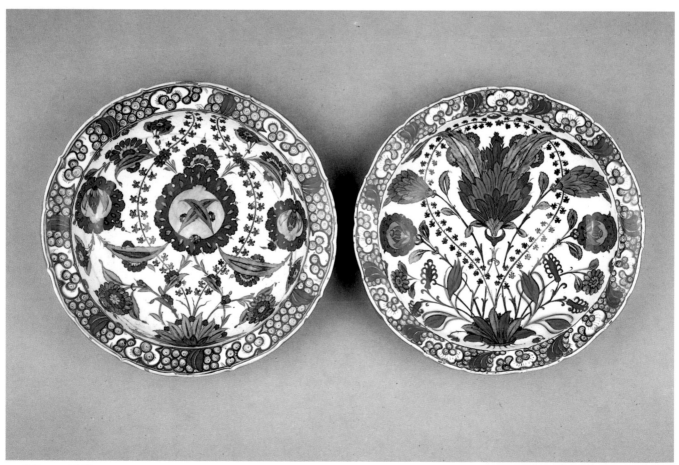

149 (*left*), 145 (*right*)

(?*M. comosum*) and possibly *Celosia cristata*, the cockscomb, introduced into European gardens around 1550. There is a closely related dish, possibly by the same hand, in the Victoria and Albert Museum (Salting Bequest, C.1194.1910).

146 Dish

c. 1550–70
DIAM. 34.8 cm; H. 5.5 cm
BM, G. 1983.52, Godman Bequest
Literature: Lane 1957; Rogers 1984; Rogers 1985a; Washington 1987,
 no. 175

The dish, which has a bracketed rim, is painted underglaze in cobalt and turquoise with a panelled design on the rim, and alternate cloud scrolls and slender flowering stems in the cavetto. The centre is filled with vases of stylised flowers set on a tray or bowl and a ground of stylised hyacinths and cloud scrolls set in a lobed frame.

The cloud scrolls and the curving leaf scrolls, almost like tadpoles, are a legacy from earlier sixteenth-century blue and white (cf. no. 131) and are still to be found in the decoration of Iznik pottery of the 1560s–70s. The flowers, which are far from naturalistic, have some stems broken to fit them into the design, a trait largely characteristic of the dishes with bole-red painted with florists' flowers of the 1560s–70s or later. The central vase, possibly after a piece of imported Venetian glass, is closely paralleled in illustrated Italian works on floriculture published in the same decades. This suggests that Iznik blue and turquoise wares, which evidently derive from the 'Abraham of Kütahya' group, remained in fashion for most of the sixteenth century.

147 Dish (illustrated on p. 199)

*c.*1550–70
H. 5.5 cm; DIAM. 39 cm
BM, OA 78.12–30.530, Henderson Bequest

The dish, which has a bracketed rim, is painted underglaze in greyish-green black, cobalt, turquoise and pale manganese-purple. The rim bears alternate tufts of leaves and posies of flowers on a cobalt ground. The rest of the surface, including the cavetto, bears steeply curving stems of hollow composite chinoiserie lotuses, rose-buds, composite feathery leaves, half-rosettes and tulips rising from a tuft of serrated leaves. The underlying sketch in black is visible in places.

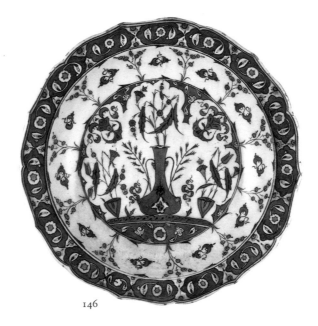

146

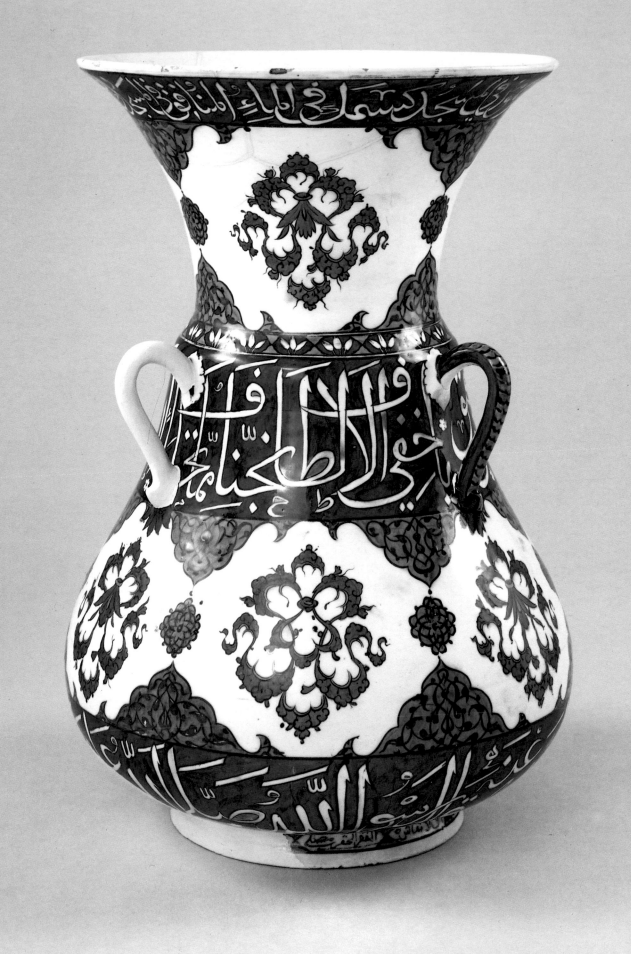

148 Mosque lamp

956/1549
From the Dome of the Rock in Jerusalem
H. 38.5 cm
BM, OA 87.5–16.1, gift of C. Drury Fortnum
Literature: Fortnum 1869, 387–97

The mosque lamp is painted underglaze in black cobalt and turquoise with bands of *basmala* and *ḥadīth* at the neck and base, a bolder Koranic inscription at the waist, and cloud scrolls alternating with triangular panels of arabesque. The broken base bears a fragmentary and somewhat illiterate inscription [*sic*] – *ol:deryā* [1 word illegible] *kim Iznīk de: Eşrefzāde-dir: fī sene 956* [in figures]: *fī şehr-i Cumāzil: ūlā nakkāş al-fakīr al-ḥakīr Muşlī* – a reference to the Qādirī mystic ᶜAbd Allāh-i Rūmī (d. probably in 874/1469–70 at Iznik). There is a cut-down version of this mosque lamp but without the inscription, also in the British Museum (G. 1983.57).

The date Cumādā I 956/June 1549 has been regarded as a convenient terminus for the 'Damascus' style in Iznik pottery and coincides with the later stages of Süleyman's restorations at the Ḥaram al-Sharīf in Jerusalem. But the tenor of the craftsman's inscription (he was evidently a decorator, not a potter) suggests a dedication not to the Ḥaram al-Sharīf but to the shrine of Eşrefzade, at Iznik, which was founded and endowed by one of Bayazid II's daughters, Mükrime Hatun (d. 932/1517–18). Eşrefzade is stated by Evliya Çelebi in the mid-seventeenth century to be the patron of the Iznik potters, but we have no information for the sixteenth century. However, as a royal foundation, the shrine would have continued to attract gifts such as this mosque lamp from eminent visitors. How it reached Jerusalem is unknown.

The carefully pointed inscription, at the waists of the two lamps, is elegantly composed to fill the space both horizontally and vertically; it must be from a stencil prepared by a calligrapher probably on the spot, since the result depended on the exact dimensions of the biscuit-fired vessels.

149 Dish (illustrated on p. 200)

c. 1550–70
DIAM. 35.5 cm
BM, G. 1983.46, Godman Bequest
Literature: Rogers 1985a, fig. 24

The dish, which has a bracketed rim, is painted underglaze in black, tones of cobalt, turquoise, sage-green and manganese-purple with a central pomegranate-artichoke motif wreathed by hyacinth stems, swirling sprays of feathery leaves and composite chinoiserie lotuses, all springing from a leafy tuft. The rim is a wave and rock scroll with plume-like triglyphs.

The artichoke motif derives evidently from the decoration of *ferronnerie*-pattern Venetian Italian velvets. The overall design of the dish is a more sophisticated version of no. 161.

150

150 Dish

2nd half of 16th century
DIAM. 42.5 cm; H. 9 cm
TKS 15/6086
Literature: Raby and Yücel 1983, 38–48; Washington 1987, no. 163

The dish, which has a bracketed rim, has relief carving of steeply undulating palmette scroll, stylised chinoiserie cloud cartouches and a central plumed hexagon with radial lotuses, derived from a tile design, under an opacified pale bluish-white glaze, which is heavily chipped.

The palmette scroll on the rim characterises a group of dishes with bole-red represented notably in the British Museum and in the Gulbenkian Museum in Lisbon, some of which may be as late as the seventeenth century; the first appearance of such 'green' wares, a substitute for Chinese celadon, which was believed to detect the presence of poison, is indeed in inventories and official documents of the late sixteenth and early seventeenth centuries referring both to 'green' wares (*akhḍar* in the Arabic sources) and to white wares (*beyāż, ahyaḍ*). It is possible that they were produced along with other monochromes, blue, salmon-pink and dull red or mauve, which, however, are far too low in quality to have been made for the court. The tile design from which the central hexagon rather incongruously derives is a variant of a well-known Iznik pattern (cf. no. 137), but the closest parallel is a 'Damascus' tile dish (no. 151) with composite foliate or floral forms and a virtually identical border, *c.* 1550 or later.

148

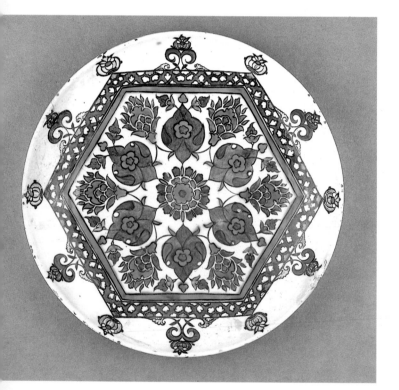

151

151 Shallow dish

c. 1550–70
DIAM. 31.2 cm
BM, G. 1983.47, Godman Bequest
Literature: Cf. Raby and Yücel 1983, 38–48

The shallow dish, with curving sides, is painted underglaze in grey, turquoise, brushed cobalt and washy manganese, with a hexagon filled with pointed oval medallions and stylised chinoiserie lotuses, and a diaper border and palmette finials or tassels. The design derives from tiles and but for the finials is identical with that depicted on the greenish-white Iznik dish (no. 150).

Although the choice of design is somewhat incongruous, the finish, like that of other dishes of this shape and size in the British Museum and in the Gulbenkian Museum in Lisbon, is brilliant and of the highest quality.

152 Mosque lamp

c. 1570
H. 47.5 cm
Çinili Köşk 41/16
Literature: Kühnel 1938, pl. 26; Istanbul 1983, E. 154; Washington 1987, no. 195

The large mosque lamp, with pierced base, is painted underglaze in black, brushed cobalt, bole-red and turquoise with composite chinoiserie lotuses and sprays of buds or composite feathery leaves. The neck bears the *shahāda* reserved in white with scattered blossoms and leaves, carefully drawn and composed and evidently the work of a professional calligrapher. Between each of the three handles is a conspicuous boss with black arabesques and an eight-petalled flower at the centre.

The lamp is one of two from the mosque of Sokollu Mehmed Paşa at Kadırga Limanı in Istanbul, inaugurated in 979/1571–2, and was evidently made for presentation to the mosque on this occasion. Like a more elaborate mosque lamp from Süleymaniye now in the Victoria and Albert Museum (131.1885) and evidently an inauguration gift for that mosque, its shape is unexplained. It follows Mamluk Syrian or Egyptian practice in being made as a standing vessel, even though intended to be hung, but neither the origin nor the purpose of any of the bosses has been elucidated. The exceptionally careful composition and execution of the decoration are fully in keeping with the famous tiles which decorate the interior of Sokollu Mehmed Paşa's mosque.

152

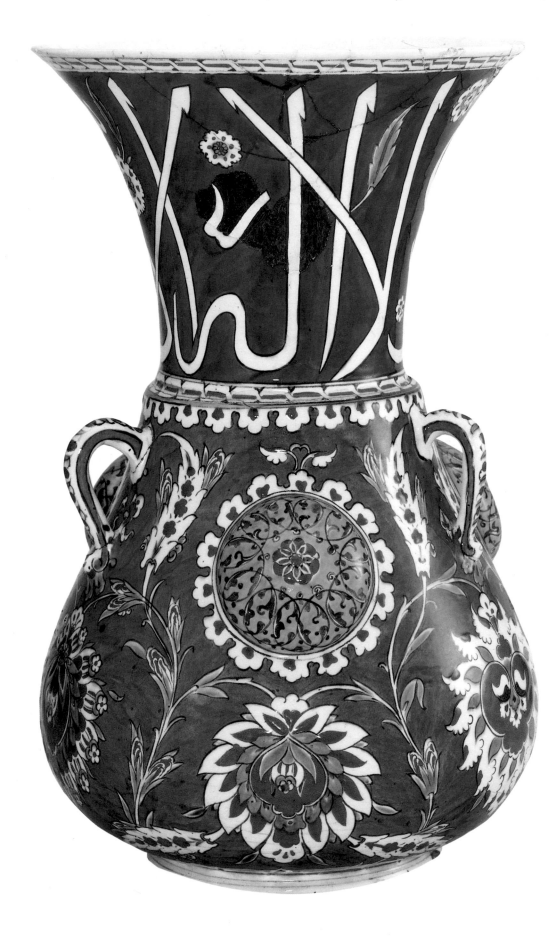

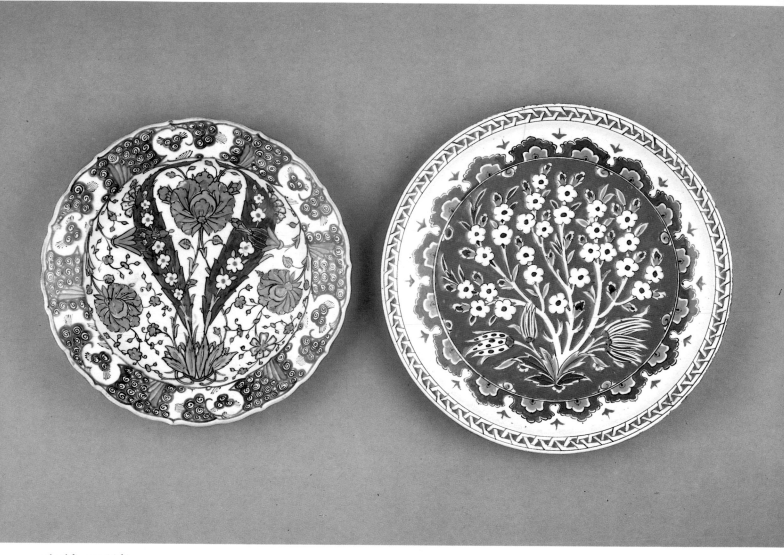

161 (*left*), 153 (*right*)

153 Dish

Later 16th century
DIAM. 35 cm
BM, OA 78.12–30.481, Henderson Bequest

The flat dish, which has a projecting flat rim after a metalwork shape (cf. no. 62), is painted in black, cobalt, bole-red and greenish-turquoise, with a bouquet of flowering prunus branches and striped or spotted tulips rising from a leafy tuft. The rim bears a cable band.

154 Spherical hanging ornament

c. 1560–80
H. 24.5 cm
BM, G. 1983.120, Godman Bequest
Literature: Rogers 1985b, figs 7, 7a; Washington 1987, no. 196

The lower half of the ornament is painted underglaze in black, turquoise, cobalt and bole-red with cloud clips, stylised chinoiserie lotuses and split-palmettes in an expanding ogival pattern. Such ornaments (known in Ottoman inventories as 'eggs' (*yumurda*) and made of a great variety of materials) are generally supposed to derive from spherical or ovoid glass ornaments hung above enamelled glass Mamluk mosque lamps. The great cast-iron polycandela which were hung in Ottoman mosques were far too low to make large mosque lamps and globes above them at all practicable, and the circumstances of their use are therefore obscure. However, Gerlach who visited the tomb of Selim II at Ayasofya (d. 1574) very shortly after it was opened remarks on the shiny glass ornaments (*Spiegelwerk*) hung all around it on fine silken strings. Globular ornaments are also sometimes claimed to have been obstacles to rats or mice running down the chains to drink the oil in the lamp; but that is unlikely to have been their prime purpose.

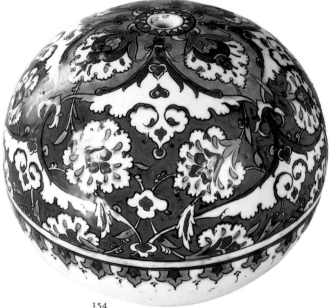

154

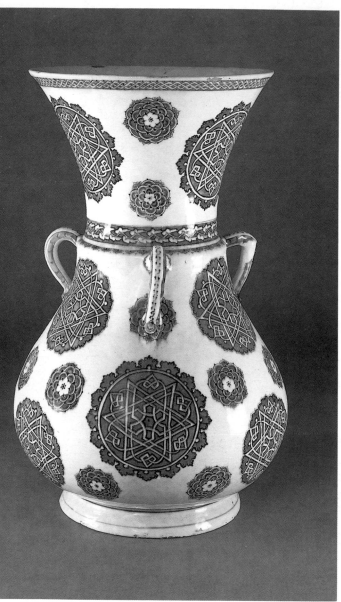

155

155 Mosque lamp

c. 1560–80
H. 34 cm
BM, G. 1983.122, Godman Bequest
Literature: Rogers 1985b

The mosque lamp is painted underglaze in greyish-blue with stencilled medallions and scaly rosettes, the former with interlaces in the form of six-pointed stars. At the rim and round the neck are chain bands or arabesques, and the handles are, as usual, painted as if they were the belly of a snake. Underneath is a polychrome rosette.

156 Dish

c. 1560–80
DIAM. 32.5 cm
BM, G. 1983.100, Godman Bequest
Literature: Rogers 1985b

The flat dish, which has a low rim, is painted underglaze in black, cobalt, greenish-turquoise and bole-red with an eight-petalled rosette and a seven-petalled star-flower at the centre, ingeniously composed to give no fewer than four different concentric blossoms. The angular chain band on the rim, like the shape of the dish, suggests the decoration of metalwork (cf. no. 62). The concentric rosette design, rather exceptionally, has analogues in a number of later sixteenth-century Bursa silks.

157 Dish

Later 16th century
DIAM. 29.3 cm
BM, OA 78.12–30.486, Henderson Bequest

The shallow dish, with curving sides, is painted underglaze in black, cobalt, copper-green and dull bole-red. A leafy lotus form is flanked by symmetrical stems broken at the apex with feathery leaves, and with spotted tulips, campanulas and campions rising from a leafy tuft. At each side is half a cloud clip.

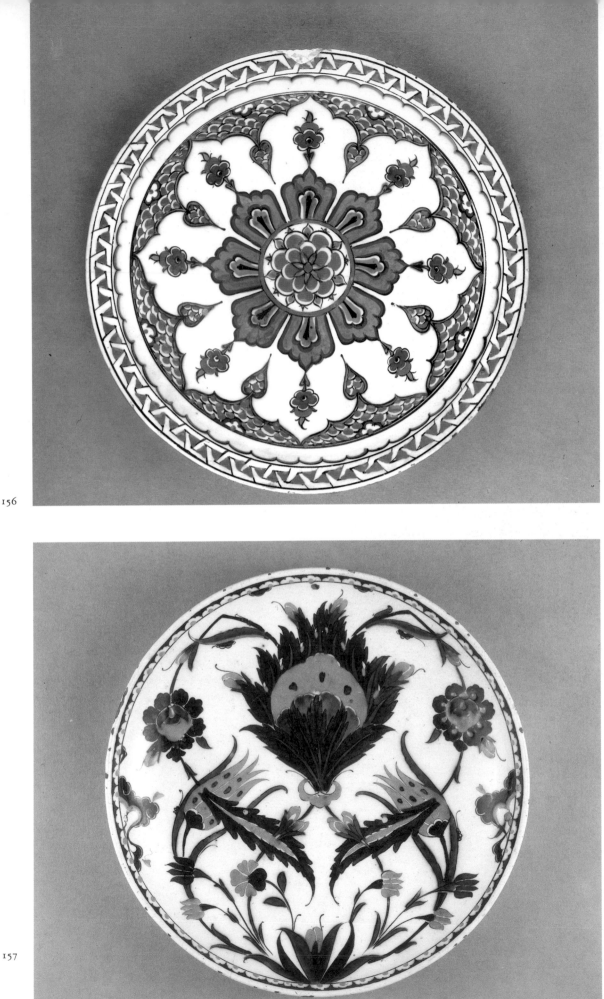

156

157

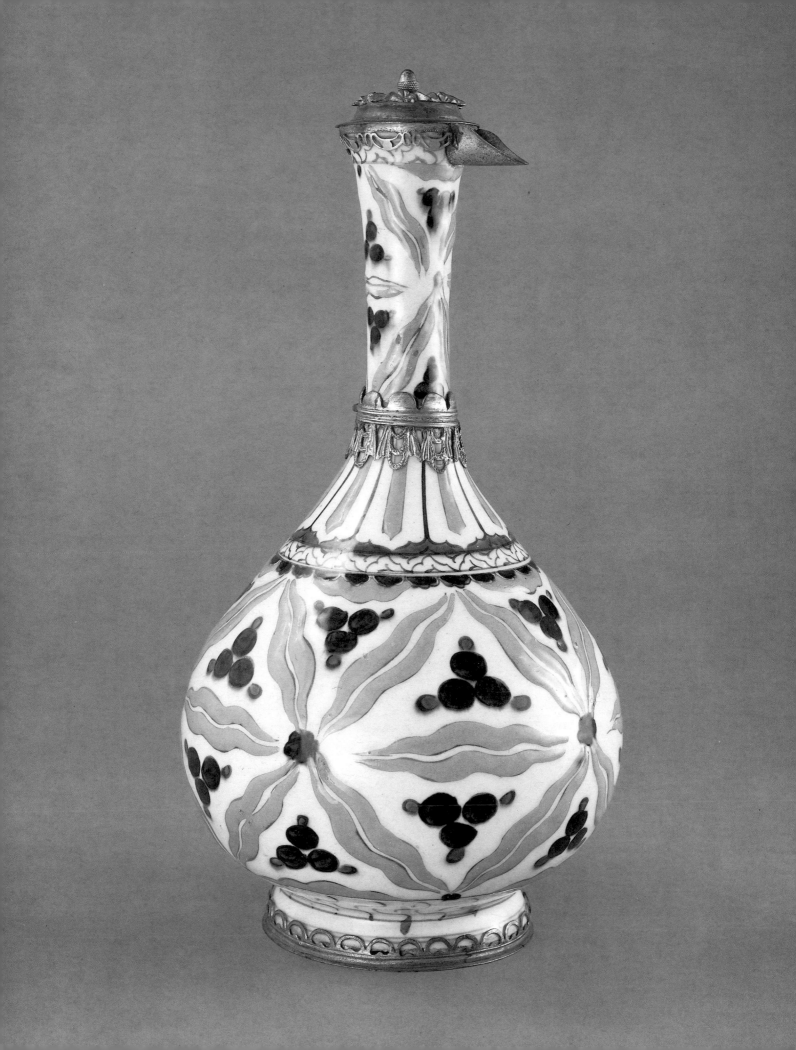

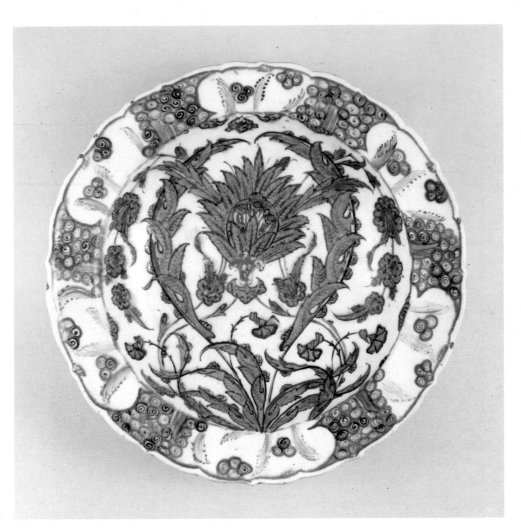

159

158 Bottle

Later 16th century
H. 28.5 cm
BM, OA 78.12–30.466, Henderson Bequest
Literature: London 1976, no. 418; London 1983b, no. 138

The bottle is painted underglaze in black, cobalt, greenish-turquoise and dull bole-red with tiger stripes and triple spots and bands of fluting and meanders. The gilt-copper mounts are later, possibly Ottoman.

159 Dish

Post 1560
H. 6.5 cm; DIAM. 29.8 cm
BM, OA 78.12–30.502, Henderson Bequest
Literature: London 1983b, no. 142; Washington 1987, no. 189

The dish, which has a bracketed rim, is painted in black, runny cobalt, turquoise and bole-red with a central feathery lotus (cf. no. 149) wreathed by composite feathery leaves, with half-blossoms along their midribs, and by broken prunus stems. The composition, which is set not quite vertical, rises from a tuft of violets and smaller feathery leaves with half-blossoms. The broad rim is painted with a highly stylised wave and rock scroll.

If the shading and veining of the leaves suggest a drawing in the *ṣāz* style (for example, no. 50b), the dish is also a version of a better designed dish in the 'Damascus' group which is not by any means so clearly indebted to a drawing. The more crowded composition and more careless execution are fairly typical of Iznik wares with bole-red, when the demand for *tiles* in the period 1560–80 became overwhelming.

158

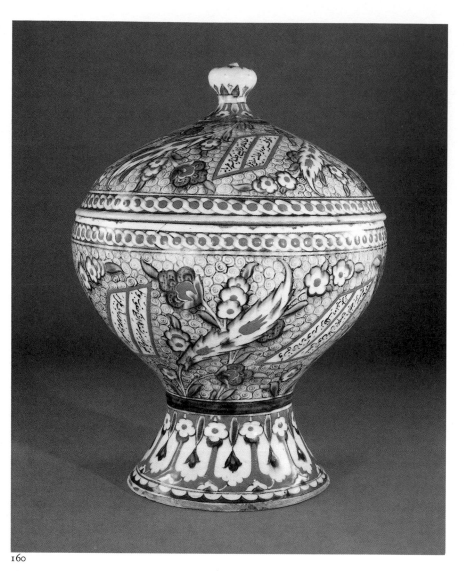

160

160 Covered wine bowl

Later 16th century

H. (overall) 36 cm

BM, G. 1983.139, Godman Bequest

Literature: Ali Nehad Tarlan, *Hayâlî Bey divanı* (Istanbul, 1945); Iz 1966–7, 224; Rogers 1984, fig. 5

The vessel is painted underglaze with blossoms and feathery leaves picked out in cobalt, greenish-turquoise and bole-red on a ground of black curls. The cover and the base bear poetic couplets in careless *nastaʿlīq*, rather as if a manuscript page had been cut up and stuck on: these are a well-known mystical *ğazel* by one of Süleyman's favourite poets, Ḥayālī (d. 1556), and most of a *ğazel* by Revānī (d. 930/1524), a notorious drunkard, with praise of the coming of spring and the pleasures of drink. Such inscribed Iznik vessels are rare, and although the quality of this bowl leaves something to be desired, the choice of verse by two of Süleyman's favourite poets is a clear harking back to the glories of his reign.

161 Dish (illustrated on p. 206)

c. 1560

DIAM. 30.8 cm

BM, G. 1983.97, Godman Bequest

Literature: Rogers 1985a, fig. 8

The dish, which has a bracketed rim, is painted underglaze in black, tones of cobalt, turquoise and bole-red with a wave and rock scroll at the rim, and a central chinoiserie lotus wreathed by prunus stems on feathery leaves and flanked by symmetrically disposed lotuses and blossom scroll. The leafy tuft below the blossoms has root-like appendages below, a reminiscence of the treatment of lotus bouquets on early Ming blue and white.

The design, exemplifying a general tendency in the wares of the bole-red group, is a simplified, coarser version of lotus dishes (cf. nos 145 and 149). The broad rim, in particular, is too heavy for the central composition, which may have been conceived without a border at all.

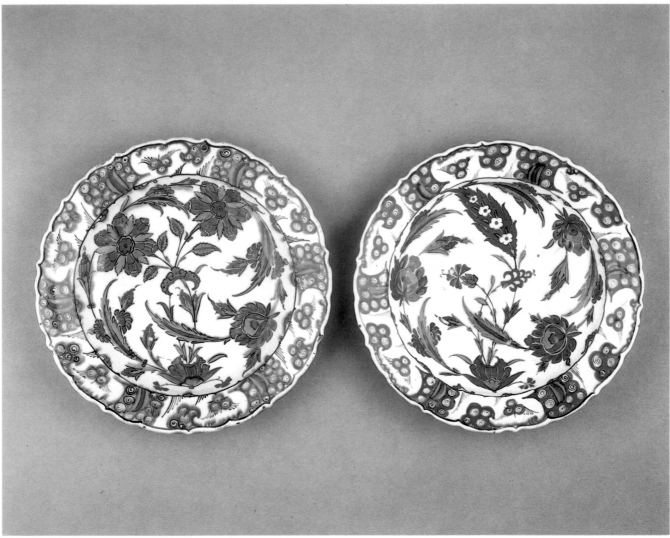

162a–b

162a–b Pair of dishes

Later 16th century
DIAM. 30.5; 29.8 cm
BM, OA 78.12–30.500–1, Henderson Bequest

The two dishes, which have bracketed rims, are decorated with whiskery wave and rock scrolls with polychrome triglyphs, painted underglaze in black, cobalt, greenish-turquoise and bole-red. One bears a steeply curving spray of chinoiserie lotuses and feathery leaves enclosing a pair of stylised roses composed of rose-buds and leaves. The other has a similar lotus and leaf spray enclosing a sparse bunch of flowers – muscari, dianthus and a long leaf with prunus blossoms along the midrib. Each springs from a tuft which has been metamorphosed into a sort of pot.

163 Covered bowl

Later 16th century
H. 22.5 cm
BM, FB Is. 5, bequest of Sir Augustus Wollaston Franks
Literature: Washington 1987, no. 197

In design and execution closed Iznik shapes (jugs, covered bowls or *Humpen*) are generally less *soigné* than dishes, and the

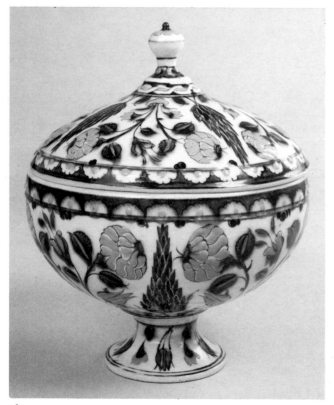

163

present piece, brilliant in appearance as it is, has much simplified decoration and underglaze colourants which have tended to run. Wares of this group were widely imitated in the mid-seventeenth century in the 'Candiana' wares of Padua and other northern Italian kilns.

164 Tile panel

Dated 982/1574–5
218 × 122 cm
TKS 8/1067
Literature: Istanbul 1983, E. 157; Washington 1987, no. 210, and refs

The tile panel from the chamber adjacent to the Sultan's bath in the Topkapı Saray Harem, restored by Murād III, dated 982/1574–5, is painted in black, turquoise, cobalt, manganese-purple, bluish-green and bole-red with flowering prunus and bunches of hyacinths, variegated tulips and carnations springing from leafy tufts. The borders have bolster-like motifs composed of a counterchange of split-palmettes; the spandrels have imbricated cloud scrolls; and above are two panels of Persian *nastaʿlīq*, recording the completion of a belvedere (*şāhnişīn*) for the bath in 982.

The design is a slight simplification of panels of flowering prunus on the *qibla* wall of the Süleymaniye (inaugurated 1557), in the portico of the mausoleum of Hürrem (d. 1558), also at the Süleymaniye, and on the façade of the mosque of Rüstem Paşa (d. 1561) in Istanbul. Prunus panels first occur in the illuminated panels of the Karahiṣārī Koran, written 953/1546–7 (no. 15a), although tile panels being larger allow richer detail. Prunus tile panels also occur on the façade of the Sünnet Odası (in the Topkapı Saray); in the mosque of Selimiye in Edirne: in the library of Ayasofya; and even in the mosque of Sultan Ahmed. There is, however, apparently no standard term for the design in any contemporary document.

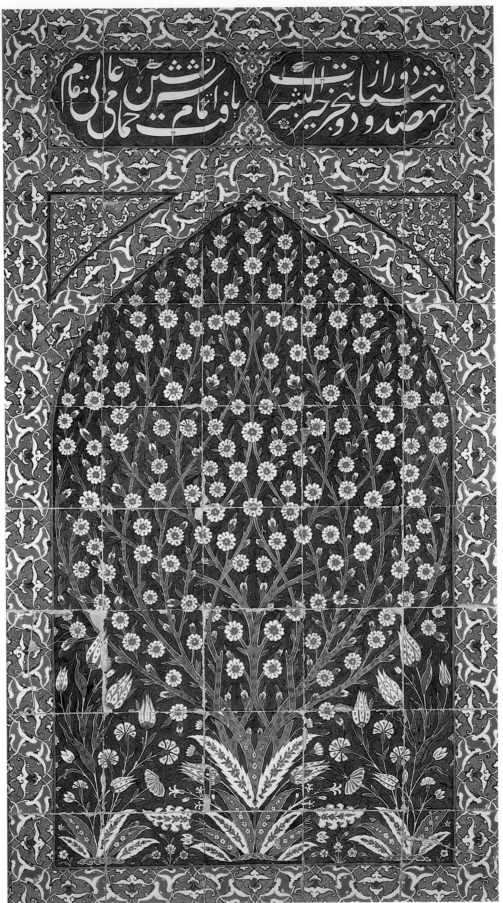

Glossary

'abā Heavy woollen cloth used for outer garments. Fine woollens in the sixteenth-century Ottoman Empire were almost all imported, from Italy, France, Spain and northern Europe.

ābānībāfān Weavers of *ābānī* cotton or silk cloth, generally white, embroidered with saffron-coloured silk, used for turbans, quilt covers or sheets, wrappers, etc.

abjad (Turkish *ebced*) The use of the letters of the Arabic alphabet with numerical values to form chronograms, topical phrases which when the letters are added up give a particular date. For example, the word *Kharāb* ('ruined') gives the date of Tamerlane's destruction of Damascus, 803/1400–1.

abrī (Persian 'cloudwork') A term used by contemporary writers for the irregularly contoured ground illumination of lines of calligraphy, forming shapes contrasting with the pattern of the script.

'Acem Persia, a Persian. The Arabic *'Ajam* simply seems to have meant 'a non-Arab', with a certain derogatory implication.

akçe A silver coin, the chief unit of account in the Ottoman Empire.

alif The first letter of the Arabic alphabet – A – which was often held to determine the proportions of the other letters. In *abjad* it is the number 1.

arabesque (Ottoman Turkish *rūmī*) Interlacing foliate scrollwork, often symmetrical, with split-palmettes or fat buds, absorbed into the Ottoman repertory from illumination or stencilled designs for bindings in fifteenth-century Mamluk Egypt and Syria. From this source also derive animated or peopled scrolls (Arabic *waqwāq*).

āya Verse of the Koran.

basmala (Arabic *besmele*) 'In the name of God, the Merciful, the Compassionate', the opening words of the Koran, used customarily as the opening of any text.

basse taille A refinement of champlevé enamelling, with translucent enamels applied over chased gold or silver reliefs, practised, in combination with opaque enamel colours, in later sixteenth- and seventeenth-century Ottoman Istanbul.

bina emīni The Clerk of the Works appointed to oversee one of the Sultan's particular building works and charged with procuring materials and accounting for the disbursement of the funds provided.

Bīrūn The outer section of the Sultan's household which also included high officers and officials of the administration of the Empire. Some were attached to the janissaries but others were not *kapıkulları* at all. Among them were the Standard Bearer (Mīr-i 'Alem), the Master of the Horse (Mīr Āḫūr, Imrahor), the Chief Pursuivant (Çavuşbaşı) and their staffs, and the Sultan's bodyguard, the Hassekis.

calligraphy By 1500 Arabic, Persian and Ottoman Turkish were written in various hands. *Kufic*, with angular letter forms and ligatures, was archaic and occurs only in mannered decoration. *Naskhī* ('copyist's script'), a rapidly written, legible hand, is scarcely calligraphy at all but in Turkey from *c.* 1570 onwards evolved at the court as a fine bold hand. *Muḥaqqaq* (probably in the Arabic sense of 'tightly woven') was rounded with well-formed letters and was much used for the texts of finely written small-format Korans. *Thulth* (Turkish *sülüs*) is a bold rounded script with some swash letters used for titles, or, occasionally, for emphasis (although Arabic scripts lack the precise roman-italic distinction). *Nastaʿlīq*, characterised by the capricious elongation of certain letters, the smoothing out of the line and a generally diagonal movement, was fashionable from the late fourteenth century onwards. It was not practised at all in Syria or Egypt and was only rarely used for Korans, but in Safavid Persia and Mughal India its practitioners were much esteemed, and many *nastaʿlīq* album leaves

survive, often with implausible attributions. The Ottoman Chancery also employed *taʿlīq* which with *tawqīʿ* was one of the canonical six scripts and which is characterised by unorthodox ligatures, and *dīvānī*, which was used almost exclusively for fermans or documents of State.

ceb A form of more legible *dīvānī* script according to the historian Muṣṭafā ʿĀlī invented by Maṭrākçı Naṣūḥ. Its appearance is difficult to guess at, but since one of the reasons for the use of *dīvānī* was to guard against forgery *ceb* may have been considered to detract from its prime purpose.

Celalis Rebels or insurgents against the central government in the sixteenth century, comprising disaffected elements of very diverse sorts.

cemāʿat A group of people, applied to regiments, like the janissaries or to those in the palace service – bakers, laundrymen, camel-drivers, porters, surgeons, etc., as well as to jewellers, tailors, glaziers, carpet weavers, and so on. The term does not seem to have had any technical sense, although presumably the latter groups were also members of guilds (*esnāf*).

cemāʿat-i müşāherehōrān (literally, 'those receiving monthly stipends') Groups of officials and palace employees including entertainers, poets, musicians, buffoons, dwarfs, pastry cooks and spies but rarely, if ever, the palace craftsmen.

chinoiserie In Islamic art briefly the selective use of Chinese motifs, both foliate and animal, without concern for their symbolism. The former include lotus and peony scroll, although with a tendency to subordinate radial or concentric compositions to a vertical axis. The latter include *qilin* (the Chinese unicorn), lions entwined with beribboned balls, phoenixes (*fenghuang*), cloud deer, dragons and cranes, incorporated into the repertory of early Safavid marginal illumination or used to depict the monsters of Iranian legend.

Direct Chinese connections with Herat and Iran were closest under the early Ming rulers (*c.* 1420–30) and virtually non-existent by 1500: hence the independent evolution of chinoiserie, through deliberate adaptation or pastiche or successive copyists' errors, so that it ultimately became unrecognisable to the Chinese themselves.

cloud scrolls, bands etc. A reminiscence of the deeply curved and convoluted ribbons which in Chinese art of the Han period were already decorated with excrescences, and in Islamic decoration from 1500 to 1700 were the most influential of all chinoiserie motifs. They appear as *clips*, sometimes known as 'cloud collars', deriving most probably from lobed panels; looped *bands*; and serpentine forms, often notched, hooked or with imbricated excrescences. The bands and serpentine forms are often asymmetrically disposed, but in much Ottoman and Safavid illumination are combined by a clip into a symmetrical bracket-like motif, which may be extended by further segments to either side. Clouds in painting from the early fifteenth century onwards also show strong chinoiserie influence, with loops, tentacles and imbrications, but the effect is rather far removed from the abstract cloud bands. The Ottoman *ḫaṭāyī* style makes particular use of this motif.

composite Used here for motifs which break down into series of distinct elements, particularly in Ottoman art, with lotuses made up of prunus blossoms and stylised rose-buds. There are native sources for such composite motifs, but their earliest documented appearance is in Venetian textiles datable to the early fifteenth century, which circulated all over the Near East.

counterchange (or reciprocal patterns) The contrast of positive and negative shapes, where a pattern and its ground may both be read as a coherent arrangement of motifs. Such tricks of design are particularly associated with the Dutch artist M.C. Escher.

cüz' (Arabic *juz'*, *ajzā*) Traditionally one-thirtieth part of

the Koran, frequently directed to be read one a day in a pious foundation for the benefit of the founder. It became customary to bind each part separately and such sets, in lavishly decorated wooden chests, were then presented to the royal tombs of Istanbul. For reasons which are still obscure not all the *cüz'* (pl. *eczā*) of such Korans are of identical length.

Defterdar Treasurer and accountant of the Ottoman Empire responsible for registering all income and expenditure. Under Süleyman the two principal treasurers were those of Anatolia and Rumeli (Turkey in Europe), but the major cities of the Ottoman provinces, Aleppo, Damascus, Cairo and Baghdad, all had their own.

devşirme Christian children levied as and when necessary for training for posts in the palace, the administration or other military corps. They formed the most famous, though not necessarily the largest, element in the janissaries, and many of them reached the highest office.

dirham A silver coin, in the Arab provinces of the Ottoman Empire an equivalent to the *akçe*; a measure of weight for fine materials, including spices and silver. The *şarʿī* dirham, fixed by the religious authorities, was 3.125 g, but the dirham weight officially in use until the seventeenth century seems to have been the *Tabrīzī* dirham (3.072 g). This was superseded by the *Rūmī* dirham of 3.207 g. It could well have been in use in everyday life for decades before it was made the standard for the coinage. To confuse the matter still further silver was weighed at the mines of Sidrekapsı (Mademokhoria) in northern Greece in the Damascus dirham (3.086 g).

dīvān An anthology of poems arranged in the alphabetical order of the final letters of the various end-rhymes.

Divan (Dīvān-i Humāyūn) The Council of State presided over by the Grand Vizier which administered the Ottoman Empire. The Sultan customarily did not attend but observed its proceedings from behind a screen in the Council Chamber (Kubbealtı).

dīvānī The standard script for fermans issued under Süleyman the Magnificent, formal and difficult to forge, probably standardised by his High Chancellor (Nişancı) Celālzāde Muṣṭafā. It was the speciality of the Chancery scribes.

eczā' see *cüz'*.

ehl-i ḥiref (also *erbāb-i ḥiref*) Craftsmen, artisans, members of guilds. The term occurs *inter alia* in the palace registers where it has been thought to apply to specially privileged craftsmen in the palace service, but the evidence for the view is so far inadequate.

Enderūn The inside service of the Sultan's Household staffed by the pages (İç Oğlans, although not necessarily adolescents), mostly of *devşirme* origin, and for most of the sixteenth century by the White Eunuchs. It included the Pantry (*Kiler*) and the Treasury (*Hazine*), but the most important was the Privy Chamber (Has Oda), the Sultan's personal attendants who from the time of Selim I had had the honour of guarding the Prophet's Cloak (Hırka-i Saadet) and other relics which he had brought back from Mecca on the submission of the Hijaz. The Imperial Household was an aristocracy of talent as well as privilege, and from its members were recruited the Sultan's ministers and the highest military governors (Beglerbegs) of the Ottoman Empire.

esnāf (pl. of Arabic *şinf*) The organisation of town dwellers into groups somewhat similar to the medieval and Renaissance European guilds, although for tax purposes as much as for the control of production or distribution. They were, however, organised to the benefit of their members, and the restrictive practices in which they engaged were very comparable to those of the European guilds.

fātiḥa The opening chapter of the Koran.

ferman An edict of the Sultan, also known as *berāt*, *hüküm*,

nişān-ı şerīf (from the initial formula *nişān-ı ʿālişān-ı şerīf*), *ḫaṭṭ-ı şerīf*, etc.

fetvā (Arabic *fatwā*) A written answer to a legal question issued by the Şeyhülislam or some other qualified official interpreter of the Koranic law (*şeriat*). It may or may not also give the grounds for the judgement.

forsa Non-Muslim prisoners of war or convicted criminals sentenced to a period (definite or indefinite) in the galleys (*kürek*) or other forced labour.

ğazel (Arabic *ghazal*) A favourite lyric verse form, in Ottoman court poetry, normally of five or six couplets, in one of the standard classical metres, the first couplet and the second line of the subsequent couplets all rhyming. It was conventional for the poet to indicate his authorship by apostrophising his pen name in the final couplet.

gebr (cf. Ottoman *gâvur/giaour*) Originally a fire-worshipper, but in the sixteenth century a general term of abuse for Christians and other non-Muslims: heathen, infidel.

ğubarī A minute rounded script taking its name from Arabic *ghabr* ('dust').

ḥadīth A recorded tradition of the sayings and actions of the Prophet Muḥammad in the light of which the text of the Koran could be interpreted.

ḥajj Pilgrimage to the Holy Places of Islam which was incumbent on every Muslim at least once during his lifetime. It was to be fulfilled at the end of the Muslim year, in the month of Zilhicce (Arabic *Dhuʾl-Ḥijja*).

ḥaraka The pointing of an Arabic text, obligatory when the Koran was copied out, to ensure that the vowels were correct and to eliminate the possibility of ambiguity or textual corruption.

ḥaram A ritual enclosure, employed primarily for the great Muslim shrines of Mecca and Medina (generally known as the Ḥaramayn/the two *ḥarams*) and also for the enclosure of the Dome of the Rock and the Aqṣā Mosque on the Temple Mount in Jerusalem (the Ḥaram al-Sharīf).

Vakfs to the Ḥaramayn, the Ḥaram al-Sharīf and, for example, Hebron were exempt from paying the canonical tithe (*ʿushr*) prescribed in the *sharīʿa* (Ottoman *şerīat*) or sacred law of Islam.

Hassa Miʿmar Court Architect, charged with the execution of the Sultan's works.

Hasseki Sultan Imperial concubine or woman of the palace who having born the Sultan a son received his special favours. The title continued to be given to Roxelana even though, in contrast to normal Ottoman practice, she became Süleyman's wife.

ḫaṭāyī see *chinoiserie, cloud scrolls*

Humpen Tankard-shaped German vessels, manufactured in metal or glass from the sixteenth century onwards. The prototype appears, from the decoration of Iznik pottery imitations, to have been stitched leather mugs.

ʿilmiye Those of the higher administration of the Ottoman Empire who were graduates of the great Istanbul *medreses*; the professors and lecturers in these *medreses*; and the theologians and lawyers occupying high positions in the clerisy of the Istanbul and Ottoman provinces.

imām The leader of prayers.

ʿimāret Public kitchen distributing food to the needy, by the reign of Süleyman the Magnificent an essential part of any major pious foundation. Süleymaniye is even known in the documents as the *ʿImāret-i ʿĀmire*, indicating the relative importance of this institution.

inʿām defter Monthly palace register of stipends, allowances, rewards, gratuities and honours distributed to the royal ladies and their households, courtiers, high officers and visiting ambassadors from foreign powers.

International Timurid style Chinoiserie peony and lotus scroll (and to a lesser extent figural motifs) which reached Central and Western Asia via the early fifteenth-century embassies to and from the Ming rulers of China, adapted at the Timurid and Turcoman courts of Herat, Tabriz, Shiraz and Baghdad, primarily for illumination and book-binding.

janissaries (Turkish, *yeniçeri*) The Ottoman crack infantry troops, partly composed of boys recruited from the *devşirme* and paid from the Treasury, not by military fiefs.

kaatı see *ḳıṭʿa*.

kadı (Arabic *qāḍī*) A judge, in the Ottoman Empire, administering both Islamic law (*şeriat*) and *ḳānūn* (administrative or criminal law).

Kadınlar Saltanatı 'Harem rule', particularly from the early seventeenth century onwards when the dominating force in Ottoman politics became the Queen Mother (Valide Sultan), and appointments to office were sought not from the Sultan but from the favourites in his Harem who used their influence to procure them.

kalemiye The financial branch of the higher Ottoman bureaucracy educated in the Chancery rather than in the great *medreses* of Istanbul. Under Süleyman its importance increased considerably, possibly on the initiative of his High Chancellor (Nişancı), the historian Celālzāde Muṣṭafā

ḳānūn A set of laws, or statutes, mostly administrative or criminal in content, issued by the Sultan and designed to complement the traditional sacred law of Islam (*şeriat*).

ḳānūnnāme A code of laws distinct from the *şerīat* regulating the administration of the Ottoman Empire. That attributed to Süleyman the Magnificent seems in fact to have been compiled under Bayazid II in the 1490s.

kapıkulu (literally, 'slave of the Porte') Primarily a product of the *devşirme*, a member of a janissary regiment, but also applied to anyone, either slave or free, employed in military, administrative or palace service.

kaside (Arabic *qaṣīda*) An ode, congratulatory, or panegyric, longer than a *ğazel* but with a somewhat similar rhyme scheme.

katı see *ḳıṭʿa*.

kaza Sub-district, administered by a *kadı*.

Kazasker (from Kadi ʿAsker/'military judge') The highest post in the Ottoman legal system. Under Süleyman he was entitled the Kazasker of Rumeli (Turkey in Europe).

khizāna Repository, treasury, also known to have included fine manuscripts in the fifteenth and sixteenth centuries.

kilermeni Armenian bole, a ferruginous slip, used as a base for gilding: painted underglaze to give the characteristic tomato red on Iznik pottery from *c.* 1560 onwards; and, in the kitchen accounts of Mehmed the Conqueror, as a remedy for indigestion.

ḳıṭʿa (modern Turkish *kaatı*) Cut-paper work; either for calligraphy, in which a skilful practitioner could produce both a positive and a negative from a single sheet of writing; or for decoration in which elaborate collages reproduced garden scenes, flowers, animals, etc. Both were highly popular in sixteenth-century Turkey, which has been credited with the invention of the latter type.

Kızılbaş Supporters of the Safavids among the Turcoman tribes of eastern Anatolia and north-west Iran. They owe their name 'Red heads' to the conspicuous red felt bonnets they wore.

kul A slave of the Sultan, educated in the palace and in the service of the State. Although a large number of the military administrators under Süleyman were slaves, the term was sometimes used to cover anyone legally in the Sultan's service.

kursī, kürsü Wooden throne or pulpit in mosques or *medreses* for the sermons of a preacher (*vāʿiz*), particularly following the Friday prayer or on certain nights in Ramaḍān.

madrasa see *medrese*.

matara (from Arabic *maṭhara*) A vessel for purification. A term for ewers or canteens for water, hot or cold.

medrese Roughly the equivalent of the colleges of medieval Oxford and Cambridge with a strong emphasis on a theological trivium, the study of Muslim tradition, the exegesis of the Koran (*tefsīr*) and Islamic law. Under Süleyman the *medrese*-system was highly centralised, and its top graduates formed the *ʿilmiye*, or clerisy, who formed the most important element of the Ottoman bureaucracy.

mekteb Koran school for orphans.

mersiye A lament on the death of a beloved figure particularly associated with the memorial rites of Muḥarram among the Shīʿa.

mevācib defter Register of daily or monthly wages, or retainers, of those in the palace employ, the janissaries, etc.

mücellid işi (literally 'book-binder's work') Leather or paper filigree especially as used to decorate the *doublures* of bindings.

muezzin The giver of the call to prayer attached to a mosque or other pious foundation.

müftī The high legal official whose duty it was to give written legal opinions (*fetvā*) in problematic cases in the Muslim law (*şerīat*). The Nişancı or High Chancellor, Celālzāde Muṣṭafā, for most of Süleyman's reign was deemed so expert in *ḳānūn* that he was even, paradoxically, known as the Müftī-ı Ḳānūn, performing evidently the same function for administrative law.

mülk Freehold property, which in the Ottoman Empire could be obtained only by a direct grant from the Sultan.

müsteğallāt Provision for investment property to be bought with surplus income from a *vakf* to increase the income and hedge against inflation.

mütevelli (Arabic *mutawallī*) The chief trustee or administrator of a pious foundation (*vakf*).

nafaḳa defter Register of rations, wages or living allowances paid to the janissary troops and other Ottoman state employees.

nahiye The smallest administrative unit in the Ottoman Empire.

nakkaş (pl. Arabic *nakkāşīn*; Persian *nakkāşān*; Turkish *nakkaşlar*) Decorator, painter.

nakkaşhane A term currently used for the scriptorium of the sixteenth-century Ottoman sultans. Claims that it was a sort of design centre are probably anachronistic.

nazīre Virtuoso imitation of a *ğazel* using the identical rhymes but to a different subject.

Nişancı The High Chancellor, the head of the Ottoman Chancery responsible for drawing up documents of State (*fermans*) and also in theory for affixing the imperial monogram (*tuğra*) which then authenticated them. In practice the Nişancı was more concerned with their language and in guaranteeing that they were in conformity with Ottoman law.

nisba An epithet, relating to someone's lineage or provenance, often as a means of identifying him.

otağ-ı Humāyūn The Sultan's tent on campaign, the military headquarters, but for all practical purposes a travelling palace.

pencik slaves The one-fifth part of prisoners of war which was the Sultan's right, conscripted into military service.

rahle Stand for a Koran or other books, often folding and generally wood, often with elaborate carving and inlay. A standard piece of furniture for royal mausolea in Ottoman Turkey.

reciprocal pattern see *counterchange*.

reis Sea captain, particularly a corsair in Ottoman service.

Reisülküttab The Chief Secretary or Chief Clerk to the Dīvān-ı Humāyūn, responsible for the drafting of legislation and documents of state.

rūmī see *arabesque*.

Safavids Militant Shīʿīs of Sufi origin, tracing their descent from Shaykh Safī al-Dīn (d. Ardebil 1334), who gained power in Persia in 1501 and became a strongly nationalist dynasty. They were Süleyman's principal opponents in the East.

sancak A regimental banner or standard, by metonymy applied to a major fief or military governorate. Beneath the larger banners in special metal cases it was customary to hang small format Korans.

ṣāz (Turkish 'reed') A swash feathery leaf, possibly deriving from chinoiserie bamboo, much used in sixteenth-century Ottoman decoration for textiles and pottery, where it is also treated as a *composite* form, sometimes almost as an acanthus swag.

sefer-i Humāyūn A major campaign on which the Sultan was present in person.

sefine (Arabic *ṣafīna*, 'ship') A common characterisation of *dīvānī* script, where the ends of the lines rise like the prow of a ship.

Şehnameci The official Court historian. The first to be appointed was ʿĀrifī who wrote the *Süleymānnāme*, a panegyric chronicle of Süleyman's reign up to the year 1555.

Şehzade The title of the Ottoman princes. The quarter Şehzadebaşı in Istanbul owes its name to the mosque built by Sinan in memory of Süleyman's favourite son, Şehzade Mehmed (d. 1543).

seraser (literally Persian, 'the whole way/from one end to another') Cloth of gold or silver.

Serasker (also *Serdar*) Commander-in-Chief, the Sultan's deputy on a *sefer-i Humāyūn*. Under Süleyman a Grand Vizier normally appointed for a single campaign.

şeriat (Arabic *sharīʿa*) The holy law of Islam.

serlevha (from Persian *sar*/'head' and Arabic *lawḥa*/'panel') Illuminated frontispiece, usually double, directly preceding the opening page of a book.

seyfiye ('the men of the sword') The military élite.

şeyh (Arabic *shaykh*) An honorific term applied to heads of *medreses*, Sufis and in general to graduates of the higher *medreses*.

Şeyhühislam The head of the *ʿilmiye* under the sixteenth-century Ottoman sultans. The historians of this period normally refer to him, however, as the *müftī*.

shādda In written Arabic, Ottoman Turkish and Persian a device to indicate that a letter is doubled.

shahāda The basic statement of the Muslim faith: 'I bear witness that there is no god but God. Muḥammad is His Prophet.'

Shāhnāme (Ottoman *Şehnāme*) In the first place, the 'Book of Kings' of the eleventh-century Persian poet Firdawsī, the national epic of Iran. In Ottoman usage of the later sixteenth century also applied to panegyric chronicles of the Sultans' or their predecessors' reigns.

shamsa (Ottoman *şemse*) Circular, oval or star-shaped illuminated medallion, generally decorating the first page (f. 1a) of a grand manuscript and often bearing the title or book plate of the personage who ordered the work.

sharīʿa see *şeriat*

siyāḳat Treasury hand, with little *tashkīl* and barely differentiated letter-forms developed, probably deliberately, to make account books inaccessible to outsiders or as a precaution against forgery.

softa (corruption of Persian *sūkhte*/'burned') Popular term for unemployed graduates or drop-outs from *medrese* education who served as a focus of civil disturbance.

sorguç Jewelled turban ornament with plumes of peacock, osprey or crane feathers. In contrast to the Safavids the Ottoman sultans and their courtiers seem to have worn only one at a time.

Sultan In Ottoman usage the title of the ruler of the empire. It was also accorded, possibly as a courtesy title, to princes long before their accession. For princesses and for the royal ladies the title followed their names.

sürgün Conscription or deportation to Istanbul of craftsmen or notables practised by Mehmed the Conqueror and his successors to build up or replenish the skilled labour force.

taʿlīq (from Arabic *ʿallaqa*/'to suspend') A swash script, practised in the chanceries of later Islam with numerous unorthodox ligatures: *talik* in modern Turkish, somewhat misleadingly, is used instead of the more general *nastaʿlīq*.

tashkīl The addition of dots to differentiate the letters of the Arabic alaphabet.

ṭawwāf Circumambulation of the Kaʿba at Mecca, one of the most important rites of the *ḥajj*.

tefsīr Exegesis of the Koran, a principal subject in *medrese* education.

temlīk (cf. *mülk*) A grant of freehold property by the Sultan. The grant would then be recorded in a *temlīknāme* and noted in the central registers.

tuğ Yak tails (later horse tails) attached to a pole surmounted by a golden ball, an ancient symbol of Turkish royalty. The Sultan's officials were presented with a *tuğ* of an appropriate number of tails on their appointment to office. The sultan on campaign might parade with as many as nine.

tuğra The imperial Ottoman authentication of documents of state, consisting of the Sultan's monogram and the formula *al-muẓaffar dāʾiman* ('ever victorious').

ʿunwān Illuminated headpiece, often uninscribed, beginning a text, generally on f. 1b of a manuscript.

ustād al-kutub A title, not so far frequently attested, ascribed to Ḳaramemī, Süleyman's chief illuminator, indicating presumably that he was head of the imperial scriptorium and in charge of book production.

vakf Land or other sources of revenue immobilised in perpetuity for pious or charitable purposes usually associated with pious foundations – a *medrese*, an *ʿimāret*, a mosque, etc. – singly or in combination.

vakf ahlī A family trust, designed to protect descendants against confiscation or expropriation of the assets but highly vulnerable to inflation. Once the outgoings of the pious foundation had been disbursed, named descendants had a right to a proportion of the surplus revenue. In Süleyman's reign such surpluses amounted often to almost fifty per cent.

vakfiye The endowment deed of a pious foundation (*vakf*) giving the statutes and specifying in perpetuity the buildings erected with lists of staff on the foundation and stipulation of their emoluments in money or kind.

zaviye Convent of dervishes.

zülm Injustice, oppression.

Bibliography

Note The bibliographies of the individual catalogue entries are select. For more complete references the interested reader should consult Washington 1987.

Abel, Armand, *Gaibī et les grands faïenciers égyptiens d'époque mamlouke* (Cairo, 1930)

Abrahamowicz, Zygmunt, *Katalog dokumentow tureckich. Dokumenty do dziejów Polski i krajów osciennych w latach 1455–1672* I (Warsaw, 1959)

Achard, P., *La vie extraordinaire des frères Barberousse, corsaires et rois d'Alger* (Paris, 1939)

Adıvar, A. A., *Osmanlı Türklerinde Ilim* (Istanbul, 1970)

'Ahmad Pasha, Kara', *EI²*; 'Ahmed Paşa, Kara', *IA*

Ahrens, W. 'Die 'magischen Quadraten' al-Būni's', *Der Islam* XII (1922), 157–77

Akalay (Tanındı), Zeren, 'Tarihi konularda ilk Osmanlı minyatürleri', *STY* II (1969), 102–15; III (1970), 151–66

———— 'XVI yüzyıl nakkaşlarından Hasan Paşa ve eserleri', *I. Milletlerarası Türkoloji Kongresi: 3. Türk Sanatı Tarihi* (Istanbul, 1979), 607–25

Akçura, Yusuf, *Pirî Reis haritası hakkında izahname* (Ankara, 1935)

Akimushkin, O. F., 'O pridvornoi kitabkhane Sefevida Takhmasba I v Tabrize', *Srednevekovy Vostok. Istoriya, Kul'tura, Istochnikovedeniye* (Moscow, 1981), 5–20

Albèri, Eugenio (ed.), *Relazioni degli ambasciatori Veneti al Senato* IIIa/1 (Florence, 1840)

———— (ed.), *Le relazioni degli ambasciatori Veneti al Senato durante il secolo decimosesto* III/3 (Florence, 1855)

Alexander, D. G., 'Two aspects of Islamic arms and armour', *Metropolitan Museum Journal* 18 (1983), 97–107

ʿĀlī, Mustafā, *Menākib-i Hünerverān*, modernised as *Hattatların ve kitap sanatçılarının destanları* by Müjgan Cunbur (Istanbul, 1982)

'ʿAlī Pasha, Semiz', *EI²*; 'ʿAli Paşa, Semiz', *IA*

'Alkās Mīrzā', *EI²*; 'Elkas Mirza', *IA*; 'Alqās Mīrzā', *Encyclopaedia Iranica*

Allan, James, and Julian Raby, 'Metalwork', *Tulips, Arabesques and Turbans*, ed. Y Petsopoulos (London, 1982), 17–53

Allen, W. E. D., *Problems of Turkish power in the sixteenth century* (London, 1963)

Alpay, Günay Kut, 'Lāmiʿī Chelebī and his works', *Journal of Near Eastern Studies* XXXV/2 (Chicago, 1976)

Altay, Fikret, 'The vestments of the Sultans', *Apollo* XCII (July, 1970), 62–3

Altınay see Refik, Ahmet

Altındağ, Ülkü, *Topkapı Sarayı Müzesi Osmanlı Saray Arşivi Kataloğu* I (Ankara, 1985)

Anafarta, N., *Hünername: Minyatürleri ve sanatçıları* (Istanbul, 1969)

Ancillon, Charles, *Histoire de la vie de Soliman second, empereur des Turcs* (Rotterdam, 1706)

Anhegger, R., *Beiträge zur Geschichte des Bergbaus im osmanischen Reich, Europäische Türkei* I–II (Istanbul-Zurich, 1943–4)

———— 'Istanbul su yollarının inşasına aid bir kaynak, Eyyûbî'nin Menākib-i Sultān Süleymān'ı, *TD* I (Istanbul, n.d.), 119–38

Anon., *L'Incoronazione del Sultan Suleyman Magnifico e le feste chi si fecero* (Venice, 1589)

Appuhn, H., and C. von Heusinger, *Riesenholzschnitte und Papiertapeten der Renaissance* (Brunswick, 1976)

Aretino, Pietro, *Il primo libro della corrispondenza*, ed. E. Nicolini (Rome, 1913)

Arıkan, Zeki, 'Busbeck ve Osmanlı Imperatorluğu', *Osmanlı Araştırmaları/The Journal of Ottoman Studies* IV (Istanbul, 1984), 197–224

Arseven, Celal Esad, *Les arts décoratifs turcs* (Istanbul, n.d.)

ʿAsalī, Kāmil, *Min āthārinā fī Bayt al-Muqaddas: Takiyyat Khāssakī Sultān, al-khānāt, munshaʾāt al-mīya, al-hammām, al-ashila* (Amman, 1982)

Askenazy, S., 'Listy Roxolany', *Kwartalnik Historyczny* 10 (Łwów, 1896), 113–17

Aslanapa, O., 'Täbriser Künstler am Hofe der Osmanischen Sultane in Istanbul', *Anatolia* 3 (1958), 15–17

———— 'The art of bookbinding', *The arts of the book in Central Asia*, ed. Basil Gray (UNESCO, 1979), 59–91

'Al-Asmāʾ al-Husnā', *EI²*

Atasoy, Nurhan, 'Shoes in the Topkapı Palace Museum', *Journal of the Regional Cultural Institute* II/1 (Winter 1969), 5–31

———— 'Nakkaş Osman'ın padişah portreleri albümü', *Türkiyemiz*, year 2, no. 6 (1972), 2–14

———— *Ibrahim Paşa Sarayı* (Istanbul, 1972)

Atasoy, Nurhan, and Filiz Çağman, *Turkish miniature painting* (Istanbul, 1974)

Atıl, Esin (ed.), *Turkish Art* (Washington DC–New York, 1980)

———— *Süleymanname: The illustrated history of Süleyman the Magnificent* (Washington DC–New York, 1986)

d'Avezac Macaya, M., 'Note sur un atlas hydrographique aujourd'hui au Musée Britannique', *Bull. de la Soc. de Géographie de Paris* XIV (1850), 217

Babinger, Franz, *Reliquienschacher am Osmanenhof im XV. Jahrhundert* (Munich, 1956)

Bacqué-Grammont, J.-L., 'Un plan ottoman inédit de Van au XVIIe siècle', *Osmanlı Araştırmaları/The Journal of Ottoman Studies* II (Istanbul, 1981), 97–122

———— 'Autour d'une correspondance entre Charles Quint et Ibrahim Paşa', *Turcica* XV (1983), 231–46

Bagrow, L., *Matheo Pagano, a Venetian cartographer of the 16th century* (Jenkintown Pa., 1940)

'Bâkî', *IA*

Balpınar, Belkis, 'Classical kilims', *Halı* 6/1 (Spring 1983), 13–20

'Barbaros Hayreddin', *IA*

Barışta, Örcün, *Osmanlı imparatorluk dönemi Türk işlemelerinden örnekler* (Ankara, 1981)

Barkan, Ö. L., *Süleymaniye camii ve imareti inşaatı* I–II (Ankara, 1972; 1979)

———— 'Istanbul saraylarına ait muhasebe defterleri', *Belgeler* IX (Ankara, 1979), 1–380

Barkan, Ö. L., and E. H. Ayverdi, *Istanbul vakıfları tahrir defteri 953 (1546) tarihli* (Istanbul, 1970)

Bartol'd, V. V., 'Mir Ali-shir i politicheskaya zhizn', *Sochineniya* II/2 (Moscow, 1964), 199–260

———— 'O pogrebenii Timura', trans. J. M. Rogers, *Iran* XII (1974), 65–87

Bataillon, Marcel, *Le docteur Laguna auteur du 'Voyage en Turquie'* (Paris, 1958)

Bates, Ülkü, 'The patronage of Sultan Süleyman: The Süleymaniye complex', *Erzurum Üniversitesi Edebıyat Fakültesi Dergisi (In Memoriam A H Gabriel)* (Erzurum, 1978), 65–76

Baudier, Michel, *The History of the Serrail and of the Court of the Grand Seigneur, Emperor of the Turks*, trans. Edward Grimestone (London, 1635)

Baumgarten, Martin, see Donauer, C.

Behrnauer, W.E.A., *Sulaiman des Gesetzgebers Tagebuch auf seinem Feldzuge nach Wien im Jahre 935/6 d. H.=J.1529 n. Chr.* (Vienna, 1858)

Belon du Mans, P., *Les obseruations de plusieurs singularitez et choses memorables trouuées en Grèce, Asie, Iudée, Egypte, Arabie et autres pays estranges* (Paris, 1588)

Bennigsen A., and Chantal Lemercier-Quelquejay, 'Les marchands de la cour ottomane et le commerce des fourrures dans la seconde moitié du XVIe siècle', *Cahiers du Monde Russe et Slave* XI/3 (1970), 363–90

Benzoni, Girolamo, 'Il "farsi turco" ossia l'ombra del rinnegato', *Venezia e i Turchi* (Banca Cattolica del Veneto, Milan, 1985), 91–133

Berchem, Max van, *Matériaux pour un Corpus Inscriptionum Arabicarum. Deuxième partie. Syrie du Sud. I. Jérusalem 'Ville'* (Cairo, 1922); II. *Jérusalem 'Haram'* (Cairo, 1927)

Berchet, G., *Relazioni dei consoli veneti nella Soria* (Turin, 1886)

Berker, Nurhayat, 'Kaşbastı (diadem)', *TED* XIII (1973), 9–23

———— 'Saray mendilleri', *Fifth International Congress of Turkish Arts*, ed. Géza Fehér Jr (Budapest, 1978), 173–81

Berkovits, Ilona, *Corvinen-Handschriften aus der Bibliothek des Königs Matthias Corvinus* (Berlin, 1963)

Bertolotti, A., *Artisti veneti in Roma nei secoli XV, XVI and XVII* (Venice, 1884; reprinted Bologna 1965)

Bikkul, A. U., 'Topkapı Sarayi Müzesinde Türk kılıçları üzerinde bir inceleme', *TED* IV (1962), 20–8

Blochet, E., 'Une lettre d'Ibrahim Pacha à Charles Quint', *Revue de l'Orient Chrétien* II (1897), 302–6

Bombaci, Alessio, 'Les toughras enluminés de la collection de documents turcs des Archives d'Etat de Venise', *Atti del Secondo Congresso Internazionale di Arte Turca* (Naples, 1965), 41–55

Bonnaffé, E., 'Sabba da Castiglione: Notes sur la curiosité italienne à la Renaissance', *Gazette des Beaux-Arts* 30 (1884), 19–33

Boralevi, Alberto, 'Three Egyptian carpets in Italy', *Carpets of the Mediterranean Countries, 1400–1600*, ed. Robert Pinner and W. B. Denny (London, 1986), 205–20

Boškov, V., 'Zum Problem des Objekts der Liebe in der osmanischen Divanpoesie', *ZDMG* Supp. II (Wiesbaden, 1974), 124–30

Botero, Giovanni, *Relazioni Universali* (Brescia, 1599)

Boxer, C. R., *The Portuguese seaborne empire 1415–1825* (Harmondsworth, 1973)

Braun, G., and F. Hogenberg, *Civitates Orbis Terrarum* (Cologne, 1575–1615)

Bräunlich, E., *Zwei Türkische Weltkarten* (Leipzig, 1937)

Busbecq see Forster, Edward S.

Çabuk, Vahit (ed.), *Divan-i Muhibbî. Kanunî Sultan Süleyman'ın Şiirleri*, 1–3 (Istanbul, 1980)

Çağman, Filiz, 'XV yy. kağıt oymacılık (kaatı) eserleri', *Sanat Dünyamız* 3/8 (September 1976), 22–7

———— 'The miniatures of the *Divan-i Hüseynî* and the influence of their style', *Fifth International Congress of Turkish Art*, ed. Géza Fehér Jr (Budapest, 1978), 231–59

———— 'Serzergeran Mehmet Usta ve eserleri', *Kemal Çığ'a Armağan* (Istanbul, 1984), 51–88

Çağman, Filiz, and Zeren Tanındı, *Topkapı, The Albums and illustrated manuscripts*, ed. J. M. Rogers (London, 1986)

Campbell, A., 'Portolan charts from the late thirteenth century to 1500', *The Chicago History of Cartography. I. The Ancient and Medieval Worlds from pre-history to c. 1470* (Chicago, 1987), 371–463

Carswell, John, 'Syrian tiles from Sinai and Damascus', *Archaeology in the Levant: Essays for Kathleen Kenyon*, ed. R. Moorey and Peter Parr (Warminster, 1978), 269–96

———— 'Sin in Syria', *Iran* XVII (1979), 15–22

———— 'Ceramics', *Tulips, Arabesques and Turbans*, ed. Y Petsopoulos (London, 1982), 73–119

———— 'The tiles in the Yeni Kaplıca baths at Bursa', *Apollo* CXX (July, 1984), 36–43

Carswell, John, and C. J. E. Dowsett, *The Kütahya tiles and pottery from the Armenian Cathedral of St James in Jerusalem* I–II (Oxford, 1972)

Cassini, G., *Piante e vedute prospettiche della città di Venezia (1479–1855)* (Venice, 1971)

Castellani, Eutimio, *Catalogo dei firmani ed altri documenti legali emanati in lingua araba e turca concernenti i santuari, le proprietà, i diritti della Custodia di Terra Santa conservati nell'archivio della stessa Custodia in Gerusalemme* (Jerusalem, 1922)

Çavuşoğlu, Mehmed, '16. yuzyılda yaşamış bir kadın şair: Nisâyî', *Tarih Enstitütüsü Dergisi* IV (1978), 405–16

———— 'Şehzade Mustafa mersiyeleri', *Tarih Enstitütüsü Dergisi* XII (=Prof Tayyib Gökbilgin hatıra sayısı) (Istanbul, 1982), 641–86

Çeçen, Kâzım, *Süleymaniye suyolları* (Istanbul, 1986)

Celâlzâde Mustafâ see Kappert, P.

Çetintürk, Bige, 'Istanbul'da XVI. asır sonuna kadar hassa halı sanatkarları', *Türk San'atı Tarihi. Araştırma ve Incelemeleri* I (1963), 715–31

Charrière, E. *Négotiations de France dans le Levant* I–IV (Paris, 1848–60)

Çığ, Kemal, 'Türk ve Islam Eserleri Müzesindeki minyatürlü kitaplarının kataloğu', *Şarkiyat Mecmuası* 3 (1959), 50–90

———— *Türk kitap kapları* (Istanbul, 1971)

Cipolla, C. M., *Guns and sails in the early phase of European expansion, 1400–1700* (London, 1965)

———— *Le macchine del Tempo. L'orologia e la Società (1300–1700)* (Bologna, 1981)

Concina, E., 'Città e forti nelle tre isole nostre del Levante', *Venezia e la difesa del Levante da Lepanto a Candia 1570–1670* (Venice, 1986), 184–94

Contin, Pietro Ginori, *Lettere inedite di Charles de l'Escluse (Carolus Clusius) a Matteo

Caccini, floricultore fiorentino (Florence, 1939)

Csapodi, Csaba, and Klara Csapodi-Gárdonyi, *Bibliotheca Corviniana. Die Bibliothek des Königs Matthias Corvinus von Ungarn*, 2nd edn (Budapest, 1978)

Csontosi, Janos, 'A Konstantinapolybol erkezett Korvinak bibliografiai ismertetese' (Bibliographical report on the Corvinian manuscripts from Constantinople), *Magyar Könyvszemle* (1877), 157–218

Çulpan, Cevdet, *Türk Islam tahta oymacılık sanatında rahleler* (Istanbul, 1968)

—— 'Istanbul Süleymaniye camii kitabesi', *Kanunî Armağanı* (Ankara, 1970), 291–9

Curatola, Giovanni, 'Tessuti e artigianato turco nel mercato veneziano', *Venezia e i Turchi* (Banca Cattolica del Veneto, Milan, 1985), 186–95

Dağlıoğlu, Hikmet Turhan, *On altıncı asırda Bursa* (Bursa, 1940)

Dalsar, F., *Turk sanayi ve ticaret tarihinde Bursa'da ipekçilik* (Istanbul, 1960)

Dames, M. Longworth, 'The Portuguese and the Turks in the Sixteenth Century', *JRAS* (1921), 1–28

Davey, R. P. B., *The Sultan and his subjects* (London, 1907)

Decei, A. 'Un "Fetih-name-i Karabuğdan" (1538) de Nasuh Matrakçı', *Fuad Köprülü Armağanı* (Istanbul, 1953), 113–24

Degenhart, Bernhard, and Annegrit Schmitt, *Jacopo Bellini, The Louvre album of drawings* (New York, 1984)

Deissmann, G., *Forschungen und Funde im Serai. Mit einem Verzeichnis der nichtislamischen Handschriften im Topkapi Serai zu Istanbul* (Berlin-Leipzig, 1933)

Delatte, A., 'L'armement d'une caravelle grecque au XVIᵉ siècle, d'après un manuscrit de Vienne', *Miscellanea Mercati* III (1946), 490–508

Demiriz, Yıldız, '16. yüzyıla ait tezhipli bir Kuran', *STY* VII (1977), 41–58

—— *Osmanlı kitap sanatında natüralist üslûpta çiçekler* (Istanbul, 1986)

Denny, W. B. 'A sixteenth century architectural plan of Istanbul', *AO* VIII (1970), 49–63

—— 'Turkish ceramics and Turkish painting. The role of the paper cartoon in Turkish ceramic production', *Essays in Islamic art and architecture in honor of Katharina Otto-Dorn*, ed. Abbas Daneshvari (Malibu, 1981), 29–36

—— 'Dating Ottoman works in the Saz style', *Muqarnas* I (1983), 103–21

—— 'The origin and development of Ottoman Court carpets', *Carpets of the Mediterranean countries, 1400–1600*, ed. Robert Pinner and W. B. Denny (London, 1986), 243–59

Deny, J. and J. Laroche, 'L'expédition en Provence de l'armée de mer du Sultan Suleyman sous le commandement de l'Amiral Hayreddin Pacha dit Barberousse (1543–1544)', *Turcica* I (1969), 161–211

Derman, M. Uğur, 'Kanunî devrinde yazı san'atımız', *Kanunî Armağanı* (Ankara, 1970), 269–89

—— 'Türk san'atında icazetnameler ve taklid yazıları', *VII Türk Tarihi Kongresi, Kongreye sunulan bildiriler* II (Ankara, 1973), 728–32

—— *Türk hat san'atının şaheserleri* (Istanbul, 1982)

Dickson, M. B., and S. C. Welch, *The Houghton Shahname* I–II (Harvard, 1981)

Dilger, Konrad, *Untersuchungen zur Geschichte des osmanischen Hofzeremoniells im 15. und 16. Jahrhundert* (Munich, 1967)

Dimand, M., and Jean Mailey, *Oriental rugs in the Metropolitan Museum of Art* (New York, 1973)

Donati, L., 'Due immagini ignoti di Solimano I (1494–1566)', *Studi orientalistici in onore di Giorgio Levi della Vida* I (Rome, 1956), 219–33

Donauer, C., *The Travels of Martin Baumgarten*, trans. A. and J. Churchill, *A collection of voyages and travels* I (London, 1732)

Dorez, Leon (ed.), *Itinéraire de Jérôme Maurand d'Antibes à Constantinople, 1544* (Paris, 1901)

Duda, D., 'Ein Beispiel der Tabrizer Buchkunst am Osmanenhof', *KO* XII/1–2 (1978–9), 61–78

—— *Die illuminierten Handschriften und Inkunabeln der Österreichischen Nationalbibliothek* IV. *Islamische Handschriften* I. *Persische Handschriften* I–II (Vienna, 1983)

Düzdağ, M. Ertuğrul, *Şeyhülislam Ebussuûd Efendi fetvaları ışığında 16. asır Türk hayatı* (Istanbul, 1972)

'Ebüssu'ûd', *IA*

Edler de Roover, Florence, 'Andrea Banchi, Florentine silk-manufacturer and merchant in the fifteenth century', *Studies in Medieval and Renaissance History* III (Lincoln, Nebraska, 1966), 223–85

'Eflâk ve Boğdan', *IA*

Eichhorn, Albert, 'Kronstadt und der orientalische Teppich', *Forschungen zur Volks-und Landeskunde* XI/1 (Bucharest, 1968), 72–84

Elton, G. R., *Reformation Europe, 1517–1559* (London, 1963)

Emmanuel, I. S., *Histoire de l'industrie des tissus des Israélites de Salonique* (Paris, 1936)

Ennès, P., and L. Kalus, 'Un plat d'Iznik à inscription turque', *Revue du Louvre et des Musées de France* XXIX/4 (1979), 258–60

Epstein, M. A., *The Ottoman Jewish communities and their role in the fifteenth and sixteenth centuries* (Freiburg im Breisgau, 1980)

'Erdel', *IA*

Erdmann, Hanna, '"Die Matte muss alt sein". Zur Kulturgeschichte des Gebetsteppichs', *Festschrift für Peter Wilhelm Meister zum 65. Geburtstag* (Hamburg, 1975), 11–18

Erdmann, Kurt, 'Kairener Teppiche I. Europäische und Islamische Quellen des 15–18 Jahrhunderts', *AI* V (1938), 179–206; II. 'Mamluken und Osmanenteppiche', *AI* VII (1940), 55–81

—— 'Die Fliesen am Sünnet odası des Topkapı Sarayı in Istanbul', *Aus der Welt der islamischen Kunst. Festschrift Ernst Kühnel*, ed. Richard Ettinghausen (Berlin, 1959), 144–53

—— 'Ka'bah-Fliesen', *AO* III (1959), 193–7

—— 'Neuere Untersuchungen zur Frage der Kairener Teppiche', *AO* IV (1961), 65–105

—— 'Neue Arbeiten zur türkischen Keramik', *AO* V (1963), 191–219

Erünsal, Ismail E., 'Turk edebıyatı tarihine kaynak olarak arşivlerin değeri', *Türkiyat Mecmuası* XIX, 1977–9 (Istanbul, 1980), 213–22

—— 'Türk edebıyatı tarihinin arşiv kaynakları. II. Kanunî Sultan Süleyman

devrine ait bir in'amat defteri', *Osmanlı Araştırmaları/The Journal of Ottoman Studies* IV (Istanbul, 1984), 1–17

Ettinghausen, Richard, 'Die bildliche Darstellung der Ka'ba im islamischen Kulturkreis', *ZDMG* 87 (Leipzig, 1934), 111–37

—— 'Abrī painting', *Studies in Memory of Gaston Wiet*, ed. M Rosen-Ayalon (Jerusalem, 1977), 345–56

Evans, J., *A history of jewellery, 1100–1870*, 2nd edn (London, 1970)

Evans, R. J. W., *Rudolf II and his world. A study in intellectual history, 1576–1612* (Oxford, 1973)

Eyice, Semavi, 'Avrupa'lı bir ressamın gözü ile Kanunî Sultan Süleyman. Istanbul'da bir Safevi elçisi ve Süleymaniye camii. Kanunî Sultan Süleyman'ın portreleri hakkında bir deneme', *Kanunî Armağanı* (Ankara, 1970), 129–70

—— 'Elçihanı', *TD* XXIV/24 (1970), 93–130

Falk, Fritz, *Edelsteinschliff und Fassungsformen im späten Mittelalter und im 16. Jahrhundert: Studien zur Geschichte der Edelsteine und des Schmucks* (Ulm, 1975)

Faroqhi, Suraiya, 'Textile production in Rumeli and the Arab provinces. Geographical distribution and internal trade (1560–1650)', *Osmanlı Araştırmaları/The Journal of Ottoman Studies* I (Istanbul, 1980), 61–83

—— 'On yedinci yuzyıl Ankara'sında sof imalatı ve sof atölyeleri', *Istanbul Üniversitesi Iktisat Fakültesi Mecmuası* 41/1–4, 1982–3 (Istanbul, 1984), 237–59

—— 'Der osmanische Herrschaftsbereich 1350–1650', *Handbuch der europäischen Wirtschafts- und Sozialgeschichte*, ed. Hermann Kellenbenz (Klett-Cotta 1986), 1246–84

Fehér, G. Jr, *Türkische Miniaturen aus den Chroniken der Ungarischen Feldzüge* (Budapest, 1970)

—— 'Kanunî Sultan Süleyman preisende Inschriften zweier Buda stammender Renaissance-Kunstgegenstände', *Kanunî Armağanı* (Ankara, 1970), 203–6

Fekete, Lajos, 'Das Heim eines türkischen Herrn in der Provinz im XVI. Jahrhundert', trans. M. Tayyib Gökbilgin, *Belleten* XLIII (1979), 457–80

Fekete, Ludwig, *Einführung in die osmanisch-türkische Diplomatik der türkischen Botmässigkeit in Ungarn* (Budapest, 1926)

Fekhner, M., *Torgovlya russkogo gosudarstva so stranami Vostoka v XVI v.*, 2nd edn (Moscow, 1956)

Ferīdūn, Aḥmed, *Münşeātü'l-Selāṭīn* I–II (Istanbul, 1274–5/1858)

Fischer, E., *Melchior Lorichs* (Copenhagen, 1962)

Fischer, Sir Godfrey, *Barbary legend. War, trade and piracy in North Africa, 1415–1830* (Oxford, 1957)

Fleischer, Cornell H., *Bureaucrat and intellectual in the Ottoman Empire. The historian Mustafâ Âli (1541–1600)* (Princeton, 1986)

Flemming, Barbara, *Verzeichnis der orientalischen Handschriften in Deutschland*, XIII, *Türkische Handschriften* II.1 (Wiesbaden, 1968)

—— 'Şerīf, Sultan Ġavrī und die "Perser"', *Der Islam* 45 (1969), 81–93

—— 'Literary activities in Mamluk halls and barracks', *Studies in memory of Gaston*

Wiet, ed. M. Rosen-Ayalon (Jerusalem, 1977), 249–60

Fletcher, J. F., 'China and Central Asia, 1368–1884', *The Chinese world order*, ed. J. K. Firbank (Cambridge, Mass., 1968), 206–24

Forrer, L, *Die osmanische Chronik des Rustam Pascha* (Leipzig, 1923)

—— 'Handschriften osmanischer Historiker in Istanbul', *Der Islam* 26 (1946), 173–220

Forster, Edward S. (trans.), *The Turkish letters of Ogier Ghislain de Busbecq* (Oxford, 1927; 1968)

Fortnum, C. D. E., 'On a lamp of Persian ware made for the mosque of Omar at Jerusalem in 1549', *Archaeologia* XLII (1869), 387–97

Frey, K. 'Studien zu Michelagniolo Buonarotti und zur Kunst seiner Zeit, Part 3' *Jahrbuch der Königlichen Preussischen Kunstsammlungen* XXX (1909), Beiheft, 103–80

Fujioka, Ryoichi, and Gakuji Hasebe (eds), *Sekai toji zenshu XIV Min* (Ming Dynasty) (Tokyo, 1976)

Gasparini, Elisabetta, *Le pitture murali della Muradiye di Edirne* (Padua, 1985)

Gassot, J., *Le discours du voyage de Venise à Constantinople* (Paris, 1606)

Gaudefroy-Demombynes, M., *Le pèlerinage à la Mekke* (Paris, 1923)

Geijer, Agnes, and C. J. Lamm, *Orientalische Briefumschläge in schwedischem Besitz* (Stockholm, 1944)

Stephan Gerlachs des Aeltern Tagebuch . . . an die Ottomanische Pforte zu Constantinopel . . . durch den Wohlgeborenen Herrn David Ungnad . . . vollbrachter Gesandschaft (Frankfurt am Main, 1674)

Gervers, Veronika, *The influence of Ottoman Turkish textiles and costume in Eastern Europe* (Royal Ontario Museum, Toronto, 1982)

Gettens, R. J., and G. L. Stout, *Painting materials. A Short Encyclopaedia* (New York, 1966)

Geuffroy, A., *Briefve description de la cour du Grant Turc* (Basle, 1543)

Gevay, A., *Legatio Joannis Hoberdancz et Sigismondi Weichselberger ad Solimanum I imperatorem Turcorum issu Ferdinandi I regis Hung. Boh., etc obita anno MDXXVIII* (Vienna, 1827)

'Ghulām', *EI²*

Gibb, E. J. W., *A history of Ottoman poetry III. AD 1520–AD 1600*, ed. E. G. Browne, (London, 1904)

—— *Historiarum sui temporis libri* I–II (Florence, 1550–2; Paris, 1553–4; Basle, 1577)

Gökbilgin, M. Tayyib, 'Süleyman I', *IA*

—— *XV–XVI asırlarda Edirne ve Paşa livası* (Istanbul, 1952)

—— 'Rüstem Paşa ve hakkındaki ithamlar', *TD* VIII (1955) 11–50

—— 'Arz ve raporlarına göre Ibrahim Paşa'nın Irakeyn seferindeki ilk tedbirleri ve futûhâtı', *Belleten* XXI (1957), 449–82

—— 'Venedik Devlet arşivindeki vesikalar külliyatında Kanunî Sultan Süleyman devri belgeleri', *Belgeler* I/2 (Ankara, 1964), 119–220

—— 'Kanunî Sultan Süleyman'ın 1566 Sigetvâr seferi, sebebleri ve hazırlıkları', *TD* XVI (1966), 1–14

—— 'Kanunî Sultan Süleyman'ın Macaristan ve Avrupa siyasetinin sebep ve âmilleri geçirdiği safhalar', *Kanunî Armağanı* (Ankara, 1970), 5–39

—— 'Kanunî Sultan Süleyman devri müesseseleri ve teşkilatına ışık tutan Bursa şer'iye sicillerinden örnekler', *Ord. Prof. Ismail Hakkı Uzunçarşılı'ya armağan* (Ankara, 1976), 91–112

Gökyay, Orhan Şaik, 'Risale-i Mimariyye—Mimar Mehmet Ağa–Eserleri', *Ord. Prof. Ismail Hakkı Uzunçarşılı'ya armağan* (Ankara, 1976), 113–215

—— 'Tilsimli gömlekler', *Türk folkloru araştırmaları yıllığı* III (1976), 93–112

—— 'Dûcentnâme', *Destursuz bir bağa girenler* (Istanbul, 1982), 79–103

Goldthwaite, Richard A., *The Building of Renaissance Florence: An economic and social history* (Baltimore, 1980)

—— 'The Renaissance economy: The preconditions for luxury consumption', *Aspetti della vita economica medievale, Convegno Federigo Melis* (Florence-Pisa-Prato, 1984), 659–74

Göllner, Carl, 'Stampe contemporanee sull'espugnazione di Rodi', *Bibliofilia* LIII, (Florence, 1941), 12–16

—— *Turcica: Die europäische Türkendrucke des XVI. Jahrhunderts* I–II (Bucharest-Baden Baden, 1961–8)

Gönül, Macide, 'Some Turkish embroideries in the collections of the Topkapı Sarayı Museum in Istanbul', *KO* VI/1 (1969), 43–76

Goodwin, Godfrey, *A history of Ottoman architecture* (London, 1971)

Göyünç, Nejat, 'Salomon Schweigger ve seyahat-namesi', *TD* XII/17–18 (1963), 119–40

Gray, Basil, '*Kitābkhāna*: library or workshop: transition in the 14th–15th century', *First European Conference of Iranian Studies* (Turin, 1987)

Grey, C. (ed.), *A narrative of Italian travels in Persia in the fifteenth and sixteenth centuries* (London, Hakluyt Society, 1873)

Grosz, August, and Bruno Thomas, *Katalog der Waffensammlung in der Neuen Burg* (Vienna, 1936)

Grube, E. J., 'A school of Turkish miniature painting', *First International Congress of Turkish Arts, Ankara 1959* (Ankara, 1961), 176–209

—— 'Masterpieces of Turkish pottery in the Metropolitan Museum of Art and in the private collection of Mr James J. Rorimer in New York', *First International Congress of Turkish Arts, Ankara 1959* (Ankara, 1961), 153–75

—— 'Herat, Tabriz, Istanbul. The development of a pictorial style', *Paintings from Islamic Lands*, ed. R. H. Pinder-Wilson (Cassirer, Oxford, 1969), 85–109

Guilmartin, J. F., *Gunpowder and galleys. Changing technology and Mediterranean warfare at sea in the sixteenth century* (London, 1974)

Gyllius, Petrus, (Pierre Gilles), *The Antiquities of Constantinople, etc.*, trans. J. Ball (London, 1729)

Habanel, A. and E. Eskenazi, *Fontes hebraici ad res oeconomicas socialesque terrarum balcanicarum saeculi XVI pertinentes* (Sofia, 1958)

Haemmerle, Albert, *Buntpapier* (Munich, 1961)

Hale, J. R., *Renaissance war studies* (London, 1983)

—— *War and Society in Renaissance Europe, 1450–1620* (London, 1985)

Hammer-Purgstall, J. von, *Geschichte des osmanischen Reiches* I–(Pest, 1828–)

—— *Wien's erste aufgehobene türkische Belagerung* (Vienna, 1829)

—— 'Observations sur les chemises talismaniques des musulmans, et particulièrement sur celle qui se conserve dans le couvent des Cisterciens nommé Neukloster, près de Vienne, en Autriche', *JA* IX (1832), 219–48

—— (trans.), *Narrative of travels in Europe, Asia and Africa in the seventeenth century by Evliyá Efendi* (London, 1844)

—— *Geschichte der Chane der Krim unter osmanischen Herrschaft* (Vienna, 1856)

Han, Verena, 'Orijentalni predmeti u Renesanskom Dubrovniku', *Priloži za Orijentalnu Filologiju i Istoriju Jugoslovenskih naroda pod Turskom Vladarinom* 6–7 (1956–7)

'Harīr II. The Ottoman Empire', *EI²*

Hasluck, F.W., *Christianity and Islam under the Sultans* I–II (Oxford, 1928; New York, 1973)

'Hayâlî', *IA*

Heckscher, E. F., *Mercantilism*, trans. M. Shapiro (London–New York, 1955)

Herberstain/Herberstein, Sigismund von, *Actiones* (Vienna, 1560)

Herklots, G. A., *Islam in India or the Qānūn-i Islām. The Customs of the Musulmāns of India . . . by Ja'far Sharif*, ed. William Crook (Oxford, 1921)

Hess, A. C., 'The evolution of the Ottoman sea-borne empire in the age of the Oceanic discoveries, 1453–1525', *American Historical Review* LXXV (1970), 1892–1919

—— 'The battle of Lepanto and its place in Mediterranean history', *Past and Present* 57 (1972), 53–73

Heyd, Uriel, *Ottoman documents on Palestine, 1552–1615* (Oxford, 1960)

—— 'Moses Hamon, chief Jewish physician to Sultan Süleyman the Magnificent', *Oriens* XVI (1963), 152–70

Hinds, Martin, and Hamdi Sakkout, *Arabic documents from the Ottoman period from Qaṣr Ibrīm* (Egypt Exploration Society, London, 1986)

Hobson, R. L., with contributions by Sir Percival David and Bernard Rackham, 'Chinese porcelains at Constantinople', *TOCS* XI (1933–4), 9–21

Holter, K., 'Studien zu Ahmed Feridun's Munşe'āt es- selāṭīn', *Festgabe Hans Hirsch* (Innsbruck, 1939), 429–51

Huart, C., *Les calligraphes et les miniaturistes de l'Orient musulman* (Paris, 1908)

'Hürrem Sultan', *IA*; 'Khurrem', *EI²*

Huth, H., '"Sarazenen" in Venedig?', *Festschrift für Heinz Ladendorf* (Cologne, 1970), 58–68

Ibn Iyās, *Badā'i' al-Zuhūr*, trans. Gaston Wiet as *Journal d'un bourgeois du Caire* II (Paris, 1960)

'Ibrahim Paşa, Pargalı', *IA*; 'Ibrāhīm Pasha' *EI²*

Inal, Güner, 'Kahire'de yapılmış bir Hümayünname'nin minyatürleri', *Belleten* XL (1976), 439–65

Inalcık, Halil, 'Osmanlı Imperatorluğunun kuruluş ve inkişaf devrinde Türkiye'nin iktisadî vaziyeti üzerinde bir tetkik münasebetiyle', *Belleten* XV (1951), 629–90

—— 'Bursa and the commerce of the Levant', *Journal of the Economic and Social History of the Orient* III (1960), 131–47

—— 'Süleiman the Lawgiver and Ottoman law', *Archivum Ottomanicum* I (The Hague, 1969), 105–38

—— *The Ottoman Empire: the Classical age, 1300–1600* (London, 1973)

—— 'The question of the closing of the Black Sea under the Ottomans', *Archeion Pontou* 35 (1979), 74–110

—— 'Introduction to Ottoman metrology', *Turcica* XV (1983), 311–48

—— 'The Yürüks: Their origins, expansion and economic role', *Carpets of the Mediterranean countries, 1400–1600*, ed. Robert Pinner and W. B. Denny (London, 1986), 39–65

Inalcık, Halil, and Heath W. Lowry (eds.), *Sultan Süleyman the Magnificent and his times* (Washington DC-Chicago, 1988)

Inan, Afet, *Turk amiralı Pîrî Re'is'in hayatı ve eserleri. Pîrî Re'is'in Amerika haritası (1513–1528)* (Ankara, 1954)

Iorga, N., *Geschichte des osmanischen Reiches* I–V (Gotha, 1908–13)

Ipşirli, Mehmet, 'XVI. asrın ikinci yarısında kürek cezası ilgili hükümler', *Tarih Entstitütüsü Dergisi* 12 (=*Prof. Tayyib Gökbilgin hatıra sayısı*) (Istanbul, 1982), 203–48

Irwin, R. G., 'Egypt, Syria and their trading partners 1450–1550', *Carpets of the Mediterranean countries, 1400–1600*, ed. Robert Pinner and W.B. Denny (London, 1986), 73–82

Ivanov, A. A., V. G. Lukonin, L.S. Smesova, *Yuvelirniye izdeliya Vostoka, drevnii, srednevekovy period* (Moscow, 1984)

Iz, Fahir, *Eski Turk edebıyatında nazim* I–II (Istanbul, 1966–7)

Festschrift Georg Jacob (Leipzig, 1932)

Jacob, Georg, *Sultan Soliman des Grossen Divan in einer Auswahl* (Berlin, 1903)

Jacobs, E., *Untersuchungen zur Geschichte der Bibliothek im Serai zu Konstantinopel* I (Heidelberg, 1919)

Jenkins, H. D., *Ibrahim Pasha* (New York, 1911)

The Chronicles of Rabbi Joseph ben Joshua ben Meir, the Sphardi, trans. C.H.E. Bialloblotzky, I–II (London, 1835)

Kahle, Paul, *Baḥriyya, Das türkische Segelhandbuch für das Mittelandische Meer vom Jahre 920* (Berlin–Leipzig, 1926)

—— *Die verschollene Columbuskarte von 1498 in einer türkischen Weltkarte von 1513* (Berlin–Leipzig, 1933)

—— 'A lost map of Columbus', in id. *Opera Minora* (Leyden, 1956), 247–65

—— 'Nautische Instrumente der Araber im Indischen Ozean', in id., *Opera Minora* (Leyden, 1956), 266–77

Kappert, Petra, *Die osmanischen Prinzen und ihre Residenz Amasya im 15. und 16. Jahrhundert* (London, 1976)

Kappert, Petra (ed), *Geschichte Sultan Süleyman Kanunîs von 1520 bis 1557, oder Ṭabaḳāt ül-Memālik ve Derecāt ül-Mesālik von Celālzāde Muṣṭafā genannt Koca Nişancı* (Wiesbaden, 1981)

Karabacek, A. H., *see* Salmān, 'Īsā

Karabacek, J. von, 'Suleiman der Grosse als Kunstfreund', *WZKM* XXVI (1912), 5–10

—— *Zur orientalischer Altertumskunde IV. Muhammedanische Kunststudien* (Vienna, 1913)

Karahan, Abdülkadir, *Figanî; Kanuni Sultan Süleyman şairlerinden Figanî ve divancesi* (Istanbul, 1966)

Karamsin, M., *Histoire de l'Empire de Russie*, trans. Baron de St Thomas and Jauffret (Paris, 1819–26)

Karatay, Fehmi Edhem, *Topkapı Sarayı Müzesi kütüphanesi Farsça yazmalar kataloğu* (Istanbul, 1961)

—— *Topkapı Sarayı Müzesi kütüphanesi Türkçe yazmalar kataloğu* I–II (Istanbul, 1961)

—— *Topkapı Sarayı Müzesi kütüphanesi Arapça yazmalar kataloğu* I–IV (Istanbul, 1962–9)

Katona, István, *Historia critica primorum Hungariae ducum* I–XLI (Pest, 1778–1810)

Keene, M., 'The lapidary arts in Islam. An underappreciated tradition', *Expedition* (University Museum, University of Pennsylvania, 1982), 24–39

'Kefe', *IA*

Kerametli, Can, 'Osmanlı devir ağaç işleri, tahta oyma, sedef, bağa ve fildişi kakmalar', *TED* IV (1961), 5–13

'Kharīṭa', *EI²*

'Kırım', *IA*

Kissling, H. J., 'Zur Geschichte der Rausch- und Genussgifte im Osmanischen Reich', *Süd-Ost Forschungen* XVI (Munich, 1957), 342–55

'Kızıl-Bāsh', *EI²*

'Kızılbaş', *IA*

Klinger, L., and J. Raby, 'Barbarossa and Sinan: A portrait of two Ottoman corsairs from the collection of Paolo Giovio', *Ateneo Veneto*, ed. E. J. Grube (Venice, 1988)

Knecht, R. J., *Francis I* (Cambridge, 1982)

Kolsuk, A., 'Osmanlı devri çini kandilleri', *TED* XV (1976), 73–91

Kortepeter, C. Max, 'Ottoman imperial policy and the economy of the Black Sea region in the sixteenth century', *JAOS* LXXXVI (1966), 86–113

—— *Ottoman imperialism during the Reformation, Europe and the Caucasus* (New York, 1972)

Köseoğlu, Cengiz, *Topkapı, The Treasury*, ed. J. M. Rogers (London, 1987)

Kovachich, M.G., *Scriptores rerum Hungaricarum minores* II (Buda, 1798)

Kraelitz, Friedrich, *Osmanische Urkunden in Türkischer Sprache aus dem zweiten Hälfte des 15. Jahrhunderts. Ein Beitrag zur osmanischen Diplomatik* (Vienna, 1921)

Krahl, Regina, with Nurdan Erbahar, ed. John Ayers, *Chinese ceramics in the Topkapı Saray Museum, a complete catalogue* I–III (London, 1986)

Kreševljaković, Hamdija, 'Rustem Paşa, veliki vezir Sulejmana II', *Nastavni Vjesnik* XXXVI (Zagreb, 1928), 272–87

Kretschmayr, Heinrich, 'Ludovico Gritti, eine Monographie', *Archiv für österreichische Geschichte* LXXXIII (Vienna, 1897), 1–106

Kropf, Lajos, 'A British Museum Korvin-kodexe' (The Corvinian manuscript of the British Museum), *Magyar Könyvszemle* (1896), 1–8

Kühnel, Ernst, *Die Sammlung türkischer und islamischer Kunst im Tschinili Köschk* (Berlin–Leipzig, 1938)

—— 'Die osmanische Tughra', *KO* II (1955), 69–82

Kühnel, E., and L. Bellinger, *Cairene rugs and others technically related* (Washington, DC, 1957)

Kunt, I. Metin, *Sancaktan eyalete* (Istanbul, 1978)

—— *The Sultan's servants. The transformation of Ottoman provincial government 1550–1650* (New York, 1983)

Kuran, Aptullah, 'The mosques of Sinan', *Fifth International Congress of Turkish Art*, ed. Géza Fehér Jr (Budapest, 1978), 559–68

—— *Mimar Sinan* (Istanbul, 1987)

Kürkçüoğlu, K. E., *Süleymaniye vakfiyesi* (Ankara, 1962)

Kurz, Otto, 'A gold helmet made in Venice for Sultan Suleiman the Magnificent', *Gazette des Beaux-Arts* 74 (1969), 249–58

—— *European clocks and watches in the Near East* (London, 1975)

—— 'Libri cum characteribus ex nulla materia compositis', id., *The decorative arts of Europe and the East* (London, 1977), section XXI

La Gournerie, M. E. de, *Histoire de François I* (Tours, 1860)

Laguna, Andrés, *Avventure di un schiavo dei Turchi*, trans. and ed. Cesare Acutis (Milan, 1983)

Lane, Arthur, 'The Ottoman pottery of Isnik', *AO* II (1957), 247–81

Lane, F. C., 'The Mediterranean spice trade. Further evidence of its revival in the sixteenth century', *American Historical Review* XLV (1940), 581–90; reprinted in id., *Venice and History. Collected papers* (Baltimore, 1966), 25–34

Lefaivre, A., *Les Magyars pendant la domination ottomane en Hongrie 1526–1722* (Paris, 1902)

Lesure, M., 'Notes et documents sur les relations véneto-ottomanes. I. 1570–73', *Turcica* IV (1972), 134–57

Lewenklau (Leunclavius), Hans, *Neuwe Chronica Türckischer Nation von Türckhen selbst beschrieben* (Frankfurt am Main, 1595)

Lightbown, R., 'L'esotismo', *Storia dell'arte italiana*, X. *Conservazione, falso, ristauro* (Turin, 1981), 443–87

'Lokman, Seyyid', *IA*

Longquan Qingci (Industry Department Zhejiang province, Beijing, 1966)

Luchner, Laurin, *Denkmal eines Renaissance-Fürsten: Versuch einer Rekonstruktion des Ambraser Museums von 1583* (Vienna, 1958)

'Luḳmān b. Sayyid Ḥusayn', *EI²*

Lybyer, A. H., *The government of the Ottoman Empire in the time of Suleiman the Magnificent* (Cambridge, Mass., 1913)

—— 'The Ottoman Turks and the routes of Oriental trade', *English Historical Review* XXX (1915), 577–88

Mackie, Louise W., 'A Turkish carpet with spots and stripes', *Textile Museum Journal* 4/3 (1976), 5–20

—— 'Rugs and textiles', *Turkish Art*, ed. Esin Atıl (Washington DC-New York, 1980), 299–393

Mahir, Banu, 'Saray nakkaşhanesinin ünlü ressamı Şah Kulu ve eserleri', *Topkapı Sarayı Müzesi: Yıllık* I (1986), 113–30

Majer, H.-G., 'Ibrahim Pascha', *Biographisches Lexicon zur Geschichte Südosteuropas* II (Munich, 1976), 210 ff.

Marmora, Andrea, *Della Historia di Corfù descritta da Andrea Marmora nobile corcyrese libri otto* (Venice, 1672)

Martin, J. L. B., *Treasure of the Land of Darkness. The fur trade and its significance for Medieval Russia* (Cambridge, 1986)

Massing, J. M., 'Jacobus Arboratensis: étude préliminaire', *Arte Veneta* 31 (1977), 42–52

Matuz, J., *Herrscherurkunden des Osmanensultans Süleyman des Prächtigen. Ein chronologisches Verzeichnis* (Freiburg im Breisgau, 1971)

—— *Das Kanzleiwesen Sultan Süleymans des Prächtigen* (Wiesbaden, 1974)

Mayer, L. A., *Islamic woodcarvers and their works* (Geneva, 1958)

—— *Islamic metalworkers and their works* (Geneva, 1959)

—— *Islamic armourers and their works* (Geneva, 1962)

Mazzariol, G., and T. Pignatti, *La pianta prospettica di Venezia del 1500* (Venice, 1963)

'Mehmed Paşa, Sokollu', *IA*

Meinecke, Michael, 'Die osmanische Architektur des 16. Jahrhunderts in Damaskus', *Fifth International Congress of Turkish Art*, ed. Géza Fehér Jr (Budapest, 1978), 575–95

—— 'Die Erneuerung von al-Quds/Jerusalem durch den Osmanensultan Sulaimān Qānūnī', *Studies in the History and Archaeology of Palestine* IV (forthcoming)

Meinecke-Berg, V., 'Marmorfliesen. Zum Verhältnis von Fliesendekorationen und Architektur in der osmanischen Baukunst', *KO* VIII/2 (1972), 35–59

Ménage, V. L., 'The "Map of Hajji Ahmed" and its makers', *Bull. SOAS* XX (1958), 291–34

—— 'Some notes on the devshirme', *Bull. SOAS* XXIX (1966), 64–78

—— 'On the constituent elements of certain sixteenth century Ottoman documents', *Bull. SOAS* XLVIII/2 (1985), 283–304

Menavino, Giovanni Antonio, *I costumi et la vita de' Turchi* (Florence, 1551)

Meriç, Rıfkı Melûl, *Turk nakış sanatı tarihi araştırmaları I. Vesikalar* (Ankara, 1953)

—— *Türk cild sanatı tarihi araştırmaları I. Vesikalar* (Ankara, 1954)

—— 'Bayramlarda Padişahlara hediye edilen san'at eserleri ve karşılıkları', *Türk San'atı Tarihi. Araştırma ve İncelemeleri* I (Istanbul, 1963), 764–86

—— *Mimar Sinan, hayatı, eserleri* (Ankara, 1965)

Merriman, R. B., *Suleiman the Magnificent, 1520–1566* (Cambridge, 1944)

Miller, Barnette, *The Palace school of Muhammad the Conqueror* (Cambridge, Mass., 1941)

Miller, Yuri, A., *Khudozhestvennaya keramika Turtsii* (Leningrad, 1972)

—— 'O nekotorykh kontaktakh iskusstva Turtsii XVI–XVII vekov s khudozhestvennoi kul 'turoi drugikh stran', *Trudy Gosudarstvennogo Ermitazha* XIX (1978), 106–14

Mills, J. V. G. (ed.), *Ma Huan, Ying-yai Sheng-lan, The overall survey of the Ocean's shores* (Hakluyt Society, Cambridge, 1970)

Minorsky, V., T. Minorsky and B. N. Zakhoder, *Calligraphers and Painters. A Treatise of the Qāḍī Aḥmad son of Mīr Munshī (c. A.H.1015/AD 1606)* (Washington DC, 1959)

Mordtmann, J. H., 'Das Observatorium des Taqī ed-Dīn zu Pera', *Der Islam* 13 (1923), 82–93

Mraz, Gottfried, 'The role of clocks in the Imperial honoraria for the Turks', *The clockwork universe. German clocks and automata 1550–1650*, eds Klaus Maurice and Otto Mayr (Washington DC-New York, 1980), 37–48

Mugler, Otto, 'Edelsteinhandel im Mittelalter und im 16. Jahrhundert', doctoral dissertation (Munich, 1928)

Muller, Georg Eduard, *Die Türkenherrschaft in Siebenbürgen. Verfassungsrechtliches Verhältnis Siebenbürgens zur Pforte, 1541–1688* (Hermannstadt-Sibiu, 1923)

Necipoğlu-Kafadar, Gülru, 'The Süleymaniye complex in Istanbul, an interpretation', *Muqarnas* 3 (1985), 92–117

—— 'Plans and models in 15th and 16th century Ottoman architectural practice', *Journal of the Society of Architectural Historians* XLV/3 (September 1986), 224–43

Nicandre de Corcyre, *Voyages*, ed. J.-A. de Foucault (Paris, 1962)

Nicolay, Nicolas de, Sieur d'Arfeuille, *Navigations and voyages made into Turkey*, trans. T. Washington (London, 1585)

Oberhummer, Eugen, *Konstantinopel unter Sultan Suleiman dem Grossen: aufgenommen im Jahre 1559 durch Melchior Lorichs* (Munich, 1902)

—— 'Eine türkische Karte zur Entdeckung Amerikas', *Anzeiger der Akademie der Wissenschaften in Wien* (Jahrgang, 1931), 99–112

Öney, Gönül, *Turkish ceramic tile art* (Tokyo, 1975)

Ongan, Halit, *Ankara'nın iki numaralı şer'iye sicilleri, 1 Muharrem 997–8 Ramazan 998* (Ankara, 1974)

Orgun, M. Zarif, 'Tuğra, tuğralarda el-muzaffer daima duası ve Şah unvanı', *TTAED* V (Istanbul, 1949), 201–20

Orhonlu, Cengiz, 'XVI. asrın ilk yarısında Kızıldeniz'de Osmanlılar', *TD* XII/16 (1962), 1–24

—— 'Hint kaptanlığı ve Piri Reis', *Belleten* XXXIV (1970), 235–74

Otto-Dorn, K., *Das islamische Isnik* (Berlin, 1941)

—— 'Osmanische ornamentale Wandmalerei', *KO* I (1950), 45–54

—— *Türkische Keramik* (Ankara, 1957)

Öz, Tahsin, *Turkish textiles and velvets: XIV–XVI centuries* (Ankara, 1950)

Özergin, M. K., 'Temürlü sanatına ait eski bir belge: Tebrizli Ca'fer'in bir arzı', *STY* VI (1974–5), 471–58

Panofsky, Erwin, *Albrecht Dürer* II (Princeton, 1943)

Parry, V. J., 'Renaissance historical literature in relation to the Near and Middle East (with special reference to Paolo Giovio)', *Historians of the Middle East*, ed. Bernard Lewis and P. M. Holt (London, 1962), 277–89

Parry V. J., and M. E. Yapp, *War, technology and society in the Middle East* (London, 1975)

Partner, Peter, *Renaissance Rome, 1500–1559. A portrait of a society* (Berkeley-Los Angeles, 1976)

Pavet de Courteille, A. J. B. M.-M., *Histoire de la campagne de Mohacz* (Paris, 1859)

Petrasch, Ernst, *Die Türkenbeute*, 2nd edn (Karlsruhe, 1977)

Petsopoulos, Yanni (ed.), *Tulips, Arabesques and Turbans* (London, 1982)

Pinner, Robert, and W.B. Denny (eds.), *Carpets of the Mediterranean countries, 1400–1600* (London, 1986)

'Pirî Reis', *IA*

'Piyale Paşa', *IA*

Planiscig, Leo, *Die Estensische Kunstsammlung. I. Skulpturen und Plastiken des Mittelalters und der Renaissance* (Vienna, 1919)

Pognon, E., 'Les plus anciens plans de villes gravés et les évènements militaires', *Imago Mundi* XXII (1968), 13–19

Pope, J. A., *Chinese porcelains from the Ardebil shrine* (Washington DC, 1956)

Pope-Hennessy, John, *The portrait in the Renaissance* (London–New York, 1966)

Raby, J., 'A seventeenth century description of Iznik-Nicaea', *Istanbuler Mitteilungen* 26 (1976), 149–88

—— 'Court and export: Part I. Market demands in Ottoman carpets, 1450–1550'; 'Court and export: Part II. The Uşak carpets', *Carpets of the Mediterranean countries, 1400–1600*, ed. Robert Pinner and W. B. Denny (London, 1986), 29–38; 177–87

Raby, J., and Ünsal Yücel, 'Blue and white, celadon and white wares: Iznik's debt to China', *Oriental Art* XXIX/1 (1983), 38–48

Radojković, B., 'Plaques de reliure des évangéliaires des XVI et XVII siècles', *Muzej Primenjene Umetnosti, Zbornik* 3–4 (1958), 5–84

Rāġib, Yūsuf, 'Essai d'inventaire chronologique des guides à l'usage des pèlerins du Caire', *Revue des Etudes Islamiques* XLI (1973), 259–80

Raymond, A., *Artisans et commerçants au Caire au XVIIIe siècle* I–II (Beirut-Damascus, 1973–4)

Refik, Ahmet, *Hicrî onikinci asırda Istanbul hayatı 1100-1200* (Istanbul, 1930)

—— *Hicrî on birinci asırda Istanbul hayatı (1000–1100)* (Istanbul, 1931)

—— *Mimar Sinan* (Istanbul, 1931)

—— *On altıncı asırda Istanbul hayatı (1553–1591)* (Istanbul, 1935)

Reusner, N., *Operis collectanei epistolarum turcicarum libri* XIV (Frankfurt am Main, 1598–1600)

Riefstahl, R. M., 'Early Turkish tile revetments in Edirne', *AI* IV (1937), 259–81

Rogers, J. M., 'Innovation and continuity in Islamic urbanism', *The Arab City. Proceedings of a symposium held in Medina, Saudi Arabia*, eds. I. Serageldin, Samir al-Sadek and R. R. Herbert (Riyad, 1982), 53–61

—— 'The State and the Arts in Ottoman Turkey. I. The stones of Süleymaniye', *IJMES* 14 (1982), 71–86; 'II. The furnishing and decoration of Süleymaniye', *IJMES* 14 (1982), 283–313

—— 'The Godman Bequest of Islamic pottery', *Apollo* CXX (July 1984), 24–31

—— 'A group of Ottoman pottery in the Godman Bequest', *The Burlington Magazine* (March 1985), 134–45

—— 'Iznik pottery in the British Museum', *Halı* 26 (April-June 1985), 50–7, 92

—— 'An Iznik mosque lamp and globe in the Godman Bequest, The British Museum', *Orientations* (September 1985), 43–9

—— 'Ottoman luxury trades and their regulation', *Osmanistische Studien zur Wirtschafts- und Sozialgeschichte. In Memoriam Vančo Boškov*, ed. Hans-Georg Majer (Wiesbaden, 1986), 135–55

——— 'An Ottoman palace inventory of the reign of Bayazid II', *CIEPO, Cambridge 1984, Proceedings*, ed. J.-L. Bacqué-Grammont and E. van Donzel (Istanbul, 1987), 40–53

——— 'Plate and its substitutes in Ottoman inventories', *Pots and Pans*, ed. Michael Vickers (Oxford, 1986), 117–36

——— 'The Arts under Süleyman the Magnificent', *Sultan Süleyman the Magnificent and his times*, ed. Halil Inalcık and Heath W. Lowry (Washington DC-Chicago, 1988)

Ruscelli, Ieronimo, *Lettere di principi, le quali o' si scrivono da principi, o' a principi, o' ragionan di principi* I (Venice, 1564–77)

'Rüstem Paşa', *IA*

Rypka, J., 'Briefwechsel der Hohen Pforte mit den Krimchanen im II. Bande von Feridun's Münşeāt', *Festschrift Georg Jacob* (Leipzig, 1932), 241–69

Sacken, Eduard, Freiherr von, *Die K. K. Ambraser Sammlung* (Vienna, 1855)

Sadan, J., *Le mobilier au Proche Orient médiéval* (Leyden, 1976)

Sahillioğlu, Halil, 'On beşinci yuzyıl sonunda Bursa'da iş ve sanayi hayatı, kölelikten patronluğa', in *Mémorial Ömer Lutfî Barkan*, ed. J.-L. Bacqué-Grammont (Paris, 1980), 179–88

Şahin, Faruk, 'Kütahya çini-keramik sanatı ve tarihinin yeni buluntular açısından değerlendirilmesi', *STY* IX–X (1979–80), 259–86

St Clair, Alexandrine, *The image of the Turk in Europe* (New York, 1973)

Saint-Genois, Baron de, and G. A. Yssel de Schepper, (eds), 'Missions diplomatiques de Corneille Duplicius de Schepper, dit Scepperus', *Mémoires de l'Académie Royale des sciences, des lettres et des beaux-arts de Belgique* XXX (Brussels, 1857), 1–251

Sakisian, A., 'A propos d'une coupe en agate au nom du sultan timouride Hussein Baicara', *Syria* VI (1925), 274–9

——— 'Les faiences du bain de Selim II au Harem du Vieux Sérail', *Mélanges Syriens offerts à M René Dussaud* II (Paris, 1939), 959–63

Salm, W. (ed.), *Beschreibung der Reisen des Reinhold Lubenau* I–II (Königsberg, 1912, 1930)

Salmān, ʿIsā, 'Hattat ve tezhibci Nişaburlu Şah Mahmud', trans. A. H. Karabacek, *Vakıflar Dergisi* XII (1978), 329–34

Sansovino, Francesco, *Historia universale dell' origine et imperio de' Turchi* (Venice, 1564)

——— *Venetia città nobilissima et singolare* (Venice, 1581)

Sanuto, Marino, *Diarii*, 58 vols (Venice, 1881–1901)

Savory, R. M., 'The Qizilbash, Education and the Arts', *Turcica* VI (1975), 168–76

Sayılı, Adnan, "Ala al Din al Mansur's poem on the Istanbul observatory', *Belleten* XX (1956), 429–84

Schaendlinger, A. C., *Die Feldzugstagebücher des ersten und zweiten ungarischen Feldzugs Süleyman I* (=*WZKM*, supplementary vol. 8), (Vienna, 1978)

——— *Die Schreiben Süleymans des Prächtigen an Karl V, Ferdinand I und Maximilian II* I–II (Vienna, 1983)

——— 'Die osmanisch-Habsburgische Diplomatie in der ersten Hälfte des 16. Jahrhunderts', *Osmanlı Araştırmaları/The Journal of Ottoman Studies* IV (Istanbul, 1984), 181–96

Schulz, J., *The printed plans and panoramic views of Venice (1496–1799)* (Venice, 1970)

——— 'Jacopo de' Barbari's view of Venice. Map-making, city views and moralized geography before the year 1500', *Art Bulletin* LX (1978), 425–74

Schuster, Hans-Siegfried, 'Ein Talisman mit magischen Quadraten', *Festschrift Werner Caskel*, ed. H. Graf (Leyden, 1968), 290–307

Schweigger, Salomon, *Ein newe Reyssbeschreibung auss Teutschland nach Constantinopel und Jerusalem . . .* (Nuremberg, 1608)

Simon, Bruno, 'I rappresentanti diplomatici veneziani a Costantinopoli', *Venezia e i Turchi* (Banca Cattolica del Veneto, Milan, 1985), 56–69

Skelton, R. A., Introduction to facsimile edition of Bordone's *Isolario* (1528) (Amsterdam, 1966)

Skelton, Robert, 'Characteristics of later Turkish jade carving', *Fifth International Congress of Turkish Art*, ed. Géza Fehér Jr (Budapest, 1978), 795–807

Smart, Ellen, 'Fourteenth century Chinese porcelain from a Tughlaq palace in Delhi', *TOCS* XLI (1975–7), 199–230

Sohrweide, Hanna, 'Dichter und Gelehrter aus dem Osten im Osmanischem Reich (1453–1600)', *Der Islam* 46 (1970), 263–302

——— 'Der Verfasser der als Sulaymān-nāma bekannten Istanbuler Prachthandschrift', *Der Islam* 47 (1971), 286–9

Soliman the Magnificent going to mosque. From a series of engravings on wood published by Domenico de' Franceschi at Venice in MDLXIII, privately printed for Sir William Stirling Maxwell (Florence and Edinburgh, 1877)

Soucek, Svat, 'The "Ali Macar Reis atlas'" and the Deniz kitabı: their place in the genre of portolan charts and atlases', *Imago Mundi* XXV (1971), 17–27

——— 'A propos du livre d'instructions nautiques de Pirî Reis', *Revue des Etudes Islamiques* XLI (1973), 241–55

Sourdel-Thomine, Janine, 'Clefs et serrures de la Kaʿba', *Revue des Etudes Islamiques* XXXIX/1 (1971), 29–88

Soysal, Ismail, 'Turk-fransız diplomasi münasebetlerinin ilk devri', *TD* III/5–6 (1953), 62–94

Spallanzani, M., *Ceramiche orientali a Firenze nel Rinascimento* (Florence, 1978)

Spiess, Otto, 'Ein Ferman Sultan Süleyman des Prächtigen an König Johann Sigismund von Siebenbürgen', *Jean Deny Armağanı* (Ankara, 1958), 213–20

Stchoukine, I., *La peinture turque d'après les manuscrits illustrés* I. *De Suleymān Iᵉʳ à ʿOsmān II, 1520–1622* (Paris, 1966)

Stephan, St J. H., 'An endowment deed of Khasseki Sultan. Dated the 24 May 1552', *QDAP* X (1944), 170–94

Stirling Maxwell *see Soliman the Magnificent going to mosque*

Stöcklein, H., 'Die Waffenschätze im Topkapı Sarayı zu Istanbul', *AI* I (1934)

Taeschner, Franz, 'The itinerary of the first Persian campaign of Sultan Süleyman the Magnificent, 1534–6, according to Naṣūḥ al-Maṭrākī', *Imago Mundi* XIII (1956), 53–5

Tanındı, Zeren, 'Islam resminde kutsal kent ve yöre tasvirleri', *Journal of Turkish Studies* (=*Orhan Şaik Gökyay Armağanı* II), (1983), 407–37

'Resimli bir hac vekaletnamesi', *Sanat Dünyamız* 9, no. 28 (1983), 2–6

——— 'Rugânî Türk kitap kaplarının erken örnekleri', *Kemal Çığ'a Armağan* (Istanbul, 1984), 223–52

——— *Siyer-i Nebi. Islam tasvir sanatında Hz. Muhammed'in hayatı* (Istanbul, 1984)

——— 'Cilt sanatında kumaş', *Sanat Dünyamız*, Year II, no. 32 (1985), 27–34

——— '13–14 yüzyılda yazılmış Kur'anların Kanunî döneminde yenilenmesi', *Topkapı Sarayı Müzesi. Yıllık* I (Istanbul, 1986), 140–52

Tapan, Nazan, 'Sorguçlar', *Sanat* 6 (1977), 99–107

Taşkıran, N., *Hasekinin kitabı* (Istanbul, 1972)

Tauber-Königshofen Honiger, Nicolai von, *Hoffhaltung des Türckhischen Kaisers und Othomanischen Reichs Beschreibung* (Basle, 1573)

Tavernier, J. B., *Nouvelle relation du Serrail du Grand-Seigneur* (Paris, 1675)

——— *The Six voyages of John Baptiste Tavernier, Baron of Aubonne, made English by J.P.* (London, 1677)

——— *Collections of travels through Turkey into Persia and the East-Indies*, etc. (London, 1684)

Tekeli, S., *16ncı asırda osmanlılarda saat ve Takiyuddin'in mekanik saat konstruksuyonuna dair en parlak yıldızlar adlı eseri* (Ankara, 1966)

Teplov, V., *Russkiye predstaviteli v Tsaregrade, 1496–1821* (St Petersburg, 1891)

Terzioğlu, Arslan, *Moses Hamons Kompendium der Zahnheilkunde* (Munich, 1977)

Tezcan, Hülye, and Selma Delibaş, *Topkapı. Costumes, embroideries and other textiles*, ed. J.M. Rogers (London, 1986)

Tezcan, Turgay, 'Topkapı Sarayı Müzesindeki Turk miğferleri', *Sanat Dünyamız* 2/5 (September 1975), 21–7

Thuasne, L., *Gentile Bellini et Sultan Muhammed II* (Paris, 1888)

Al-Ṭībī, Muḥammad b. Ḥasan, *Jāmiʿ maḥāsin kitābat al-kuttāb*, ed. Ṣalāḥ al-Munajjid (Beirut, 1962)

Tiepolo, Lorenzo, *Relazione della Siria (1560)*, ed. E. A. Cicogna (Venice, 1857)

Tietze, Andreas, 'Muṣṭafā ʿĀlī on luxury and the status symbols of Ottoman gentlemen', *Studia Turcologica memoriae Alexii Bombaci dicata* (Naples, 1982), 577–90

Titley, N. M., 'Istanbul or Tabriz? The question of provenance of three sixteenth-century Neva'i manuscripts in the British Library', *Oriental Art* XXIV/3 (1978), 292–6

——— *Plants and gardens in Persian, Mughal and Turkish Art* (London, 1979)

——— *Miniatures from Turkish Manuscripts. A catalogue and subject index of paintings in the British Library and the British Museum* (London, 1981)

——— *Persian miniature painting, and its influence on the art of Turkey and India. The British Library collections* (London, 1983)

Tooley, R. V., 'Maps in Italian atlases of the sixteenth century', *Imago Mundi* III (1939), 12–47

Tosyeri/Tosyalı, R. Osman, *Edirne Sarayı* (Ankara, 1957)

Travelstead, R., 'An ornamental ceramic globe from the Ottoman period', *Apollo* CXV (April 1982), 237

Tschudi, Rudolf, 'Ein Schreiben Süleymans I. an Ferdinand I', *Festschrift Georg Jacob*, ed. Theodor Menzel (Leipzig, 1932), 317–28

Tucci, Ugo, 'Tra Venezia e mondo Turco: i mercanti', *Venezia e i Turchi* (Banca Cattolica del Veneto, Milan, 1985), 38–55

Turan, Şerafettin, *Kanunî'nin oğlu Şehzade Bayezid vakʿası* (Ankara, 1961)

——— 'Osmanlı teşkilatında Hassa mimarları', *Tarih Araştırmaları Dergisi* I/1 (1963), 157–202

——— '1560 tarihinde Anadolu'da yiyecek maddeleri fiyatlarını gösteren bir Iran elçilik hey'eti masraf defteri', *DTCF Dergisi* XXII (Ankara, 1965)

——— 'Rodos'un zaptından Malta muhasarasına', *Kanunî Armağanı* (Ankara, 1970), 47–117

Türkoğlu, Sabahettin, 'Saray kuyumculuğu', *Sanat Dünyamız* 11/34 (1985), 2–17

Uluçay, M. Cağatay, *Osmanlı sultanlarına aşk mektupları* (Istanbul, 1960)

——— 'Yavuz Sultan Selim nasıl padişah oldu', *TD* VI (1954), 53–90; VII (1954), 117–42; VIII (1955), 185–200

——— *Haremden mektuplar* (Istanbul, 1956)

——— 'Kanunî Sultan Süleyman ve ailesi ile ilgili bazı notlar ve vesikalar', *Kanunî Armağanı* (Ankara, 1970), 227–57

——— *Harem* II (Ankara, 1971)

Umur, Suha, *Osmanlı Padişah Tuğraları* (Istanbul, 1980)

Ünal, Ismail, 'Çin porselenleri üzerindeki Türk tarsiâtı', *Türk San'atı Tarihi. Araştırma ve incelemeleri* I (Istanbul, 1963), 674–714

Ünsal, B., 'Topkapı Sarayı arşivinde bulunan mimari planlar üzerine', *Türk San'atı Tarihi. Araştırma ve incelemeleri* I (Istanbul, 1963), 168–97

Ünver, A. Süheyl, *Ressam Nigârî. Hayatı ve eserleri* (Istanbul, 1946)

——— *Müzehhip Karamemi* (Istanbul, 1951)

——— *Istanbul rasathanesi* (Ankara, 1969)

Ünver, A. Süheyl, and Gülbün Mesara, *Türk ince oyma sanatı: kaatı* (Istanbul-Ankara, 1980)

Uzunçarşılı, I. H., *Osmanlı devleti teşkilatından kapukulu ocakları* I–II (Ankara, 1943–4)

——— *Osmanlı devletinin Saray teşkilatı* (Ankara, 1945)

——— *Osmanlı devletinin Merkez ve Bahriye teşkilatı* (Ankara, 1948)

——— 'Onaltıncı asır ortalarında yaşamış olan iki büyük şahsiyet: Tosyalı Celalzade Mustafa ve Salih Çelebiler', *Belleten* XXII (1958), 391–441

——— 'Şah Ismail'in zevcesi Taclı Hanım'ın mücevheratı', *Belleten* XXIII (1959), 611–19

——— 'Iran Şah'ına iltica etmis olan Şehzade Bayezid'in teslimi için Sultan Süleyman ve oğlu Selim tarafından Şah'a gönderilen altınlar ve kıymerli hediyeler', *Belleten* XXIV (1960), 103–10

——— 'Kanunî Sultan Süleyman'ın vezir-i âzam Makbul ve Maktul Ibrahim Paşa damadı değildir', *Belleten* XXIX (1965), 355–61

——— 'Şehzade Mustafa'nın ölümünde medhali olan vezir-i âzam Rüstem Paşa'nın ikinci sadaretinde Yeniçerilerin ağalarından şikayeti hâvi Kanunî Sultan Süleyman ile Rüstem Paşa'ya pek ağır mektupları', *Belleten* XXXI (1967), 191–200

——— 'Sancağa çıkarılan Osmanlı şehzadeleri', *Belleten* XXXIX (1975), 659–96

——— 'Nahil ve nakıl alayları', *Belleten* XL (1976), 55–65

——— 'Osmanlı sarayında ehl-i hiref "sanatkarlar" defterleri', *Belgeler* XV (Ankara, 1986), 23–76

Villalón, Cristóbal (Andrés Laguna), *Viaje de Turquia, Autobiografías y Memorias*, ed. M. Serrano y Sans (Madrid, 1905)

Wace, A. J. B., 'The dating of Turkish velvets', *Burlington Magazine* LXIV (1934), 167–70

Walsh, J. B., 'The revolt of Alqās Mīrzā', *WZKM* 68 (1976), 61–78

Wearden, Jennifer, 'Siegmund von Herberstein. An Italian velvet at the Ottoman Court', *Costume* 19 (1985), 22–9

Weitnauer, A., *Venezianischer Handel der Fugger* (Munich-Leipzig, 1931)

Wethey, H., *The paintings of Titian. II. The Portraits* (London, 1971)

Winter, Heinrich, 'Catalan portolan maps, and their place in the total view of cartographic development', *Imago Mundi* XI (1954), 1–12

Wittek, P., 'The Turkish documents in Hakluyt's Voyages', *Bulletin of the Institute of Historical Research* XIX (1942–3), 121–39

——— 'Notes sur la Tughra ottomane', *Byzantion* XVIII (1948), 311–34

Woodhead, C. M., 'An experiment in official historiography. The post of Şehnameci in the Ottoman Empire, c. 1555–1605', *WZKM* 75 (1983), 157–82

Wulzinger, K., 'Melchior Lorichs Ansicht von Konstantinopel als topographische Quelle', *Festschrift Georg Jacob*, ed. Theodor Menzel (Leipzig, 1932), 353–68

Wüstenfeld, F., *Geschichte der Stadt Mekka, nach den arabischen Chroniken bearbeitet* (Leipzig, 1861)

Yağmurlu, Haydar, 'Topkapı Sarayı Müzesi kütüphanesinde imzalı eserleri bulunan tezhip ustaları', *TED* XIII (1973), 79–131

Yenişehirlioğlu, Filiz, 'Şehzade Mehmed türbesi çinileri üzerinde gözlemeler',

Bedrettin Cömert'e Armağan (Istanbul, 1980), 449–56

Yetkin, Şerare, 'Turk kilim sanat'ında yeni bir gurup. Saray kilimleri', *Belleten* XXXV (1971), 217–27

——— 'Osmanlı Saray halılarından yeni örnekler', *STY* VII (1977) 143–64

Yücel, Ünsal, 'Türk kılıç ustaları', *TED* 7–8 (1964–5), 59–99

——— 'Thirteen centuries of Islamic arms', *Apollo* XCII (July 1970), 46–9

Yurdaydın, Hüseyin G., 'Kitab-i bahriye'nin telifi meselesi', *DTCF Dergisi* X (Ankara, 1952), 143–6

——— *Kanunî'nin cülûsü ve ilk seferleri* (Ankara, 1961)

——— 'Muradî ve eserleri', *Belleten* XXVII (1963), 453–66

——— *Naṣūḥü's-Silāḥī (Maṭrākçī), Beyān-i Menāzil-i Sefer-i 'Irākeyn-i Sulṭān Süleymān Ḫān* (Ankara, 1976)

Zaky, Abdel Rahman, 'Medieval Arab arms', *Islamic arms and armour*, ed. Robert Elgood (London, 1979), 202–12

Zand, M., 'What is the tress like? Notes on a group of standard Persian metaphors', *Studies in memory of Gaston Wiet*, ed. M. Rosen-Ayalon (Jerusalem, 1977), 463–79 'Zâtî', *IA*

Zick-Nissen. J., 'Die "Tebriser Meister" und kunsthandwerkliche Produkte in Berliner Sammlungen', *Festschrift für Peter Wilhelm Meister* (Hamburg, 1975), 62–70

——— 'Some rare pieces of Ottoman blue-and-white ceramics', *IVe congrès international d'art turc* (Aix-en-Provence, 1976), 249–56

Exhibition Catalogues

BALTIMORE 1957 *The art of bookbinding, 525–1950 AD* (Walters Art Gallery, Baltimore, 1957)

BERLIN 1971 Peter Dreyer, *Tizian und sein Kreis: 50 venezianische Holzschnitte aus dem Kupferstichkabinett* (Staatliche Museen Preussischer Kulturbesitz, Berlin, 1971)

BERLIN 1982 *The arts of Islam: Masterpieces from the Metropolitan Museum of Art* (Museum für Islamische Kunst, Dahlem, Berlin, 1982)

BERLIN 1986 *Islamische Kunst. Verborgene Schätze* (Selm, Schloss Cappenberg–Berlin-Dahlem, 1982)

CHICAGO 1981 Gulnar Bosch, John Carswell and Guy Petherbridge, *Islamic bindings and book-making* (Oriental Institute, University of Chicago, 1981)

CHICAGO 1985 John Carswell, *Blue and white. Chinese porcelain and its impact on the Western world* (Smart Gallery, University of Chicago, 1985)

DÜSSELDORF 1973 *Islamische Keramik* (Hetjens Museum, Düsseldorf, 1973)

FRANKFURT 1985 *Türkische Kunst und Kultur aus osmanischer Zeit* (Museum für Kunsthandwerk, Frankfurt am Main, 1985)

ISTANBUL 1956 *Eski çekmeceler* (Topkapı Saray Museum, Istanbul, 1956)

ISTANBUL 1958 *Kanunî Sultan Süleyman sergisi* (Topkapı Saray Museum, Istanbul, 1958)

ISTANBUL 1966 *Kanunî Sultan Süleyman'ın 400. ölüm yıldönümü dolaysiyle sergisi kataloğu* (Süleymaniye Library, Istanbul, 1966)

ISTANBUL 1983 *The Anatolian Civilisations/Anadolu Medeniyetleri Sergisi* (Istanbul, 1983)

ISTANBUL 1986 Ayşegül Nadir (ed.), *Osmanlı Padişah fermanları/Imperial Ottoman Fermans* (TIEM, Istanbul, 1986)

KARLSRUHE 1955 *Der Türkenlouis, zum 300. Geburtstag des Markgrafen Ludwig Wilhelm von Baden* (Badisches Landesmuseum, Karlsruhe, 1955)

LONDON 1976 *The arts of Islam* (Hayward Gallery, London, 1976)

LONDON 1983 *The Eastern carpet in the Western world, from the 15th to the 17th century* (Hayward Gallery, London, 1983)

LONDON 1983 *Islamic art and design, 1500–1700* (British Museum, London, 1983)

LONDON 1984 J. Rawson, *The Lotus and the Dragon* (British Museum, London, 1984)

MILAN 1987 *Anatolia. Immagini di civiltà. Tesori dalla Turchia* (Milan, 1987)

MOSCOW 1979 *Sokrovishcha prikladnogo iskusstva Irana i Turtsii XVI–XVII vekov iz sobranii gosudarstvennykh muzeyev Moskovskogo Kremlya* (Kremlin Armoury, Moscow, 1979)

MUNICH 1910 Friedrich Sarre, F. R. Martin and Max van Berchem, *Die Ausstellung von Meisterwerke Muhammedanischer Kunst in München 1910 I–IV* (Berlin, 1912)

MÜNSTER 1983 *Münster, Wien und die Türken* (Münster, 1983)

NEW YORK 1983 Thomas Kren (ed.), *Renaissance painting in manuscripts. Treasures from the British Library* (New York, 1983)

NUREMBERG 1985 *Wenzel Jamnitzer und die nürnberger Goldschmiedekunst 1500–1700* (Germanisches Nationalmuseum, Nuremberg, 1985)

PARIS 1953 *Splendeur de l'art Turc* (Musée des Arts Décoratifs, Paris, 1953)

PARIS 1977 *L'Islam dans les collections nationales* (Paris, 1977)

SCHALLABURG 1982 *Matthias Corvinus und die Renaissance in Ungarn, 1458–1541* (Schloss Schallaburg, Niederösterreich, 1982)

SINGAPORE 1978 *Exhibition of Chinese blue and white ceramics* (Southeast Asian Ceramic Society, Singapore, 1978)

TOKYO 1985 *Uygarlıklar ülkesi Türkiye. Land of civilisations, Turkey* (Tokyo, 1985)

VIENNA 1980 *Wien 1529: Die erste Türkenbelagerung* (Vienna, 1980)

VIENNA 1983 *Österreich und die Osmanen* (Nationalbibliothek, Vienna, 1983)

WARSAW 1983 *Tkanina turecka XVI-XIX w. ze zbiorów polskich* (National Museum, Warsaw, 1983)

WASHINGTON 1966 *Art Treasures of Turkey* (Smithsonian Institution, Washington DC, 1966)

WASHINGTON 1987 Esin Atıl, *The age of Süleyman the Magnificent* (National Gallery of Art, Washington DC, 1987)

Concordance

London 1988	Washington 1987	London 1988	Washington 1987	London 1988	Washington 1987	London 1988	Washington 1987
1	—	42	38	83	86	124	138
2	—	43a–b	39a–b	84	87	125	139
3	—	44	40	85	88	126	140
4a–b	—	45a–d	41a–d	86	89	127	150
5	—	46a–b	42a–b	87	84	128	168
6	—	47	—	88	95	129	166
7	—	48	—	89	96	130	—
8	1	49	44	90	98	131	—
9	2	50a–d	45a–d	91	99	132	170
10	3	51	47	92	100	133	181
11	5	52a–b	48a–b	93	101	134	—
12	6	53a–f	49a–f	94	102	135	—
13	7	54	76	95	103	136	178
14	8	55	77	96	106	137	180
15a–b	9a–b	56	78	97	107	138	183
16	10	57	79	98	108	139	186
17	11	58	80	99	109	140	—
18	12	59	81	100	110	141	—
19	13	60	82	101	111	142	—
20	14	61	83	102a–b	112a–b	143	—
21	15	62	50	103a–b	113a–b	144	—
22	16	63	54	104	115	145	—
23	17	64	55	105	114	146	175
24a–b	18a–b	65	56	106	116	147	—
25	19	66	57	107	118	148	—
26	20	67	—	108	119	149	—
27	21	68	61	109a–b	121a–b	150	163
28	24	69	62	110	122	151	—
29	25	70	63	111	123	152	195
30	27	71	64	112	124	153	—
31	26	72	66	113	125	154	196
32a–b	28a–b	73	67	114	126	155	—
33	29	74	68	115	127	156	—
34	32	75	69	116	128	157	—
35a–b	33a–b	76	70	117	129	158	—
36	23	77	71	118	130	159	189
37	22	78	72	119	131	160	—
38	—	79	73	120	132	161	—
39	35	80	74	121	133	162a–b	—
40	36	81	91	122	134	163	197
41	37	82	85	123	137	164	210